Aesthetics and Politics in
Modern German Culture

Aesthetics and Politics in Modern German Culture

FESTSCHRIFT IN HONOUR OF RHYS W. WILLIAMS

edited by

Brigid Haines
Stephen Parker
Colin Riordan

PETER LANG

Oxford · Bern · Berlin · Bruxelles · Frankfurt am Main · New York · Wien

Bibliographic information published by Die Deutsche Nationalbibliothek.
Die Deutsche Nationalbibliothek lists this publication in the Deutsche
Nationalbibliografie; detailed bibliographic data is available on the
Internet at http://dnb.d-nb.de.

A catalogue record for this book is available from the British Library.

Library of Congress Cataloging-in-Publication Data:

Aesthetics and politics in modern German culture : festschrift in honour
of Rhys W. Williams / [edited by] Brigid Haines, Stephen Parker, Colin
Riordan.
 p. cm.
 "The papers... were delivered at a conference, Aesthetics and Politics
in Modern German Culture, which was held in honour of Professor Rhys W.
Williams ... the conference took place, from 31 August to 2 September
2008, at the University of Wales Conference Centre, Gregynog Hall"
--Foreword.
 Includes bibliographical references and index.
 ISBN 978-3-03911-355-2 (alk. paper)
 1. Aesthetics, German--Congresses. 2. Political
culture--Germany--Congresses. I. Haines, Brigid, 1959- II. Parker,
Stephen, 1955 Apr. 22- III. Riordan, Colin, 1959- IV. Williams, Rhys W.,
1946-
 BH221.G34A26 2010
 700.943'0904--dc22
 2009034416

ISBN 978-3-03911-355-2

© Peter Lang AG, International Academic Publishers, Bern 2010
Hochfeldstrasse 32, CH-3012 Bern, Switzerland
info@peterlang.com, www.peterlang.com, www.peterlang.net

Printed in Germany

Contents

Foreword

The papers, the appreciation and the poem that have been collected in the present volume were delivered at a conference, Aesthetics and Politics in Modern German Culture, which was held in honour of Professor Rhys W. Williams upon his retirement from the Chair of German at Swansea University in the summer of 2008. Aptly, the conference took place, from 31 August to 2 September 2008, at the University of Wales Conference Centre, Gregynog Hall. Over the years, Gregynog has lent its convivial atmosphere to many conferences in which Rhys has played a leading role. The papers were delivered by the large number of Rhys's colleagues and former PhD students who had occasion to thank him for the hugely enabling support that he has given to them in their academic careers over many years. The conference schedule placed papers according to broad themes in modern German culture, all of which reflect Rhys's research interests: Expressionism and *Neue Sachlichkeit*; Representing/Resisting National Socialism; West German Writing; GDR Spaces and Voices; Exploring Masculinities in Fiction; Performing Politics, Performing Humour; Intertexts and Difference; and Lives and Letters. This distribution of papers worked well, stimulating lively discussion. We hope that the retention of that distribution for publication will facilitate readers' enjoyment of this volume. The poem written in Rhys's honour by Mererid Hopwood and the appreciation by David Basker precede the papers. Mererid and David paint a vivid picture of the very human qualities that Rhys always brought to bear in his academic activity, enriching the experience of those who had the good fortune to work with him. As editors, we are delighted to be in a position to publish all the papers that we have been offered, as well as two others from colleagues who could not attend the conference, Moray McGowan and Neil Donahue. We'd like to thank our authors for their co-operation in the preparation of the manuscript, which has enabled us to publish so

many pieces within the parameters agreed with our publisher, Peter Lang. We'd like to thank Graham Speake and his team at Peter Lang for their valuable support and Cara Banerji-Parker for compiling the index.

Brigid Haines, Swansea
Stephen Parker, Manchester
Colin Riordan, Essex

Cywydd Ffarwelio Rhys

MERERID HOPWOOD

Mae awr i fwynhau miri, y mae awr
mi wn am hwyl cwmni,
ond nawr, yn ein dathliad ni,
mae un na fynnaf mo'ni.

Awr dawel dy ffarwelio – ond awr drist
awr drom, nad â heibio
waeth awr yw a ddaw'n ei thro
ar alaw pob ffarwelio.

O'r Dderwen Fawr, awr y hon
a'n geilw yn y galon,
wele hi o Ben-y-lan
a bro hudol Glanbrydan,
o Lansamlet a Sgeti
wele nawr mae'n galw ni –
o Fryn-y-môr a Threforus
down a rhown ddiolch i Rhys.

Ynot ti mae Abertawe'n – dre wen
yn draeth ac yn heulwen,
ac o hyd, ti'r gweilch a'u gwên,
a sŵn alaw San Helen.

A thra bydd gorwel gwelw – tra bydd tre
tra bydd trai a llanw
a'u lliw llwyd, bydd, ar fy llw,
y don yn dweud dy enw.

Professor Rhys W. Williams.

Professor Rhys W. Williams: An Appreciation

DAVID BASKER

Inspired by a personal memory, I should like to begin my account of the career of Professor Rhys Williams by addressing the subject of levitation. I had been in Swansea as a postgraduate student for about three weeks when I was persuaded by my new Head of Department to set off in a 'luxury coach' for the annual meeting of German departments in the University of Wales at the conference centre at Gregynog in Powys. Three stomach-churning hours on the B-roads of mid-Wales later we arrived and, following some Alka Seltzer, an agreeable dinner and an even more agreeable evening in the bar, I witnessed something remarkable in the small hours of the morning. The aforementioned Head of Department, who had enjoyed plenty of what the bar had to offer by this point, swung himself up onto a table and, as if suspended by wires from the ceiling, in a prone position balanced his whole body weight on his finger-tips above the table surface. As a feat of levitation by a senior academic, it was second to none. To the growing frustration of the assembled twenty-year-old, athletic male students, no one could even come close to emulating the gravity-defying exploit. Our levitator was, of course, Professor Rhys Williams. And this was just the tip of the iceberg as far as his mystical powers were concerned: the double-headed coin trick and the disappearing coin trick followed (indeed, a well-worn joke in Swansea has it that he could make any departmental deficit disappear in much the same way). Naïve though it may sound, I was spellbound: here was some-one who could, in quick succession, speak with authority about any aspect of German literature and culture, give a closely argued assessment of the best scrum half ever to play for the All Whites (Robert Jones, of course), and make a 50-pence-piece vanish into thin air. What impressed me that evening is what has impressed everyone who has come into contact with Rhys in the course of his career: his outstanding academic achievements

and professional successes have always been allied with a very wide range of interests, an incorrigible sense of fun and the capacity to enjoy life to the full under any circumstances. While my focus here will, of course, be on Rhys's professional career, an appreciation of that career needs to look outside the strictly academic too.

To begin at the beginning, Rhys came into the world in 1946 in what is now the Celtic Manor Hotel on the edge of the M4, then one of Gwent's leading hospitals. His father, M. J. Williams, was a clergyman – I should perhaps say the most important clergyman – in the Baptist Union of Wales at the time and he subsequently rose to become leader of the church and receive that typically Welsh accolade of being known simply by his initials. M. J.'s career shaped Rhys's early life in ways his father had not, perhaps, intended. Growing up in Milford Haven and attending his father's services two or three times every Sunday, Rhys quickly developed a thorough knowledge of the Bible, a scepticism for religion and a capacity to memorise and replay in his head poems and rugby matches, which helped to kill the boredom. It was clearly not with the intention of preparing to follow in his father's footsteps into a career in the church, therefore, that Rhys first moved to Swansea as an eleven-year-old to attend secondary school. It is a curious fact that that secondary school – Bishop Gore in Swansea – was the same school in which Rhys's wife Kathy would become a teacher some years later. Like nearly all Welsh grammar schools Bishop Gore had high academic standards, which Rhys easily met. It is worth noting, too, that Bishop Gore provided the first opportunity for Rhys to encounter life in Germany, through the town's twinning agreement with Mannheim. Travelling to Germany became then – and still is, for Rhys – an experience of fascination, excitement and freedom.

In 1965 Rhys left Swansea for the bright academic lights of Oxford, having been awarded the Welsh Foundation Scholarship to study at Jesus College, where he read French and German. He rose easily to the challenges which study in Oxford offered and, among other accolades, was awarded the Junior Heath Harrison Scholarship, which he spent at the LMU in Munich. Oxford gave Rhys the opportunity to immerse himself in European literature and in the real ales of the Cotswolds. In characteristic fashion, he studied hard and still found time to enjoy himself and, of

course, to meet his future wife, Kathy. He graduated in 1968 with first-class honours and inevitably won a Major State Studentship, which enabled him to move on to postgraduate study at Jesus College. He settled, for the topic of his DPhil, on the works of Carl Sternheim, a subject ideally suited to someone who combined an incisive, positivistic reading of literature with a keen and subtle sense of humour. This period saw further opportunities to live and work in Germany, first at the *Literaturarchiv* in Marbach as a result of a further prize, then as a *Lektor* at the University of Erlangen in northern Bavaria. Thus began a close relationship with *Frankenwein* which continues to this day.

Rhys was awarded his DPhil – 'Carl Sternheim's Aesthetics in Theory and Practice' – in 1973, having already begun his first academic job, a Tutorial Research Studentship at Bedford College in London. In 1974 he moved to a lectureship in German at the University of Manchester, where he worked for the next ten years. This, of course, was in the days when a German department consisted of a series of period specialists, each jealously guarding his or her own turf. It is characteristic of Rhys's versatility that the post in Manchester was actually the 'eighteenth-century job' in that department, to which he turned his hand easily; but it was some time before he was allowed to set foot in the areas in which his real academic interests lay: Expressionism, post-war literature of the two Germanies, and contemporary German literature. Eventually he was able to establish a set of courses on twentieth-century German literature that appealed to undergraduate students and inspired the best of them to go on to complete postgraduate study with Rhys as their supervisor. Indeed, it is one of Rhys's great achievements in our profession that he has consistently attracted PhD students, instilled in them a practical approach to completing their research, and prepared them effectively for successful academic careers: there are a Vice-Chancellor, a number of professors, and an even larger number of senior lecturers and lecturers who owe their successful careers to this hard-headed approach. In terms of his own academic research, the Manchester years saw an enviable list of prominent publications in areas that chart his developing interests: a series of articles on Sternheim, Carl Einstein and Georg Kaiser and the publication of his DPhil dissertation as a book are accompanied by an increasing number of essays on more

recent figures: Heinrich Böll, Alfred Andersch, Martin Walser and Sieg-fried Lenz, to name just a few. These publications served to establish his reputation as one of the leading experts on modern German literature of his generation.

While Rhys's career clearly flourished in Manchester, there is an extent to which he was in an alien environment, a Welshman abroad; perhaps it was the lack of a decent rugby team, perhaps it was the northern accent, perhaps it was the rain-soaked newspapers clinging to his legs as he walked through the streets of Rusholme on the way to work. Whatever the precise reason, with the encouragement of some prominent academics outside Manchester who had read and been impressed by his growing body of work, Rhys was persuaded to begin applying for chairs elsewhere. As luck would have it, the first opportunity that arose was the chair of German in a very familiar location and he was immediately successful: in 1984, Rhys was appointed to the Chair in Swansea and returned to the place that he had always regarded as home. I am sure that those who worked in Swansea at that time will forgive me for saying that German was not in a particularly strong position. While Rhys's predecessor, Morgan Waidson, certainly had his qualities – as the excellent library holdings in German in Swansea prove – the drive to build a large, flourishing department was not among them. Rhys quickly set about addressing the relative weaknesses of German with a combination of sharp political acumen, single-minded determination and the ability to charm the birds off the trees – or, should I say, money out of the Vice-Chancellor. Pity the Professor of Engineering or Chemistry who thought that he was dealing with just another Arts professor who would roll over and play dead in the face of their attempts to grab money and power at the expense of languages. It is perhaps still among one of Rhys's favourite compliments that one Swansea colleague bemoaned: 'They have put a gangster in charge of the German department'.

The Al Capone of German studies made a series of strategic appoint-ments to German in Swansea that, almost at a stroke, turned it into a depart-ment that was attractive to students of all sorts and had a vibrant research culture. Undergraduate numbers grew rapidly; and his success in attracting research students was transported easily from England to Wales as he super-vised a series of PhDs that focused on the same area: the continuities in

writing before and after 1945. Rhys was behind the strategic decision to focus research in a single broad area, so that expertise could be shared, and the idea proved to be a recipe for research success. German grew steadily through the 1980s and into the early 1990s, in terms of numbers of staff, undergraduates and postgraduates. Both in Swansea and in the subject area nationally Rhys was tireless in committing himself to the success of the German department, even if it meant unreasonable demands on his own administrative time and patience. I particularly remember him regaling anyone who would listen with stories of the absurd trivialities that occupied the time of the IT working party of which he became chair, and which bore the wonderful *sprechende Name* of the 'Small Users Committee'; 'Small Users' will surely be the name of the campus novel that Rhys will inevitably write. What is more, German under Rhys led the way for the other languages in Swansea: quickly it became clear that the old departments of Romance Studies and German and Russian, far from being burdens for the university to carry, could become – as separate language departments of French, German, Italian, Russian and Hispanic Studies – drivers of Swansea's reputation. As a result of his efforts, new chairs were appointed in all of the language areas, and the School of European Languages, with Rhys as its head, became an increasingly big fish in the ponds of UWS and language studies nationally. By 1988, he was Dean of the Faculty of Arts, too. Lest those who have not seen him in committee action think he had become a card-carrying *appa-ratchik* who lived only for committee work by now, I believe he still holds the record for the fastest Faculty meeting in Swansea's history (the fact that the Whites were playing a Rugby match with a 2.30 kick-off that afternoon is, of course, purely incidental). My point might sound facetious, but, to return to my opening remarks, it seems to me that the secret of his success in university politics has always been the willingness to take on any task, without allowing himself to take it too seriously or lose sight of the outside world. Inevitably, then, Rhys soon rose to the position of PVC, a post that he – amazingly – held for over ten years. A measure of his successes in these areas is that, for several years in the late 1990s, he was simultaneously Head of the German Department, Head of the School of European Languages, Cost Centre Manager for Languages, Dean of Admissions for the University and PVC (Academic). Not all colleagues have always realised

how much that commitment to the success of languages has fostered and protected the departments concerned over the years.

Perhaps one of the most amazing aspects of Rhys's career is that, despite his obvious commitment to university politics and administration and to nurturing his subject area, he has continued throughout his time in Swansea to steer the research activities of the German Department very effectively and to maintain his personal reputation as a researcher of the highest quality. Expressionism and the literature of the Federal Republic have been the main focal points of his own publications during the Swansea years and he is clearly among the leading experts in both fields in Britain. It seems incredible that he also found time to conceive of and – with Colin Riordan's help – implement an ambitious writer-in-residence project in Swansea. The idea for the project, well fed over a number of weeks with the inspirational Welsh nutrient known as Brains' bitter, became the Centre for Contemporary German Literature, out of which some twelve volumes of essays, interviews and previously unpublished works by some of Germany's most prominent writers have been produced: Volker Braun, Uwe Timm, Sarah Kirsch, Jureck Becker and Herta Müller are just some of the writers who would never have come to Swansea had it not been for Rhys and Colin's efforts. Indeed, there is a small but growing presence of references to Swansea in German literature as a result of these activities: Uwe Timm has written a short story set in Laugharne and which ends at High Street station; and Rhys appears in Sarah Kirsch's poems on a number of occasions, as 'mein grauäugiger Gastgeber', for example, and as 'mein bester mir zugeteilter Professor'.[1] In fact, any research into the activities of the Centre would reveal some fascinating stories, too. Take, for example, the hopelessly disorganised author, who managed on the day of his departure from Swansea to forget his passport, but was able to prove his identity at passport control by showing the officials a picture of himself on the dust-jacket of one of his books. The Centre has certainly enlivened all of Swansea's research activities and, here as elsewhere, Rhys leaves a powerful

1 Sarah Kirsch, 'Mumbles-Bay', in *Erlkönigs Tochter* (Stuttgart: Deutsche Verlags-Anstalt, 1992), 38.

legacy, which will be much harder to carry forward without his commitment and enthusiasm.

It would, of course, do no justice to Rhys's career if I were to restrict my comments to his activities inside the institutions in which he has worked. He has worked equally tirelessly to promote those institutions to the outside world and to further the subject of German Studies nationally and internationally in ways that are too numerous to mention. Just to give you a flavour: he has represented Swansea in a range of roles at the level of the University of Wales and, more recently, lobbied the Welsh Assembly Government to further the interests of Swansea University and of languages in particular; he has been Vice-President and President of the CUTG; he has served as external examiner and external assessor at a very wide range of UK institutions; his judgement and scrupulous fairness have been used well by funding bodies including the British Academy, the AHRC and the DAAD; and he has served as President of the *Carl-Einstein-Gesellschaft* and as a member of the committee of the *Alfred-Andersch-Gesellschaft*. The *Auslandsämter* of most of the universities in Bavaria count him among their friends; and there is a *Gasthaus* on the outskirts of Bamberg at which, for over ten years, we met our students on their intercalary year, where Rhys is greeted like a member of the family.

It is clear from this brief account that Rhys has enjoyed an extremely full and varied career and he has affected the lives of his colleagues and countless students in many different ways. I have only made passing allusion to his interests outside his professional life which, as I have said, have maintained in him an admirable sense of perspective, even at the most pressured professional times: his love of rugby and cricket, his passion for detective novels, for solving crosswords, for cooking and for the red wines of Bordeaux. The memory with which my account begins, of that scene of levitation in the bar at the Gregynog conference centre, lies about twenty years in the past; time catches up on everyone and I am not sure that a repeat performance is likely. The underlying point defeats the passage of time, however: the most appropriate way to mark Rhys's retirement is to express here, on behalf of everyone who has encountered him in his career, a heartfelt appreciation of his ability to combine a serious engagement with academic interests with as much sheer enjoyment as possible.

Carl Einstein, Daniel-Henry Kahnweiler and the Aesthetics of Cubism

DUNCAN LARGE

Introduction

In recent years, Rhys Williams' research publications have focused on German literature of the post-1945 period, with two distinct clusters of interest: on the one hand Alfred Andersch, the *Gruppe 47* and what one recent article calls 'Der Wiederaufbau der deutschen Literatur' in the immediate post-War period,[1] on the other contemporary writing, especially the work of those writers who have visited the Centre for Contemporary German Literature which he and Colin Riordan established at Swansea in 1993. Any comprehensive appreciation of Williams' work nevertheless needs also to address an area of his output which continues to form an alternative pole of his productivity, namely the German Expressionist writing of the early decades of the twentieth century. In this context one thinks, of course, primarily of his work on Carl Sternheim, which established his international research reputation in the late 1970s and 1980s – Sternheim the subject of his landmark critical study in 1982, and the 'Text + Kritik' volume he edited with Heinz Ludwig Arnold in 1985.[2] But it is instructive to note that a fascination with Expressionism is characteristic not just of

1 Rhys W. Williams, 'Der Wiederaufbau der deutschen Literatur', *Aus Politik und Zeitgeschichte*, 18 June 2007, 12–18. Online at <http://www.bpb.de/publikationen/ZMK8L8,0, Der_Wiederaufbau_der_deutschen_Literatur.html>.

2 Rhys W. Williams, *Carl Sternheim. A Critical Study* (Berne: Peter Lang, 1982); *Carl Sternheim*, eds Rhys W. Williams and Heinz Ludwig Arnold (Munich: Text + Kritik, 1985).

Rhys Williams' early work, and that his publications list – to cite examples just since the turn of the millennium – includes essays and encyclopedia articles not merely on Sternheim but on Expressionist prose fiction and the Expressionists' reception of Goethe, on Georg Kaiser, Ernst Toller, Gustav Landauer and the figure on whom I want to focus here, the writer, critic and political activist Carl Einstein (1885–1940).[3]

Rhys Williams on Carl Einstein

In the 1980s, Williams' articles on Einstein[4] established him at the forefront of international research on this – at that stage still relatively neglected – figure and led to his election in 1987 as Chair of the fledgling *Carl-Einstein-Gesellschaft* (in which capacity he served for five years till 1992). Developing his interest in the aesthetics of Sternheim (which dates right back to his doctoral dissertation and earliest articles)[5] into a broader treatment of the relation between Expressionism and the visual arts, Williams' work on Einstein in the 1980s focused on the impact of Einstein's pioneering 1915 essay *Negerplastik*, and on the implications of its primitivism for the aesthetics of the Expressionist movement. *Negerplastik* (with its 119 illustrations) was rapidly and widely admired as the first Western study to treat African art *as* art (rather than ethnography). In it, Einstein deliberately adopts what

3 For details, see the comprehensive list of Rhys Williams' publications in this
 volume.
4 Rhys W. Williams, 'Primitivism in the Works of Carl Einstein, Carl Sternheim and
 Gottfried Benn', *Journal of European Studies*, 13 (1983), 4, 247–67; 'Carl Einstein's
 Negerplastik and the Aesthetics of Expressionism', in *Expressionism in Focus*, ed.
 Richard Sheppard (Blairgowrie: Lochee, 1987), 73–92.
5 See especially Williams, 'Carl Sternheim's Aesthetics in Theory and Practice', unpub-
 lished D.Phil. dissertation, University of Oxford, 1973; 'Carl Sternheim's Image of
 Van Gogh', *Modern Language Review*, 72 (1977), 1, 112–24; 'From Painting into
 Literature: Carl Sternheim's Prose Style', *Oxford German Studies*, 12 (1981), 139–57.

one might call a hyper-formalist approach – the works on which he comments are deliberately de-individualised, dehistoricised, decontextualised – and he treats the example of African sculpture as offering solutions to a series of formal, theoretical problems which he isolates in contemporary Western art, specifically the crisis (as he perceives it) in its representation of three-dimensional space ('die Voraussetzung aller Plastik, der kubische Raum').[6] As Williams points out, although *Negerplastik* was the work which established Einstein's reputation across Europe, he would revise and indeed reject a good deal of its interpretative baggage in the art-critical works that followed, especially in his 1926 overview of *Die Kunst des 20. Jahrhunderts* but in some respects even as early as his volume on *Afrikanische Plastik* in 1921, which followed hard on the heels of the second edition of *Negerplastik* the previous year.

For Williams, then, *Negerplastik* is primarily of interest as a document of its time – as what he terms 'one of the most frequently mentioned but perhaps least accessible tracts of German Expressionism'[7] – and he duly subjects it to what one might call a symptomatic reading, highlighting the respects in which it betrays the concerns of its age. He draws out three specific features of Einstein's early work, firstly what he calls its 'epistemological framework':[8] *Negerplastik* is, among other things, a densely theoretical meditation on the constitution (dematerialisation) of the art object, which derives from Einstein's education in the German aesthetic and philosophical tradition as a student in Berlin.[9] In addition to the Nietzschean, Jungian, Bergsonian and German Romantic influences and echoes which Williams discerns in Einstein's early work, two features of the analysis seem to me to

6 Carl Einstein, 'Negerplastik', in *Werke. Berliner Ausgabe*, eds Hermann Haarmann and Klaus Siebenhaar, 5 vols (Berlin: Fannei & Walz, 1992–6), vol. 1 (1994), 234–52 (239).

7 Williams, 'Primitivism', 249.

8 Williams, 'Primitivism', 252.

9 See Liliane Meffre, 'Carl Einstein et Daniel-Henry Kahnweiler: leur conception du cubisme', *Umění / Art*, 49 (2001), 2, 132–36 (134). On Einstein's aesthetics more generally, see Heidemarie Oehm, *Die Kunsttheorie Carl Einsteins* (Munich: Fink, 1976).

be particularly pertinent here: on the one hand, Williams likens Einstein to Husserl and considers the analytic method practised in *Negerplastik* 'akin to the process of phenomenological reduction';[10] on the other, he draws attention to the influence on Einstein of Wilhelm Worringer's 1907/8 dissertation *Abstraktion und Einfühlung.*[11]

A second move made by Williams in these pieces on Einstein's *Negerplastik* – and one which is wholly characteristic, as the title of this volume attests – is to focus on the nexus of aesthetics and politics in Einstein, to highlight the political and more broadly speaking ideological implications of his primitivist aesthetic. Williams links the transformative, liberatory rhetoric of *Negerplastik* with Einstein's contemporary articles in one of the key Expressionist periodicals, *Die Aktion*, on the one hand, and, on the other, with his active political involvement in the revolutionary uprisings of the immediate post-War period, his participation in the Revolutionary Soldiers' Council in Brussels in November 1918 and the Spartacist revolt in Berlin over the succeeding months. As Williams puts it in his 1983 article 'Primitivism in the Works of Carl Einstein, Carl Sternheim and Gottfried Benn', 'Einstein's revaluation of African art is [...] by extension politically revolutionary',[12] or again in 'Carl Einstein's *Negerplastik* and the Aesthetics of Expressionism' (1987): 'Einstein had been associated with opposition to

10 Williams, 'Carl Einstein's *Negerplastik*', 75; cf. 82.

11 Williams, 'Primitivism', 255, and 'Carl Einstein's *Negerplastik*', 81. See also Williams, 'Wilhelm Worringer and the Historical Avant-Garde', in *Avant-Garde / Neo-Avant-Garde*, ed. Dietrich Scheunemann (Amsterdam and New York: Rodopi, 2005), 49–62 (55–59), and Williams, 'Wilhelm Worringer', in *The Dictionary of Art*, ed. Jane Shoaf Turner (London: Macmillan, 1996), 33, 383–85. On Einstein and Worringer, see also Neil Donahue, 'Analysis and Construction: The Aesthetics of Carl Einstein', *German Quarterly*, 61 (1988), 3, 419–36, and Andreas Michel, '"Our European Arrogance": Wilhelm Worringer and Carl Einstein on Non-European Art', in *Colors 1800/1900/2000. Signs of Ethnic Difference*, ed. Birgit Tautz (Amsterdam: Rodopi, 2004), 143–62. On Worringer more generally, see *Invisible Cathedrals. The Expressionist Art History of Wilhelm Worringer*, ed. Neil H. Donahue (University Park: Pennsylvania State University Press, 1995).

12 Williams, 'Primitivism', 253.

the War: *Negerplastik* was, at least by implication, a further contribution to that opposition.'[13]

A third aspect of Rhys Williams' approach to Einstein is to tease out (for Einstein leaves it largely implicit) the close correlation between this understanding of African art and artistic developments in contemporary Paris. A decade before *Negerplastik*, the Fauves (Vlaminck, Matisse, Derain) had begun to explore the inspiration of African masks, but more recently the example of the Cubists, for Einstein, reinforced in spectacular fashion his arguments concerning the redemptive potential of this new kind of representation.[14]

As Williams points out, the main reason why Einstein knew so much about the innovations and challenges of Cubism – in the period during which *Negerplastik* was gestating, 1912–15, and after – was his close friendship with the Parisian gallery owner Daniel-Henry Kahnweiler (1884–1979). Kahnweiler has gone down in history as 'Picasso's dealer', but he was a great deal more than this; more even than 'just' the dealer of the 'Big Four' Cubists of the so-called 'heroic years', whom Kahnweiler's biographer Pierre Assouline calls the 'four musketeers of Cubism',[15] namely Picasso, Georges Braque, Juan Gris and Fernand Léger. In the words of the sub-title to the centenary exhibition held 1984–5 in his honour at the Pompidou Centre in Paris, Kahnweiler was pre-eminent as 'dealer, publisher, writer'.[16] In his capacity as a publisher, Kahnweiler's successive imprints[17] pioneered the concept of the 'beau livre', bringing together poets and artists in the production of high-quality illustrated texts, and in this manner Kahnweiler was responsible for publishing the first works of writers as

13 Williams, 'Carl Einstein's *Negerplastik*', 80.

14 Williams, 'Primitivism', 251f.

15 '[L]es quatre mousquetaires du cubisme'. Pierre Assouline, *L'homme de l'art. D.-H. Kahnweiler 1884–1979* (Paris: Gallimard, 1988), 5.

16 See *Daniel-Henry Kahnweiler. Marchand, éditeur, écrivain*, eds Isabelle Monod-Fontaine and Claude Laugier (Paris: Centre Georges Pompidou, 1984).

17 'Editions Kahnweiler' (1909–14), 'Editions de la Galerie Simon' (1920–40) and 'Editions de la Galerie Louise Leiris' (1940–79). See *Daniel-Henry Kahnweiler*, 179–92.

distinguished as Guillaume Apollinaire, André Malraux, Antonin Artaud, Georges Bataille and Michel Leiris. Kahnweiler's work as historian and aesthetician of Cubism is of no less significance: his short monograph *Der Weg zum Kubismus* – first published in 1920, although its composition dates back to 1916 and his time in exile in Berne during the War years – is celebrated as one of the earliest and most profound reflections on the movement.[18] In 1946 Kahnweiler published a monograph on his favourite among the Cubist artists, Juan Gris, which continues to be well received,[19] and he was writing and publishing his own works well into the post-1945 period, amassing all told a substantial body of work.

In the remainder of this article I want to expand on Rhys Williams' brief comments on Einstein and Kahnweiler and look in more detail at the relationship between the two men, and between their aesthetics in particular. I want to argue that the aspects of Einstein's reading of African art which Rhys Williams highlights – its 'epistemological framework' and its political implications – actually set it at variance with Cubism, on Kahnweiler's reading,[20] and that Williams' astute, prescient analysis of the 1980s establishes a strand in Einstein criticism which has become the consensus only much more recently. At this stage I should perhaps also explain that my own interest in this topic derives from some months I spent over 20 years ago (1986–7) revising and editing my friend Orde

18 Even if more recent, revisionist treatments have sought to set Kahnweiler's initially
 highly influential neo-Kantian approach to the history of Cubism in context. See
 Mark Cheetham, *Kant, Art, and Art History. Moments of Discipline* (Cambridge:
 Cambridge University Press, 2001); David Cottington, *Cubism and its Histories*
 (Manchester: Manchester University Press, 2004); and *A Cubism Reader. Documents
 and Criticism, 1906–1914*, eds Mark Antliff and Patricia Leighten (Chicago and
 London: University of Chicago Press, 2008).

19 Einstein's preference was for Georges Braque, to whom he devoted a monograph in
 1934. Planned monographs on Gris and Léger failed to materialise.

20 Kahnweiler was, however, relatively unusual in this respect. For the contemporary
 political debates over the context of cubism, see especially Mark Antliff and Patricia
 Leighten, *Cubism and Culture* (London: Thames and Hudson, 2001) and *A Cubism
 Reader*.

Levinson's translations of Kahnweiler's writings, which piqued my interest in the man and the milieu.

Einstein and Kahnweiler

The biographical details of the relationship between Einstein and Kahnweiler are straightforward to sketch out. The two men were almost exact contemporaries: Kahnweiler was born in 1884 in Mannheim, Einstein less than a year later, 100 miles downriver in Neuwied, near Koblenz. They were both scions of Rhineland German Jewish families, both initially destined to follow in the bourgeois footsteps of their respective fathers – the two even worked in the same bank in Karlsruhe, though a year apart, and they never met at this stage; they probably first met in Paris in 1904/5,[21] after they had both forsaken family expectations in pursuit of a more artistic calling. Einstein's frequent visits to Paris thereafter meant that the two could conduct their affairs in person and there is no (extant) correspondence between them till after the First World War, then from 1921 they corresponded with greater or lesser regularity (58 letters survive in all) till shortly before Einstein's suicide in 1940.

Although the two never adopted the 'tu/Du' form in their correspondence (Kahnweiler was of a formal disposition and not the sort of man one readily did that to), it is clear that they became increasingly intimate, and Einstein did finally start using Kahnweiler's affectionate nickname 'Heini'. Einstein treated Kahnweiler as a confidant to whom he could entrust his innermost concerns – both personal and artistic. This is evident from the most extensive and by some margin the most interesting and celebrated of these letters, from Einstein to Kahnweiler in June 1923, a kind of manifesto which runs to eleven pages of artistic self-justification, setting out what

21 See Meffre, 'Daniel-Henry Kahnweiler et Carl Einstein: Les affinités électives', in *Daniel-Henry Kahnweiler*, 85–90 (85).

he explicitly calls a 'Cubist' aesthetic for his writing[22] – a self-evaluation
which is reinforced by Kahnweiler much later, in his monograph on Gris,
when he praised Einstein's debut novel *Bebuquin oder die Dilettanten des
Wunders* (1912) as 'Cubist' and at the same time praised Einstein's writing
on Gris in glowing terms: '[he] has written what are without doubt the
most profound pages on Gris's art'.[23] The mutual respect and admiration of
the two men is frequently in evidence elsewhere, too, and not just in their
praise for each other's writings. For example, during the First World War
Kahnweiler's entire stock was confiscated while he was in Swiss exile, and
after the forced sale of Kahnweiler's paintings in 1921–3 Einstein writes a
robust defence of his friend in the article 'Gerettete Malerei, enttäuschte
Pompiers', praising Kahnweiler as the only German to have done justice to
Cubism.[24] In 1930 Kahnweiler in turn published a collection of Einstein's
poems, *Entwurf einer Landschaft* (typically with five lithographs by Gaston-
Louis Roux), which was the first work of Einstein's published in France.[25] In
his last letter to Kahnweiler, dated 6 January 1939, Einstein adopts a wistful,
valedictory tone and spells out just how important Kahnweiler had been
to him, commenting: 'it is perhaps one of the best things in my life that we
two were almost always in agreement on the important things'.[26]

22 As Assouline points out in *L'homme de l'art*, 133, Kahnweiler had a knack for getting
 otherwise taciturn artists to open up to him.
23 '[Il] a écrit sans doute les pages les plus profondes sur l'art de Gris'. Daniel-Henry
 Kahnweiler, *Juan Gris. Sa vie, son œuvre, ses écrits* (Paris: Gallimard, 1946), 183,
 218.
24 See Carl Einstein, 'Gerettete Malerei, enttäuschte Pompiers', in *Werke. Berliner
 Ausgabe*, vol. 2, 334–41.
25 Carl Einstein, *Entwurf einer Landschaft* (Paris: Editions de la Galerie Simon,
 1930).
26 '[C]'est peut être une des meilleurs [*sic*] choses de ma vie, que nous deux étions
 presque toujours d'accord sur les choses importantes'. Carl Einstein and Daniel-Henry
 Kahnweiler, *Correspondance, 1921–1939*, ed. and trans. Liliane Meffre (Marseille:
 Dimanche, 1993), 108.

Conflicting Interpretations:
Liliane Meffre and Yve-Alain Bois

Now all this mutual admiration was taken at face value by the leading French critic and doyenne of Carl Einstein studies (indeed successor to Williams as Chair of the *Carl-Einstein-Gesellschaft*) Liliane Meffre. Meffre has certainly been tireless in her promotion of Einstein: as well as being the author of two monographs on Einstein's work and co-editing the third volume of the Einstein *Werkausgabe*,[27] of more immediate concern to us here is the fact that she also edited the correspondence between Einstein and Kahnweiler (published 1993 in a bilingual French/German edition), and amongst numerous essays on Einstein published two on what she termed the 'elective affinities' between the two men.[28]

The first of these, published in 1984, strikes me as an idealising over-statement of the closeness of the two men's intellectual relationship. The essay begins: 'The friendship between Daniel-Henry Kahnweiler and Carl Einstein was one of those total friendships, perfect in all points, character-ised by profound intellectual affinities. The two had in common [...] above all the same conception of art, the same unconditional passion for Cubism.'[29] Now it may be clear that Kahnweiler drew heavily on Einstein's *Negerplastik* in formulating his own remarks on the relation between Cubism and Afri-

27 See Meffre, *Carl Einstein et la problématique des avant-gardes dans les arts plastiques* (Berne and New York: Peter Lang, 1989); Meffre, *Carl Einstein, 1885–1940. Itinéraires d'une pensée moderne* (Paris: Presses de l'Université de Paris-Sorbonne, 2002); and Carl Einstein, *Werke Bd. 3, 1929–1940*, eds Marion Schmid and Liliane Meffre (Vienna: Medusa, 1985).

28 See Einstein and Kahnweiler, *Correspondance*; Meffre, 'Daniel-Henry Kahnweiler et Carl Einstein' and Meffre, 'Carl Einstein et Daniel-Henry Kahnweiler'.

29 'L'amitié entre Daniel-Henry Kahnweiler et Carl Einstein fut une de ces amitiés totales, en tous points parfaites, caractérisée par des affinités intellectuelles pro-fondes. Tous deux avaient en commun [...] surtout la même conception de l'art, la même passion inconditionnelle du cubisme'. Meffre, 'Daniel-Henry Kahnweiler et Carl Einstein', 85.

can art, from *Der Weg zum Kubismus* in 1920 to 'L'art nègre et le cubisme' of 1948,[30] but this obvious debt evidently blinded some critics, Meffre in particular, to other nonetheless salient differences in their aesthetic positions. Only a year after Williams' first article on Einstein – which might have alerted readers to important differences from Kahnweiler – Meffre publishes this remarkably naive piece in the catalogue which accompanied the 1984–5 Kahnweiler exhibition in Paris, and which consequently remains to this day, unfortunately, by far the highest-profile treatment of the relation between the two men. There is very little in Meffre's 1984 essay on Kahnweiler's own writings; instead, Kahnweiler is characterised primarily as a sounding-board for Einstein, and the emphasis is very much on their personal friendship, with the two comrades in arms both fighting the Cubist cause hand in hand: 'The two men always made common cause when it was a matter of defending Cubism and its painters.'[31] Although Meffre does mention Einstein's radical politics and the influence on his aesthetics of his study of Ernst Mach's empiriocriticism,[32] she fails to take these leads any further, and the result is a curiously one-sided treatment.

In his substantial 1987 article 'Kahnweiler's Lesson',[33] the French-American critic Yve-Alain Bois initially follows Meffre in linking Einstein and Kahnweiler together, focusing (in the by now traditional manner) on Kahnweiler's debt to Einstein in his interpretation of the relation between Cubism and African art – the close relation between *Negerplastik* and Kahnweiler's much later text 'L'art nègre et le cubisme'. Away from the limited context of the relation between Cubism and African art, though, Bois's piece begins to drive a wedge between the two, when he focuses latterly on what he sees

30 See Kahnweiler, *Der Weg zum Kubismus* (Munich: Delphin-Verlag, 1920), and 'L'art nègre et le cubisme', *Présence africaine*, 3 (1948), 367–77, reprinted in Kahnweiler, *Confessions esthétiques* (Paris: Gallimard, 1963), 222–36.

31 'Toujours les deux hommes ont fait front quand il s'agissait de défendre le cubisme et ses peintres'. Meffre, 'Daniel-Henry Kahnweiler et Carl Einstein', 87.

32 Meffre, 'Daniel-Henry Kahnweiler et Carl Einstein', 88 and 89.

33 Yve-Alain Bois, 'Kahnweiler's Lesson', trans. Katharine Streip, *Representations*, 18 (April 1987), 33–68; reprinted in Bois, *Painting as Model* (Cambridge, MA and London: MIT Press, 1990), 65–97, 280–93.

as 'Kahnweiler's Lesson', Kahnweiler's signature *semiotic* interpretation of Cubism as a kind of writing, which fuses a neo-Kantian aesthetic with proto-Saussurean linguistics. What emerges is a picture of Kahnweiler which is a far cry from the ultimately quasi-mystical terms of Einstein's analysis, although Bois, too, fails to drive home this particular point.

When Meffre prefaces her edition of the Einstein-Kahnweiler correspondence in 1993 with another essay on the relation between the two, her position – on the closeness of the two men's friendship and correlatively their work – shows no advance on 1984,[34] but in 2001 a remarkable shift in her position is in evidence when she publishes a lecture specifically on Einstein and Kahnweiler's conceptions of Cubism (in a relatively obscure Czech art journal), in which she finally acknowledges the differences between them and tacitly overturns her earlier claims. On Einstein's political stance she finally wins through to the position Rhys Williams had adopted almost 20 years before, writing: 'In their immediate understanding of what was at stake in Cubism, Kahnweiler and Einstein develop the same criteria and the same reading. But Carl Einstein, through his political engagement and his radical temperament, makes demands that are different to Kahnweiler's.'[35] Kahnweiler, after all, was a convinced pacifist,[36] and although generally left-leaning, particularly in his early years in Paris, he always endeavoured to remain politically indifferent if at all possible – it was bad for business otherwise. For example, it is entirely typical that when he was in exile in Berne he only realised after the event that while immersed in the study of aesthetics in the University Library he had been sitting next to the Bolshevik revolutionary Grigory Zinoviev.[37]

On what Williams termed the 'epistemological framework' of Einstein's writing, Meffre in her 2001 article also acknowledges the profound

34 See Meffre, 'Introduction', in Einstein and Kahnweiler, *Correspondance*, 11–19.

35 'Dans leur compréhension immédiate des enjeux du cubisme, Kahnweiler et Einstein développent les même critères et la même lecture. Mais Carl Einstein, par son engagement politique et son tempérament radical, pose d'autres exigences que Kahnweiler'. Meffre, 'Carl Einstein et Daniel-Henry Kahnweiler', 134.

36 Assouline, *L'homme de l'art*, 218.

37 Assouline, *L'homme de l'art*, 228.

importance of Mach to the development of Einstein's aethetics, and contrasts this explicitly with Kahnweiler's abiding Kantianism.[38] And since 2001 this view of the *divergence* between the two writers has certainly become the new orthodoxy, adopted in other key contributions to the debate, most notably by the English-language critics Nicola Creighton, Charles W. Haxthausen and David Quigley.[39]

Conclusion

In conclusion, then, I quote from Einstein's celebrated letter to Kahnweiler of June 1923: 'Ich weiß schon sehr lang, daß die Sache, die man "Kubismus" nennt, weit über das Malen hinausgeht'.[40] Kahnweiler recalled Einstein saying something similar in one of their last conversations, too, which he reports as: 'All the same, Cubism would not have excited us as it did if it had been a purely optical affair'.[41] Both writers are in agreement that the importance of Cubism lies in its pointing beyond itself as (merely) a 'revolutionary' artistic practice, but I hope to have demonstrated here, following Rhys Williams, that they differ significantly on the question wherein this transcendence lies. The difference between the two is best summed up by Haxthausen, when he writes, citing *Der Weg zum Kubismus*:

38 Meffre, 'Carl Einstein et Daniel-Henry Kahnweiler', 135.
39 See: Nicola Creighton, 'The Revolution of the Word Follows the Revolution of the Eye: Carl Einstein and Cubism in Image and Text', in *Reading Images and Seeing Words*, eds Alan English and Rosalind Silvester (Amsterdam and New York: Rodopi, 2004), 37–56; Charles W. Haxthausen, 'Carl Einstein – Notes on Cubism', *October*, 107 (2004), 159–68 (159f.); David Quigley, *Carl Einstein. A Defense of the Real* (Vienna: Schlebrügge. Editor, 2007), 153f.
40 Einstein and Kahnweiler, *Correspondance*, 139.
41 'Tout de même, le cubisme ne nous aurait pas passionnés comme il l'a fait si ç'avait été une affaire purement optique'. Kahnweiler's letter to René Leibowitz of 20 February 1942 is cited in Assouline, *L'homme de l'art*, 242.

Kahnweiler relates the process [of Cubist aesthetic appreciation] to the Kantian synthesis described in the first *Critique*, in which differing representations in the mind are reconciled in their diversity in a single act of cognition. And, ultimately, the painting is reconciled with the known, familiar world as given. Einstein, by contrast, locates the origins of the Cubist project not merely within a problematic of painting but within a larger epistemological crisis: 'a skepticism concerning the identity of objects'. For him [...] the Cubist's brief is not the representation of objects, but a pictorial figuration of visual (and mental) process.[42]

Kahnweiler's interpretation of the transcendence of Cubism ultimately remains a conservative, neo-Kantian one with its emphasis on the construction of the aesthetic object in the mind of the observer, with what he termed in a crucial 1915 essay the 'Gegenstand der Aesthetik',[43] and this cannot but be at variance with Einstein's welcoming of the dematerialisation of the art object, a more post-Kantian, Machian view expressed as early as the 'Anmerkungen' of 1914: 'Gegenstand der Kunst sind nicht Objekte, sondern das gestaltete Sehen'.[44] The June 1923 letter continues after the point where I broke off the quotation above: 'Ich weiß schon sehr lange, daß nicht nur eine Umbildung des Sehens [und somit des Effekts von Bewegungen] möglich ist, sondern auch eine Umbildung des sprachlichen Aequivalents und der Empfindungen'.[45] For Einstein, then, Cubism's new way of seeing generates a new way of writing, as in his own *Bebuquin*, but also ultimately what Williams calls a new 'aesthetic of political action',[46] and on this point he and Kahnweiler will always agree to differ.

42 Haxthausen, 'Carl Einstein – Notes on Cubism', 160. Compare Quigley, *Carl Einstein*, 154: 'Einstein follows the original impetus of the Cubists beyond Kahnweiler's explicit Kantianism, going beyond the mere transformation of representational space, towards an entirely different notion of cognitive-aesthetic experience'.

43 See Kahnweiler, *Der Gegenstand der Ästhetik* (Munich: Heinz Moos Verlag, 1971).

44 Einstein, 'Anmerkungen', in *Werke. Berliner Ausgabe*, vol. 1, 214–17 (215). The divergence between the two men on this point was already the subject of Birgit Raphael's article 'Vergleich zwischen den Kubismustheorien von Daniel-Henry Kahnweiler und Carl Einstein', *kritische berichte*, 13 (1985), 4, 31–37.

45 Einstein and Kahnweiler, *Correspondance*, 139.

46 Williams, 'Carl Einstein's *Negerplastik*', 84.

The (Re)generation Game:
Discourses of Age and Renewal between Expressionism and the *Neue Sachlichkeit*

JON HUGHES

This essay is concerned with a subject that is familiar, yet of continued interest to scholars of literary and cultural history: the function of the 'generation' and the generational as topoi of cultural and literary discourse.[1] Western culture continues to define its chronologies through a generational lens. This applies as much to historical scholarship and its narratives of succeeding 'generations' as it does to a youth-orientated popular culture and its rapid succession of 'generations', from the *68er* and the punk generation of the 1970s through to the 'Generation X' of the 1990s and, most recently, 'Generation Facebook'. It is, clearly, related to forms of transition, and to the perception of newness, and for this reason the emergence and application of generational discourses in German culture is unsurprising; they certainly played a pivotal and defining role in the culture of the Weimar Republic, which will form the focus of this article. That we should uncritically *accept* this form of discourse, however naturally it comes to us and however convenient such labels are, is far from clear, and recent research, such as the interdisciplinary socio-historical work promoted within the Graduiertenkolleg Generationengeschichte at the University of Göttingen, has productively sought to analyse and problematise the history of the term.[2] It had acquired, by the early twentieth century, an ideological encoding beyond its original and literal meaning, a process for which the

1 See, for example, *Generation. Zur Genealogie eines Konzepts – Konzepte von Genealogie*, eds Sigrid Weigel et al. (Munich: Fink, 2005).

2 http://www.generationengeschichte.uni-goettingen.de/fopro.pdf, date accessed 30 January 2009.

'identity shock' of the First World War proved to be an accelerant.[3] The 'Concept of the Generation' provides a chapter in Jose Ortega y Gasset's investigation of history and modernity in *El Tema de Nuestro Tempo* (1923) and was revealingly resonant in Germany, where it was defined (in Zygmunt Bauman's view 'canonised') by Karl Mannheim in 1928.[4] For Mannheim, a 'generation' – a 'Generationseinheit' – of individuals not only shares the period in which it was born, but a sense of identity that emerges through collectively experienced events and phenomena.[5] For example, in the case of 'second-generation' Americans in the early twentieth century, whose image of assertive, energetic modernity, intersecting with the image of America itself as a 'young' nation, proved highly influential, the physical distance from their family's origins demanded a radical reorientation around the present.[6] For many Germans, particularly younger ones, the end of empire and the experience of war and defeat had a comparable formative effect. Bauman writes persuasively of the impact of this sense of absolute division from the past, and from past selves, that was not unique to, but undeniably pronounced in Germany.[7]

In Germany and elsewhere in Europe, the 'peer bonding' encouraged by the military had helped to reinforce a 'generational identification' that had already been a hallmark of the young Expressionists of the second decade of the century, and which began to erode established class identities.[8] It is no coincidence that a key literary anthology of the early Weimar Republic, Kurt Pinthus's *Menschheitsdämmerung* (1920), is declared by the editor not merely to be a collection of work by 'Dichter, die *zufällig* zur

3 Zygmunt Bauman, *The Art of Life* (Cambridge: Polity, 2008), 60.
4 Bauman, 57. Ortega y Gasset's volume is translated into English as *The Modern Theme*, trans. James Cleugh (London: Daniel, 1931).
5 Karl Mannheim, 'Das Problem der Generationen', in Mannheim, *Wissenssoziologie. Auswahl aus dem Werk*, ed. Kurt H. Wolff (Neuwied-Berlin: Luchterhand, 1964), 509–65.
6 See Jon Savage, *Teenage. The Creation of Youth 1875–1945* (London: Pimlico, 2008), 55.
7 Bauman, 61.
8 Savage, 155–56.

selben Zeit leben' (my emphasis).[9] In historically locating the work he explicitly rejects a 'vertical', causal model in favour of one of 'horizontal' synchrony and simultaneity. Pinthus's synchronic methodology allows a musical metaphor – the disparate parts of an orchestra come together, symphonically, to create harmony, just as he hopes, in his volume, to be able to tap into what he terms 'die Musik unserer Zeit, das dröhnende Unisono der Herzen und Gehirne'.[10] Both Mannheim's and Pinthus's assumptions are consistent with and reflective of an understanding of social and cultural history as a narrative of 'Brüche', of violent and abrupt transitions between generations. The customary periodisation of the Weimar period's troubled modernity implies an acceptance of this narrative, and it is reflected in the self-understanding of many Germans, for whom, according to Helga Karrenbock, the 'Schlagwort' 'Generation' operated as a 'Schlüsselbegriff für die kulturelle Situation der Zwanziger Jahre überhaupt'.[11] I shall scrutinise this phenomenon, not with the intention of rejecting the 'generational' model of periods, but of exploring the broader implications of the fact that so many accepted it. It led, for example, to a pronounced concern with 'youth', and to the valorisation of the qualities associated with youth; it relates to the leitmotif of 'Vatermord', and beyond that to an ongoing tendency to define the present in contradistinction to the past, or, more simply, to prioritise the 'new' over the 'old'.

Underpinning these tendencies in the aftermath of the war, and informing my argument here, is the related motif of '*re*generation'. Significantly, the desire for regeneration – literally, for a re-becoming (Neuwerden) – finds expression before 1914, and was an integral element of the emerging, pan-European modernist consciousness; regeneration, in this mode of thought, could only commence if an appropriate end, namely through

9 Kurt Pinthus, 'Zuvor', in *Menschheitsdämmerung. Ein Dokument des Expressionismus*, ed. Pinthus (Reinbek: Rowohlt Taschenbuch, 2000), 22–32 (22).

10 Pinthus, 22.

11 Helga Karrenbock, 'Die "Junge Generation" der Zwanziger Jahre – oder: "Vom Angriff der Gegenwart auf die übrige Zeit"', in *Literatur und Kultur im Österreich der Zwanziger Jahre. Vorschläge zu einem transdisziplinären Epochenprofil*, ed. Primus-Heinz Kucher (Bielefeld: Aisthesis, 2007), 103–18 (103).

war, had first been reached. This influential theoretical construct, with its motifs of death and rebirth, reflected considerable naivety about the reality of modern 'total' warfare, but despite the rude awakening this resulted in for many, as a discourse it nevertheless could be said to inform post-war German culture in decisive ways.

The distinctly literary processes through which Germans sought to articulate their sentiments and hopes in 1918–19 are revealing. As Wolfgang Schivelbusch documents in his recent study of the peculiar 'culture' of defeat, metaphors abound. Heinrich Mann, amongst others, sought to diagnose the defeat and collapse of the regime in pathological terms, as a symptom of a national 'Krankengeschichte'.[12] Many younger Germans, in seeking radical alternatives to the 'decadence' of the past in revolutionary left-wing politics or in extreme forms of nationalism, hoped that 1918 would prove to be a 'reinigendes Gewitter', a 'Fegefeuer' that would permit national renewal – just as many had invested comparable expectations in the arrival of war in 1914.[13] Indeed, for those who had experienced and survived front-line combat, the *Front-Erlebnis* itself was formative; it was in some cases understood as a passion, a baptism of fire – to use one common image – from which a generation emerged, if not stronger, then at least free from oppressive assumptions and illusions.[14] The chaos of 1918 and 1919 allowed temporary hopes that the shared experience of combat and danger would not just change perspectives on life but allow the creation of a new type of citizen, perhaps even a new type of human. Writing in 1918, Hermann Keyserling, the philosopher and utopian thinker, suggests: '[Es] kommt während aller Umwälzungen das Heil von denen, welche geschwächt sind oder am tiefsten gelitten haben. Nur sie finden in sich nicht allein die Kraft, sondern überhaupt den Anlaß zu radikalem Neuwerden'.[15] This evocative imagery – motifs of sickness, suffering and recovery; storms;

12 Quoted in Wolfgang Schivelbusch, *Die Kultur der Niederlage. Der amerikanische Süden 1865; Frankreich 1871; Deutschland 1918* (Frankfurt a.M.: Fischer Taschenbuch, 2003), 231.

13 Schivelbusch, 251; 275.

14 Schivelbusch, 277.

15 Quoted in Schivelbusch, 278.

fires – came to play a role in the various mythologies central to fascist thought, but equally finds numerous parallels in contemporary cultural production, and particularly in the manifestos and practice of Expressionism that, significantly, found new relevance and immediacy after the War. Pinthus, in his foreword to *Menschheitsdämmerung*, evokes a world defined by uncertainty and constant change, in which age-old certainties and authorities have crumbled, and argues for the continued relevance of the central themes of Expressionist art, which he identifies in the 'Vorbereitung und Forderung neuer, besserer Menschheit'.[16] That this work was self-consciously and programmatically associated with and *addressed to* a particular generation, and thus partook of the perceived immediacy of youth and of rebellious modernity, was of course a significant driver of its continued reception and influence.

The prevalence of apocalyptic imagery reflects a deep-seated desire for transformation that transected political and social affiliations, but in its categorical nature was also problematic. In accounting for the emergence of a generational consciousness in the teens of the twentieth century, Jon Savage has observed the potential difficulty in the attempt radically to distance oneself from the past: a vacuum is created that is difficult to fill – in the case of Expressionism, excited assertions of 'Menschheit' were really not enough – and the risk of 'mirroring the values they had so violently rejected' was rarely acknowledged by the young extremists of this era.[17] For many younger Germans the investment of such utopian dreams in the new Republic was to result in disappointment and an ongoing sense of unrepaired damage, and of destabilisation.[18] This was also the epoch of the self-identifying 'lost' generation of those who came of age during and immediately after the War, whose sense of distinctiveness, of hiatus, was articulated in terms of 'lost' years, of premature age, and of disorientation.[19] Writing in 1925, in the programmatic opening section of his remarkable

16 Pinthus, 23.
17 Savage, 135.
18 Schivelbusch, 284.
19 Compare Karrenbock's analysis (110–11) of Erich Kästner's discussion of 'Die junge Generation' of the 1920s.

travelogue *Die weißen Städte*, Joseph Roth reflects a sense of accelerated experience and insight:

> Nur wir, nur unsere Generation, erlebte das Erdbeben, nachdem sie mit der voll-ständigen Sicherheit der Erde seit der Geburt gerechnet hatte. Uns allen war es wie einem, der sich in den Zug setzt, den Fahrplan in der Hand, um in die Welt zu reisen. Aber ein Sturm blies unser Gefährt in die Weite, und wir waren in einem Augenblick dort, wohin wir in gemächlichen und bunten, erschütternden und zauberhaften zehn Jahren hatten kommen wollen. Ehe wir noch erleben konnten, erfuhren wir's.[20]

Roth shares the conviction that the war has, in effect, opened the eyes of survivors and granted them insight – Erich Kästner writes, in his genera-tional poem 'Jahrgang 1899', of those who have 'der Welt in die Schnauze geguckt'[21] –, but what for others was of potential benefit is characterised by Roth as unnatural, as a form of paralysing cynicism. Indeed, in an epoch in which *Der Zauberberg* was for many *the* key novel, resignation is a domi-nant tone, just as motifs of stasis and superfluousness are tellingly recur-rent as programmatic assertions in high-impact texts such as Remarque's *Im Westen nichts Neues* (1929).

Yet it is also possible, thinking beyond Roth's and Remarque's genera-tional pessimism, to construct an alternative account of German-language cultural development after 1918, in which the reception of texts explicitly interrogating a damaged society – Ernst Toller's brutal drama *Hinkemann* (1922) is a good example – provides evidence of society's self-healing, regen-erative instincts. In a defeated nation, as Schivelbusch argues, such instincts often receive a psychological boost, with the initial 'Verliererdepression' quickly transforming into a euphoric, carnival mood of 'Erlösung' and liberation; this mood, partly common to all participants in the war, is related by Schivelbusch to the 'Tanzwut' of the 1920s, a decade of passionate

20 Joseph Roth, *Werke*, eds Fritz Hackert and Klaus Westermann, 6 vols (Cologne: Kiepenheuer & Witsch, 1989–91), vol. 2, 452.

21 Erich Kästner, 'Jahrgang 1899': 'Wir haben der Welt in die Schnauze geguckt,/anstatt mit Puppen zu spielen./Wir haben der Welt auf die Weste gespuckt,/soweit wir vor Ypern nicht fielen', in Kästner, *Herz auf Taille* (Berlin: Dressler, 1959[?]), 11–13 (12).

popular enthusiasm for the escapism offered by jazz and the dance hall, and later, iconically, for the regimented 'Girlmaschinen' of the chorus line.[22] It is noticeable that jazz and related, exuberant dance forms such as the Charleston, were embraced alongside other American phenomena as manifestations of the *Zeitgeist*. Siegfried Kracauer, in attempting to define the particular qualities of jazz, suggested that the music was embraced as pure 'Gegenwart', as an immersion in the present moment: 'Eine Gegenwart, die dem Krieg den Rücken zugekehrt hatte und zunächst nur sich selber bestätigen wollte'.[23]

This desire to step outside history, as it were, to abandon one's social and historical identity in music and dance, and the implicit association of the energy, playfulness and athleticism of jazz and of dancing with youth, and the widespread perception of them as new, modern and 'young' phenomena, feed into a broader process of reaction to and rejection of tradition that has cultural as well as political significance. Jazz, in particular, though arguably of real relevance only in an urban context, was often defined in contradistinction to the restrained 'Haltung' many saw as typically, and fatally, 'German'.[24] Admittedly, such readings of a musical form that was almost exclusively identified with African-Americans were undoubtedly often coloured by the embedded racism of the age, but the admiring responses of liberal commentators who relished the liberating 'otherness' of jazz are nonetheless revealing in their celebration of it as a symptom of renewal. Writing in 1926, Yvan Goll highlights the involuntary, instinctive impulses triggered by jazz: 'Die Neger sind da. Ganz Europa tanzt bereits nach ihrem Banjo. Es kann nicht anders. [...] Hier sind ein Untergang und

22 Schivelbusch, 21, 22; see also 319–27.

23 Siegfried Kracauer, 'Renovierter Jazz' (1931), in Kracauer, *Schriften*, ed. Inka Mulder-Bach, 5 vols (Frankfurt a.M.: Suhrkamp, 1990), vol. 2, 390–32 (390).

24 Savage, 125; Schivelbusch, 320. On the 'mythologisation' of jazz in Weimar, and for a dose of healthy historical scepticism about many of the accepted truisms of Americanism and Americanisation in Weimar Germany, see Thomas Saunders, 'How American was it? Popular Culture from Weimar to Hitler', in *German Pop Culture. How 'American' is it?* ed. Agnes C. Mueller (Ann Arbor: University of Michigan Press, 2004), 52–65 (esp. 55–56).

Anfang verquickt. [...] Die Neger tanzen mit ihren Sinnen. (Während die Europäer nur noch mit dem Intellekt tanzten.)'.[25]

The emphasis Goll and others place on liberation and renewal has political resonance, at least in the defeated nations, as did Expressionism in its numerous motifs of 'Aufbruch' and youthful triumph; however, the valorisation of jazz's distinctive qualities, such as spontaneity, instinct, and immediacy, informs theoretical writings and literary practice well beyond the accepted limits of Expressionism, the cultural movement with which the first wave of reception of jazz in Germany coincides. Even as it became more integrated into the mainstream, jazz retained its status as a sort of dissonant, 'anti'-cultural music; in terms of contemporary conservative thinking it was very much the product of Americanised 'civilisation', not of German 'culture', and as such the discourses associated with it relate to the negotiation of a modern, democratic German identity. They offer additional context not only for the resonance of motifs of patricide and regicide in art and literature, but for the continued vehemence with which a severing of ties to the past – cultural, social, political, and even aesthetic – is insisted upon in cultural discourse throughout the 1920s as a necessary step in defining a modern identity in German culture. In a radical departure from a culture in which the veneration of age and experience was taken for granted, the image that was most often held up as a model for such an identity was one of youth, and it manifested itself with particular insistence in the 1920s.

'Youth', as a transitional phase between childhood and adulthood, was, to use the term used by Savage in his recent study, a relatively recent 'creation', and, in Germany at least, had been subject to competing discourses of militarist instrumentality and morbid, decadent romance.[26] The controversial reception of Wedekind's *Frühlings Erwachen* (published 1891) reflected not only the prudishness of Wilhelmine society and anxieties about disturbingly high rates of teenage suicide, but a reluctance to acknowledge

25 Yvan Goll, 'Die Neger erobern Europa', in *Manifeste und Dokumente zur deutschen Literatur 1918–1933*, ed. Anton Kaes (Stuttgart: Metzler, 1983), 256–58 (257).
26 Savage, 17–18; on Prussian education, Savage, 103.

the legitimacy of the drama's focus: adolescence as a distinct life stage with particular needs, which is shaped by social and educational conditions.[27] Attitudes to young people in Western societies in the late nineteenth and early twentieth centuries were paternalistic, and coloured by deterministic and biological patterns of thought; they overlapped with contemporary perceptions and fears of the 'masses' in general. 'Youth', understood as an aberrant form of childhood exuberance, a dangerous 'force of nature', tended, as Savage suggests, to be viewed as potentially disruptive, as a condition predisposed to radical rejection of the authoritarian status quo.[28] This helps explain why it was treated with such suspicion, and subject to controlling mechanisms and structures, in the imperial nations before 1914, and puts into perspective the significance of the ways in which the young democracy of the Weimar Republic became so preoccupied with youthfulness. Social commentators, such as Augusta von Oerzen, remarked upon a perceived 'Verschiebung der Altersgrenze', an 'Epidemie des Jungseins', which seems to have cut across the familiar periodisation of the epoch;[29] the phenomenon emerged with particular insistence in the carnivalesque or 'dream'-like turmoil in the early years of the Republic, but is equally a significant element in the reception and assimilation of 'American' discourses of 'rationalisation' in the period of stabilisation up to 1929.

By the late 1920s, then, this 'epidemic' of youth saw younger Germans abandoning the respectful obedience of preceding generations, although without the same vehemence of the 'Vatermörder' of recent years – it was simply a fact, von Oerzen suggests, that 'das Alter' had become 'unmodern'. It was something to be ignored: 'Man fragte sich einander nicht erst nach den Eltern. Man hatte sie gar nicht'.[30] Older generations too, encouraged

27 The term, to describe the socially and biologically distinct period between 'childhood' and 'adulthood', was coined by G. Stanley Hall in the late nineteenth century. See Savage, 66–69.

28 Savage, 83.

29 Augusta von Oerzen, 'Umgang mit Menschen', in *Der erfolgreiche Mensch*, ed. Ludwig Lewin, 3 vols (Berlin: Allgemeine Deutsche Verlagsgesellschaft / Eigenbrödler, 1928), vol. 2, 203–46 (239).

30 Herbert Schlüter, quoted by von Oerzen, 239.

by such intersecting phenomena as the popularity of the *Sportbewegung* and *Körperkultur*, a dramatic deformalisation of fashions, and the perceived modernity of the 'new', youthful woman, attempted physical and psychological transformation, redefining and appropriating notions of 'youth' in a manner that anticipates the social impact of the youth movements of the second half of the twentieth century. Amongst contemporary responses to the trend one finds, by the end of the 1920s, the widespread conviction that the changes undergone by German society demanded a profound psychological, and perhaps even a philosophical response. Writing in 1928, the educational theorist Ludwig Lewin characterises Germany's recent past in terms of metamorphosis rather than transition, resulting in :

> Durch die Wandlung und Umwälzung im Politischen wie im Sozialen, im Zusammenleben der Menschen wie in der Seele des Einzelnen, hat sich eine Auflösung aller Formen vollzogen, das Fundament alles menschlichen Zusammenlebens: die Anerkennung von Autorität und Überlegenheit des Ranges, der Stellung, der Erfahrung oder auch nur des Alters, ist ins Wanken gekommen, der Begriff der Autorität morsch geworden.[31]

Lewin's suggestion is that prescribed codes of behaviour, including the automatic reverence for authority and for age (and the linking of the two), are now open to question. Ignoring the processes of 'rationalisation' – Germany's successful appropriation of American industrial practices – that in the same period could be said to be eroding individuality and autonomy, Lewin uses his essay to make a plea for a corresponding change in behaviour, which should become, like the widely projected international image of liberated 'youth', more spontaneous, more situation-specific, and less self-conscious. The potential significance of this encoding of 'youth' for the establishment of new forms of German identity did not, of course, escape nationalist and conservative ideologues, whose competing discourses of discipline, self-sacrifice, and service offered a radically different model of identity.

31 Ludwig Lewin, 'Der erfolgreiche Mensch', in ed. Lewin, vol. 1, 17–45 (30).

The aesthetic-cultural discourse that shaped the movement from Expressionism through to the *Neue Sachlichkeit*, and encompassed such phenomena as sport, jazz, and cinema, parallels and reflects these developments. Generational experience informs it, and in a 1929 article, Pinthus, still thinking in terms of 'generational' literature, attempts a classification of the qualities of contemporary writing by arguing that it is characterised by 'manly' objectivity in contrast to the 'youthful' emotionality of the previous generation. He evokes the transition between literary styles, peculiarly, both as one of ageing and maturing (from 'Jüngling' to 'Mann'), and as one of death and rebirth. The violent imagery is justified with explicit reference to the violence of recent history, and a hard-nosed lack of illusions is posited as a *beneficial* side-effect of early trauma: '[Die] Kriegszeit und Nachkriegszeit zerstörten die heranwachsende Jugend; [...] Diese jungen Menschen waren nie jung, sondern wurden früh-reif. Wurden schon als Kinder illusionslos'.[32]

Echoing Roth, Pinthus tentatively links the tendency in contemporary writing towards 'Sachlichkeit' with the experience of the War and its aftermath, and the subsequent undermining of romantic ideals at a formative age. Elsewhere, however, generational experience informs discourse less explicitly. For example: in a 1926 article, in an example of programmatic theoretical writing that parallels arguments that were later to be voiced by Döblin, Benjamin and others, Hermann von Wedderkop, editor of *Der Querschnitt*, argues that traditional conceptions of the novel are outdated. He criticises what he sees as the artifice of plotlines, central to traditional conceptions of narrative fiction, instead appropriating as an aesthetic model the fragmentary, 'event'-orientated nature of newspaper-reporting and the cinema, which seem to be more rooted in the present and thus more 'real' (there is a parallel to Kracauer's understanding of jazz as 'Gegenwart'). He writes:

> Es kann ohne weiteres unterstellt werden, daß der große Roman, das große Ungeheuer, das seinem Publikum von der Vorbereitung seines Helden bis zu dessen Nachruf nach dem Tode oder der definitiven Entlassung ins Ungewisse nichts schenkt, daß dessen

32 Kurt Pinthus, 'Männliche Literatur', in ed. Kaes, 328–33 (328).

Zeit vorbei ist. Das neue [...] Publikum, das die Zeitung liebt, das das Vorstadtkino dem Theater vorzieht, wird sich an derartig pompös langweilige Entwicklungen nicht mehr gewöhnen können. Grund: es liebt das Wesentliche, die Abkürzung, die Bewegung.[33]

The naïve reclaiming of newspaper writing and film as unmediated 'reality' was typical of proponents of 'neusachlich' innovation in the mid-1920s, and was subject to justified scrutiny and criticism from commentators including both Kracauer and Roth before the end of the Weimar period. What is interesting is that here, and in his praising in the same article of the 'spielerisch', spontaneous qualities of jazz, Wedderkop's attempted aesthetic reorientation of contemporary culture towards new media is presented in terms of an opposition between the 'old' and the 'new', between conservative impulses and an exaggerated vision of the contemporary world as socially-levelled, 'playful', direct, mobile and rooted in the present. The implicit identification here of aesthetic-ideological categories relates, I would argue, not only to the attacks on tradition and authority that are, in a way, inherited from Expressionism, but more positively to attempts to redefine literary practice, genre, and form in the 1920s. They anticipate, for example, the categories that Sabine Becker has identified as definitive of the 'neusachlich' prose fiction of the later Weimar period.[34] These in some ways rather varied texts, which include novels by Irmgard Keun, Hans Fallada, Lion Feuchtwanger, Erik Reger, Erich Kästner and others, share a focus on the contemporary world and the everyday life; they strive for a directness of language and 'Massenwirksamkeit' (something that is equally true of contemporary poetry by Brecht, Kästner, Hannes Küpper, Mascha Kaléko and others); they dispense with traditional models of fully-rounded 'heroes',

33 Hermann von Wedderkop, 'Wandlungen des Geschmacks', in *Der Querschnitt. Das Magazin der aktuellen Ewigkeitswerte 1924–1933*, ed. Christian Ferber (Berlin: Ullstein, 1981), 163–68 (165).

34 See Sabine Becker, *Neue Sachlichkeit*, 2 vols (Cologne: Böhlau, 2000), vol. 1, *Die Ästhetik der neusachlichen Literatur (1920–1933)*, esp. 196–230; see also 'Neue Sachlichkeit im Roman', in *Neue Sachlichkeit im Roman. Neue Interpretationen zum Roman der Weimarer Republik*, ed. Sabine Becker and Cristoph Weiss (Stuttgart: Metzler, 1995), 7–26, esp. 10–13.

with fully presented pre-histories and projected futures, and anchor both the narrative perspective and story to 'kurze Lebensabschnitte' from the lives of (usually) young, and (implicitly) typical people.[35] Many 'play' with structure, voice, and perspective, employing fragmenting montage effects or inserting documentary or statistical material, just as Brecht, striving, literally, to rejuvenate the stale high culture of bourgeois theatre, incorporates innovations derived from the mass enthusiasm for sport, which he admired for its atavistic, socially levelling qualities and potentially subversive orientation around a passionately lived present moment. There is a concern, then, not merely to represent or describe the lives of Wedderkop's 'neues Publikum' but to attempt formal adaptations that are appropriate to a world of generational affiliations and scepticism about continuities and traditions.

Generational discourses, and in particular the assertion of a fluid identity that is as much the product of present circumstances and experiences as it is of fixed markers such as nation or class, are the product of forms of change so rapid it would seem to preclude traditional forms of development, influence and inheritance. As such they have been of formative importance for German society and culture. Paradoxically, they underpin groupings and tendencies that have traditionally been categorised, in keeping with such discourses, as separate – they inform the manifestos of pre-war Expressionism, the utopian declarations of the immediate post-war period, the disillusionment of the self-styled 'lost' generation, and the supposedly 'sachlich' art and literature of urban youth in the years of economic crisis. They can, as I have suggested in connection with the function of notions of 'youth', be identified as a driver of the era's regenerative impulses, its evolving modernity, and indeed its modernism. Yet this is not, of course, a story with a happy ending, and perhaps it is necessary to conclude on a pessimistic note: Germany, for all the efforts to define herself as a comparably 'young' nation, was not America. The generational mode of thought also proved to be problematic. In the insistence upon the value of the present and the new, and in the categorical rejection of a past that was deemed to

35 Becker, 'Neue Sachlichkeit im Roman', 13.

have failed – something the *Neue Sachlichkeit*, in its fondness for mani-
festos, shared with Expressionism – it risked ignoring the lessons of the
past. Perhaps, then, it is no surprise that the same discourses, and related
notions of 'regeneration', could subsequently, after 1933 and with disastrous
consequences, be merged with forms of collective identity – nation, *Volk*,
race – that subsumed the liberal and liberating impulses that had been a
hallmark of German modernity in the 1920s.

Lion Feuchtwanger, *Jud Süß* and the Nazis

CHRISTIANE SCHÖNFELD

Lion Feuchtwanger's journey into exile was marked by hardship, loss and revulsion towards the barbaric Nazi state and its all too willing collaborators. However, his literary texts, articles, speeches and letters from 1933 to 1958 reveal the author's agency, loyalty, humanity and unwavering sense of humour.[1] Together with his wife Marta, Feuchtwanger spent the last twenty-five years of his life in France, New York and California, never following his original intention to return to Germany. Far from his *Heimat*, in his writing Feuchtwanger repeatedly evokes an imaginary Germany and the space he considers home. For the Jewish author, Nazism is 'der Wiedereinbruch der Barbarei in Deutschland', personified by the 'Triumvirat des Ekels' Hitler, Göring and Goebbels.[2] The Hitler regime is, in his view, a grotesque, bizarre aberration – 'die ungeheure, blutige Groteske, die sich in uns und an uns allen austobt' – as he puts it in his 1940 novel *Exil*.[3] In *Der falsche Nero*, Feuchtwanger voices his disgust at the lack of resistance of both Germans and the international community: 'Das Scheußlichste: vor diesem dreiköpfigen Höllenhund wälzt sich wirklich in Staub und

1 It is the latter qualities that link this paper to Rhys Williams, whose friendship I treasure. Thank you, dear Rhys, for all the support, inspiration and laughter! I would also like to express my gratitude to Michaela Ullmann at the Feuchtwanger Memorial Library, USC, Los Angeles, the *Feuchtwanger Gesellschaft*, the *Stiftung Deutsche Kinemathek*, Berlin and Ian Wallace, who encouraged me to take a closer look at Feuchtwanger and Harlan and their respective Jud Süß texts. See my essay 'Lion Feuchtwanger and Veit Harlan: *Jud Süß*', in *Feuchtwanger and Film. Feuchtwanger-Studien*, 1, ed. Ian Wallace (Oxford: Peter Lang, 2009).

2 Lion Feuchtwanger, *Der falsche Nero* (Berlin: Aufbau, 1980), 206.

3 Lion Feuchtwanger, *Exil* (Berlin: Aufbau, 1956), 816.

Exstase die Welt?[4] As if to reassure himself, Feuchtwanger repeatedly states in articles and speeches that the Third Reich is but a malfunction of an otherwise honourable and effective community, a mere and temporary glitch. Eventually, reason will triumph over idiocy, he believes; Germany will be restored and he will then conclude his *Wartesaal* trilogy properly with an epilogue entitled 'Rückkehr'. Until then, the 'hiccup' that is the Third Reich will be addressed by exposing the ruthlessness and folly of its architects and accomplices, the grave moral devastation amongst the German people, and, in an act of resistance, by evoking humanitarian values in order to defend an attainable image of Germany in keeping with the author's ideals.

In exile, the author's words turn into an apotropaic shield, his works become tools to combat the 'immutable forces of antagonism' and to evoke his unwavering belief in humanity.[5] In 'Jews and Nazis', Feuchtwanger stresses his belief in the German people, even though part of the population has fallen prey to Nazi propaganda:

> Never before has the patient German people been so lied to and deceived. And never before, not even by its worst enemies, have the German people been so misrepresented as by their own official press. It is not true that the atrocities, which have occurred, are a spontaneous outbreak of a people's wrath. They are the result of fourteen years of the most malign atrocity propaganda. The German people are not anti-Semitic. The German people are not militaristic. The German people are not barbarians. [...] It is not true that the German people are behind the present Government. [...] I am convinced that the barbarians who are at present in the saddle will not succeed in eliminating in Germany the laws of humanity, of justice, and of social understanding.[6]

I shall illustrate this moral battle between humanitarian and barbaric impulses by focusing on Feuchtwanger's literary work *Jud Süß*, based on the historical figure Josef Süß Oppenheimer, Veit Harlan's 1940 anti-Semitic

4 Feuchtwanger, *Der falsche Nero*, 207.
5 See Elisabeth Bronfen's discussion of David Fincher's film *Se7en* in: *Home in Hollywood* (New York: Columbia University Press, 2004), 5.
6 Lion Feuchtwanger, 'Jews and Nazis', *Everyman*, 29 April, 1933, 529.

propaganda film of the same title, and Feuchtwanger's reaction to this manipulation and abuse of his work. Harlan's *Jud Süß* is not a straightforward transposition of Feuchtwanger's phenomenally successful novel and play into the film medium.[7] Nevertheless, Feuchtwanger's texts and the Nazis' anti-Semitic melodrama are closely linked. In his open letter to seven Berlin actors, he wrote that Harlan's film evidently perverted his novel:

> Ich lese im *Völkischen Beobachter*, dass Sie die Hauptrollen gespielt haben in einem Film *Jud Süss*, der in Venedig preisgekrönt worden ist. Der Film zeigt, berichtet das Blatt, das wahre Gesicht des Judentums, seine unheimliche Methodik und vernichtende Zielsetzung; er zeigt das unter anderm dadurch, dass er vorführt, wie der Jude Süss sich eine junge Frau durch die Folterung ihres Gatten gefügig macht. Kurz, wenn ich das geschwollene, am Bombast des Führers geschulte Geschwafel ins Deutsche übersetze, dann bedeutet es: Sie haben, meine Herren, aus meinem Roman *Power* (*Jud Süss*) mit Hinzufügung von ein bisschen Tosca einen wüst anti-semitischen Hetzfilm im Sinne Streichers und seines *Stürmers* gemacht.[8]

The synopsis of the film highlighted the instantly recognisable perversion of Feuchtwanger's text: the depiction of the young woman and the sexual abuse she endures. She is indeed a prime example of the Nazis' ruthless misrepresentation. Her character, rape and tragic death demonstrate the Nazis' abuse of the Jewish writer's work.

Hitherto, scholars have, however, regularly identified the location of the literary and film text in a specific chapter of Württemberg history as the only common factor.[9] This view is based on research by Friedrich

7 See Lion Feuchtwanger, 'Offener Brief an sieben Berliner Schauspieler', Feuchtwanger Memorial Library, Special Collections, University of Southern California, Box D8a, typescript, 7 pages. Published in *Atlantic Monthly*, April 1941; German original in *Aufbau* (New York), 4 July 1941.

8 Feuchtwanger, 'Offener Brief', typescript, 1. *Power* was the title of the American translation of Feuchtwanger's novel and also the American title of Lothar Mendes' 1934 film *Jew Süss*.

9 See, for example, Dorothea Hollstein, *'Jud Suess' und die Deutschen. Antisemitische Vorurteile im nationalsozialistischen Spielfilm* (Frankfurt/Main: Ullstein, 1983), 78; Stefan Mannes, *Antisemitismus im nationalsozialistischen Propagandafilm. 'Jud Süß' und 'Der ewige Jude'* (Köln: Teiresias, 1999), 27.

Knilli and Siegfried Zielinski, who stated in 1983: 'In Wirklichkeit aber hat der Harlan-Film mit dem Drama und Roman *Jud Süß* nur die historische Vorlage gemeinsam, sonst nichts'.[10] Consequently, the complexity of the relationship between Feuchtwanger's text and its perverted adaptation has largely been ignored.

Among the various literary adaptations of the historical Jud Süß or Joseph Ben Issachar Süßkind Oppenheimer (1698–1738), beginning with Wilhelm Hauff's 1827 novella, Feuchtwanger's 1925 novel has been the most successful.[11] The novel was preceded by the play *Jud Süß*, which Feuchtwanger wrote in 1916 and which premiered in Munich in 1917.[12] He withdrew the play a couple of years later and began working on the novel, believing it to be a more suitable genre. While the play introduces Süß as the Duke's already established 'Geheimer Finanzienrat', the novel begins prior to their first meeting and offers a much more detailed and multi-facetted account of time and place as well as of the main characters, convincingly unfolding their psychology. The basic idea and structure as well as the key narrative strands, however, remain largely identical.

Feuchtwanger tells the highly ambivalent story of the vain and ruthless businessman, the elegant, popular socialite and subservient Jew Josef Süß Oppenheimer, who enables Karl Alexander's court to flourish while profiting from his endeavours. Feuchtwanger presents a decadent, weak ruler, avaricious and insatiably materialistic men, women seduced by power and charm, and an anti-Semitic people that might kill Jews or 'nagende Würmer' (265) for the fun of it – 'aus purem Gaudium'. (408) The subtext of the charismatic Jew's quest for political influence and financial wealth is his great, albeit naïve ambition to acquire enough power to enable the

10 Friedrich Knilli and Siegfried Zielinski, 'Lion Feuchtwangers *Jud Süß* und die gleichnamigen Filme von Lothar Mendes (1934) und Veit Harlan (1940)', in *Lion Feuchtwanger*, ed. Heinz Ludwig Arnold (Munich: Text & Kritik, 1983), 99–121 (100).

11 Lion Feuchtwanger, *Jud Süss* (Berlin: Aufbau, 1991). Hereafter references will be given in brackets in the text following quotations.

12 Lion Feuchtwanger, *Jud Süß. Schauspiel in drei Akten (vier Bildern)* (Munich: Georg Müller, 1918).

liberation of the Jewish race. However, in Süß Feuchtwanger also creates a father. His fictional Süß has a daughter, who is a symbol of innocence, beauty and kindness – and whom he keeps hidden away in a house near Hirsau in order to shield her from the corrupting influences of the world he made his home. The white house in Hirsau is located within a *hortus conclusus* reminiscent of a Renaissance painting, a delightful walled garden filled with flowers, ensconcing the Virgin Mary and symbolising her purity and virginity. The characterisation of Süß's daughter (called 'Tamar' [palm tree] in Feuchtwanger's drama and 'Naemi' [pleasantness] in the novel) is entwined with the beauty, unaffectedness and isolation of the garden. This blossoming, perfect home of his daughter mirrors the young woman in the eyes of her father: she is pure love and the fountain of life, the 'best part'[13] of Josef Süß – the part of his soul that has remained untouched by all the ruthless compromises, vain ambitions and insalubrious dealings.

Feuchtwanger's Süß is an absent, but loving and kind father who is idolised by his daughter. By equipping this historical figure with father-hood, Feuchtwanger not only reflects on his and his young wife Marta's own experiences of the deep love for and devastating loss of a baby daughter, he also creates a human being. Not a monster, as the court documents will have it, but a person who makes compromises in order to advance professionally. Süß chooses to focus on his career and accumulate material riches and, essentially, power. Only the creation of Tamar/Naemi truly highlights the problematic nature of this path. Only when his daughter dies does Süß begin to understand properly the tragic emptiness of his pursuits. Her life-less body speaks of the violent nature of the Duke and his world. But it also demonstrates the consequences of her father's transgression and calls for resistance. Süß's subsequent revenge on the Duke leads to his own destruction, but this is no longer his concern.

Feuchtwanger's depiction of the suave, power-hungry Jew Süß is not meant to be anti-Semitic. It is an intuitive and sagacious study of the price of success in general and of the historical figure Joseph Süßkind Oppenheimer

13 Lion Feuchtwanger, *Jud Süß. Schauspiel in drei Akten*, 64.

as an example of a 'Mann, der Erfolg hat'[14] in particular. With hindsight, Feuchtwanger's astonishment at the criticism and abuse of his work is surprising. In 1929 he refers to the, in his view, peculiar interpretations and severe criticism from both Jews and anti-Semites that his depiction of Jewish characters evoked.[15] However, he was convinced that 'weder die Nationalsozialisten noch die Zionisten daraus Kapital schlagen können'.[16] But it requires little effort to isolate critical descriptions and negative character traits of Feuchtwanger's Süß. Once the character is thus reduced and contextualised according to Nazi ideology, the depiction of the ruthless and determined Jew could all too easily be included in anti-Semitic narratives.[17] Feuchtwanger's repeated descriptions of Süß's love of power – 'So spannte er ein Netz von Unternehmungen, vielfältig verästelt übers Land. Er dehnte sich und badete in der Macht' (151) – could be placed alongside examples of Nazi propaganda such as Fritz Hippler's supposed 'documentary film' *Der ewige Jude* (1940) or Erich Waschneck's *Die Rothschilds* (1940) that outline the Jews' supposed worldwide conspiracy to expand their power and eventually cause the downfall of the Aryan race.

In 1940, the historical figure Josef Süß Oppenheimer became the epitome of the threatening, ruthless Jew of anti-Semitic Nazi propaganda and the perfect example of a carefully designed construction of deviance. Harlan's *Jud Süß* is probably the most infamous of all Nazi propaganda films and has been discussed by many scholars in the field. The complicity of the German film industry becomes apparent when examining the

14 Lion Feuchtwanger, 'Über die Ursachen meines Erfolgs', typescript (2 pages), Feuchtwanger Memorial Library, Special Collections, University of Southern California, Box D8a, 1. Feuchtwanger had originally planned to write a novel inspired by another 'Mann, der Erfolg hat', Walther Rathenau. See Lion Feuchtwanger, 'Über *Jud Süß*', *Freie Deutsche Bühne*, 5 January 1929 and William Small, 'In Buddha's Footsteps. Feuchtwanger's *Jud Süß*, Walther Rathenau, and the Path to the Soul', *German Studies Review* 12 (1989), 3, 469–85.
15 Feuchtwanger, 'Über *Jud Süß*'.
16 Feuchtwanger, 'Über *Jud Süß*'.
17 For a comparison of Veit Harlan's *Jud Süß* and Hitler's *Mein Kampf*, see Daniel Knopp, *Wunschbild und Feindbild der nationalsozialistischen Filmpropaganda* (Marburg: Tectum, 1997), 50–70.

production of the film. Marta Feuchtwanger refers to Lothar Mendes' 1934 film adaptation of Feuchtwanger's novel when commenting on the Nazis' anti-Semitic version: 'The Nazis had of course noticed this big success of the movie, and they thought that they would take advantage of it and also the success of the book. They made a movie and turned everything into the contrary. It was a very anti-Semitic movie, and the greatest actor, Werner Krauss, played I think four or five parts, each one more anti-Semitic than the other.'[18]

Goebbels, 'der kleine, gerissene, ehrgeizzerfressene Betrüger'[19] as Feuchtwanger calls him, arranged for a screening of Mendes' film during the pre-production phase of the Nazi version. The audience included the director Veit Harlan and his co-scriptwriter Ludwig Metzger.[20] Despite the disapproving interpretations by a few critics that both Feuchtwanger's play and novel had engendered, his work and Mendes' adaptation were diametrically opposed to Nazi anti-Semitism. Goebbels was, however, adamant that 'a new film version had to be made'.[21] The result was, in Feuchtwanger's view, a 'Schandwerk',[22] which was packed with visual quotes from Mendes' adaptation.

The Ufa film was shot with a stellar cast, including: Ferdinand Marian (Jud Süß), Heinrich George (Herzog Karl Alexander), Werner Krauss (Rabbi Loew, Süß' assistant Levy, and other Jewish characters), Kristina Söderbaum (Dorothea Sturm), Eugen Klöpfer (her father, Landschaftskonsultent Sturm), Albert Florath (Obrist Röder) and Malte Jäger (Dorothea's

18 Marta Feuchtwanger, *An Émigré Life. Munich, Berlin, Sanary, Pacific Palisades*, interviewed by Lawrence M. Weschler, completed under the auspices of the Oral History Program, University of California, University of Southern California, 1976, vol. 2, 552. Lothar Mendes' *Jew Süss* premiered in 1934. The film was released in the USA as *Power* (like the American translation of Feuchtwanger's novel).

19 Feuchtwanger, *Der falsche Nero*, 206.

20 For the production history of the film, see Susan Tegel, 'Veit Harlan and the Origins of *Jud Süss*, 1938–39', *Historical Journal of Film, Radio and Television* 16 (1996), 4, 515–31, here 520.

21 Tegel, 526.

22 Feuchtwanger, 'Offener Brief an sieben Berliner Schauspieler', 5.

fiancé Faber).[23] As well as Harlan, Krauss, Klöpfer, George and Florath knew Feuchtwanger well, having appeared in his play *Jud Süss*. Feuchtwanger was shocked when he learned that they had agreed to participate in this propaganda film:

> Ich stelle mir vor, wie Goebbels gelegentlich zu einem von Ihnen sagt: 'Und da wäre dann noch dieser Jud Süss. Feuchtwanger hat ihn so populär gemacht, und er hat, objektiv, wie diese Juden nun einmal sind, auch alles so bequem zur Schau gestellt, was sich gegen den Juden ausdeuten lässt. Da könnte man doch einfach hingehen und sich das klauen. Man braucht nur die andern zwei Drittel des Buches zu unterschlagen, und man könnte die besten Geschäfte machen.'[24]

Feuchtwanger's novel and Harlan's film share a number of similarities, especially the characterisation of Josef Süß Oppenheimer as a businessman, who is vain, hardnosed and ambitious, attractive and charismatic, and the representation of the central female figure as both an ideal and a site of violence. The attempted rape and subsequent suicide are, in both Feuchtwanger and Harlan's texts, the climax and the turning point of the narrative. However, while Feuchtwanger depicts greed, vanity and ambition as human weaknesses of both Jews and Gentiles, Harlan focuses entirely on the initially charming and helpful Jew as a dangerous and recklessly underestimated threat. The opening credits of Harlan's film claim authenticity – 'Die im Film geschilderten Ereignisse beruhen auf Tatsachen' – and introduce Süß as a ghetto Jew in traditional attire, who hides unimaginable riches in his modest abode. Shortly after this identification of the main lead as Jewish and marginalised, seemingly safely contained in the ghetto, the film cuts to an attractive, elegantly dressed gentleman in a carriage: Süß effortlessly masks his true identity and is on his way to Stuttgart. His crossing of the border (Stuttgart is 'judenfrei'), is at the same time a violation of the com-

23 The film can be viewed at the Bundesarchiv Berlin and the British Film Institute in London. My analysis is based on a viewing at the BFI.

24 Around the time the Nazis took power, a large edition of the novel *Jud Süß* was published. A few volumes were burnt, the rest were sold in Austria and Switzerland for foreign currency. See Feuchtwanger, 'Offener Brief an sieben Berliner Schauspieler', 2 ff.

munity. The film focuses on Süß as an insatiable and merciless egomaniac, lacking conscience, gifted only in manipulation and the accumulation of wealth. The Jew here is clearly depicted as the deviant other.[25] Klaus Kreimeier rightly links the timing of anti-Semitic propaganda films and the Nazis' strategic organisation of mass murder.[26] The threat to the community lies in the adaptability of Süß, as representative of his entire race, and his desire to erode the community from within. His cunning flexibility and heartlessness make him dangerous, his fantastic wealth is his asset, and his sexualisation highlights the potentially fatal rupture of the community through the destructive force of his presence.

Nazi film's heartthrob Ferdinand Marian's dark Süß is placed early on in opposition to young, blond Dorothea Sturm, who is played by Harlan's wife Kristina Söderbaum. She is presented as a symbol of health and purity, beauty and youth – clearly a representative of the Nazis' ideal woman and an 'Aryan' version of Feuchtwanger's Tamar and Naemi. In a complete inversion of the narrative structure and intention of Feuchtwanger's novel and play, the ideal woman here is not the adoring and adored daughter of a Jew, but is placed in opposition to the deviant Other, whose victim she inevitably becomes. It is the Jew, not the Duke, who is the rapist. However, the description of the Duke's attempted rape of Süß's daughter and her subsequent suicide in Feuchtwanger's play and novel are almost identical and have clearly impacted on the Nazi version of the story. Feuchtwanger's description of Süß's daughter's violation and death bears striking similarities to the rape of Dorothea Sturm by Jud Süß in the Nazi film script. In all three texts, the sexual assault on the virgin victim and the pitiless

25 On deviance see, for example, Linda Schulte-Sasse, 'Courtier, Vampire, or Vermin? *Jew Süß*'s Contradictory Effort to Render the "Jew" Other', *Perspectives on German Cinema*, eds Terry Ginsberg and Kirsten M. Thompson (New York: Hall, 1996), 184–220.

26 Klaus Kreimeier, 'Antisemitismus im nationalsozialistischen Film', *Jüdische Figuren in Film und Karikatur. die Rothschilds und Joseph Süß Oppenheimer*, ed. Cilly Kugelmann (Thorbecke: Sigmaringen, 1995) 135–67; here 142 ff.: 'Timing des Massenmords und der "Reklame" für den Tod der Juden'.

destruction of the unequivocal symbol of purity and beauty is the climax of the narrative.

The Duke's carnal, even carnivorous, desire – labelling Naemi 'Braten' (313) and 'frisches Weiberfleisch' (315) in Feuchtwanger's novel – is comparable to Harlan's depiction of Süß's predatory sexuality in the film. In a reversal of Feuchtwanger's literary texts and, specifically, the tragic events leading to the death of Süß's sweet daughter, the central female figure of the Nazi film – the pure, good-natured 'Dorothea'[27] – is the daughter of Süß's political opponent, the Protestant *Landschaftskonsultent* Sturm. The rape here is presented as the final and most significant act of Süß's violent transgression. The Jew as sexual beast and vampire, sucking the life spirit from individual and community alike is, of course, a common motif in anti-Semitic propaganda.

Feuchtwanger's play depicts a disgusting, greedy, but at the same time playful and naïve Duke, who calls Süß's beautiful, young daughter 'Täubchen' and 'Tierchen',[28] while in Harlan's film, Süß the rapist compares his victim to a 'Vogel'. In all three texts – play, novel and film – the victim is labelled 'Kind' or 'Kindchen', addressed by the informal 'du' and told not to be fearful. In all three texts, a sexually aroused, brutal tyrant attacks a terrified, fragile child who seeks strength and protection in prayer.[29] In Harlan's film, Süß shows Dorothea an enormous diamond ring, a 'proper' ring in his bedroom. The significance of the ring, as a symbol of Josef Süß Oppenheimer's success and power, also links this scene to Feuchtwanger's novel, in which Süß's 'Solitär' is a prized possession. As a symbol of his achievements Süß even wears the ring for his execution and takes it with him to his grave.

The consequences of the rape or attempted violation are fatal, both in Harlan's film and Feuchtwanger's texts: Tamar and Naemi fall or throw themselves from the roof of their idyllic home near Hirsau, Dorothea in

27 The name derives from the Greek *doron* (gift) and *theos* (God), emphasising again her ideal womanhood.
28 Feuchtwanger, *Jud Süß. Schauspiel in drei Akten*, 95 and 96.
29 Feuchtwanger, *Jud Süß. Schauspiel in drei Akten*, 97, 'Tamar (sich windend, entsetzt): Nicht! Nicht! (Sinnlos Gebete lallend)'.

the film drowns herself, a recurring fate of Kristina Söderbaum's screen personae, earning her the nickname 'Reichswasserleiche'. Dorothea's death unites the people of Stuttgart for the purpose of self-preservation and national renewal, as her rape and death unambiguously signify the imminent disintegration of their community. During this sequence of the film, Dorothea's young husband gently lays her body down on the steps of the castle. The camera closes in on her beautiful, perfect face, virtually caressing her ideal form. For twelve long seconds[30] the audience sees nothing but her lifeless, faultless features, while Wolfgang Zeller's tragic score underlines the injustice of her untimely death. These twelve long seconds highlight the Nazis' simple logic: it is time to act. In order to safeguard our identity and our homes, the Jew has to die. Thus the masses shriek their approval when one of the officers declares: 'Der Jude muß weg!'.

The narrative structure of the propaganda film is linear and one-dimensional, suggesting a sense of identity predominantly by constructing difference. Jews are depicted as despicable, dangerous human beings who threaten the fabric of a healthy, solid community. Despite the fact that none of the collaborators in this Nazi propaganda film openly discussed the illegal, Jewish writer Feuchtwanger's bestseller *Jud Süß* as the backdrop of their *Hetzfilm*, there is reason to believe that all involved in the production of the film were familiar with Feuchtwanger's text. Moreover, it seems, not only was the film script in part influenced by Feuchtwanger's interpretation of the historical figure Süß Oppenheimer, but it was, in fact, Feuchtwanger's *Jud Süß* that was dissected, twisted and adapted to fit the demands of an aggressive anti-Semitic agenda. In line with the anti-Semitic misrepresentation of Feuchtwanger's texts, the injustice of Süß's death penalty, clearly emphasised by Feuchtwanger and Mendes, is presented by Harlan and his Nazi collaborators as the exact opposite: a just and necessary punishment. The insufferable pain at the loss of his beloved daughter in Feuchtwanger's texts is turned into the wrath and complete lack of empathy in Harlan's version. The victim is, in both literary texts and Nazi adaptation,

30 The scene is significantly shorter in the DVD version at International Historic Films, Inc. than in the BFI copy used in this paper.

an almost sacred, untouched, perfect young woman, filled with goodness and tenderness. The ideal of beauty, purity and wholeness is transferred from the 'hebräische Venus' Naemi/Tamar to Dorothea Sturm, a symbol of an idyllic community and of ideal Nazi womanhood. Josef Süß Oppenheimer's humanity is mirrored in Feuchtwanger's Naemi – his monstrosity is reflected in Harlan's Dorothea Sturm.

Feuchtwanger's *Jud Süß* is an exploration of our self-image as civilised, modern human beings, whereas the film is a call for genocide. A reading of Veit Harlan's *Jud Süß* as an adaptation illustrates the mechanisms of 'the fearsome, word-and-thought defying banality of evil', as Hannah Arendt put it in her *Eichmann in Jerusalem*.[31] The production of *Jud Süß* as cinematic entertainment and anti-Semitic propaganda demonstrates how the everyday banality of individual (in)action, the cowardly silences, and seemingly minor compromises eventually lead to crimes before which 'our human understanding recoils in bewilderment'.[32] While the magnitude of death and suffering during the genocidal Nazi regime might be beyond our ability to comprehend or adequately describe, film projects such as *Jud Süß* hold, as Hamlet put it, 'the mirror up to nature' exemplifying, as Feuchtwanger would have it, human weakness and 'the destructive urge with which Nature has endowed us (…) modern barbarians'.[33]

After burning his books, stripping him of his citizenship and doctorate, taking possession of his home and his library, the Nazis' appropriation of Feuchtwanger's bestselling work, their adaptation of *Jud Süß*, was itself nothing less than a brutal violation. Feuchtwanger wished to 'ameliorate the condition of mankind through literature'.[34] Veit Harlan and his all

31 Hannah Arendt, *Eichmann in Jerusalem. A Report on the Banality of Evil* (New York: Penguin, 1977), 252.

32 J. M. Coetzee, 'Portrait of the Monster as a Young Artist', *NYRB* 54 (2007), 2, 11.

33 Feuchtwanger, 'Are we modern Barbarians' (1932), typescript (4 pages), Feuchtwanger Memorial Library, Special Collections, University of Southern California, Box D8a, folder 6, 4.

34 Lion Feuchtwanger, 'Speech upon arrival in England' [?] [no date, unclear orig.], typed, 1 page, probably 1927. Feuchtwanger Memorial Library, Special Collections, University of Southern California, Box D8a, folder 3.

too willing colleagues helped to prepare the ground for mass murder. Yet, Feuchtwanger exhibited no desire to take revenge on those who turned his *Jud Süß* into an anti-Semitic propaganda piece. Their punishment, in Feuchtwanger's opinion, would be transformation, a slow disintegration of self and, most importantly, a loss of talent, as he states in his open letter to his former colleagues in 1941: 'Es ist dies: man kann, fürchte ich, nicht sieben Jahre hindurch gesinnungsloses, schlechtes Theater machen, ohne dass man an Talent einbüsst. Sonderbarerweise verlumpt mit der Seele auch die Kunst.'[35] He signed his open letter as 'Ihr alter Lion Feuchtwanger' – still unchanged, stubbornly believing in the goodness of mankind and his imaginary Germany, his home.

35 Feuchtwanger, 'Offener Brief an sieben Berliner Schauspieler', 7.

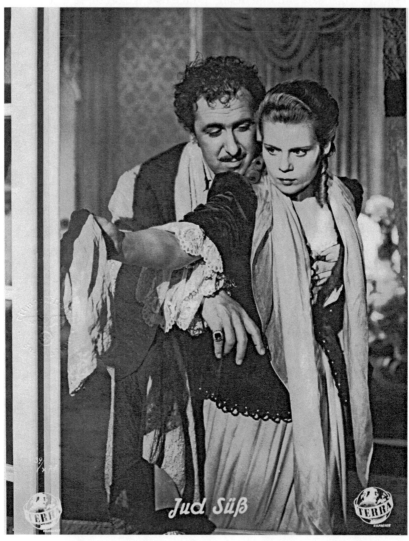

Kristina Söderbaum and Ferdinand Marian in Veit Harlan's *Jud Süß* (1940).

Prodigal Parturition? Walter Bauer's Poem 'Ich bin dein Sohn, Europa'

MORAY MCGOWAN

After 1945, in a ruined, defeated, subjugated, divided, discredited and demoralised Germany, many permutations of the ideas of 'Europa' circulating before 1945 were invoked, both as consolation and as counter-strategy, in response to the physical, moral and spiritual circumstances in which Germans now found themselves. Idealistic and cynical, altruistic and instrumental invocations of 'Europa' are seen side by side, sometimes in the same sentence. Thoroughgoing Nazis, right-wing nationalists, cultural conservatives, apolitical members of 'inner emigration', principled but passive opponents, active resisters, former exiles and camp inmates: all were jostling for discursive and sometimes political position in the post-war world, and all invoked 'Europa' to do so. These groupings of course overlapped, and so did the versions of 'Europa' on which they drew.[1]

Thus it is important, on the one hand, to avoid the clichés of endemic German belligerence beloved in the British popular media, and so to take account of the constructive, often self-denying contribution of post-1945 (West) German 'Europapolitik' to the reconstruction, peace and well-being of Europe. However, on the other hand, volumes such as Frank Niess's *Die*

1 It is a sign of the quantity and range of German ideas of 'Europa' in the latter 1940s that neither Paul Michael Lützeler's groundbreaking anthologies of German ideas of 'Europa', such as *Plädoyers für Europa*, ed. Lützeler (Frankfurt/Main: Fischer, 1987), Lützeler, *Die Schriftsteller und Europa. Von der Romantik bis zur Gegenwart* (Munich and Zurich: Piper, 1992), or *Hoffnung Europa. Deutsche Essays von Novalis bis Enzensberger*, ed. Lützeler (Frankfurt/Main: Fischer, 1994), nor Stephen Brockmann's wide-ranging and thorough article 'Germany as Occident in the Zero Hour', *German Studies Review*, 25 (2002), 3, 477–96, mention the work discussed here.

europäische Idee. Aus dem Geist des Widerstands,[2] though its title is per-
fectly justified in its own right, should not mislead us to see contemporary
Germany and its ideas of 'Europa' as emerging unsullied from an 'anderes
Deutschland' of resistance, exile, or the July 1944 plotters. In fact, the real
dynamism of German contributions to the European idea and its political
application since the 1940s has come from the way they emerged from,
rather than in simple opposition to, their deeply problematic antecedents.
One does not need to accept the polemical position of John Laughland's
The Tainted Source. The Undemocratic Origins of the European Idea[3] to
be very aware, for example, that the National Socialists too extensively
deployed 'Europa' rhetoric and even in certain senses promoted policies
with a European dimension. 'Europa' is a floating signifier, and it is always
necessary to look closely at the positions from and toward which the idea
of 'Europa' is articulated in any given text.

The ideas of 'Europa' most widely current in German culture in and
outside Germany prior to 1933 had been, firstly, 'Europa' as the *Abendland*,
the occidental cultural tradition, whether in the conservative sense, bound
closely to Western Christianity, or in a wider sense which embraced the
achievements of European modernism and its very questioning of the
conservative tradition; secondly, 'Europa' as the post-Enlightenment, post-
French Revolution tradition of rationality, and of liberal and federal democ-
racy; thirdly, 'Europa' as an internally homogenised, largely autarchic single
market; fourthly, 'Europa' as a hegemonic power; and fifthly, 'Europa' as a
bulwark against 'Asiatic' despotism and 'African' primitivism. These versions
of 'Europa' exist in many variants and overlapping forms, of course, and for
example, after 1933 the National Socialist blend of racism, anti-bolshevism
and single-market *Großraumwirtschaft* combined the latter three versions
of 'Europa' into their grotesque apogee in ways which echoed and won
the partial approval of many Europeans who rejected National Socialism
as a whole. As the fortunes of war turned, the Nazis increasingly invoked
that first idea of 'Europa' as the *Abendland*, the overarching Occidental

2 Frankfurt/Main: Suhrkamp, 2001.
3 London: Little Brown, 1997.

cultural heritage, to both justify and desperately recruit support for their crusade against bolshevism. In just one of countless examples, Max Clauss' *Tatsache Europa* (1943) blurs German and European identity in noting 'die aus dem Krieg entstandene Tatsache unserer europäischen Schicksalsgemeinschaft [...] Die bolschewistische Grundwoge brandete wild dagegen an, um sich immer wieder am sprungbreiten Widerstand des deutschen, des europäischen Soldaten zu brechen.'[4]

Meanwhile, in the German resistance, linking in this respect with the ideals being preserved and championed in other European resistance movements, 'Europa' was a democratic federation of nations and a humanistic cultural tradition.[5] On one level, this was everything Nazism was not, and the sincerity of that stance is not questioned here. Nonetheless, there were noteworthy overlaps. For example, it is clear from many of the surviving texts of the 20 July 1944 plotters or the Kreisauer Kreis with which they were associated, that they identify 'Europa' as 'den Gegensatz zu der Horde aus der Steppe,'[6] with the anti-bolshevist crusade. Carl Goerdeler's 'Praktische Maßnahmen zur Umgestaltung Europas' of early 1944 invokes the need to unite Europe (in a series of steps from customs union to political union) to create another world-ranking power alongside the USA, the Soviet Union and the British Empire. In 'Die Aufgaben deutscher Zukunft', written on the run from the Gestapo in early August 1944, Goerdeler calls for an 'Europa' that will be a free union of equal partners. But the complete abandonment of the at least implicit idea of German hegemony in a new Europe came late for many of the July 1944 plotters. Goerdeler's 'Das Ziel' (1941), for example, expects a post-Nazi Germany, certainly to have learned from recent history to avoid imposing its power by crude force, but also

4 Max Clauss, *Tatsache Europa* (Prague, Amsterdam, Berlin & Vienna: Volk und Reich, 1943), 7.

5 See Niess; also *Europa-Föderationspläne der Widerstandsbewegungen 1940–1945. Eine Dokumentation*, ed. Walter Lipgens (Munich: R. Oldenbourg, 1985).

6 A. Delp, 'Meditation über Europa in der Neujahrsnacht', written in prison on 1 January 1945 by a priest and member of the Kreisauer Kreis; quoted in Lipgens, 173–74; Delp also states emphatically: 'ein Europa [...] ohne mitführendes Deutschland gibt es nicht'. (174)

to play, effectively, a dominant and militarily active role in defending this 'Europa': 'In die Führung Europas wird diejenige Nation hineinwachsen, die gerade die kleinen Nationen achtet und ihre Geschicke mit weisem Rat und weiser Hand, nicht mit brutaler Gewalt zu leiten versucht'.[7]

No invocation of 'Europa' in German writing of the latter 1940s can operate free of these ambivalent and problematic echoes. In the following, I look briefly at Hans Werner Richter's novel *Sie fielen aus Gottes Hand* (1951) and slightly more extensively at Walter Bauer's poem 'Ich bin dein Sohn, Europa', published in 1947. Both Richter and Bauer belong to the literary circles around the journal *Der Ruf*, Richter as its co-editor. In the journal's first number, fellow co-editor Alfred Andersch published an essay, 'Das junge Europa formt sein Gesicht', which is equally revealing of the cultural, intellectual and linguistic origins of post-1945 ideas of 'Europa', but which is widely cited and discussed and therefore not considered here. By taking examples not from revanchist or culturally conservative circles, but from those with real, if by the early twenty-first century somewhat battered and relativised anti-Nazi, anti-restorative credentials, I wish to show the unavoidable ambivalence of German 'Europa' discourse in the latter 1940s.

For example, in the place of the utterly discredited German nationalism, 'Europa' could be invoked as a conveniently abstract and at this historical juncture positively charged homeland, free of the guilt associated with 'Deutschland' (European guilt, for example over colonialism, was in any case less of a problem for Germans, who had long lost their colonies). We see this in an extract from Richter's novel *Sie fielen aus Gottes Hand*, referring to the immediate post-war situation in Europe: 'Ganze Völker wurden kollektiv verdammt und für schuldig erklärt, und gleichzeitig sammelten sich die Getriebenen und Vertriebenen aller Nationen im Schoß dieser Völker. Viele irrten durch Europa und strebten seiner Mitte zu, dort wo

7 'Das Ziel', quoted in Lipgens, 123–25; here 124. Cf. Claus von Stauffenberg's 'Europa-Briefe', reprinted in the same volume.

Hunger und Elend war und der Krieg einen Dschungel der Gesetzlosigkeit zurückgelassen hatte.'[8]

Europe's post-war devastation is evoked in this last sentence, but its root causes are obscured. Rather than addressing the material realities of a destructive process for which Nazi Germany was unquestionably responsible, the text subsumes Germany into an 'Europa' which is both suffering victim of an unnamed cataclysm and nurturing mother to whom Europe's displaced millions can turn, even though these millions were displaced in many cases as a direct result of Nazi policies. The text's perspective obscures agency, allowing German readers both to participate in victim status and to re-experience their geo-political centrality at the bosom of Europe in a positive anthropomorphic allegory (a trope that can be traced back at least to Sebastian Münster's *Cosmographia* in the latter sixteenth century).[9]

Walter Bauer's 'Ich bin dein Sohn, Europa' anticipates and possibly, given their close association and the fact that Richter knew Bauer's poem from at the latest 1947, provides a model for Richter's use of this image of 'Europa' as mother. Certainly, Bauer's poem provided the title and conception for the volume *Deine Söhne, Europa. Gedichte deutscher Kriegsgefangener*, edited by Richter (1947).[10] The volume was reprinted unchanged, except for a short and essentially affirmative afterword by Richter, in 1985.[11] Bauer's poem has a narrating 'Ich' readily affixable allegorically to the German nation or at least metonymically to the generation of youth returning scarred by war and yearning for, yet robbed of a homeland, the generation of Wolfgang Borchert's *Draußen vor der Tür* (also 1947). The

8 Hans Werner Richter, *Sie fielen aus Gottes Hand* (Reinbek: Rowohlt, 1980) (first published 1951), 356.

9 Caryl Phillips' novel *The Nature of Blood* (London: Faber & Faber, 1988), set at the Second World War's end partly in a refugee camp in Cyprus containing 'the refuse of old Europe', anthropomorphises Europe with none of Richter's (or, as we shall see, Bauer's) pathos. Philips writes, 'In Cyprus, I have watched as Europe spits the chewed bones in our direction. (The flesh she has already swallowed.)' (12)

10 *Deine Söhne, Europa. Gedichte deutscher Kriegsgefangener*, ed. Hans Werner Richter (Munich: Nymphenburger Verlagshandlung, 1947).

11 *Deine Söhne, Europa. Gedichte deutscher Kriegsgefangener*, ed. Hans Werner Richter (Munich: DTV, 1985). Bauer's poem is quoted from this edition, 13–17.

narrator of 'Ich bin dein Sohn, Europa' is a German soldier in his tent at the moment of uncertainty between the end of the war and the beginning of an unknown future. At this liminal moment,

> nenne ich mit aller Liebe und Zartheit deinen Namen:
> Europa.
> [...]
> Du leuchtest in der Nacht des Verlorenen, Europa
> [...]
> Und nun
> wage ich meinen ersten Schritt wieder dir entgegen, alte geliebte Mutter,
> teure Mutter unserer Herzen, die wir in Blindheit und Irrtum verwüsteten.

This last line suggests genuine contrition. There are echoes of Brecht's allegorisation, in his poem 'Deutschland' (1933), of Germany as a suffering mother spoiled and degraded by her sons, whose responsibility it now is to restore her honour and well-being: 'O Deutschland, bleiche Mutter/ Wie sitzest du besudelt/Unter den Völkern'.[12] However, Bauer's contrition comes not at the moment of the Nazi takeover, but only at the moment of defeat. Brecht, as the Nazi era draws to an end, returns to and revises his image of mother Germany in a second poem entitled 'Deutschland' (written around 1945 in American exile). Now he represents Germany as a monstrous mother pig rendering her dwelling uninhabitable (sows notoriously squash, and sometimes devour, their young).[13] Bauer in contrast transfers the pathos of the mother allegory essentially unchanged from Germany to 'Europa', rescuing from the ruinously discredited national allegory the narcissistic self-location of the poetic subject as errant son.

Moreover, Bauer's catalogue of the landscapes and artifacts which have helped define his conception of 'Europa' is highly ironic, yet probably unconsciously so, given the pathos that pervades the poem. In his youth,

12 Bertolt Brecht, *Werke. Große kommentierte Berliner und Frankfurter Ausgabe*, eds Werner Hecht, Jan Knopf, Werner Mittenzwei and Klaus-Detlef Müller, 30 vols (Berlin, Weimar and Frankfurt: Aufbau and Suhrkamp, 1988–2000), vol. 11, 253–54.

13 'Die Sau macht ins Futter/Die Sau ist meine Mutter', Brecht, *Werke*, vol. 15, 161.

books and maps had awakened dreams of European culture in him. Though these artifacts perished in the rubble of his home, Europa remained in his heart, and comforted him, 'wo ich auch sein mochte', by reminding him 'daß ich dein Sohn sei'. Where he was, of course, was bestriding Europe with the conquering Wehrmacht, experiencing its cultural monuments directly. His cosmopolitan experience of European culture includes the graves of Verdun, 'in denen meine Brüder liegen', but in the early 1940s is in fact the direct result of the Wehrmacht's rapid early campaigns with their relatively low casualties and their capture, at least in the West, of many monuments of European heritage intact.[14] This makes Bauer's narrator's position very different, for all the superficial similarities, to that, say of the brother of the British historian E. P. Thompson, who, shortly before being killed alongside the Bulgarian partisans with whom he was fighting, wrote in 1943: 'How wonderful it would be to call Europe one's fatherland, and think of Krakow, Munich, Rome, Arles, Madrid as one's own cities'.[15]

Bauer's poem is in no sense triumphalist. The architectural monuments, such as Chartres cathedral, or the works of the European mind like the 'Band Platon, den ich bei mir hatte, verschmutzt und aufgelöst', console by offering meaning amidst the meaninglessness of war, but the consolatory meaning does not transcend or outweigh the meaninglessness. The recalled voices of 'Franzosen, Griechen, Italienern, Männern und Frauen, die Europa in ihren Herzen hatten', too, talking to whom strengthened his hopes for a better future Europe, are juxtaposed with images of Europe's dead. However, these voices appear at a late stage in the poem and in the development it narrates, 'am letzten Tag, dem Tage des Aufbruchs in die Feuerwolke', an image which suggests the apocalyptic battles of the last

14 Max Frisch comments in 1946 on this characteristic experience of young Germans: 'Sie kennen die Normandie und den Kaukasus, aber nicht Europa; sie lernten alles nur als Sieger kennen', and how almost no-one in post-war Germany seems to escape the 'Verwechselung von Ursache und Folgen'. Max Frisch, *Tagebuch* (Zurich and Munich: Ex Libris, 1950), 38.

15 Quoted in Ole Weaver, 'Europe since 1945: Crisis to Renewal', in *The History of the Idea of Europe*, eds Kevin Wilson and Jan van der Dussen (London: Routledge, 1995), 152.

months of the war and certainly a later period than the one in which he participates in the conquerors' gaze on Europe's monuments. That is, rather as some, at least, of the anti-Nazi conservatives who played a key role in the July 1944 plot only really unequivocally severed their dream of 'Europa' from Hitler's plans for European expansion after Stalingrad, after triumph turned to defeat, so too the sequence of ideas in Bauer's poem suggests a narrator whose perception of 'Europa' only latterly takes on the pacifist, federalist ideals of the resistance.

Moreover, the poem's 'Europa' excludes implicitly through what it includes explicitly: the narrator recalls 'das Blatt mit der provençalischen Landschaft von Vinzent van Gogh, die ich mit mir trug und an die Wände russischer Bauernhäuser heftete:/Das warst du, Europa'. This image asserts art's ability to supply aesthetic, spiritual and ethical continuities and consolations in the midst of the disruptions of war, and even to function as an act of quiet resistance, in the display of a modernist work by a painter decried by the Nazis as degenerate. But it also disturbs in what it omits: from other narratives of the German-Russian conflicts of World War II, the reader is likely to associate 'russische Bauernhäuser' with bodies, not art prints, nailed to those walls of peasant houses which were actually left standing.[16] Moreover the narrator's domesticating, civilising gesture of pinning up the picture is also one of territorial marking and possession-taking. He makes his gesture in Russian peasant houses where there are no peasants, and the gesture is repeated, in a plurality, a succession of Russian peasant houses: not one, but many peasant families remain erased from this poem as its omission of them re-performs their erasure by the ravages of the war itself.

Bauer's poem draws to a close with the image of the prodigal son: 'den Verlorenen, mit tiefer Schuld Beladenen [...] Ich bin dein Sohn, heim-gekommen zu dir'. But this self-positioning as the prodigal son is not

16 There is a striking contrast between Bauer's text and the images of ruined Russian peasant houses, of scattered icons and slaughtered animals, in the early photographs of Herbert Tobias. See *Der Fotograf Herbert Tobias (1924–1982). Blicke und Begehren*, ed. Ulrich Domröse (Göttingen: Steidl, 2008).

straightforwardly humble; it also puts moral pressure on the addressee to offer Christian forgiveness. The poem's final words are 'Auch ich bin Europa', staking a claim that implicitly goes deeper than the guilt he has, though only once, expressed shortly before. For the narrator is not only son, but mother, just as, in Richter's novel, Germany became mother of 'Europa', having shortly before been her ravager. Bauer's narrator declares: 'Ich trage dich in mir, auch in mir wirst du von neuem geboren'. And 'Europa' is the patient as well as the nurse: 'Wir wollen dich heilen'. Thus the narrative subject of the poem is not only the erring son and the destructive force in Europe, but the nurturing, creative force too. In a narrative gesture reminiscent of the reality of an immediate post-war world where identities were sometimes completely remade – peeling off his Wehrmacht uniform, as it were, to reveal the European underneath – the poet is able to present himself as having been spiritually consoled and ethically reconstructed, or even perhaps rendered immune against the errors of Nazism, by European culture and the European idea. One may find it too harsh, given the context of the poem's supposed production in a POW camp, to read this simply as self-exculpation or the attempt to salvage cultural authority from unconditional defeat. However, it is, surely, at best an essentialist mystification of the tasks facing democratic reconstruction of Europe. Moreover, whatever right a given German intellectual in post-1945 Europe may retain or once again earn to contribute to that reconstruction does not emanate from a self-appointed role as the womb of Europe's cultural rebirth.

In any case, there is more to the context of this poem's production than first meets the eye, throwing up contradictions, distortions and falsifications typical of many German writers in the latter 1940s, and rendering their visions and invocations of 'Europa' highly ambivalent. Bauer was born into a working-class family in Merseburg in 1904, and worked as a packer before becoming a schoolteacher. His *Stimmen aus dem Leuna-Werk* (1930) placed him close to the tradition of socialist workers' literature, and in 1947 he claims his books were, after 1933, banned by the Nazis who saw him 'als

unerwünschter und volksfeindlicher Schriftsteller'.[17] In fact he published at least nine books between 1935 and 1944, including *Tagebuchblätter aus Frankreich* (1941), which was in a fifth edition by 1942. It is ironically in keeping with his self-reinvention after 1945 that the 'Europäisches Lesebuch' he published in 1947, dedicating it to 'den jungen Deutschen, die an die Wirklichkeit Europas glauben', is entitled *Die zweite Erschaffung der Welt*.

In a biographical statement of 1948, Bauer contradicts his own self-description as a banned writer by acknowledging his *Tagebuchblätter aus dem Osten*, published in 1944. He insists though that this book was intended, and was understood at the time, as a 'Bekenntnis zum europäischen Geist'.[18] Significant sections of the *Tagebuchblätter aus dem Osten* read like a rehearsal for the poem, 'Ich bin dein Sohn, Europa', and anticipate Bauer's re-positioning of himself in the post-war period through his invocation of 'Europa'. In the *Tagebuchblätter* too, 'Europa' is a mythical goddess, and the setbacks of the Wehrmacht from 1943 on, the territorial losses and the plummeting conditions and living standards of its soldiers, are stylised into a spiritual enrichment: 'Wir, die nicht nur am Fett der Erde hängen [...] wir sind deiner bewußt geworden und haben die Binden vor den Augen verloren, die uns hinderten, dein Wesen zu sehen'.[19] The sparse Russian steppe, aestheticised into a place of ascetic revelation, is the perfect contrast to the European abundance of Greece, and a vision of 'Europa' develops from discussions with fellow soldiers in Russia and via field post from all the occupied lands of Europe.

Bauer's closing reflections in the *Tagebuchblätter* reinterpret Nazi expansion as a process whereby, almost dialectically, the German squaddie

17 Walter Bauer, *Die zweite Erschaffung der Welt. Ein europäisches Lesebuch* (Recklinghausen: Bitter, 1947), 293.

18 *Welt und Wort*, 3 (1948), 225; quoted in Helmut Peitsch, '"Am Rande des Krieges"? Nichtnazistische Schriftsteller im Einsatz der Propagandakompanien gegen die Sowjetunion', *kürbiskern* (1983), 3, 126–49 (126). Bauer's comment that this book also expressed that 'Geist der Welt, der die Grenzen verachtet', only confirms the complete absence of ironic self-awareness in his writing.

19 Quoted in Peitsch, 138.

could discover humanist 'Europa': 'Vielleicht mußten wir so weit geweht werden, um, ferne von deinem Wesen, zu erkennen, was du bist, welches Leben du für uns bedeutest – und wer wir sind für alle Zeit: deine Söhne'.[20] Wehrmacht service as such did not of course make Bauer a Nazi or even a camp-follower. His poetry can certainly be read as 'documents of protest and compassion', as one of the few studies of his once widely published, now forgotten work puts it.[21] His invocation of European humanism was deeply felt. But the parallels between his texts of 1944 and 1947 remind us that the ideas of 'Europa' which began to emerge from the prison camps and the rubble of post-1945 Germany had complex and problematic antecedents. The democratic humanist hopes for a federal Europe formulated prior to 1945 in German as well as other European resistance movements cannot be completely purified of their echoes of the Nazi dream of a European *Großraum*; sincere desires to escape the poison of nationalism blend with aspirations to a supra-individual identity which can be seen as nationalism in disguise; energies of reconciliation blend with attempts to submerge issues of responsibility in a rhetoric of a common European suffering. When the democratic humanist Bauer of *Die zweite Erschaffung der Welt* writes in 1947 of the German soldiery of World War Two that 'wir gingen als Europäer fort und kehrten als Europäer [...] zurück',[22] that single, seemingly limpid identification of his ideals and its apparent straightforward repetition contain in a nutshell the whole complexity, ambivalence, political and historical fluctuation and contingency of the 'European idea'.

20 Quoted in Peitsch, 138. Here too one notes the absence of critical self-awareness in Bauer's writing: these soldiers were, after all, not blown all over Europe, but marched there, or indeed often drove, in trains, lorries or armoured vehicles.

21 Angelika Arend, *Documents of Protest and Compassion. The Poetry of Walter Bauer* (Montreal: McGill-Queen's University Press, 1999).

22 *Die zweite Erschaffung der Welt*, 9.

The Limits of Consensual Film-Making? Representing National Socialism on the Screen and German 'Normalisation'

PAUL COOKE

The history film has long played a pivotal role in the German film industry. It was, for example, central to the international success of the New German Cinema in the 1970s and early 1980s. Films such as Volker Schlöndorff's Oscar-winning *Die Blechtrommel* (1979), Helma Sanders-Brahms' *Deutschland bleiche Mutter* (1979) and Rainer Werner Fassbinder's *BRD Trilogie* (*Die Ehe der Maria Braun* (1979); *Die Sehnsucht der Veronika Voss* (1982); and *Lola* (1981)), all of which addressed critically Germany's National Socialist past, brought the nation's film-makers the type of international recognition that they had not enjoyed since the days of Weimar. With German unification, interest in this period has grown exponentially, fuelled by a series of very public debates, from the controversy surrounding the *Wehrmacht Ausstellung* of the mid-1990s to the political storm aroused by the proposed memorial to the Expellees.[1] It is no surprise, therefore, that the period should continue to attract the attention of film-makers, and that such films have played a key role in the re-ignition of interest in German film amongst international audiences.

What has changed, however, is the dominant tone of the films produced. Eric Rentschler comments, for example, that while Fassbinder, Wenders and other members of the '68er' protest generation produced films that 'interrogated images of the past in the hope of refining memories and

1 For further discussion see Bill Niven, *Facing the Nazi Past. United Germany and the Legacy of the Third Reich* (London: Routledge, 2001); Bill Niven, 'Introduction: German Victimhood at the Turn of the Millennium', in *Germans as Victims*, ed. Bill Niven (Basingstoke: Palgrave, 2006), 1–25.

catalysing changes', contemporary cinema lacks 'oppositional energies and critical voices', aiming instead for what he terms a cinema of 'consensus', an impulse which is, he suggests, nothing more than 'an emanation of an over-determined German desire for normalcy'.[2] In this article, I wish to look at the relationship between some recent examples of the German history film, the notion of 'consensus' cinema and its relationship to the question of German 'normalcy', 'Normalisation' being a much debated term since the late 1990s, denoting the nation's putative position as a now 'normal' state that might move beyond its guilt for past crimes to become an equal partner in the international community of nations. On the one hand I ask the question, how problematic is 'cinematic consensus' and does it have to be seen as a worryingly conservative, even revisionist cultural impulse? On the other, I look at the consumption of such films in order to explore the extent to which this at times troubles the ostensibly consensual dynamic of their narratives. In so doing, I ask whether such films actually help to highlight the limits of contemporary 'normalisation', whilst also signal-ling a new and necessary stage in the nation's critical engagement with the legacy of the Third Reich.

The Cinema of Consensus

On the face of it, expressions of cinematic 'consensus' would indeed seem to be found throughout the recent wave of films that explore the National Socialist period and are often interpreted as an attempt to draw a line under the past. Here one might mention Max Färberbock's *Aimée & Jaguar* (1999), the story of a lesbian love affair between a Jewish and Aryan couple negotiating life in a war-torn Berlin, or *Rosenstrasse* (2003), Margarethe

2 Eric Rentschler, 'From New German Cinema to the Post-Wall Cinema of Consensus', in *Cinema and Nation*, eds Mette Hjort and Scott Mackenzie (London: Routledge, 2000), 260–77 (263–64).

von Trotta's portrayal of the Aryan women who protested against the internment of their Jewish husbands. These films present what could be termed 'Schlindler's List' moments, that is, stories which, like Spielberg's 1993 blockbuster, give heroic accounts of non-Jewish solidarity with Jewish victims, thereby suggesting the continuation of a kernel of German humanity during the period that was not extinguished by the Nazi take-over and has once again taken hold in the present-day state. One could also point to a range of narratives from Volker Schlöndorff's *Der Neunte Tag* (2004), to Marc Rothemund's Oscar-nominated *Sophie Scholl – Die letzten Tage* (2005) and Roland Suso Richter's hit television mini-series *Dresden* (2006). These present similarly heroic moments but through an overtly Christological prism that offers the contemporary German spectator a redemption narrative, their stories of heroic suffering and sacrifice seeming to point forward to, and thus offer a moral foundation stone for, the present-day, now normal, Berlin Republic. Or, there is a whole raft of films that consider the extent to which 'ordinary' Germans themselves might be seen to have been 'victims' of the National Socialists and the ways in which the population at large suffered during and in the aftermath of the war, a suffering that, it is often suggested in the press, can only now be acknowledged.[3] Such films include Sönke Wortmann's *Das Wunder von Bern* (2003), discussed below, as well as numerous other television mini-series, including Kai Wessel's story of the plight of a group of expellees, *Die Flucht* (2007), and Joseph Vilsmaier's *Die Gustloff* (2007), which depicts the sinking of the refugee ship the *Wilhelm Gustloff* on 30 January 1945. Most controversial of all in this regard are films such as Dennis Gansel's story of life in an elite Nazi boarding school *NaPolA. Elite für den Führer* (2004) and Oliver Hirschbiegel's account of the last days of Hitler, *Der Untergang* (2004), films that almost entirely ignore broader questions of German culpability for past crimes, asking to what extent we should now even forgive certain National Socialists. Indeed, should we view some members of the regime itself as 'victims' of the time? Or, if seeing a figure

3 For further discussion see Paul Cooke, 'The Continually Suffering Nation? Cinematic Representations of German Victimhood', in Niven, *Germans as Victims*, 76–92.

such as Hitler as a 'victim' is impossible, should we at least acknowledge his 'suffering' at the end of the war?

Such apparent expressions of political normalisation invariably go hand in hand in these consensus films with what is, for their critics at least, an equally lamentable form of what might best be termed 'aesthetic normalisation', with German film-makers moving away from the avant-garde, self-reflexive sensibilities of the New German Cinema to produce straightforwardly melodramatic, identificatory narratives that follow international genre rules and can therefore resonate with mainstream international film audiences. Hirschbiegel's film, for example, was sold around the world with great success as 'One of the best war movies ever made',[4] the ostensible authenticity of the German-speaking cast giving the director and his producer Bernd Eichinger a huge market advantage over British and US depictions of the same story. For Hirschbiegel and Eichinger, of course, cinematic consensus is hardly to be viewed as a weakness of contemporary German film-making. This is a point expressed even more forcefully by Florian Henckel von Donnersmarck, the director of the Oscar-winning *Das Leben der Anderen* (2006), who argues in response to the claim that he is a 'consensual' film-maker:

> Those who repeat this verdict presumably want Germany to be lumbered with the kind of mediocrity that has induced so many 'consensus people', from Wilhelm Weiller to Wolfgang Petersen, to flee the country! If 'consensus film' is supposed to mean the same as 'trivial' or even 'bad film', then I want to make a lot more bad and trivial films in my career.[5]

For film-makers who are concerned with attracting audiences to their work, there is nothing wrong with the continuity-style mainstream fare

4 Eric Hansen 'Downfall', http://www.hollywoodreporter.com/thr/reviews/review_ display.jsp?vnu_content_id=1000630570, date accessed 15 September 2008.

5 Annette Maria Rupprecht, 'Florian Henckel von Donnersmarck – XXL', *German Films Quarterly*, March 2006, http://www.german-films.de/en/germanfilmsquaterly/ seriesgermandirectors/florianhenckelvondonnersmarck/index.html, date accessed 15 September 2008.

that people actually like to watch, and from the point of view of a German film industry that is on the up, they would seem to have a point.

Re-evaluating the Nature of Consensus

However, is there anything more to this recent wave of German history films than politically revisionist narratives that sell well internationally? At this point, it is interesting to observe that it is not only film-makers such as Henckel von Donnersmarck who seem intent upon valorising the 'consensus' film, at least in terms of its aesthetics. As Tim Bergfelder has pointed out, while German film production since the War has been dominated by mainstream entertainment films, the academy has tended to focus on the work of a small number of more esoteric film-makers.[6] Through the work of Bergfelder and others, this has shifted in recent years, with scholars starting to re-evaluate the German popular film tradition.[7] With regard to the popular history film, specifically, commentators have begun to argue for the value of the emotional, affective power of mainstream cinema to produce what Alison Landsberg has termed 'prosthetic memory', allowing spectators to 'suture' themselves 'into pasts they have not lived', thereby offering them a 'visceral' empathetic experience of history.[8] For Landsberg, it is the popular film with mass appeal that is particularly well placed to achieve this. She rejects Rentschler's notion that a mainstream 'consensual' aesthetic necessarily produces an ultimately conservative, political message. Working at the interface of 'public' history and 'private' individual memory, such films can, in her view, complicate and problematise both,

6 Tim Bergfelder, *International Adventures. Popular German Cinema and European Co-Productions in the 1960s* (Oxford and New York: Berghahn, 2005).
7 See for example, *Light Motives. German Popular Film in Perspective*, eds Randall Halle and Margaret McCarthy (Detroit: Wayne State, 2003).
8 Alison Landsberg, *Prosthetic Memory. The Transformation of American Remembrance in the Age of Mass Culture* (New York: Columbia University Press, 2004), 14.

allowing the spectator to 'inhabit other people's memories *as* other people's memories and thereby respecting and recognizing difference.' Of crucial importance in relation to the German context is, as Daniela Berghahn notes, the generational shift that has taken place.[10] The accusatory glare of the New German Cinema, which sought to question the silence of the 68ers' parents about their acceptance of the Hitler regime, is now giving way to the perspective of a younger generation of artists and, more importantly, audiences who have a less fraught relationship with the past and who are hungry for knowledge. Thus, for this new generation, the recent wave of history films with their personalised melodramatic accounts of life during the period, provides, it would seem, a far more immediate and accessible *experience* of the past than is to be found in earlier films.[11]

As such, these films can be seen as a particularly obvious example of what has been identified by Martin Walser and others as a new 'Geschichts-gefühl' at work in the representation of the past across society, marking a new phase in the process of *Vergangenheitsbewältigung*.[12] For their support-ers, such films are a 'Zeichen der Emanzipation', as Eckhard Fuhr puts it, writing in *Die Welt* about *Der Untergang*. For Fuhr, 'Die Deutschen haben ihre Geschichte, aber sie haben sie nicht mehr am Hals'. This distance from the past in turn allows film-makers at last 'Hitler in die Augen zu schauen', and thereby effect a final 'Versöhnung mit der "Tätergeneration"', a sense of 'Versöhnung' which is anathema to critics such as Rentschler.[13]

9 Landsberg, 24. Emphasis in original.
10 Daniela Berghahn, 'Post-1990 Screen Memories: How East and West German Cinema Remembers the Third Reich and the Holocaust', *German Life and Letters*, 59 (2006), 294–308 (296).
11 For an overview of the status of the popular film as historical text see Marcia Landy, *Cinematic Uses of the Past* (Minneapolis: University of Minnesota Press, 1997); Robert Brent Toplin, *Reel History. In Defense of Hollywood* (Lawrence: University of Kansas Press, 2002); Robert Rosenstone, *History on Film/Film on History* (New York: Longman, 2006).
12 Quoted in Johannes von Moltke, 'Sympathy for the Devil: Cinema, History, and the Politics of Emotion', *New German Critique*, 34 (2007), 3, 17–43.
13 Eckhard Fuhr, 'Auf Augenhöhe', *Die Welt*, 25 August 2004.

However, far from marking a moment when the past can finally be put to rest, perhaps such films actually at last mark the beginning of a genuine process of historical *Aufarbeitung*. Thomas Elsaesser, for example, hints at this in his discussion of the presentation of history in the New German Cinema. Drawing on Freud's essay 'Trauer und Melancholie' (1917) and his notion of *Fehlleistung*, Elsaesser suggests that the world reflected in much of the New German Cinema was caught in an ultimately self-destructive loop of melancholic repetition, in which the films' protagonists were invariably able only to perform the failure of the nation to mourn its past, a process of mourning which is necessary to a true comprehension of the nation's guilt and which in turn could bring about the population's final redemption.[14] For a real process of working through the past to begin, such 'performed failure' must give way to a more direct, emotional response to the past that can mourn the loss of both the 'right' and 'wrong' people, as Elsaesser puts it, a response that we see reflected perhaps in this new phase of film-making. On the one hand, such an emotional response might well lead to a new process of reflection. As Johannes von Moltke suggests in his analysis of *Der Untergang*, it is, for example, surely impossible to watch Bruno Ganz' portrayal of Hitler in a vacuum. The very fact that we are at times put into a position as spectators in the film where we are asked to sympathise with Hitler's point of view does not mean that we can forget his crimes. Instead, it potentially allows us to reflect anew on the nature of these crimes and the ways they have been, and can be, represented.[15] On the other hand, following Elsaesser, might the point of this new phase actually be to move away from critical reflection towards the straightforward sentimental expression of the pain of the past?

By way of example of the contrast between presenting the past as 'performed failure' which leads to destruction versus the kind of direct expression of emotion that potentially provides a way out of the repetitive

14 Thomas Elsaesser, 'New German Cinema and History: The Case of Alexander Kluge', in *The German Cinema Book*, eds Tim Bergfelder, Erica Carter and Deniz Göktürk (London: BFI, 2002), 182–91.
15 Von Moltke, 42.

loop of melancholia, let us compare Wortmann's *Das Wunder von Bern*
with Fassbinder's *Die Ehe der Maria Braun* (1979). At the end of Wort-
mann's story of a returning soldier attempting to come to terms with both
the past and his life in the new Germany, set against the backdrop of the
country's 1954 Football World Cup win, we see the man break down in
tears, overwhelmed both by the nation's footballing victory and the weight
of his past, his tears signalling the moment when he can accept, and be
accepted by, his new life. This direct, overtly sentimental expression of
mourning for the past contrasts noticeably with the inability of Fassbinder's
eponymous heroine to express emotion, an inability that has explicitly
destructive consequences, leading her inadvertently to blow up her home
to the soundtrack of Herbert Zimmermann's radio commentary from the
same World Cup win. Thus, far from drawing a line under the past, do
these films not actually support the continued engagement with history,
allowing the German spectator to find an affective point of connection
with the period and thus the possibility of finally undertaking a necessary
process of mourning work, contingent on evoking the kind of emotions
these recent films present?

Consuming Consensus and Cyberspace

Of course, whether the consensus film is to be dismissed or praised, what
cannot be denied is the point made by Matthias Fiedler that, for better or
worse, such films have had a major impact on current debates about the
politics of memory in Germany, debates that reveal anything but consen-
sus.[16] This same lack of consensus becomes even clearer when we look at

16 See Matthias Fiedler, 'German Crossroads: Visions of the Past in German Cinema
 after Reunification', in *Memory Contests. The Quest for Identity in Literature, Film, and
 Discourse since 1990*, eds Anne Fuchs, Mary Cosgrove, and Georg Grote (Rochester:
 Camden House, 2006), 127–45.

the competing ways such film texts are consumed by spectators not only in cinemas but in a variety of internet fora. Such films invariably provoke controversy, continuing to keep alive public discussion of this period of history, constantly calling into question the place of National Socialism in the pre-history of today's 'Berlin Republic', and challenging the notion that 'normalisation' is now a given.

Of particular interest in this regard is the growing phenomenon of 'Hitler-Kunst' which, as Harald Martenstein notes, is a new genre of art that has swept the cyber world.[17] Such art can take a wide variety of forms, but of interest to this present discussion is the way internet users are exploiting 'Web 2.0' technology to create their own films, commonly referred to as 'mash ups', combining video and sound from a number of sources to produce, often humorous, new film texts. There are, for example, numerous mash ups that parody *Der Untergang*. The most developed of these is the 'Hannerbersch' series, produced by two film-makers from Rheinland-Pfalz who have redubbed clips from the film with comedy voices. The thick 'Eifler Platt' accents of the new soundtrack presents the Nazi elite as provincial bumpkins, thereby undermining the pathos of the original film, showing how ridiculous these pompous men were, and rejecting a view of the film as a serious war movie, as it was advertised around the world.[18] In this series, through their choice of accent, the creators highlight the German-ness of the Nazis. They reject any sense that the ruling elite was divisible from ordinary, 'normal' Germans. Instead, the Nazis themselves are por-

17 Harald Martenstein, 'Adolf auf der Couch', *Die Zeit*, 4 January 2007. The most well-known example of this phenomenon is the 'Hitler Leasing' mash up, made by the film student Florian Wittman. Here we see a clip of a speech by Hitler from Leni Riefenstahl's *Triumph des Willens* (1935) overdubbed with the voice of cabaret artist Gerhard Polt who is performing a routine about being ripped off by a car leasing company. The film was widely praised in the press, although Polt's publishers were less amused and sued the film-maker for copyright infringement. Florian Wittman, 'Hitler Leasing', http://www.youtube.com/watch?v=q-7QoiOH9r0, date accessed 12 September 2006.

18 See, for example, 'Untergang Part 4 "leck mich am A..Abend"', http://de.youtube.com/watch?v=V5ecvugDONc&feature=related, posted 7 May 2007. Information on the film-makers gathered by email 13–14 December 2007.

trayed as 'normal' Germans from the provinces, and in so doing, National Socialism is presented as a specifically German problem with which the nation must still deal.[19]

In this regard we might also mention a number of other web phenomena connected to the consumption of contemporary cinema. These include film sites that point out continuity and factual errors in many of the films mentioned, such as 'dieSeher.de'. Here we learn, for example, that if Siegfried (Martin Goeres), one of the school children in *NaPolA* had really wet himself while sleeping, as the narrative at one point suggests he does, the stain on his pyjamas would have been a completely different shape.[20] Or, we can read commentators arguing about the accuracy of having Goebbels' 'Totaler Krieg' speech playing on the radio as Sophie is brought in for interrogation in *Sophie Scholl*.[21] Such error sites specifically and internet fan community sites more generally can be found on a huge range of films. Indeed, as Marnie Hughes-Warrington notes, they are increasingly becoming part of the mainstream industry, with production companies using them to feed information to fans about their films, in order to increase ticket sales and, more importantly in terms of revenues, to promote the tie-in DVD, which, of course, gives the spectator the opportunity obsessively to re-watch and scrutinise scenes from the movies, not least in order to find further errors.[22] In the far less capitalised German industry there is little evidence of such subtle manipulation, although film companies do appear to intervene if they do not like the tone of the discussion, as is evident with one posting on the 'dieSeher.de' site refuting the rumour that rightwing

19 The film has also inspired a cartoon by the well-known cartoonist Walter Moers, similarly to be found on youtube, where we see the Führer singing in his bunker, refusing to give up as the world collapses around him. Walter Moers, 'Der Bonker', http://www.youtube.com/watch?v=IC41_2yBaiY, date accessed 15 September 2007.

20 Posting by Jens, http://www.dieseher.de/film.php?filmid=1120, date accessed 19 February 2008.

21 Discussion posted by various, http://www.dieseher.de/filmnk.php?filmid=899, date accessed 16 December 2006.

22 Marnie Hughes-Warrington, *History Goes to the Movies. Studying History on Film* (London: Routledge, 2007), 180.

extremists had been employed as extras on Hirschbiegel's film.[23] The overwhelming feeling one gets from reading postings on this and other sites is that commentators wish to celebrate the failures of these films, thereby implicitly highlighting their own superior historical knowledge and the fact that they have not been taken in by the comfortable, 'consensual' message these films ostensibly deliver.

That said, in numerous blogs and discussion boards that are currently debating this recent crop of history films, one also find the opposite impulse, namely that spectators are learning from these narratives and as a result these films are, indeed, being consumed as forms of 'prosthetic memory', as defined by Alison Landsberg. If one explores the reception of these films on the International Movie Database, for example, we find users praising the affective power of the melodrama in these stories, as well as their attention to detail which, it would seem, is helping to bring this period of history alive to at least some present-day spectators both in Germany and abroad. 'Due to its high authenticity, great actors and an important message, this movie could become as important as *Schindler's List* already is, in order to show today's youth the insanity of Hitler and the whole Third Reich' (comment on *Der Untergang*); 'his film is as unsettling as it is moving' (comment on *Sophie Scholl*); 'I just thought it was fantastic. I never cried so hard' (comment on *NaPolA*) are typical of the posts such films attract.[24]

Here one might also mention the 'Fan Fiction' phenomenon, where Internet users write their own stories based on films they have seen. One 30-year-old author from Hessen, who writes under the pseudonym Allaire Mikháil, for example, has written several stories about the relationship of Albrecht and Friedrich in *NaPolA* in German and English:

23 Posting by casino, http://www.dieseher.de/filmni.php?filmid=832, date accessed 19 February 2008.

24 See http://uk.imdb.com/title/tt0363163/; http://uk.imdb.com/title/tt0426578/; http://uk.imdb.com/title/tt0384369/board/nest/86036505 respectively, date accessed 5 December 2007.

Winter Dreams

He dreams of what he should have done.

In his dreams, he does not lose his head. In his dreams, he shakes away the hands of his comrades and jumps back into the hole in the ice. In his dreams, he dives until his lungs hurt and the cold permeates his very bones. In his dreams, his outstretched fingers grab one of Albrecht's cold hands. In his dreams, he is strong enough to drag his friend back to the surface, and as if by miracle, they find the hole again, and soon the grey winter sky is above them, and their breath rises in clouds in the cold air. In his dreams, Christoph and the others take Albrecht's shivering form from his frozen arms, rub him dry and lead them to their room in the castle. In his dreams, they lie down on their cots and span the distance between their beds with their arms, link their fingers, never let go, and Albrecht smiles at him despite his chattering teeth.

Here, his dreams end. It doesn't matter whether they are both dismissed from the Napola in disgrace, sent to the Eastern Front, thrown into the cells in the basement or disciplined severely in another way by an enraged Gauleiter.

Sometimes, he thinks even dying together would have been almost unbearably sweet.

The night before the boxing match, he doesn't dream.

That's when he knows he has already decided.[25]

In this and a number of other pieces the author focuses on the tragedy of Albrecht's death. Writing from the perspective of Friedrich, the author imagines a world in which Albrecht survives. Following Landsberg's model, Mikháil would clearly seem to empathise with the film's protagonist, looking to explore and enhance the emotive power of the melodrama in his text and thereby ultimately re-experience Friedrich's trauma as it is presented in the film.

Finally, it should be noted that many of the sites which discuss these films in a variety of ways also include threads that spin off into broader discussions about the War in general and at times quite complex debates on the place of National Socialism in the historical consciousness of contemporary society, such as one finds in the debates that these films engender in the German press. On the International Movie Database, as well as a whole host of other fan discussion boards, there are numerous questions

25 Allaire Mikháil, http://allaire.skeeter63.org/AllaireFanfic.htm, date accessed 19 February 2008.

and comments about such films that develop into discussions on, *inter alia*, German national identity, anti-Semitism or the status of events such as the bombing of Coventry or Dresden as war crimes.[26]

Thus, we are left with the question, does the affective power of these films, and the emotions they evoke in the spectator, become a means of troubling the ostensible political consensus of their diegesis, suggesting that, in their consumption at least, they still have the ability to 'refin[e] memories and catalys[e] changes', to return once more to Rentschler's critique of post-Wall German film?[27] Moreover, does their mass appeal, a result of their indulgence of the kind of aesthetic consensus many critics also lament, with the potential to reach a far wider audience than most of the films of the New German Cinema, make them even better placed to achieve this end? Or, do they perhaps suggest that the process for which the films of the New German Cinema were a catalyst has simply entered a less reflective, more sentimental, but nonetheless equally necessary phase, where a genuine process of historical *Aufarbeitung* can, at last, begin?

26 See, for example, the discussion on Jewish identity in *Aimée & Jaguar*, http://uk.imdb. com/title/tt0130444/board/nest/7087545, date accessed 5 December 2007, or the discussion about the representation of Nazis in German war films, which takes as its starting point Stefan Ruzowitzky's Oscar winning film, *Die Fälscher* (2007), but which spins off into several discussions of guilt for Allied bombing, or the place of SS soldiers within normalisation debates, http://www.imdb.com/title/tt0813547/board/nest/71696011, date accessed 24 December 2007. See also discussions on film.the-fan.net, http://film.the-fan.net/?titel=15294&word=mein%20fuehrer, or 'Movie Infos', http://community.movie-infos.net/thread.php?threadid=7239, date accessed 19 February 2008.

27 Rentschler, 263–64.

Tinker, Tailor, Nazi, Sailor: Generic Stereotypes of German Combatants in Wolfgang Petersen's *Das Boot*

IAN ROBERTS

In *War Stories*, historian Robert G. Moeller argues that 'the fiftieth anniversary of the war's end made clear that [...] the German search for a useable past is not at an end'.[1] At a time when the success of German war films such as *Der Untergang* (Oliver Hirschbiegel, 2004) and *Sophie Scholl – Die letzten Tage* (Marc Rothemund, 2005) has triggered fresh discussions about depictions of the Second World War, and particularly of the portrayal of Germans in combat (notably concerning their status as victim or perpetrator), it is illuminating to return to a film which established the German-produced war film as worthy of international attention: a film which cost a then-record DM32 million to make and went on to earn $11.5 million in the USA alone; which received six Academy Awards upon its release in 1981; and which took established Hollywood tropes of the close-knit band of warriors and subverted them to a peculiarly German concept – Wolfgang Petersen's submarine film *Das Boot*.

Petersen portrays the German elite submarine arm at a distance of some thirty years from the events portrayed. In those three decades the German *Vergangenheitsbewältigung* debate had produced a canon of literary and filmic images of the German soldier at war, serving a regime he detested, yet serving it well. The impetus here, then, is to ascertain how *Das Boot* fits into this canon. What interests me in particular is how the film apparently conforms to the templates adopted by the post-war literary and filmic genre,

1 Robert G. Moeller, *War Stories. The Search for a Useable Past in the Federal Republic of Germany* (Berkeley and London: University of California Press, 2003), 20.

and yet the characterisation is nevertheless much more complex. Was this due simply to the temporal displacement which Günter Rohrbach, head of Bavaria Studios, claimed at the time of filming? In an interview in 1980 he claimed, '[Ich bin] überzeugt, daß es 35 Jahre nach Kriegsende möglich sein muß, unbefangener an einen solchen Stoff heranzugehen'.[2]

Yet the ongoing debate concerning Germans' status as perpetrators and victims sparked by W. G. Sebald's *Luftkrieg und Literatur* (1999) and the release of generically rather conventional (albeit highly successful) films such as *Der Untergang* suggest that temporal displacement is not, in itself, an automatic guarantee of impartiality. How then might a film produced in the early 1980s be suitable as a model for a successful film of (West) German *Vergangenheitsbewältigung*? As Anne Fuchs identifies in her study of contemporary accounts of the war, there is still an 'intrinsic tension' apparent in films and literature dealing with the war, which demonstrate 'the emotional need for some kind of positive [...] cultural heritage, on the one hand, and the cognitive engagement with the history of the Third Reich, on the other'.[3] Debates about collective memories of the war are therefore, she argues, as fresh and as vital now as they ever were.

On 2 February 1933 Adolf Hitler attended the Berlin premiere of the Ufa production *Morgenrot*. Directed by Gustav Ucicky, *Morgenrot*, which depicted a World War I German submarine crew bravely facing certain death in the aftermath of an attack by the Royal Navy, played on the supposed readiness of the German people to accept sacrifice for the greater good of the nation. Thus it fitted neatly into the Nazis' concept of *Volksgemeinschaft*. In a key sequence, as the boat's captain and first officer calmly contemplate their fate, the commanding officer confesses, 'Zu leben versteh'n wir Deutsche vielleicht schlecht, aber sterben können wir fabelhaft'. Even in these first days of the *tausendjähriges Reich*, templates were being established which exhorted the German people to contemplate acts

2 Günter Rohrbach, '*Das Boot*: Als Wahnsinn imponierend', *Der Spiegel*, 34 (1980), 53, 78–81 (80).

3 Anne Fuchs, *Phantoms of War in Contemporary German Literature, Films and Discourse* (Basingstoke: Palgrave Macmillan, 2008), 7.

of collective sacrifice. Moreover, the elite submarine arm was deemed particularly suitable as a vehicle to convey to the viewing public such exemplary behaviour.

With the capitulation of German forces in May 1945 literature and film were once again mobilised to review the gruelling experiences of the war years, and to seek a balance over contentious issues of *Mitläufertum*. The *Kahlschlagliteratur* of Alfred Andersch, Hans Werner Richter and Wolfdietrich Schnurre sought to foreground the individual experience of the footsoldier, subsumed – however reluctantly – into the collective will of the *Volk* and concerned predominantly with their own survival. Subsequently the Cold War began to influence West German writers and film-makers alike, adding emotional complexity to an already overwhelming topic of guilt and innocence, and the status of Germans (combatant or otherwise) as victims of, or perpetrators in, the Nazis' acts. As Robert G. Moeller points out, it was film, rather more than literature, which enjoyed a privileged position in shaping the collective memory-discourses of the recovering nation, since 'the work of cleaning up the Wehrmacht and confronting the "unmastered" past [...] took place in a space visited by millions of West Germans in the 1950s and studied very little by historians – the cinema.'[4]

Although one of the first films seen by most West Germans was Hans Burger's hard-hitting documentary about the Nazi concentration camps, *Die Todesmühlen* (1945), a number of prominent films attempted to depict the War, with the emphasis placed squarely upon the condition of the individual (or the small group) within a collective society. Whilst Wolfgang Staudte's *Die Mörder sind unter uns* (1947) primarily focused on conditions in the bombed-out German cities after the War, and the influence of former Nazis on post-war society, others sought a more explicit portrayal of the German soldier's plight. Bernhard Wicki's *Die Brücke* (1959), for instance, is unequivocal in its depiction of young German boys needlessly sacrificed

4 Robert G. Moeller, 'Victims in Uniform: West German Combat Movies from the 1950s', in *Germans as Victims*, ed. B. Niven (Basingstoke: Palgrave Macmillan, 2006), 43–61 (44).

for an utterly discredited cause. Likewise, Frank Wisbar's *Hunde wollt ihr ewig leben* (1959)[5] was one of several Stalingrad-themed adaptations from the 1950s which represented the *Landser* in action, combining a sense of individual culpability with critiques of betrayal by the German high command. To this was added an ineluctable (and at times much-criticised) sense of pride that the superior German soldier only lost the War because of bad leadership and insufficient supplies.[6] But after this initial foray into the genre of war films by German directors, the *Wirtschaftswunder*, coupled with the West German nation's inability to deal with its vexed past (analysed by Alexander and Margarete Mitscherlich in *Die Unfähigkeit zu trauern* in 1967) meant that the most successful films of the period were those of the *Heimatfilm* genre. These offered German audiences the chance to escape utterly from the tangled concepts of complicity and victim-status into an altogether more straightforward world, similar to the one offered by the Nazi film industry in the war years.

Thus, as the 1960s gave way to the 1970s, the image of the German combatant was increasingly presented to audiences by Hollywood and British film makers who were, naturally enough, inclined to cast the Germans in a negative light. *The Longest Day* (Annakin, Morton, Wicki, Zanuck, 1962), for example, or John Sturges' *The Great Escape* (1963) established a stereotype of the faceless German infantryman led by brutal, ideologically suspect Nazis. Thus, by the time Richard Burton infiltrated Schloss Adler in *Where Eagles Dare* (Brian Hutton, 1968) the generic template was firmly established. German combatants were depicted almost exclusively as ideologically-tainted Nazis leading anonymous soldiers to the slaughter in the face of plucky Allied gunfire.

Even when German literature or films attempted to depict a more balanced view, certain clichés and stereotypes demanded an approach which was nowhere more apparent than in the standard configuration of the group

5 Adapted from the novel by Fritz Wöss, published in 1958.
6 See Theodor Plievier's novel *Stalingrad* (1945), as well as Heinz Konsalik's hugely successful novel *Der Arzt von Stalingrad* (1956), filmed in 1958 by the Hungarian director Géza von Radványi.

– what J. David Slocum, writing about the Hollywood war film describes as 'the melting-pot platoon'.[7] This is, he argues 'a narrative device well-suited to the needs of movie-makers to strike a balance between the exigencies of storytelling focusing on individuals and the imperative to represent the values and stake of [...] society in films about the nation going to war'.[8] Slocum and others have identified a number of stereotypical characters in such films: these include the seasoned veteran, war-weary but experienced, and caring enough to want to get his 'boys' back home in one piece; the joker, always ready with a quip in the grimmest of situations; the callow youth, desperate to prove himself in combat; the cold-hearted killer, seemingly out to avenge some injustice perpetrated by the enemy. Critically, as Slocum goes on to explain, 'how the group is constituted and behaves can consequently be seen to express something of how society makes sense of its place in the world and in history'.[9]

German films reflect this configuration, with the added complication that victory in the conventional, military sense of the word, cannot be seen to be the aim of the 'heroes' of the film. Thus the 'politisch neutrale Landsknecht' as Jochen Pfeifer describes the *Landser* in West German literature, reluctantly does his duty, but above all seeks to preserve his own life.[10] For these characters, Pfeifer proposes, this individual is fighting a different kind of war, against the Nazi-inspired 'Kriegsmaschinerie':

> Im deutschen Kriegsroman über den Zweiten Weltkrieg wird zwischen dem einfachen Soldaten und der Kriegsmaschinerie ein tiefer Gegensatz konstruiert. Die Repräsentanten der Maschinerie sind höhere Offiziere, gläubige Nationalsozialisten und die nationalsozialistischen Politiker [...] Da der Krieg aus der Sicht dieser unselbstständigen Soldaten geschildert wird und die Autoren eindeutig zu deren Gunsten Partei ergreifen und die Maschinerie verurteilen, entsteht ein einfaches, schwarzweiß gehaltenes Bild des Verhältnisses der Soldaten zur Kriegsmaschinerie.[11]

7 J. David Slocum, *Hollywood and War* (London: Routledge, 2006), 10.
8 Slocum, 9.
9 Slocum, 10.
10 Jochen Pfeifer, *Der deutsche Kriegsroman. Ein Versuch zur Vermittlung von Literatur und Sozialgeschichte* (Königstein/Ts: Scriptor, 1991), 92.
11 Pfeifer, 111.

The release of *Das Boot* in 1981 swept away many of these assumptions, however, with a new and sensitive portrayal of German servicemen at war, and offered an alternative mode of representing German combatants. So subtle was this sea-change that many commentators overlooked the significance of Petersen's gripping depiction of the Battle of the Atlantic. Writing in 2006, Robert G. Moeller noted 'when the war returned to the big screen in forms intended for a mass audience – in Wolfgang Petersen's *Das Boot* (1981) and Joseph Vilsmaier's *Stalingrad* (1993) – crazed Nazis were pitted against innocent Germans in ways that were not unfamiliar'.[12] The simplicity of Moeller's assessment, however, fails to acknowledge Petersen's nuanced characterisation.

The novel *Das Boot* was published in 1976 and faced criticism from some quarters that the author, Lothar-Günther Buchheim, had set out to glorify the role of the German submariner and, by extension, to exonerate German involvement in the war. After initial interest in producing a film of the novel, Bavaria Studios in Munich balked at the vehemence of this criticism. After an abortive attempt to make the film in Hollywood (with a script proposing US involvement in the Battle of the Atlantic and Robert Redford as the boat's captain), production returned to Germany. The relatively-unknown Wolfgang Petersen was nominated as scriptwriter and director, and filming began in 1979.

In the weeks after its premiere on 18 September 1981 the film met with instant acclaim; it was hailed as the finest anti-war film since *All Quiet on the Western Front*. It subsequently ran as a successful TV mini-series, and a two-and-a-half-hour director's cut followed in 1998. The claustrophobic nature of submarine warfare allowed Petersen to concentrate on the intimacy of the submarine, producing a highly personal portrayal of the men who were engaged in this underwater conflict. A wide range of characters can be observed amongst the crew of U-96, and a number of common stereotypes frequently found in German post-war literature and film are apparent. But the 'melting-pot platoon' concept is subtly adapted

12 Moeller, 60–61.

to produce a greatly nuanced portrayal of German combatants, which goes a long way to explaining the film's appeal.

The character of Leutnant Werner (the autobiographical representation of Lothar-Günter Buchheim, played by the successful musician Herbert Grönemeyer) is immediately identifiable as the fresh-faced *ingénue* seen in most post-war literature and war films. He tries to fit in with the established crew, but remains something of an outsider throughout. In one scene his enthusiastic photography is curtailed when the captain points out that he should take his pictures at the end of the patrol as the unshaven faces of the crew look too fresh to be fit for propaganda purposes. Where the character of Werner proves useful to Wolfgang Petersen is as a mediator and focal point for the audience. As a newcomer on board he offers a route into the established routines and structures of the vessel in a way that an old hand would not. Through Werner the audience is granted the vicarious experience of life on board. This is particularly significant when we consider how Werner is openly in awe of the captain, whom he sees as both the ultimate war hero and the guarantor of his survival. It is no coincidence that it is Werner who runs back to rescue the Captain after the air raid at the end of the film, because he invests his Commanding Officer with an almost mythical air of indestructibility. Thus Werner acts a useful variant on the young recruit trope, since the audience identifies with his status as the outsider and can readily access the pathos of the film's conclusion. What Werner does not offer, however, is an alternative to the generic templates discussed above.

Two relatively minor characters in the wardroom largely conform to their stereotypical templates, but are worthy of brief mention. The first is the veteran Chief Engineer (played by Klaus Wennemann), as the paradigm of the older soldier who has already experienced several years of war. He is beginning to display the classic symptoms of shell shock: he is struck by abject lassitude during the many days without action, struggling to amuse himself with crossword puzzles. In one intimate and particularly clichéd scene he breaks down as he shows Werner photos of his family at home. Later, during a broadcast of a speech by Hitler he screams at the radio operator to turn it off, to the concern of the others, and the particular attention of the ideologically-correct second officer. Yet despite all this

he is also shown to be technically brilliant, saving the boat when they are stuck on the seabed after the ill-fated attempt to break through the Straits of Gibraltar.

The younger officer known simply as the 'IIWO' (Martin Semmel-rogge) also offers interesting characterisation, but little in the way of sub-verting stereotypes in the genre. He represents the joker character, always ready with a quip to raise the mood of the moment. He revels in this role, gleefully mixing 'U-Boot Spezialcocktails' at mealtimes and offering glib asides when the Nazi-inspired Executive Officer suffers misfortune. He also spends the most time working with Werner, at times baiting the newcomer over his fears. Both characters are certainly finely-portrayed examples of German servicemen on screen, but as such they are still largely conventional representations. Two further characters, however, provide more compelling evidence of the groundbreaking nature of *Das Boot*: the staunchly-committed Executive Officer, and the figure of the submarine's Captain. Both aptly illustrate how Petersen effected characterisation which transcends the tropes of post-war filmic portrayals of German combatants.

The boat's Executive Officer (played by Hubertus Bengsch) is the Party member who demonstrates unwavering faith in the *Endsieg* despite growing evidence to the contrary. His portrayal begins conventionally enough: in the opening wardroom scene he explains that he has returned to the Fatherland from his South American home to serve the cause: 'Für mich als Deutscher war es selbstverständlich'. He struggles to maintain his own exemplary standards of deportment in the light of the crew's lewd and noxious behaviour, and is regularly observed dictating Party dogma to the ship's secretary. The Captain takes no little pleasure in baiting 'unser Hit-lerjugendführer' as he calls him derogatorily, such as in the 'Sprengwagen' incident at the start of the film. Later, when the Captain asks his Executive to play 'It's a Long Way to Tipperary', he comments drily 'Die Platte wird Ihre Weltanschauung nicht schaden'.

As might be expected of a Nazi sympathiser, the Executive Officer is a highly-competent member of the crew, who does not suffer fools gladly. Gradually, however, the character gains in dimension, initially through examples of humour. He is the sole member of the wardroom to be affected by an outbreak of crabs amongst the crew, and later on his upstanding

image causes a merchant navy officer to mistake the Executive Officer for the commander of the submarine, much to the amusement of the other officers.

Already such minor scenes strike a new note in the portrayal of Nazis in West German narratives, but Petersen goes still further in his attempts to humanise this character. Perhaps the most telling scene occurs when the submarine is grounded on the seabed after an attack. In an unguarded moment, this young ideologue blurts out his fears – offering a glimpse of his hitherto suppressed humanity – as water pours into the boat. He brings a damage report to the Captain, and finally allows his carefully composed persona to slip: 'Herr Kaleun ... kriegen wir Auftrieb? Gibt's überhaupt eine Möglichkeit?'. At this moment it is quite apparent that Petersen did not intend his Nazi to remain a pastiche, a trite one-dimensional character.

And so the focus shifts to the Captain of the submarine, played to great effect by the then-relatively unknown Jürgen Prochnow. He is referred to as 'Der Alte' by the crew, and is quite evidently the focus of the film. Again, this character is on the surface at least rather stereotypical – craggy, clean-shaven, highly decorated, revelling in his crew's adulation and ever-concerned for their well-being. In the opening scene of debauchery at the Bar Royal he confides in a colleague 'Das ist nicht mehr die alte Gang', dismissing the replacements which High Command are rushing through training as 'Quexe – naßforsche Typen – Maulhelden'. He knows that he has to try everything in his power to keep his young crew alive, and time and again shots of the Captain in the boat's operations room show the faces of the crew staring at him, awaiting his next pronouncement. In the incident mentioned previously he admonishes Werner, 'Machen Sie Fotos von einlaufender Besatzung, nicht von auslaufender [...] weil sie dann Bärte haben'. He refers to his new crew members and his mission with contempt: 'Milchgesichter; Säuglinge, die an die Mutterbrust gehören. Steinalt kommt man sich vor unter den Gören. Reinster Kinderkreuzzug'.

In every sense the character of the Captain is conceived, it seems, as the archetypal old man of the sea. His respect for the ocean, and indeed for his enemy, is emphasised on many occasions as he shouts joyfully into the waves, or makes curt comments to the enemy above ('Nur zu, nur zu'). His dialogue is interspersed with lengthy periods of silence, and he

frequently rubs his beard thoughtfully as if trying to visualise the deadly game of cat and mouse developing above their heads. When resupplying in Vigo he reports 'Diesmal hatten sie uns ganz schön am Kanthaken', to which the Captain of the supply vessel replies, 'Phenomenal. Das ist die Sprache des Helden'.

Indeed it is the language of the war movie hero – whom Slocum describes as the 'exceptional "great man"' in war films.[13] It is pithy, understated, to the point. We are presented with the man whom the crew and the audience alike should regard as the ideal role model for the German combatant in the Second World War: professional and competent but with a humane streak, opposed in principle to the ideals of the regime he notionally serves, and yet fighting, if only for friend and homeland. Yet, as was the case with the character of the First Officer, the portrayal of the Captain is more complex and multi-facetted than might otherwise be expected from such a war film. Despite the romanticism, and the aura of invincibility which surrounds him, a number of sequences serve to make his position less than unequivocally positive. Two particularly unsettling episodes occur during a successful attack on a British merchant convoy. Under enemy bombardment the chief mechanic breaks under the strain and appears in the operations room, gibbering and refusing to return to his post. In a moment of high tension the Captain orders Johann to return to his post and fetches his pistol. Although the situation is resolved, it can only be assumed that the Captain is prepared to use force to reassert his authority. This runs contrary to the previous image of the benign father-figure who places the individual well-being of his men at the top of his priorities. Perhaps, the audience might reason, his actions can be excused on the grounds of acting in the best interests of the whole crew, but a later incident, when the Captain abandons shipwrecked British sailors, serves further to undermine the image of the avuncular hero. Although the crew accept that they had little choice but to abandon these men, the following scene shows the subdued mood on board, and a range of accusing glares aimed at the Captain. Indeed the Captain's own response to the incident

13 Slocum, 9.

reveals that he holds himself at least partly responsible for the deaths of the British sailors.

Each of these sequences, then, reinforces the contention that Petersen is not seeking idealistic, one-dimensional pastiches of the German sailors on board. Instead of straightforward tropes of the combatants, mirroring the Hollywood stereotypes whilst establishing the crew as victims of a brutal regime, Petersen proposes that the men involved in fighting for Hitler's *Reich* should be regarded as complex individuals with a range of motivations, hopes and fears. Having seen the characters of the Executive Officer and the Captain develop such atypical features, it should be no surprise to note that another set of generic expectations is overturned when the Nazi survives the air raid which destroys the submarine, while the Captain is seen to fall with his ship.

In contrast to many West German narratives about German involvement in the Second World War, director Wolfgang Petersen was little interested in the portrayal of the submarine crew as simplistic heroes or villains, as straightforward victims of Nazism or heinous perpetrators of evil acts; rather he set out to emphasise the humanity of the men serving on board the boat. The virtual absence of a moral stance in Petersen's characterisation is in direct opposition to the norm, where a narrative of the war from a German perspective invariably involves stereotypes easily inviting the assumption that German combatants were, at best, misguided fools and at worst, rabid Nazi sycophants. Either way, their fate as perennial cinematic losers was generally regarded as inevitable and fully deserved. Petersen confessed in an interview that the film's closing sequence, when the boat returns safely from its patrol, only for many of the crew to be killed in an air raid on their base, was deliberately downbeat: in a commentary for the Director's Cut he observes 'It's a very German ending of the film'. He relates how he cringed during test screenings in the United States as audiences cheered and clapped during the opening captions of the film, which reveal the horrendous death toll among German submariners. He then goes on to note that by the time the Captain collapses on the quayside, the bombed submarine settling onto the harbour floor, the same audiences were invariably in tears, having lived through the traumatic experiences of the crew. Although some might censure his amoral stance (since he avoids

condemnation of the sailors' lack of resistance to a regime they purport to detest), where Petersen succeeds is in his refusal to pander to stereotypes. His crew are not exonerated for their involvement in the war, but neither are they entirely censured. He reserves great admiration for the men who fight at sea in the most challenging of situations. Towering seas and personal deprivation play as large a role in the film as the terror of enemy attacks. Utilising the concept of the 'melting-pot platoon' as a starting point, the sailors are portrayed as atypically complex, three-dimensional heroes. Petersen dared to show the world, arguably for the first time, that German servicemen were first and foremost human beings, who found themselves engaged in the act of killing other humans with varying degrees of success and enthusiasm. As audiences discovered (almost against their will in some cases) that they were empathising with the crewmembers of U-96, it is apparent that Petersen succeeded in producing one of the most effective portrayals of German combatants, which – thanks to its popular medium – stands as a critical juncture in the ongoing *Vergangeheitsbewältigung* debate.

The Art of Delay: Protest and Prose in F. C. Delius's *Mein Jahr als Mörder*

STUART TABERNER

Some forty years after the events, the revolutionary fervour associated with the West German student movement of the late 1960s is today being debated with a passion which reflects, in equal measure, its lasting impact on politics and society in the present-day Federal Republic,[1] the extent to which this impact is being contested by a newly resurgent conservatism,[2] as well as by those too young to have participated in *les événements*, and, finally, its subjective significance for the individuals directly involved as they look back in their sixties to the heady days of liberation politics, sex, drugs and rock and roll. A series of media affairs, for example, the outing in 2001 of Joschka Fischer as a 'street fighter', have thus marked various stations in an ongoing 'memory contest' between political perspectives, generations and prominent public figures in relation to the way '68 is to be remembered.[3] At the same time, the near-simultaneous appearance of a number of publications such as Ingrid Gilcher-Holtey's *1968. Vom Ereignis zum Gegenstand der Geschichtswissenschaft* (1998), Wolfgang Kraushaar's *1968 als Mythos,*

1 See Ingo Cornils, 'Successful Failure? The Impact of The German Student Movement on The Federal Republic of Germany', in *Recasting German Identity. Culture, Politics and Literature in the Berlin Republic*, eds Stuart Taberner and Frank Finlay (Rochester: Camden House, 2002), 107–26.

2 See Ingo Cornils, 'The German Student Movement. Legend and Legacy', *Debatte*, 4 (1996), 2, 47–49.

3 The term 'memory contest' has usefully been introduced by Anne Fuchs. See *Memory Contests*, eds Anne Fuchs and Mary Cosgrove, *German Life and Letters*, Special Issue, 59 (2006), 2, 163–322. See also *German Memory Contests. The Quest for Identity in Literature, Film and Discourse since 1990*, eds Anne Fuchs, Mary Cosgrove and Georg Grote (Rochester: Camden House, 2006).

Chiffre und Zäsur (2000) and Gerd Koenen's *Das rote Jahrzehnt* (2001) suggests that the period is being invested, once again, with new meanings for new circumstances even as it is being 'demythologised'.

Literary fiction has been central to this process of reflecting on the place of '68 in the pre-history of what has come to be known as the 'Berlin Republic'. Indeed, already from the mid-1980s, younger writers such as Rainald Goetz, Thomas Meinecke and Andreas Neumeister had begun to approach the topic of '68, albeit rather indirectly, rejecting the political activism of the student movement in favour of an affirmation of the 'here and now' of popular culture. A desire on the part of subsequent generations to 'liberate' themselves from the overweening influence of the 68ers can be felt in the work of these authors, as well as in more obviously critical texts such as Ulrich Woelk's *Rückspiel* (1993), which examines the dogmatism of a veteran of the student movement from the perspective of his younger brother. In the cause of reclaiming an 'innocent' childhood lived in the 1970s or 1980s from the incessant 'politicisation' of the 68ers as they came to dominate culture, the media and politics, Matthias Politycki's *Weiber-roman* (1993), and a wave of later novels such as Norbert Niemann's *Wie man's nimmt* (1998), Frank Goosen's *liegen lernen* (1999), Thomas Lehr's *Nabokovs Katze* (1999), Ulrich Peltzer's *Alle oder keiner* (1999), and Dorothea Dieckmann's *Damen & Herren* (2002), substitute lifestyle for commitment, or at least for the 'overt' commitment favoured by the former activists now turned schoolteachers, journalists, social commentators and politicians. Finally, Christian Kracht's *Faserland* (1995), arguably the most influential pop novel of the 1990s, rubbishes the self-righteous moralism of the 68ers from the perspective of a still younger cohort of Germans bored by the lecturing, and self-aggrandisement, of their parents.[4]

Other, more recent novels focus less on the conflict between generations and address specific aspects of '68, namely the question of political

4 See Frank Finlay, '"Dann wäre Deutschland wie das Wort Neckarrauen": Surface, Superficiality and Globalisation in Christian Kracht's *Faserland*', in *German Literature in The Age of Globalisation*, ed. Stuart Taberner (Birmingham: Birmingham UP, 2004), 189–208.

violence and the iconic status of figures such as Herbert Marcuse, Benno Ohnesorg and Rudi Dutschke. Thus Leander Scholz's *Rosenfest* (2001); Erasmus Schöfer's *Ein Frühling irrer Hoffnung* (2001); Uwe Timm's *Rot* (2001, following his 1974 *Heißer Sommer*); Gerhard Seyfried's *Der schwarze Stern der Tupamaros* (2004); Sophie Dannenberg's *Das bleiche Herz der Revolution* (2004); Erasmus Schöfer's *Zwielicht* (2004); Peter Schneider's *Skylla* (2005, reprising his 1973 *Lenz*); and Timm's *Der Freund und der Fremde* (2005) explore the extent to which the terrorism of the 1970s can be said to have grown out of the student movement or examine the web of personal connections that melded activists, artists, intellectuals and writers into a surprisingly dynamic and influential force for social and cultural change.[5] Or they do both. These texts in particular respond to the immediate context of their publication: they may be read as engaging with challenges to the legacy of '68 in an era characterised by suspicion of ideologies, intellectual elites, and, post-9/11, the theorisation of political violence.

F. C. Delius's *Mein Jahr als Mörder* (2004), Ingo Cornils argues, 'shows how manifest injustice can lead a peaceful, intelligent young man to contemplate becoming a perpetrator of violence' whilst also making the case that the '"road to violence" was by no means as "automatic" as suggested by Koenen and other critics of the '68 movement'.[6] Delius, of course, had already addressed the causes and consequences of terrorist violence in his *Deutscher Herbst* trilogy (*Ein Held der Inneren Sicherheit*, 1981; *Mogadischu Fensterplatz*, 1987; *Himmelfahrt eines Staatsfeindes*, 1992); in his later work *Amerikahaus* (1999), he recreated the atmosphere of the movement before 1968 as a time of pre-lapsarian, that is, pre-extremist, innocence. *Mein Jahr als Mörder*, however, is different both from these

5 For a discussion of '68 in recent fiction, see Ingo Cornils, 'Literary Reflections on '68', in *Contemporary German Fiction. Writing in The Berlin Republic*, ed. Stuart Taberner (Cambridge: CUP, 2007), 91–107.

6 Ingo Cornils, 'Joined at The Hip? The representation of The German Student Movement and Left-wing German Terrorism in Recent Literature', in *Baader-Meinhof Returns. History and Cultural Memory of German Left-Wing Terrorism*, eds Gerrit-Jan Berendse and Ingo Cornils, German Monitor, 70 (Amsterdam and New York: Rodopi, 2008), 137–55 (141).

earlier works and the plurality of novels dealing with '68 by other writers mentioned above. First, *Mein Jahr als Mörder* explores the causal link between the shameful rehabilitation of former Nazis in West Germany in the 1950s and the radicalisation of the 68er generation in a manner which is more psychologically persuasive than is typical. Second, it reflects on the purpose of literature itself, both in the late 1960s, and in the present. Along the way, and just as important, the novel tells the story of Georg Groscurth, murdered by the Nazis for his courageous efforts to aid Jews, dissidents and deserters, and of his widow Anneliese, who was hounded by the Berlin and West German authorities in the 1950s for her refusal to accept re-armament and the blinkered dogmas of the Cold War.

As so often in Delius's work, *Mein Jahr als Mörder* has an obvious basis in the author's own history: its narrator, the son of a conservative pastor and a timidly conventional mother, burdened as a young man by a bad stutter, is familiar to the reader from, for example, the autobiographical works *Der Sonntag, an dem ich Weltmeister wurde* (1994)[7] and *Bildnis der Mutter als junge Frau* (2006).[8] In the present text, the now mature writer looks back, most likely from the early years of the new millennium, to April 1968 when, as a student working on his doctoral dissertation in West Berlin, he imagined that a voice on the radio (he is tuned into the Cold-War American broadcasting station *RIAS*) had commanded him to assassinate Hans-Joachim Rehse, a former judge on Hitler's notorious 'People's Court' who had signed 231 death sentences but had just been acquitted by the Federal Supreme Court. In place of the expected depiction of an act of righteous political violence, however, the reader is offered an extended recital, a veritable circumlocution over almost three hundred pages, of a previous procrastination, this one too sustained by story-telling. Thus the present-day narrator narrates his former self narrating the tale of Georg

7 See Brigitte Rossbacher, 'Unity and Imagined Community: F. C. Delius's *Die Birnen von Ribbeck* and *Der Sonntag, an dem ich Weltmeister wurde*', *German Quarterly*, 70 (1997), 2, 151–67.

8 See also my 'From Luther to Hitler? "Ordinary Germans", National Socialism and Germany's Cultural Heritage in F. C. Delius's *Bildnis der Mutter als junge Frau*', *German Life and Letters*, 61 (2008), 3, 388–99.

Groscurth, the father of a childhood friend sentenced to death by Rehse, and of Anneliese Groscurth and her vain efforts in the 1950s to achieve recognition for her husband's sacrifice and her vilification, by one side or the other, during the first, rather hot, years of the Cold War.

The narrator's detailed reconstruction of the injustices suffered by Anneliese Groscurth serves not only to honour her husband's sacrifice, repressed in the postwar period, and her own valiant efforts to resist remilitarisation in the 1950s. It also evokes the utter disillusionment of the younger generation with the hypocrisy of their unreconstructed parents. Indeed, Anneliese's courage stands in stark contrast to the passive conformism of the narrator's own parents; an entry in his mother's diary, for example, records her reaction to Anneliese's lament in May 1945 that the 'liberation' had come exactly a year too late to save her husband: 'Ich stellte mich abseits von ihnen'.[9] And the narrator's parents are not the worst culprits. Thus the text paints a depressingly comprehensive, at times overwhelming, picture of the machinations of West Germany's judicial system in the 1950s with its self-serving legalism and self-satisfied recital of democratic principles even as it protected ex-Nazis in government, business and, of course, the law. Anneliese's attempts to reverse her dismissal as a practising doctor by the West Berlin authorities following her genuine, if naive, association with an all-German, but communist inspired, 'public poll' for peace and unity are thus met with calumny in the press and the courts and years of fruitless, often malicious, attacks on her character and her husband's reputation.

These 'state injustices' form the backdrop to the radicalisation of a generation of young West Germans in the late 1960s, with the sections of the text focusing on Anneliese's story from the 1950s providing a kind of 'thick description' for an understanding of the cultural context within which the narrator and his student peers were politicised. To this extent, Delius's book offers a measure of historical texture that is often missing in other contemporary literary representations of the student movement in

9 F. C. Delius, *Mein Jahr als Mörder* (Berlin: Rowohlt, 2004), 223. Hereafter references will be given in brackets in the text following quotations.

which the causes of the protests of the second half of the 1960s – the discreditable toleration of ex-Nazis, the establishment of a form of 'democratic authoritarianism' under the cloak of anti-communism – are summarily sketched out before attention shifts to the more compelling, because more dramatic, immediacy of revolt and revolution. Yet *Mein Jahr als Mörder* moves beyond broad *sociological* explanations of how the student revolt was triggered and escalated and offers a rather revealing glimpse into the *psychological* drivers for the protests of the late 1960s, for their virulence, and for their ever immanent potential to explode into violence.

The generation of '68, personified to some extent at least by Delius's narrator, appears in the text as trapped within a series of anxious attachments and unsuccessful attempts at individuation. On the one hand, for most of the students, including the narrator, parents scarcely provide positive examples of civil courage. As such, they are easy targets for their children's disgust with the historical reality of the Nazi regime and the older generation's toleration of, if not active support for its outrages. In a key scene towards the beginning of the text, then, the narrator recalls a conversation he had as a boy of twelve or thirteen with his childhood friend Axel, Groscurth's son. In this exchange, Axel shatters the historical innocence, or, more accurately, blissful ignorance, hitherto enjoyed by his clueless playmate by failing to respect the typically expedient distinction made by the adults around them between 'Nazis' and 'Germans'. The narrator as child, therefore, knew something of the Nazis, 'die den Krieg anfingen und viele Millionen Leute sterben ließen', (22) but must now learn that it was 'die Deutschen' who killed his friend's father and that these Germans, suddenly synonymous with Nazis, were criminals. Here, the narrator suffers from a form of anxiety of influence relating to the haunting fear that a propensity for cruelty and 'extreme solutions' may be a 'German' trait, or at least a 'German' tradition.

At the same time, of course, his father is discredited. In response to the narrator's insistence that his father is also for peace – a claim made by the father himself, but linked by him not to any insight into Nazi crimes but rather to his own suffering as a French POW – Axel intones: 'Aber mein Vater hat das im Krieg schon gesagt und deiner erst danach'. (22) Here, Axel's precocious phrasing contrasts sharply with the narrator's immature

mimicking of his parents' deceptions and self-deceptions. Suddenly made aware of the truth of the recent past, and thus innocent no more, the narrator becomes literally stuck in the moment of articulation of horror, stuttering the letter 'K' in the word 'Kopf' when asking his father about the decapitation of Axel's father. His father's effortless, nonchalantly inexact response – 'Ja, es war schlimm damals [...] ich glaube, er wurde erschossen, aber er war ja ein Kommunist' (24) – compounds the son's disorientation and provokes the first instance of a compulsive fixation on the evasions of the wartime generation which, in later years, will drive an entire cohort's arguably neurotic need to confront their parents with their 'unmastered' biographies: 'Das Aber, denkt das Kind, was ist das für ein Aber?'. (24) The stutter, the loss of faith in language, and the obsessive insistence that the terrors of the past permit no imprecisions, embellishments or alterations in their telling signal a rupture with everything that might anchor the self in shared traditions and a shared culture, above all with language and storytelling.

Two possible sources of positive identification, alternatives to an identity rooted in family, nation or language, foster new complexes and scarcely resolve the absence, or rather rupturing, of healthy attachments. First, Hugo, a hippy from the United States living in London, emerges as the focus of his admiration and appears to offer, for a time at least, the chance to become part of a more relaxed, even liberated Anglo-American underground scene. The narrator's girlfriend, Katharina, who now calls herself Catherine in the French manner, similarly appends herself to Hugo, swiftly swapping French elegance for the anything-goes youth culture of 1960s Britain and California. Yet the possibility of escape into a non-German identity that Hugo promises can never be realised. The 'Engel aus London', a nickname that most likely alludes to the grace he enjoys in being able to float above the burdens which weigh down the German narrator and his compatriots, speaks of love and peace in blissful unawareness of their uncontainable outrage and, specifically, the narrator's overwhelming certainty that Nazi crimes and West German hypocrisy can only be atoned by the assassination of the former People's Court judge Rehse. (34–35) The realities of German history, and of the West German present, force the German students to be older than their years, deny them the relief of

spontaneity, and turn every discussion into a tortured, never-to-be-resolved cogitation on the theoretical implications of 'direct action' and the link between impotence and violence.

Second, and here we return to the narrator's decision to research and tell the story of Georg Groscurth and his wife Anneliese as he prepares himself mentally to carry out his plan to kill Rehse, the German resistance against Hitler appears to present an alternative, this time indigenous, model of identity to the discredited traditions and failed past cynically defended by the West German restoration. Thus he is increasingly drawn to Anneliese's struggle, an embodiment of opposition both to the Nazis and the postwar Federal Republic. Yet this too, initially at least, raises more questions than it answers: how could Groscurth have been a rescuer of Jews and political dissidents *and* personal physician for Rudolf Heß, Hitler's deputy? (44) How could he have refused to countenance any diminuition of individual dignity and yet also have tolerated fellow scientist Robert Havemann as his best friend and closest collaborator, despite Havemann's enthusiastic support for the Soviet Union under Stalin? (44) (Havemann, of course, later championed the GDR before becoming a dissident from the mid-1950s). And, most important of all, what did Groscurth's non-violent opposition achieve while the regime remained intact and continued to kill?

Towards the end of the text, the present-day narrator summarises the pre-eminent motive for his planned assassination: 'Eins wollte ich auf keinen Fall: so feige sein wie Stauffenberg. Einen Mord als notwendig erkannt, viel zu spät, aber immerhin'. (270) Via this moment of self-generated psychological insight, we glimpse the anxiety that haunts the narrator, and indeed so many of his generation: the fear of fatal delay, that to wait to act signals cowardice and compounds guilt. In a very fundamental sense, of course, the narrator and his fellow student protesters have already arrived too late, thirty-five years after Hitler's accession to power, and, as such, are condemned to experience themselves as impotent bit-part actors in a script written by the master dramatists of the Nazi regime. This fear of acting tardily motivates the students' repeated return to the question of the legitimacy of political violence. Whispered conversations overheard about weapons to be secured in the student den *Blauer Stern* on the Stuttgarter Platz (134) thus provide a glimpse into the very real possibility that some

protesters might go beyond minor skirmishes with the police such as the 'Steinesschlacht am Tegeler Weg' (269) in late 1968 or ignore pleas for reflection and restraint, for example, theologian and respected anti-Nazi Helmut Gollwitzer's call for a pause in the demonstrations to allow time for de-escalation.

For the narrator, the elaboration of a plan to kill Rehse comes as a response to precisely this fear that to fail to take direct action is to become complicit. At the same time, however, it also a matter of his image of himself as an 'intellectual': 'dass ich nicht wie ein typischer Intellektueller das Handeln aufschiebe und vor den konkreten Schritten zur Tat mich drücke'. (259) This opens up the second major theme in the novel: the role of intellectuals, and specifically of writers, and the purpose of literature. Indeed, the paralysing sensation of being a latecomer inheres equally both within the narrator's deliberation-versus-action dilemma and his scheme to murder Rehse. In the faintly theoretical, abstract manner in which he formulates his fear of behaving like a 'typischer Intellektueller' who contemplates instead of taking concrete steps 'zur Tat', the narrator recalls, conciously or not, a lengthy literary tradition in which German writers and thinkers debate the guilt that intellectuals accumulate whether via their procrastinations or via their actions – most immediately, given the revolutionary context, Toller's *Masse Mensch* (1920) comes to mind. And a few pages later, as he imagines how he would carry out his homicidal deed, he can do no better than the following:

> In der Stille eines Villenviertels, morgens gegen acht oder abends gegen sieben, das wirkte ziemlich einfallslos, aber ich konnte mir den Tatort ja nicht aussuchen, schon gar nicht eine politisch-symbolisch passende Kulisse, wie Filmleute sie bevorzugt hätten. Der Plan war einfach: mit der Waffe im Auto heranfahren, im richtigen Moment aussteigen, drei Schüsse, alles eine Frage der Pünktlichkeit. (262)

The murder scenario, he concedes, is a cliché, clearly derived from any number of gangster movies, but, he regrets, less effective on account of the fact that he cannot choose the set. And, once again, there is an immediate echo of the Weimar period: the details of the killing and its location in a 'Villenviertel' strongly recall the murder of Walther Rathenau, Jewish industrialist and Foreign Minister, who was gunned down in June 1922

in Berlin-Grunewald. Rathenau, of course, was murdered by right-wing extremists, and there were three assassins with machine guns rather than one assassin firing three shots from a pistol, but the point remains that political violence, whether from the left or from the right, is never more than an unoriginal copy.

The narrator, of course, never gets round to carrying out his plan. Rather, his retelling of the story of Anneliese and Georg is itself a form of procrastination – whether he likes it or not he is a 'typischer Intellektueller'. Indeed, at the very beginning of the text, he had already acknowledged as much: 'Wer Bescheid weiß, wer handliche Antworten hat, der kann sich auf die Straße oder vor ein Mikrofon stellen und Parolen schreien, das ist in Ordnung, aber wer nichts weiß oder fast nichts und so gebaut ist wie ich, der hat nur eine Wahl: schreiben'. (45) For the narrator, therefore, for whom nothing is ever black and white, often to his great frustration, writing is the only choice, and, indeed, it may well be the more appropriate, and the more timely, response to iniquity, injustice and ignorance: 'Wenn die Fragen schon so weit vorgeschossen, wenn die Gegensätze schwer auszuhalten sind, gibt es nur ein Mittel: an der Schreibmaschine weiterfragen, die Gegensätze zuspitzen'. (45)

For all it thematises violence and protest, Delius's *Mein Jahr als Mörder* is in truth best characterised as a robust defence of literary fiction, in the late 1960s most obviously, but also most likely into the present. What the novel recounts, then, is the story of how a young author, whose biography is markedly similar to Delius's, including details, as already noted, of his family background but also of his career – for example, his work as a *Lektor* and trips into East Berlin to see Wolf Biermann – came to define a purpose for his literary fiction. Once more, the anxiety the narrator experiences regarding the social and political utility of his writing relates to an overpowering sense of belatedness. Unlike his peers who choose the path of violent provocation, however, he is finally able to define the benefit of delay.

A debate between the narrator and writer friends on 'das "Politische"' and 'das "Schöne"' (95–96) and a mention of *Kursbuch 15*, in which Hans Magnus Enzensberger and Karl Markus Michel pondered the 'death of literature' and its replacement by political manifesto, (205) establish the

historical context for the novel's reflections on politics and writing. In both instances, he defends, implicitly or otherwise, the autonomy of fiction against those who would instrumentalise it as a purely political instrument. During the discussion with his friends, then, the narrator as young man attempted a compromise, a 'Vermittlung' (205) between *Engagement* and aesthetics; looking back decades later, he is more forthright, chastising the 'Simpelköpfe' who misunderstood *Kursbuch 15* as a *call* for the death of literature rather than a reflection on its adaptation to contemporary circumstances. Yet this sustained faith in the social relevance of fiction is shaken by his awareness that his literary interventions always come after the fact, so to speak. For example, he is incapable of imagining Groscurth and Havemann meeting clandestinely in the Berlin Zoo, (268) since he has no direct experience of such cloak-and-dagger operations. Or, he wishes that he could follow Erich Fried, Jakov Lind or Elias Canetti into exile in London and be as 'warmherzig kritisch' as Fried, as 'erotoman anarchistisch' as Lind, or as 'majestätisch meisterlich' as Canetti. He is too late to have have been expelled from Germany – nor, as a non-Jew would he have suffered this fate – and so he will never be able to strike a pose in cafés in Hampstead Heath, like Canetti, reading German newspapers 'mit verschmitztem Blick'. (136–37)

Most undermining of all, however, is his discovery that the book he has set out to write about Georg Groscurth has already been written, in 1947, by one Ruth Andreas-Friedrich, who heard the story from the man who forged documents for the group. Indeed, her description of Groscurth's activities and his execution possesses an immediacy which, significantly, leaves him 'lange Zeit sprachlos'. (276) Yet Andreas-Friedrich's volume, published in an era in which accounts of the miniscule German opposition to Hitler were scarcely relished by a majority unwilling to acknowledge its conformity, or worse, has been forgotten – it is significant that Catherine digs it up in a second-hand bookshop not in Germany but in London. There is a need, then, for the story to be told again. The narrator may not be the first to recount the tale of Georg Groscurth but he is able to update it to include the postwar injustices suffered by his wife in the West German courts and media and assert its continued relevance in new historical contexts. His initial impetus to write thus comes as a reaction to the fanaticism of his

fellow students, which causes him to return to Groscurth's *non-violent* resistance, 'entschlossen, wenigstens eins oder zwei oder vier der Gesichter der von R. ermordeten Männer sichtbar werden zu lassen'; (53) at the end of the text, he reformulates this implicit defence of fiction as a form of resistance via remembrance in more personal terms and explains why he has found his way back to Groscurth after so many years: '"Ich stellte mich abseits von ihnen" – erst dieser Satz aus dem Tagebuch meiner Mutter ließ mich wieder anfangen: Das Abseits sollte vergolten, die ungeschriebene Geschichte eines Mörders erzählt, das Geständnis gewagt werden'. (301) Writing, it seems, is an obligation to the past, not a choice.

'Glauben sie in ihrem Übermut an die Macht der Wörter?', (124) the narrator wonders when he hears from Anneliese of Groscurth's and Havemann's fateful decision to mass-produce opposition leaflets. For Groscurth, this faith in the power of words to draw attention to evil and inspire good cost him his life. For the narrator, this faith, and Groscurth's sacrifice, justify his forty-year commitment to prose – not prose *over* protest, but prose *as* protest. And as for his fear of tardy intervention, of belated action, he comes to realise that delay, too, has its advantages: 'Die Verspätung hat viele Vorteile. Die Prozesse der Anneliese Groscurth ließen sich damals noch nicht vollständig rekonstruieren. Neu entdeckte Aken, neue Forschungen erleichtern die Beschreibung Georg Groscurths und seiner Gruppe Widerstand'. (301–2) Begun in the late 1960s, published in 2004, *Mein Jahr als Mörder* is certainly long delayed but, for that, no less significant, within Delius's *oeuvre* but also as a defence of literary fiction in an era in which literary engagement occasionally appears redundant.[10]

10 For a discussion of literary engagement in the post-unification period, see my essay, '"West German" Writing in the Berlin Republic', in *Contemporary German Fiction. Writing in The Berlin Republic*, ed. Stuart Taberner, 72–90.

Suchbilder: Looking for Christoph Meckel

NEIL H. DONAHUE

The last decade has seen a resurgence of works in Germany presenting the conflict between generations in the post-war period, but the representation of this conflict differs from the first wave of narratives by the sons of Nazi fathers, who in the 1970s depicted their agonistic Oedipal rage in memoirs of generational malaise. Christoph Meckel's *Suchbild. Über meinen Vater* has proven a touchstone for variants that expand the father-son conflict to other siblings and situations.[1] For example, the title of Ute Scheub's *Das falsche Leben. Eine Vatersuche* (2006) alludes to Meckel's title. She follows his lead in her probing inquiry into her Nazi father's actions, particularly his dramatic public suicide in solidarity with the SS. Her allusion to Meckel's text underscores both its significance and how such narratives of generational conflict have shifted away from the model of filial revolt. The narratives include the daughter's view of the father in Ulla Hahn's *Unscharfe Bilder* (2003) and the child's view of the mother in Niklas Frank's *Meine deutsche Mutter.* (2005) These works are indebted to Meckel, who in 2002 followed his first *Suchbild* with *Suchbild. Meine Mutter.* Because of its continued influence on German generational literature, both fiction and memoir, Meckel's work deserves attention in its own right.

In his early narrative *Licht* (1978), Meckel established an idiom of introspection typical of *Neue Sensibilität*, analysing the sensual contours of

1 Christoph Meckel, *Suchbild. Über meinen Vater* (Frankfurt: Fischer, 1982). Hereafter references will be given in brackets in the text following quotations. In 'A Biography for the "New Sensibility": Christoph Meckel's Allegorical *SUCHBILD*', *German Life and Letters*, 39 (1986), 3, 235–44, Todd C. Hanlin indicates that the 'consequences for German literature [of Meckel's *Suchbild*] go far beyond mere documentary protest or self-serving encomium' since it is a 'new, generational allegory of contemporary relevance'. (236)

individual experience, measured against the redeeming quality of joy: 'Ich muß diese Freude empfinden können, wenn ich nicht nur ein Mensch sein soll, der mehr oder weniger einseitig funktioniert'.[2] The threat of reductive functionality brings historical context into the picture, though only implicitly into the background: in a dialectic of historical hedonism typical of the period (the personal is the political), the politics are at first only of complicated intimacy surrounding the possibility of sharing 'das Glück,'[3] but lead to the historical contingency of personal happiness within the family. *Suchbild* begins with the author's first memory of his father and of the child's feeling of happiness in his father's presence: 'Gefühl von Sicherheit und blindem Vertrauen, eine wunderbare Gewißheit in seiner Nähe'. (9)[4] That childhood memory of unqualified happiness is at the core of Meckel's intimate but anguished character study of his father as *Zeitgeschichte* in an alternately sympathetic and scathing analysis of the patriarchal male of the Third Reich and the German generation of 'total war'.

Suchbild is not a common term in German but captures the mixed motives of such a task. First, the title suggests a wanted poster for an outlaw in a western or, nowadays, for a most wanted criminal; and second, it suggests an image posted in the search for a child or other lost loved one. The title thus evokes the two emotions of prosecutorial fervour for an indictment and of anxious affection, mixed with regret. The term also indicates a visual game in a newspaper, in which the reader scans an image for hidden objects.[5] Meckel's graphic art plays with mirror image reversals and whim-

2 Christoph Meckel, *Licht* (Frankfurt: Fischer, 1980), 6.

3 Meckel, *Licht*, 24.

4 In her '*Väterliteratur*, Masculinity, and History: The Melancholic Texts of the 1980s', in *Conceptions of Postwar German Masculinity*, ed. Roy Jerome (Albany: SUNY Press, 2001), 219–42, Barbara Kosta examines a corpus of *Väterliteratur* of this period, citing Meckel's *Suchbild* as a model in terms of the author/child's 'injured narcissism' that produces a 'melancholic text'. (222) The moment of happiness experienced by the child becomes, for Kosta, a 'lost ideal' (226) at the core of this generation's melancholia, evinced in texts that chronicle a 'desire for a self-affirming proximity to a father-image that no longer exists'. (226)

5 I would like to thank Corinne Kahnke (University of Indiana) for making me aware of this usage in German.

sical constellations of objects. His narrative exploration is like a visual design, a verbal tableau of discrete memories, in which one can search for emotional truth. That truth emerges as the lost centre of childhood happiness, grounded in trust and security, which remains the foundation of later happiness: *Suchbild*'s attempt to locate and restore what went missing is a common feature of this genre.

At first, the father, Eberhard Meckel, was 'ein Vater ohne Vergleich, Spielmeister, großer Bruder, Vertrauter und Freund. [...] er war die unumstößliche Mitte des Kindseins'. (35) But the war draws the father in, despite his intentions, and he loses his house and the stability he had so cherished. The good father, inspiring trust and confidence, is followed by the punitive head of the household: 'Der beherrschte so etwas wie ein System von Strafen, ein ganzes Register', (39) including beatings. The psychological and physical punishments put an end to the child's feelings of happiness. The child's heartbreak turns into the need to confront the father, posthumously, as an adult. Long sequences of detailed description elaborate particular traits of the father and situate him in his historical circumstances. Meckel surveys the inner and outer landscape of a narrow-minded, provincial existence and focuses upon the obsessional perversity of his father's mindless 'Spinneneifer', (9) which was 'gleichermaßen konkret und irrational'. (9) He sums up: 'Mit Zuverlässigkeit und Pedanterie verwaltete er die eigene Lebenszeit. Alles Gelebte zu den Papieren. Er archivierte'. (9) Meckel's own description is extraordinarily concrete in its enumeration of the things his father collected, which the son, like the father, orders with taxonomic zeal. Yet the son's cataloguing is concrete and *rational*, an anecdotal and antidotal counterpart to his father's obsessive archival addiction, which culminates, ominously, with memorabilia of his involvement in the Third Reich: 'Er sammelte schlecht getippte Marschbefehle, [...] Entwürfe für Hitlerfeiern in der polnischen Etappe'. (10–11) Such details slip almost unnoticed into the cascade of his collectibles, and recall the Eichmann-like, pedestrian banality of an individual's participation in inhumanity on a grand scale. The father's archival compulsion and inability to reflect critically on his own complicity betray a dominant trait of the Eichmann generation, precluding any emotional involvement with his own son, who now settles accounts.

Meckel plots 'die Welt meines Vaters' (11) in the German cultural history of that generation in circles, contexts of expanding scope, in order to show his typicality for the period. He gives this dilated view of his father not to exonerate him, but rather to understand the historical tendencies he represents and where they led. After dense passages of almost elegiac evocation and enumeration of the natural attributes of the Black Forest region, its cultivation over the ages and its cultural richness at the crossroads of Europe, Meckel punctures that inflated sense of bountiful garden idyll, flipping the image to indict an ingrown arrogance, xenophobia and self-congratulatory benightedness: 'Es gibt den Hochmut des provinziellen Dickschädels mit Begriffen wie SCHOLLE und BODENSTÄNDIG-KEIT, und es gibt einen chronischen, vielfach ahnungslosen und beinahe gutartigen, oder aber hartköpfig-rustikalen Chauvinismus [...] Es gibt das breitärschig-selbstgerechte Heimatgefühl [...] Es gibt die entwicklungs-feindliche Gesinnung für Grund und Boden, Besitz und Überlieferung, Anstand und Ordnung'. (13) With his dense lists of details, heavy with nouns, names and weighty, compound adjectives, Meckel locates his father in the stratified social and historical bedrock of the region, where the father lived for almost the whole of his life, and discovers him anew, with scientific detachment, like some fossil of a strange antediluvian creature. Meckel also wants to understand him psychologically, particularly his mystical attachment to that region, which caused him to founder in the ideological tar pit of the 'Naziozooic' era. The father developed a regional mysticism, linked to but distinct from his Catholicism, which consoled him for the disappointments and perplexities of his existence: 'Er suchte und brauchte den Trost, war süchtig nach Trost, er flüchtete in die Tröstung und träumte in ihr'. (15) His melancholic sensibility disposes him to embrace 'timeless' art and experience, which transport him outside the temporal-historical realm, in which he is psychologically troubled, and restore a love of life, 'eine fast erotische Nähe' to the objects invested with that uplifting quality, a pious pathos for forms of artistic sublation. The father returns from his consolational art excursions a complete and generous, intellectually and emotionally balanced person, but Meckel's careful construction of a long passage, in its fluctuating emotional modalities around the word *Trost*, suggests that the balance is delicate.

Once Meckel has limned the contours of his father's provincial life and precarious psychological balance, he turns, again following the expanding circles from that centre, to the familial past: Meckel's grandfather (a 'Scheusal' (17)) was a prominent architect who developed the new type of bomb-resistant concrete used in the Second World War (as in the bunkers that remain to this day on the coast of France and elsewhere); his own personal appearance seemed to share the same qualities, for example, his 'Eisengesicht' (17); he was the very image of the dominant patriarch, a pillar of society and brutal enforcer of his will in the home and outside, who created in *his* son, Christoph's father Eberhard, his inner Nazi, in the combination of authoritarianism and self-subjugation, of belief in abject obedience and punitive domination: 'Geschlagen kroch er aus dem Loch seiner Kindheit'. (18) Later, his melancholic sensitivity to nature brought him together with fellow nature poets around the journal *Die Kolonne*, Peter Huchel, Elisabeth Langgässer, Günter Eich, Martin Raschke and Horst Lange, who 'fled' into so-called Inner Emigration.[6] In 1937, Eberhard Meckel even built a house outside Berlin: 'Das alles sah friedlich, erfreulich und haltbar aus', (21) and devoted himself, like many others, to banal versifications: 'Die Naturlyrik richtete sich in der Laubhütte ein, aber die Laubhütte stand auf eisernem Boden und war von Mauern aus Stacheldraht umgeben'. (22–23) *Suchbild* is a sober indictment of the father's behaviour with an undercurrent of pain and pathos. Eberhard Meckel's diary, excerpted by the author, reflects an inane absence of critical perception, as when he asks in view of Hitler: 'Wo die Würde und noble Geste?', (29) and reflects with self-satisfaction 'immer wieder, wie wunderbar es ist, mit Goethe etwa zu leben'. (29)

His father is a literary epigone of political convenience, who spins a cocoon of poetic platitudes and received ideas, suffocating his conscience and reinforcing his conformity to Nazi ideology, and leading later to his craven need for uncritical consolation. Only the discovery of the father's

6 For a recent re-appraisal of Inner Emigration, see *Flights of Fantasy. New Perspectives on Inner Emigration in German Literature*, eds Neil H. Donahue and Doris Kirchner (New York and London: Berghahn, 2005).

war diaries from the Eastern front compelled the son, nine years after his father's death, to explore the public and historical significance of his private circumstances. The son confronts the father's regime of emotional and physical punishment, and his callow, abstract emotionalism, sublated into obscure and epigonal nature poetry. The literary trope of discovered diaries allows the intersection of private and public spheres and asserts a continuum of moral accountability between the two.

The revelations of the diaries force Meckel to challenge his father, retrospectively, as a response to his private anguish and to the collective consciousness of German war guilt. Excerpts from the 1930s document the father's obtuseness toward historical context, but his war diary shows his father's obtuseness as complicity in events in Poland and the Soviet Union. Meckel Sr. tells himself: '*Es hilft nichts, es muß durchgehalten werden*'. (42)[7] He writes military propaganda with naïve devotion to his craft: '*Sehr glückliche Stunden der Tätigkeit, um das anständige Wort bemüht*', (42) for which he receives a commendation. (42) His '*soldatisches Herz*' yearns to go '*fort zu Front, Tat und männlichen Abenteuern*'. (42) In self-glorifying identification with his mission, he finds the fleeing '*Russenvolk*' indescribable and a begging Pole '*unwürdig*', (43) and sums up: '*Ein elendes Volk*'. (42) This Don Quixote in a *Stahlhelm* tries to live a German soldierly ideal while witnessing Nazi atrocities: '*Auf einem Umweg zum Mittagessen Zeuge der Erschießung von 28 Polen, die öffentlich an der Böschung eines Sportplatzes vor sich geht. ... Ein wüster Leichenhaufen, in allem Schauerlichen und Unschönen jedoch ein Anblick, der mich äußerst kalt läßt*'. (44). His son notes bluntly: 'Ihm fehlte in allem das elementare Entsetzen, weil ihm die Einsicht in den Zusammenhang fehlte'. (48) He adapts to external events, at the price of depression. His diary registers bitter frustration as he tries to exculpate himself: '*Elender Verrat der Führung am irregeleiteten Volke*'. (59) This takes its toll, hollowing out the person inside the empty shell, leaving only the 'Chauvinismus des gehobenen Untertans'. (50)

He is promoted to *Oberleutnant* and sent to Elba, where he is relatively safe until the Allied invasion. He suffers a head wound, is captured and

7 Here and below, the italics are in the original.

has an operation on his head in a prisoner-of-war camp in North Africa. Shards are left, causing him life-long headaches, depressions, speech problems and mood swings. Whether brain injury caused these symptoms or only brought them to the surface remains an open question. He is consoled by reading German classics, which provide continuity in his pre- and post-war thinking: he believes in the nobility of his spirit, while readily acknowledging collective German guilt but not personal culpability. He obsessively reconstructs his life as a list of names, in different life categories, which brings the pre-war past into the post-war present, without critical examination, simply bridging his personal Zero Hour.

The shrapnel in his brain becomes a symbol for the guilt he denies, but which alters his behaviour. In his mind, his motives have always remained pure: he does not need a letter of good conduct to avoid denazification and stylises his past into an uplifting existential crisis of individual hardship, (62) though even that comes to an end with his repatriation into the deprivations and uncertainties at home in a bombed-out Freiburg. The joy of his children at their reunion with the father is short-lived. Civilian life full of material and psychological uncertainties overwhelms him, transforming him into a tyrannical pedant. His own pathology becomes that of the family around him; even with a certain material security of work with radio and newspapers, and as a poet, his disposition remains the same, signalling to his family 'das Ende des Glücks'. (79) He remains only a hollow caricature: 'Er mußte sich als Kern der Familie erhalten, obwohl er nur ihre geplatzte Schale war'. (88) This image of the broken father who returns from war physically intact, but damaged within, has become a stock image in literature and film.

A whole generation was left 'without a model of masculinity'[8] after the patriarchal model of militaristic discipline, self-sacrifice and respect for authority had collapsed. Meckel does not turn toward father figures at the other end of the ideological spectrum, something that only created 'a deep divide between private and public spheres'.[9] Meckel's focus on life

8 Kosta, 223.
9 Kosta, 223–24.

at home from a child's perspective, which includes his mother, puts his text beyond his generation's 'pervasive discrediting of the private sphere'[10] and accounts for the influence of that text on subsequent generations. Meckel analyses his father with the acuity of an adult from the perspective of the child he once was, whose childhood he laments. Using character-istic anaphoric amplification of a phrase, he intensifies the rhetorical and emotional affect of that retrospective gaze on his childhood and on his father. He describes the *Mangelwirtschaft* of the post-war period through the repetition of sentences beginning 'Es fehlte' (93–99) in a repetitive but increasingly sonorous cadence that passes from the destroyed public sphere to intimate emotions: 'Es fehlten die Freude, der Luxus und das Glück'. (94) What is missing is not essentially material in nature, but rather 'die Folge einer fundamentalen mauvaise foi', (95) what Hans Dieter Schäfer has aptly called 'gespaltenes Bewusstsein'.[11]

Guilt left a hollow at the heart of the perpetrator generation, as it strug-gled (or not) to come to terms with its crimes. Bad faith locks the German family into an obsessive repression of the past and the evasion or allevia-tion of guilt. Salving wounds, seeking material comfort and psychological consolation preoccupies the whole country, inducing collective paralysis and torpor. The father can only look on helplessly as his son, whose artistic efforts he had condemned, eclipses him with his graphic art and poetry. Suddenly, he supports the son wholeheartedly and lives vicariously through him. The father conducts a reading that the son had to cancel at the last minute, reading the son's poems 'in einer Weise, die glauben machte, es wären seine'. (104) Like a pathetic Faust figure, the father wants to drink the magic potion of his son's poetry to re-gain his uncorrupted youth. But he cannot think beyond the uncritical platitudes and ideological common-places of another age, words like *Heimat* and *Vaterland*, which the Nazis had corrupted beyond recovery. Yet he needs their solace, however spe-cious, more than ever. Meckel describes the steadily narrowing sphere of his

10 Kosta, 223.
11 Hans Dieter Schäfer, *Das gespaltene Bewusstsein. Deutsche Kultur und Lebenswirklichkeit 1933–1945* (Munich: Hanser, 1981).

father's life. The last section of the book, recalling the opening passage, is an adult's meditation on happiness and its absence in his father: 'er sprach davon, daß er sich für glücklos hielt'. (116) In effect, he was consumed by discourses that had surrounded him in the public sphere in the past and that prevented him from finding happiness and accepting responsibility in his private life in the present.

Meckel's analysis of the private sphere behind public ideology through his father accounts for the continuing influence of his work on the current generation of writers. This 'domestic historicism' – the retrospective intimate, familial account of historical events – defined by generational experience, includes Meckel's recent account of his mother. In his first *Suchbild*, Meckel compared the mother to the father: 'Die schöne und kluge Frau war sein restloses Glück. Daß sie schärfer dachte und deutlicher sah, kritischer, leidender in der Epoche lebte, schien ihm niemals ganz bewußt zu werden'. (34) The son's identification of intellect and sensibility in the mother does not, however, redeem her inadequacies, which he dissects with undiminished acuity and acidity in *Suchbild. Meine Mutter*.[12]

He attempts to understand the emotional void ('das Fehlende', (7) 'die Leere', (7) or 'ein Vakuum' (8)) between him and his mother and, by extension, the withering norms of bourgeois propriety that she embodied and upheld ('das Angemessene verkörpernd' (13)). His emotional distance to his subject gives his portrait its analytical edge and saves it from becoming mere caricature, while charging it with latent anger, when he describes, without false piety, the emotional torture ('ein Gliederreißen der seelischen Anatomie' (7)) she subjected him to. Her sense of propriety, an empty formality, becomes simply a 'Verfälschung des Menschen' that distorts all relations: 'In alledem ging die Mitmenschlichkeit verloren'. (11) Whereas his father had once had this quality of human sympathy (or (*Mitmenschlichkeit*) before it went missing in the war, it never even surfaced in his mother's perfectly self-conscious but hollow social construction: her life seems a 'Stillstand des Lebens ... Erkältung der Seele ein Leben lang'. (105–6)

12 Christoph Meckel, *Suchbild. Meine Mutter* (Munich and Vienna: Hanser, 2002). Hereafter references will be given in brackets in the text following quotations.

Meckel's gendered modes of private and public guilt shine a harsh light on generational relations at home during and after the Third Reich.

Meckel outlines that quality of *Mitmenschlichkeit* as his standard, first for judging his parents, then all persons, in his memoir *Erinnerung an Johannes Bobrowski*.[13] There he describes another nature poet out of step with his time who, unlike his father, always tried to remain honest with himself and others. (20) Bobrowski appears as a sort of corrected father figure with whom the younger Meckel can speak and identify and in whom he finds the quality of sympathetic understanding of others, or compassion, that his father had not retained. (21) Bobrowski's 'Bedürfnis nach Ordnung' (24) in his personal life even recalls the father's obsessive orderliness, though the premise is different. Yet Meckel is also aware that Bobrowski has managed to preserve his sense of self in a way that would not necessarily endear him to the student generation of the 1970s ('sich zu entziehn, zu tarnen und zu arrangieren' (29–30)). Bobrowski also employs a certain type of false or split consciousness, dictated by historical circumstances, but – unlike Meckel's parents – in order to salvage his *Mitmenschlichkeit*. In his professional and his personal life, Bobrowski appears as 'das integre Zentrum', (36) not devoted to facile forms of *Trost* like Eberhard Meckel, but to the poetic reconstruction of his lost *Heimat*, as a positive act of recuperation, preservation and memory, rather than as a mere means of idyllic escape from the present: 'Er baute sein Haus aus Hauch, um darin zu atmen [...] – alles in allem ein unerbittliches Glück'. (53) Bobrowski recovers by working through history in his poetry, rather than trying to escape or avoid it: he finds a kind of hard-wrought *Glück*.

That memoir of Bobrowski combines with Meckel's next portrait, *Ein unbekannter Mensch*, to form the central panel, between the parents, as it were, in what is a triptych of character studies that are together a *Suchbild* about himself.[14] In *Ein unbekannter Mensch*, Meckel moves from the land-

13 Christoph Meckel, *Erinnerung an Johannes Bobrowski* (Munich and Vienna: Hanser, 1989). Hereafter references will be given in brackets in the text following quotations.

14 Christoph Meckel, *Ein unbekannter Mensch* (Frankfurt: Fischer, 1999). Hereafter references will be given in brackets in the text following quotations.

scape of Bobrowski in the East westward to France in order to introduce Matthieu, his neighbour in the French provinces; he expands his individual portrayal of him into a class and character type, an image of uncorrupted humanity of his father's generation, outside of Germany, with whom he can establish a bond of neighbourliness, almost friendship, almost fraternity, with depths of sympathy, mutual respect and acceptance, despite their lack of common interests or attitudes. In his portrait of Matthieu, Meckel has to walk a fine line to avoid creating an ahistorical character and venue, a *paysan* in the timeless French provinces, and then using that person and place as a refuge outside of (German) history: doing so would only repeat his father's error by falling into the same trap of ahistorical *Naturlyrik*. Rather, Meckel steps out of the generational polarity in Germany in order to establish a vantage point for the critical judgments in his *Suchbilder* and present an ethical ideal of common human relations. Meckel finds in the local community a 'heilige Diktatur der Gastlichkeit. Man unterliegt ihr, essend und trinkend, ... Es sind die großen Momente der Nachbarschaft'. (73) With words (*Diktatur*) to invite historical comparison, the benign and inclusive integrity of the provincial community cancels the divisive force of Nazi dictatorship in his home life and homeland, and restores a *Mitmenschlichkeit* that transcends national boundaries.

But such an idyll is under siege, now by historical forces of peacetime rather than in war. Meckel takes pain to establish historical context for his idyll of communal *Mitmenschlichkeit*. Just as the individual farmer struggles to survive, so too does the sanctity of that image: 'Ländliche Stille gibt es nicht mehr. Sie ist in Verkehr und Tourismus verlorengegangen, in der Technisierung der Landwirtschaft, [...] vom nervösen französischen Fortschrittstempo verschluckt, dem Profit lokaler Eliten zum Opfer gebracht'. (73–74) The land resounds with the sound of power machinery and motors, the sounds of development, which trouble Meckel's nights. Like Heine, lying awake thinking of Germany, Meckel cannot sleep; the tumult of historical change intrudes upon his nights, as it had in his wartime childhood, though less drastically: 'Die Nächte und Dämmerungen sind kaputt, wie die Kriegsnächte meiner Kindheit beklemmend laut, man liegt wach und erwartet den nächsten Schuß'. (12) Meckel grounds his idyllic tendencies with real historical details and considerations, (104) but the

details sometimes remind him of Germany or bring back a comparison that restores the idealisation as a vantage point for critique at a distance from Germany. Meckel seeks to maintain a balance 'aus Distanz und Nähe' as 'die Grundlage einer guten Gegenwart'. (100) That balance requires less labour for him in France than in Germany for the following reason: 'Ich bin hier so namenlos, wie ich hoffen kann, anonym und unabhängig, das ist ein Glück'. (100) His character studies constitute a conscious search for sensuous and emotional happiness through historical understanding of himself in relation to his parents and others. In each *Suchbild*, Meckel finds, like Bobrowski in his poetry and Matthieu in his fields, a measure of happiness.

In his next work of 2005, *Einer bleibt übrig, damit er berichte*, Meckel adopts a different approach to the nexus of public and private spheres than in his series of searching *Suchbilder*.[15] The first-person narrator of the introductory story goes to live as caretaker of the grounds of an abandoned and dilapidated Russian garrison, an historical ruin of the Soviet era; the sober, detached and unadorned prose describes heaped objects in decay, the abandoned detritus of the Cold War, in a 'Bestandsaufnahme der Menschenleere' (11) as he surveys and explores the terrain where 12,000 troops had been stationed: 'Ich erkunde das Gelände wie ein Spion'. (11) These texts employ a flatly objective and descriptive prose, shorn of emotional colouration and drama, recalling Robbe-Grillet, to give a perspective on historical contexts of the post-war world, from troop reductions and withdrawals to looming environmental disaster in Finland (due to an underwater dump site), to the void of European colonialism in North Africa: Meckel presents a fictional analysis of history as aftermath, as a calculus of collapse, loss, abandonment and ruin, both ideological and physical. In comparison to the earlier texts, the tension of personal confrontation and psychological exploration, of self and other, is largely absent and the narrator becomes a window, a detached observer, of historical landscapes, in which he has no investment

15 Christoph Meckel, *Einer bleibt übrig, damit er berichte. Sieben Erzählungen und ein Epilog* (Munich and Vienna: Hanser, 2005). Hereafter references will be given in brackets in the text following quotations.

and shares no personal history or emotional past. This sort of existentialist historicism keeps the individual within recognisable historical landscapes, as in his family narratives, but now History as a grand narrative has fallen into disrepair ('Die Geschichte scheint untergegangen in Raum und Zeit' (123)), just as hedonism had once collapsed as a redemptive moment for the New Sensibility.[16] Intimate relations go nowhere, and only underscore both the structural proximity and essential distance of this recent work from his earlier *Licht*. Here Meckel introduces the deflated sensibility of a witness without dramatic events, who seeks orientation among the degraded landscapes and ruins of the post-war world that still loom into the present. The different sections seem to reflect an emotional vacancy that was not there in the separate *Suchbilder*, but that very detachment might also mark the transition away from individual character studies as collective portraits of his age.

16 Hanlin (242) rightly notes that 'Just as *Suchbild* explodes the fallacies of the traditional *Innerlichkeit* of Eberhard Meckel, the work simultaneously signals an end to the desperate and lonely agonies of the "Neue Innerlichkeit". Christoph Meckel thus attempts to distance himself and his reader from the dangerous isolation of contemporary New Sensibility'. For analysis of a different sort of critique of the New Sensibility, from the perspective of postmodernism, see my 'Scents and Insensibility: Patrick Süßkind's New Historical Critique of "Die Neue Sensibilität" in *Das Parfum* (1985)', *Modern Language Studies*, 22 (1992), 3, 36–43.

Thomas Weiss's 'Polyphonic' Novel
Tod eines Trüffelschweins

FRANK FINLAY

The present paper aims to speak to an important area of Rhys Williams's academic activity, namely as an enthusiastic champion of new writing from Germany. What follows is an attempt to return the favour, as it were, by introducing a bright new literary talent, Thomas Weiss, and locating his latest novel in its immediate cultural and socio-political context. Here the controversies since 1989 on the 'right' course for German literature to steer are central, particularly the recent skirmishes in the *Literaturbetrieb* surrounding 'relevant realism' and the broadly overlapping discourse of a 'return' of the 'political novel', as the search for radical solutions to pressing economic and social problems has started to feature more prominently in the literary arena than has been the case for many years. If there is a common thread in Rhys's work, it is, perhaps, a concern with a literature which decidedly has something to say about the world, one which, from a variety of different aesthetic perspectives, is a challenge to received values and ideas of the mainstream with which it engages critically. I begin with a few words on Thomas Weiss's career before moving on to identify the parameters of key literary debates and sketch some of the contemporary issues which provide the immediate background to his *Tod eines Trüffelschweins*. My hermeneutic concern will be with the aesthetic strategies which Weiss deploys, and which I analyse in terms of a 'polyphonic' realism.

Thomas Weiss (b. 1964) became a professional writer comparatively late in life following a stint as a civil servant, an uncompleted degree as a mature student in *Germanistik*, and a lucrative job running an espresso bar in Berlin. He has been a notable beneficiary of the very generous grants available in Germany for upcoming writers which enabled him to complete his first novel *Schmitz* (2004), a moving account of the personal

and emotional torment, isolation and decline of an elderly man who lost his wife in an air crash. The book received many plaudits, and Weiss's undoubted literary promise led to further encouragement and subvention, including a prestigious Alfred Döblin fellowship, inaugurated by Günter Grass, with whom he shares the publisher, Steidl Verlag. Weiss's second novel, *Folgendes* (2006), is a critical dissection of the mores of the German bourgeoisie in the post-war period and makes a finely judged and stylistically challenging contribution to recent literary treatments of the legacy of National Socialism. It, too, was well received and was followed by *Tod eines Trüffelschweins* (2007), which merits our attention as an important intervention in aesthetic and political debates.

Some of the major controversies in the 'New Germany', as has been extensively documented, have been triggered by, and coalesced around, arguments about or between writers, their aesthetic *and* political views, as well as the *succès de scandale* of a number of individual works. So piercing has the debate been that it has attracted the considerable national and international attention of professional critics and academics, spawning a glut of anthologies of the key primary texts as well as an ever increasing secondary literature.

The great *Literaturstreit* of the early 1990s, which famously ignited around the figure of Christa Wolf, for example, set the pattern for what has proved to be an unusually disputatious and combative two decades. It also furnished the terms of reference for ensuing disputes that raged in the arts pages of the serious press and cultural journals, often blurring the line of demarcation between literary and political discourses in the process. If one looks to identify a thread running through the critique of what was notoriously dubbed *Gesinnungsliteratur* in the Wolf affair by a triumvirate of Karl-Heinz Bohrer, Ulrich Greiner and Frank Schirrmacher, then it is in its general revivification of that very German dichotomy between *Geist* and *Macht*, between 'art' and 'politics' and – frequently with this – notions of literary realism. Similar sentiments suffused the outpourings of high-profile writers in controversies later in the same decade, ranging from Botho Strauss's invectives against various perceived iniquities of 'political correctness'; to Martin Walser's insistence on subjective experience in the face of public commemorations of the Holocaust, and Peter Handke's

misguided pleas for 'justice' for the pariah state of Serbia.[1] Strauss, Walser and Handke all argued that writers who were obsessed with political concerns elided key aspects of lived experience, a view which has reverberated in the discourse, particularly strong since the turn of the millennium, on the alleged absence in the 'official' cultural memory of the 'suffering' visited on German soldiers and non-combatants during and immediately after World War II.[2]

Rather different was the spat between the critics of *Gesinningsliteratur*, who advocated in its stead an aesthetically complex literature in the best spirit of German Romantic traditions, yet embracing 'high modernism', and a number of writers, proselytising publishers and commissioning editors who were concerned by the dwindling interest among readers in the works of German authors, arguing for adaptation to an international market, which emphasised *Leselust*, strong characterisation, plot and narrative, in short a 'new readability' (*Neue Lesbarkeit*), to cite two buzz words in the *Literaturbetrieb*.[3] This general clamour for 'reading pleasure' was the mood music to a short-lived boom in new writing in the second half of the 1990s when young authors seemed to have more in common with rock stars or sporting celebrities: their public images were carefully nurtured and their media presence skilfully managed to ensure the greatest possible impact. Here, the media creation that was the *literarische Fräuleinwunder*, which, in appropriately economic parlance, catapulted young female authors, such as the photogenic Judith Hermann, to commercial and critical success, is one of the most obvious examples.[4] And yet the overemphasis on personality and appearance – with good looks regarded as essential – frequently served to homogenise under a marketing slogan disparate literary works at the

1　See Frank Finlay, 'Literary Debates and the Literary Market since Unification', in *Contemporary German Fiction. Writing in the Berlin Republic*, ed. Stuart Taberner (Cambridge: CUP, 2007), 21–38.

2　See Bill Niven's insightful discussion in the introduction to his edited collection, *Germans as Victims* (Basingstoke: Palgrave, 2006), 1–25.

3　See Finlay, 'Literary Debates and the Literary Market since Unification', 32.

4　See Peter Graves, 'Karen Duve, Kathrin Schmidt, Judith Hermann: "Ein literarisches Fräuleinwunder"?' *German Life and Letters* 55 (2002), 2, 196–207.

expense of serious engagement with their aesthetic complexities. A similar fate befell a range of 'migrant' writers, and the purveyors of the so-called *neue deutsche Popliteratur*, such as Christian Kracht.

Since the turn of the century, the tectonic plates of the *Literaturbetrieb* have shifted yet again, notwithstanding the continued impact of a figure like Kracht, whose last novel enjoyed critical and public acclaim in 2008. The South Sea bubble of 'debutants' and 'emerging writers' has been decisively pricked by a complex combination of literary, economic and wider political developments: market saturation, the end of the dotcom boom with attendant economic downturn which, in the sphere of literary production and reception, led to reduced publishers' marketing budgets, falling newspaper revenues from advertising and a 'credit-crunch' for the *Feuilleton*. Moreover, the sense of crisis which gripped the Western media following the '9/11' attacks fed the growing consensus in Germany that the 'culture of fun', of which the 'new' literature had been an important part, was as redundant as it was tasteless. There followed a re-orientation to older writers who constituted less of an entrepreneurial risk, such as Dieter Wellershof, or veterans of the 1968 movement, such as Uwe Timm and Peter Schneider, who enjoyed a considerable rehabilitation of their status. This was perhaps most strikingly the case with Günter Grass, for many the quintessential 'committed' writer and public intellectual. Evident national pride and critical reappraisal in the wake of his Nobel Prize of 1999 was followed by the rapturous reception for his sympathetic yet nuanced treatment of German 'wartime suffering' in the novella, *Im Krebsgang* (2002). Grass being Grass, however, he was to leave the biggest talking-point for his autobiography in 2006, when the furore caused by his revelation of a brief stint in the *Waffen SS* knocked considerable gloss off his rejuvenated 'moral authority'.

The shift in mood, sentiment and market conditions at the start of the new millennium presented a particularly strong challenge to a cohort of writers born between the mid-1950s and early 1960s, the so-called literary 'generation of 78' as proclaimed by Matthias Politycki, who styled themselves as wedged between the class warriors of 1968 and the late teens

of 1989, for whom the collapse of the Berlin Wall marked a caesura with the past.[5]

As well as having achieved notable literary acclaim for a number of novels, Politycki is an important player in the post-Unification 'literary field', to use Pierre Bourdieu's term.[6] He is a prolific essayist and ubiquitous 'talking-head' in a variety of media and has proven himself a skilled operator who responds to indigenous literary developments with a fleetness of foot and a keen eye for the main chance. In addition to implanting the sobriquet '78ers' in the lexicon of literary journalism, Politycki also coined the term *neue Lesbarkeit*. When that market threatened to be saturated, Politycki moved on to re-evaluate his position with the slogan that German literature had fallen prey to cultural homogeneity and was 'barking up the wrong Americanised tree'.[7]

Between 2000 and 2005 Politycki initiated annual meetings of writers, commissioning editors and critics from his generation in the luxurious surroundings of Schloss Elmau, near Garmisch-Partenkirchen. Each event unashamedly courted considerable media attention to keep the '78ers' in the public eye, no more so than in the election year of 2005 when the participants' position papers submitted in advance of the conference alighted on the purpose of the novel, the literary genre which has traditionally engaged most with social issues. The fruits of these ruminations were subsequently published in *Die Zeit* as a 'Manifesto for a Relevant Realism' and timed very deliberately to coincide and compete with the annual celebration of the avant-garde at the Klagenfurt Literary Festival with its Ingeborg Bachman Prize.

The Manifesto is a remarkable document of the '78ers'' attempt to stake out a clear position for themselves in a crowded 'literary field' by effectively seeking to tarnish the cultural capital of competing aesthetic alternatives.

5 See Stuart Taberner, *German Literature of the 1990s and Beyond. Normalization and the Berlin Republic* (Rochester, Camden House: 2005), 5–6.

6 See, for example, Pierre Bourdieu, *The Field of Cultural Production. Essays on Art and Literature* (Cambridge, Polity Press: 1993).

7 See Stuart Taberner, 'New Modernism or "Neue Lesbarkeit"? Hybridity in Georg Klein's *Libidissi*', *German Life and Letters* 55 (2002), 2, 137–48 (140).

Without naming names (but with very strong hints) this expression of disenchantment, which one might term *Polityckiverdrossenheit*, gives short shrift, *inter alia*, to moral grandstanding, self-referential neo-conservatism combined with a commitment to dubious political causes, pop self-indulgence, and epigonic historical novels. The '78ers' are exhorted to cast off previous reservations and to make themselves 'the point of focal attention in social discourse', via a renewed focus on matters of contemporary relevance in a morally and aesthetically responsible way; in short a 'relevant realism'.[8] There can be little doubt that additional impetus for this positional shift came from the growing sense of stasis and crisis in the face of the severe economic problems besetting Germany.

With an obvious intent of stirring up a public discussion, the editors of *Die Zeit* orchestrated trenchantly dissenting voices to be published in the same issue from writers Andreas Maier, Hans-Ulrich Treichel and 2004 Bachmann laureate Uwe Tellkamp.[9] This typically polarised debate rumbled on in the *Feuilleton*, and the term 'relevant realism' gained currency as convenient shorthand whenever writers alighted on issues of contemporary importance in their fiction or, as in the example of Juli Zeh's *Alles auf dem Rasen. Kein Roman* (2006), published essays dealing with a range of contemporary social, political, legal and cultural issues. Active participation in party politics was judged a further manifestation of the trend, when Eva Menasse, Michael Kumpfmüller, Juli Zeh and Feridun Zaimoğlu (but not Politycki, who declined the offer) added their voices to Günter Grass's in support of the Red-Green coalition, or Uwe Timm and Ingo Schulze made positive noises about the Left Party.[10] Related to this was a much heralded comeback for the 'political novel', which literary trend-spotters discerned in works such as Ulrich Peltzer's *Teil der Lösung* and Raul Zelk's *Der bewaffnete Freund* (both 2007), which are fictional

8 Martin R. Dean, Thomas Hettche, Matthhias Politycki and Michael Schindheim, 'Was soll der Roman', *Die Zeit*, 23 June 2005.

9 Andreas Maier, Hans-Ulrich Treichel and Uwe Tellkamp, 'Der Roman schaut in fremde Zimmer hinein', *Die Zeit*, 23 June 2005.

10 See Richard Kämmerling: 'Kollegen, das ist blamabel! Schriftsteller im Wahlkampf', *Frankfurter Allgemeine Zeitung*, 14 September 2005.

explorations of the thematic nexus of political power, protest, violence and terrorism, as variously practised in Germany, by the Red Brigades, and in Spain, by the Basque separatist movement, ETA.

'Relevant realism' also figured as a catch-all in discussions of new novels which responded to the social fall-out of the economic concerns besetting Germany. Indeed it was the stagnant growth, near-record job-lessness, and declining social welfare benefits which made the viability of the German economy in the face of rapacious global capitalism the most hotly-debated issue of the 2005 election campaign. Federal Chancellor Gerhard Schröder had been compelled, of course, to seek the dissolution of his government and elections one year ahead of schedule following the body blow of defeat in the state elections in Northrhine-Westphalia, his party's traditional industrial heartland, which had been particularly severely hit by the crisis. The immediate background to Weiss's novel was the uproar triggered deliberately in the run-up to the NRW vote by SPD Party Chairman Franz Münterfering who launched an old-style critique of capitalism. In a vain attempt to shore up core support, and by deploy-ing a biblical metaphor, Münterfering notoriously introduced a new word, *Heuschrecke*, into the political lexicon to describe the main actors in the aggressive leveraged buy-outs by overseas hedge funds and private equity firms who acquired some of Germany's highly successful and well-known companies. These investors' typical aim was to purchase the targeted enter-prise by raising loans secured against the latter's assets and added to its bal-ance sheet as debt ('leverage'), followed by aggressive restructuring, jobs cuts and the transfer of production abroad. Thereafter, the acquisition was sold off in an open share offering on the stock market at a vast profit. The fate of Grohe Water Technology, a typical member of Germany's *Mittelstand* and manufacturer of kitchen and bathroom fittings based in Münterfer-ing's constituency (but with a plant duly designated for closure in a small Brandenburg town), by the private equity 'locusts', Texas Pacific Group and Credit Suisse First Boston, was central to the veritable moral panic surrounding the *Heuschrecken*, which even pervaded popular culture in

an episode of the iconic TV detective series, *Tatort*, helping to elevate the word to number four in the annual poll for the *Unwort des Jahres*.[11]

The eponymous *Trüffelschwein* of Weiss's text is immediately recognisable as one such 'locust'.[12] Indeed, on a superficial level Weiss delivers a *Schlüsselroman*, making little effort to draw anything but the thinnest of veils over the models for his fictional characters, setting and events, thereby imbuing the text with a distinctly satirical character. This is perhaps at its most evident in the deliberately unsubtle principle behind the names he gives to people and places. For example, the company Grohe becomes Grothe, and the Brandenburg town Herzberg, Nierenberg; the fictional banker, Feldman is a cipher for Deutsche Bank supremo Dr Josef Ackermann, while David Baines of Texas Atlantic Group is modelled on David Haines of Texas Pacific Group, and so on. However the novel does much more than satirise current economic affairs.

The titular death is the assassination of Marc Schworz, a US-based, prototypical private equity *Trüffelschwein*, by Grothe's erstwhile head of security, Klaus Heuser, now chauffeur to its executives, who cold-bloodedly discharges two bullets into his victim's neck, bundles the body into the boot of the car, and sets off to Switzerland in order to deposit it on the doorstep of the firm's former owner, who had sold the family business. Heuser is apprehended later the same day and submits peacefully to the police who find his confession, written in the style of the *Rote Armee Fraktion*, and purporting to be the work of a *Kommando Georg Elser*, named evocatively after the Bavarian clock-maker who attempted to assassinate Hitler. The note justifies the 'attack on a mercenary of capital' as an act of resistance to the neo-liberal capitalism now encroaching Germany and culminates in a call to collective arms in pursuit of a 'humane economics'. (18–19)

11 http://www.spiegel.de/international/0,1518,354668,00.html documents the furore caused by Münterfering's remarks. Date accessed 31 January 2009. Critics were rightly quick to point out that Schröder's neo-liberal fiscal reforms had attracted the 'locusts' to Germany and to point up the unhappy metaphorical similarities to National Socialist propaganda.

12 Thomas Weiss, *Tod eines Trüffelschweins* (Göttingen: Steidl, 2007). Hereafter references will be given in brackets in the text following quotations.

As transpires subsequently, Heuser has in fact acted alone. Moreover, he shows the same lack of remorse as the real-life terrorists, Christian Klar and Brigitte Mohnhaupt, whom the text references, sharing other negatively connoted traits, such as absolute conviction and a Manichean worldview of 'good' pitted against 'evil'. (32)

While the assassination of a captain of industry and the equation of venture capitalism and National Socialism is a potentially huge challenge to the authorities, the case is given a fascinating twist by the fact that Heuser had once bravely served the German state in its battle against terrorism. He was an idealistic volunteer for the GSG9 anti-terrorist special forces and thus one of the feted 'Heroes of Mogadishu', who on 18 October 1977 famously liberated hostages from a hijacked Lufthansa aircraft on the runway of Somalia's main airport. They killed the terrorists with no loss of other life, triggering the events which brought to a bloody climax the so-called 'German Autumn', one of the major political events in the short history of the Federal Republic of Germany: the murder of the kidnapped industrialist Hans-Martin-Schleyer and the virtually simultaneous suicides in prison of the leading protagonists of the Baader-Meinhof group. There is little wonder that Heuser's case generates enormous media attention. The suspicion that he is part of a larger terrorist cell prompts a thorough investigation, while his motivation and the possible public impact of the murder are discussed in the German parliament by politicians clearly fearful of an avalanche of similar protests. Most worrying for the state is that Heuser's diagnosis of its current economic woes, if not his radical and murderous prescription, taps into widespread public anxiety, particularly by those in Nierenberg affected by the Grothe takeover, (11) and leads to public demonstrations of sympathy during his appeal hearing. The authorities are therefore mightily relieved when he is finally locked up for a minimum of twenty years.

Weiss's linkage of a fictional anti-capitalist political assassination with the German Autumn is one factor sufficient to make *Tod eines Trüffelschweins* of potential broader interest. Germany's often tortuous attempts to make sense of this particular chapter of its recent past and to find an appropriate way of remembering it have seen a new wave of literary, histo-

riographical and filmic representations too numerous to summarise here.[13] Noteworthy, however, is the latest documentary from ZDF's resident historian, Guido Knopp (a controversial figure in the revisionist 'wartime suffering' debate), *Das Wunder von Mogadischu*, whose inter-textual title suggests that the operation was a German miracle to set alongside the World Cup triumph of 1954 (as celebrated in the movie *Das Wunder von Bern*) and the post-war *Wirtschaftswunder*. ARD followed suit with its movie *Mogadischu*, the latest historical blockbuster from the TeamWorx production stable directed by Roland Suso Richter and first broadcast in November 2008. Weiss's novel can be regarded, therefore, as responding and contributing to the on-going 'memory contest' surrounding German left-wing terrorism. Significant, too, is his claim to have taken some of his details and inspiration from a GSG9 veteran who was disenchanted with the fate of Grohe Water Technology, and his expressed intention to recuperate for Germany's cultural memory this person's private memory of the 'Heroes of Mogadishu', which duly finds its way into the novel.[14] Unlike the hostages they liberated, it transpires that the GSG9-veterans were offered no psychological counselling and frequently struggled to reintegrate into 'normal life' after their fifteen minutes of fame, as shown in the unusually high level of suicides. (69–72)

The second factor which makes *Tod eines Trüffelschweins* interesting is its narrative structure. This is evident immediately in the central conceit of the book, namely that its focaliser, the local journalist Wolfgang Marx, is researching Heuser's case for a special issue commemorating the thirtieth anniversary of Germany's 'Year of Terror'. Weiss is thus able to provide the reader, in the book's sixty-three short, numbered sections or 'episodes', with an array of fictional documents (and thus multiple perspectives) covering Heuser's apprehension, detention, interrogation, trial and subsequent appeal, interviews with all the leading actors, and media

13 See Gerrit-Jan Berendse and Ingo Cornils, *Baader-Meinhof Returns. History and Cultural Memory of German Left-Wing Terrorism* (Amsterdam: Rodopi, 2008).

14 Axel Schalk, 'Der Sicherheitschef als Terrorist', *Zitty*, 8–21 November 2008, 70–71.

reports including his own articles. Also integrated are police, forensic and psychologist reports, transcripts of witness statements, phone taps etc, as well as the thoughts of trade unionists, management representatives and municipal officers on the consequences of the Grothe take-over. An equally important feature of the novel's structure is that this invented material is complemented by authentic, fully sourced documents which link its 'fictional' and 'real' strands. Thus, RAF-terrorist Christian Klar's damning indictment of globalisation, which in 2006 threatened to undermine his appeal for clemency, is integrated, as are the judicial determinations for the early release of Klar's comrade-in-arms, Brigitte Mohnhaupt. Similarly, dictionary and encyclopaedia definitions of the eponymous *Trüffel* and 'private equity' are cited, as well as the relevant verses of the Book of Moses relating the eighth plague of locusts, and the transcript of television's *Wort zum Sonntag* which took as its 'thought for the day' the prevalence of the *Heuschrecken* in the German economy. The distortion and abuses of insatiable capitalism, which this word encapsulates, are further emphasised by the reproduction of *Forbes Magazine*'s top fifty 'rich list' of multi-billionaires and of documents pertaining to the proven case of corruption against the VW boss Peter Hartz, who ironically gave his surname to Schröder's labour market reforms.

Weiss's documentary structure has been questioned in reviews by literary journalists, with the contention that the work is not a novel at all, rather 'eine Materialiensammlung [...] die Vorarbeit zu einem Roman'.[15] In cases where critics did acknowledge an aesthetic dimension, Weiss was charged with marshalling his material in such a way as to exonerate Heuser, thereby suggesting that political murder is justified.[16] These are serious aesthetic and ideological criticisms which invite a response. I would argue that it is precisely the 'polyphonic' structure of Weiss's text which makes it a work of narrative fiction *and* avoids an instrumental, ideological manipulation

15 Jörg Morgenthau, 'Ein politischer Mord im Grunewald', *Deutschlandradio*, 12 December 2007.

16 Walter Delabar, 'Für das System oder dagegen?', http://www.literaturkritik.de/public/rezension.php?rez_id=11689, date accessed 5 February 2009.

of the reader, evidencing the moral and aesthetic responsibility envisaged by the advocates of 'relevant realism'.

The inter-textuality and montage (and collage when one considers the referencing of photographic images of, for example, the Mogadishu operation (73)) which Weiss deploys are, of course, established devices in literature and have generated a wealth of scholarship, with, for example, theories by Mikhail Bakhtin or Julia Kristeva enjoying wide currency. Common theoretical conclusions are that placing one text alongside another generates a productive dialogue (extending, therefore, also to the 'listener'/reader) with results that can be acutely revealing, irrespective of whether parallel, counter or alternative meanings to the base text(s) are deployed. Here, Bakhtin's notion of 'polyphony' is particularly applicable. Thus a plurality of independent and unmerged consciousnesses each with its own world and/or ideology, what Bakhtin calls 'voices', are orchestrated.[17] The thematically and numerically central 'episodes' of the novel (27–40), in particular, demonstrate the efficacy of Weiss's polyphony, and can firmly refute the charge that the book advocates political violence.

Three sections (27, 28, 30) devoted to Heuser's years of service in GSG9 testify to his fundamental decency and idealism. These are punctuated with the legal judgement rejecting the 2000 appeal of one of the Mogadishu hijackers and followed by the protest of Schleyer's unreconciled widow against the likelihood of the release from prison of his murderer, Christian Klar. Next, Weiss integrates biographical data on Schleyer, particularly his career under National Socialism, which made him not least a legitimate target in the *RAF*'s eyes. Episodes 33–35 contain a GSG9 veteran's affecting account of life in the months and years after Mogadishu, 'which have never been publicly reported', (69) and a description of photographs of the bloody aftermath of the mission, emphasising its sheer trauma and cost in human life, concluding with reference to the heroes' welcome they received. Sandwiched between this and an account of Heuser's troubled return to civilian life is the authentic document of the note left by the *RAF*

17 See Simon Dentith, *Bakhtinian Thought. An Introductory Reader* (London: Routledge, 1995), 41–64.

on Schleyer's body with its reference to the 'massacres of Mogadishu and Stammheim' and an ideological tirade against imperialist 'destruction of the liberation movements'. (36) There are then three episodes respectively giving the legal determination for the early release of Brigitte Mohnhaupt in February 2007, (77–81) a telephone tap detailing an early morning raid on Heuser's flat by security services, (82–86) and a newspaper report of the distress caused to Schleyer's widow by the renewed media interest in the German Autumn and Mohnhaupt's return to liberty. (87–88) This echoes the similar sense of the impact of acts of terror on the families of victims evoked by the gruesome details of Schworz's autopsy and of his stricken widow.

In conclusion, Weiss's dialogue of fictional and authentic sources can be regarded as the formal solution to his exploration of a dialectic of violence and the problematical nexus of crime, punishment, guilt, remorse, atonement and, crucially, reconciliation that is central to ongoing debates on German left-wing terrorism. His 'polyphonic' form with its interplay of heterogeneous memory voices, including those hitherto absent in public discourse, allows the co-existence of an egalitarian empathy with multiple points-of-view *and* non-partisan political critique. What is more – and in keeping with the book's epigraph taken from the ninth chapter of Aristotle's *Poetics* – *Tod eines Trüffelschweins* succeeds on another level by imparting not 'was wirklich geschehen ist, sondern vielmehr, was geschehen könnte, d.h. das nach den Regeln der Wahrscheinlichkeit oder Notwendigkeit Mögliche'. (5) For all the superficial realistic detail and the contribution it makes to current debates about cultural memory, therefore, the novel also contains a 'what-if?' warning of immediate relevance, no more so than in the sentiments expressed by one of the guardians of the German constitution: 'Man stelle sich doch bloß einmal vor, was passiere, wenn die Arbeitnehmer von Allianz, Siemens oder Telekom, die trotz Milliardengewinn entlassen werden müssten, radikal würden und sich organisierten, womöglich im Untergrund. Da stünde ja eine Revolution ins Haus'. (117) Given the current, near collapse of the global financial system and ensuing social costs of a deep world recession, these words now resonate all the more in 2009, arguably testifying to literature's abiding potential to be 'relevant'.

The Industrial World in the Literary Topography of the GDR

DAVID CLARKE

In a recent overview of GDR literature, Martin Kane suggests that we should regard the GDR as 'a fictional place', in other words as a series of competing fictional constructs, produced not only by the state's ideology, but also by literary works, which frequently sought to imagine an alternative to the regime's version of reality.[1] However, Kane's notion of the GDR as a constructed 'place' does not extend to a consideration of how a differentiated literary topography might have contributed to such an imagining of the GDR: it leaves open the question as to whether we can identify a symbolic construction and contestation of particular sites or landscapes in GDR literature that might constitute one of its specificities.

The 'spatial turn' in literary and cultural studies in the 1990s gives us cause to consider whether its insights might be brought to bear on the literature of the GDR.[2] The central concern of this 'turn' is the attempt to understand the spatial construction of reality in culture as expressive of power relations. This general approach, as Doreen Massey has observed, tends to present the spatial as inherently conservative and stabilising.[3] My proposition will be that, in addressing the symbolic topography of GDR

1 Martin Kane, 'A Fictional Place: Constructions and Reconstitutions of the GDR before and after German Unification', in *Literature & Place 1800–2000*, eds Peter Brown and Michael Irwin (Oxford: Peter Lang, 2006), 147–66.
2 For a brief overview of this 'turn', see Alexander C. T. Geppert, Uff Jensen and Jörn Weinhold, 'Verräumlichung: Kommunikative Praktiken in historischer Perspektive, 1840–1930', in *Ortsgespräche. Raum und Kommunikation im 19. und 20. Jahrhundert*, eds Geppert, Jensen and Weinhold (Bielefeld: Transkript, 2005), 15–49 (16–20).
3 Doreen Massey, *for space* (London: Sage, 2005), 26.

novels that deal with the industrial world, we can identify a spatialisation which, precisely on account of its attempt to stabilise and validate the socialist project, reveals contradictions at the heart of that project, which the texts ultimately fail to contain. I will examine three examples spanning the period from the *Aufbau* to the beginning of the Honecker era: Karl Mundstock's *Helle Nächte* (1952); Christa Wolf's *Der geteilte Himmel* (1963); and Erik Neutsch's *Auf der Suche nach Gatt* (1973). All three texts are critical, yet ultimately affirmative in relation to the project of socialism, and in all three the site of industrial labour plays a central, yet politically complex and contradictory role.

The phrase 'the site of industrial labour' is deliberately chosen here, since the key concern of these texts is not with the *Betrieb* in its entirety, whether it be a *Kombinat*, as in *Helle Nächte*, a factory as in *Der geteilte Himmel*, or a mine as in *Auf der Suche nach Gatt*. Indeed, in the case of the second two texts, the *Betrieb* is not the setting that dominates the narrative. Instead the *locus* of the individual's physical labour is idealised as a site of proletarian authenticity and creativity, the driving forces of the socialist project, which diminish in their potency the further the subject is removed from this situation. As I will show, this idealisation has a number of consequences, not least for the authority of the Party.

Mundstock's *Helle Nächte* is a typical example of the *Aufbauroman*: it aims for a Lukácsian totality, presenting an almost overwhelmingly large cast of characters involved in the construction of *Eisenhüttenkombinat Ost* in Stalinstadt (later Eisenhüttenstadt). At the centre of the text stands one crucial episode, namely the attempt by a group of young workers to repair a section of train track, a task that must be carried out mostly with bare hands, standing knee-deep in boggy ground. The scene is presented largely through the eyes of a young female worker, Christa, whose lack of physical strength turns her attempt to grapple with one of the railway trucks stuck in the mud into an apparently impossible task. She cuts open her hand as she struggles with this immovable object, but it is at this moment that she suddenly hits upon a new way of drying out the marsh in order to make

the work easier.[4] Significantly, this moment of revelation, in which Christa sees what the middle-class engineers have failed to notice, is followed by a physical collapse. At the most extreme moment of physical exertion and self-sacrifice she is able to become what one GDR commentator on industrial literature calls 'ein schöpferischer Mensch'.[5] Mundstock is keen, however, to make clear that the innovation that occurs to Christa is not the result of her own individualistic desire to save herself such toil. Instead, her only thought is for her colleagues: 'Wieviel leichter hätten es doch die Kumpels!'. (*HN*, 261)

Throughout the rest of the novel, the willingness of other figures to accept the usefulness of Christa's suggestion becomes a measure of their usefulness to the *Aufbau*. The ideal task of the engineers, for example, is portrayed as that of translating Christa's intuition, which they initially oppose, into a concrete plan, so that the relationship between workers and technicians and managers is turned on its head. The engineers' knowledge becomes a barrier to insight into the best way to manage the industrial process; as one of the managers exclaims: 'solche gelehrten Rindviecher sind wir, daß wir nicht mal mehr auf das allereinfachste kommen!'. (*HN*, 268) Furthermore, reactions to Christa's experience, and that of the workers more generally, become a measure of political commitment to the interests of the proletariat as a whole and the SED as its alleged representative. Here the elderly middle-class chief engineer Von Battering is presented as a positive example. Although Von Battering previously regarded the workers as 'nicht mehr als Ameisen', (*HN*, 418) Christa has now made 'sein Werk zu ihrem Werk', so that he can begin to love those he once regarded as drones. (*HN*, 420) His new capacity to recognise and accept the creative role of the workers is signalled by his willingness to leave his office and go onto the building sites. (*HN*, 420) As is common in the *Aufbauroman*, the managers and Party officials who are criticised and ejected from their positions

4 Karl Mundstock, *Helle Nächte* (Halle: Mitteldeutscher Verlag, 1952), 261. Referred to in the following as *HN*. Hereafter references will be given in brackets in the text following quotations.

5 Eberhard Röhner, *Arbeiter in der Gegenwartsliteratur* (Berlin: Dietz, 1967), 36.

of power are those whose development is shown to be the exact opposite of Von Battering's: instead of moving closer to the site of physical labour, they retreat from it, as for example with the engineer Kamp who, although he is a member of the Party, is pulled up by the Party Secretary Weber for having become too distant from the workers: 'Geh an die frische Luft der Baustellen, laß dich von der Kritik der Kollegen anregen'. (*HN*, 438)

Although a close association is made between the superior insight of the workers and that of the Party, this clearly contains contradictory elements. Despite Weber's implicit claims to the contrary, the Party's authority cannot be equivalent to the authority that the workers possess on the grounds of their location at the site of industrial labour. The Party apparatus is not grounded in that industrial labour and, as the text is at pains to point out, can only retain its authority by maintaining its contact with the 'frische Luft der Baustellen', (*HN*, 438) even though this is at best a vicarious access to that experience. In this text, all political, moral and even technical authority is located at the site of industrial labour itself and in the physical exertion of the workers who occupy this site: the authority of those who stand above the workers in the managerial and Party hierarchy is measureable in terms of their proximity to that experience, but they will never have direct access to that located experience, and thus to that absolute authority as the workers do. This reading therefore bears out Peter Zimmermann's thesis that the valorisation of proletarian experience in literature of the *Aufbau* represents a potentially destabilising moment in relation to the SED's authority.[6] However, to Zimmermann's insight we can now add the topographical aspect of the representation of this experience, which emphasises not just workers *per se* as the source of authority, but their locatedness at the site of physical labour.

A similar topographic symbolism is at work in Christa Wolf's *Der geteilte Himmel*, although there are also important differences. Wolf's text is a well-known example of the *Ankunftsliteratur* that resulted from the 'Bitterfelder Weg', a literature that frequently offered representations of

6 Peter Zimmermann, *Industrieliteratur der DDR. Vom Helden der Arbeit zum Planer und Leiter* (Stuttgart: Metzler, 1984), 19.

a movement towards the site of industrial labour by middle-class figures of various kinds. Wolf's text steps back to a degree from emphasising the central importance of the direct experience of the site of industrial labour for the maintenance of socialist commitment by also showing tolerant, undogmatic functionaries, who are willing to stand up to the excesses of opportunist ideologues, whilst remaining true to socialist principles. At the same time, Wolf's portrayal of her villains has a distinctly topographical dimension. The protagonist Rita's fellow student Mangold, for example, an ideologically rigid and self-serving figure, is associated with her prospective parents-in-law, the Herrfurths, whom she accuses of an 'Ich-Bezogenheit' expressed in explicitly spatial terms.[7] Although Herr Herrfurth works in the same factory as Rita, we only ever see him in his flat, which Rita perceives as '[e]in kleines verzaubertes Inselchen, auf dem Verbannte leben'. (*GH*, 78) The Herrfurths' physical isolation reflects their political isolation from the process of building socialism, but also allows Frau Herrfurth in particular to experience a sense of power by dominating her limited environment and imposing her will upon the few 'Verbannte' who share it with her. Mangold's situation offers a parallel here: he creates a small, enclosed world for himself at the Institute where Rita is studying, separate from the industrial world, using Party ideology to browbeat his fellow students and his lecturers. The danger for Rita is that, faced with this potential fragmentation of socialist society into a series of disconnected niches, she too will be tempted to retreat from the industrial world into the private spaces she shares with her fiancé Manfred: into 'das Gefühl, daß sie abgeschlossen, sich selbst genug, in ihrer Zimmergondel über allem schwebten'. (*GH*, 99)

The industrial world initially appears as alienating as the private world of the Herrfurths (*GH*, 33) and seems physically threatening to Rita with its 'kreischendes und schmutziges Durcheinander'. (*GH*, 32) However, as opposed to the isolating niches represented by the lives of the Herrfurths,

7 Christa Wolf, *Der geteilte Himmel* (Munich: DTV, 1973), 123–24. Referred to in the following as *GH*. Hereafter references will be given in brackets in the text following quotations.

Mangold or even Manfred, it does hold out the promise of access to a community in which alienation is overcome. One barrier to such integration is the inhuman scale of the technological world, the noise and stench of which Wolf does not shy away from depicting. The resolution of this fear of technology's potentially destructive and alienating effects comes with the description of the Rita's brigade's train journey to test a new kind of railway wagon, which they have been instrumental in introducing. This episode coincides with the news of Uri Gagarin's successful space flight. In a key spatial metaphor, the trajectory of the train is presented as a parallel to Gagarin's flight path through the inhospitable wastes of space: the brigade travel in their own metal capsule through a 'Mondlandschaft ausgebeuteter Haldenfelder' (*GH*, 140) and into a near-featureless expanse of 'Weideland'. Rita asks herself if 'unser bißchen Menschenwärme ausreichen [wird], der Kälte des Kosmos standzuhalten' (*GH*, 144) in the face of this scale of technological change, yet her solution is not to retreat into the security of a private niche, but to look towards the site of that technological change itself, for which the new railway wagon provides a metaphor, to find a solution: her work in the brigade makes that technology 'durchschaubar' and thus no longer alienating, but this can only be achieved, she suddenly realises, through a sense of belonging that is no longer tied to the private sphere, but rather to the workplace: 'Ich gehöre dazu, dachte sie'. (*GH*, 145)

Unlike in the novels of the *Aufbau*, however, this sense of solidarity and purpose does not proceed automatically from the very fact of contact with the site of industrial labour. In this respect, the figure of Rolf Meternagel is key to the meaning of the text. For Rita, this former brigadier is a heroic figure, who, despite the indifference of his colleagues, works himself into the ground to improve production. (for example, *GH*, 73) Although the other workers are eventually persuaded by his calls for higher productivity at the expense of earning easy money, they have an ambiguous relationship with him: after all, it was they who betrayed him by claiming money for work they did not do, thereby costing him his job as brigadier; and there is never any indication that they are motivated by the same socialist commitment when they do agree to his plans. Meternagel's physical labour at the site of production does still provide him with the insights to improve the production process, in line with the pattern established in the *Aufbauromane*.

However, he is no longer fighting against those estranged from physical labour, but primarily against those who share the site of labour with him. The progress of socialism is, therefore, no longer predicated on the located experience of the working class in industrial production, but rather on the efforts of individuals, which Rita admits may be ultimately futile. Nevertheless, it is Rita's commitment to Meternagel that will not allow her to leave for the West with Manfred: 'Der Meternagel macht sich umsonst kaputt. Er hat sich mehr vorgenommen, als er schaffen kann. Aber gerade deshalb hätte sie nicht fertiggebracht, ihn im Stich zu lassen'. (*GH*, 175)

At the end of the text, Meternagel is promoted to the post of brigadier once more. However, as Herr Herrfurth tells Rita on her return from Berlin, Meternagel has continued to work beyond his physical capacity and has ended up in hospital. (*GH*, 191) In an echo of Christa in Mundstock's *Helle Nächte*, the manual worker's point of physical collapse testifies to commitment to the socialist cause, but here this exhaustion is placed in the context of the indifference of other workers. The stand that Meternagel takes, and which Rita looks to for a model, shows that it is still possible to find in the site of industrial labour a source of commitment to the collective project of socialism, but one in which only certain individuals stand in the way of the collapse of society into the fragmentation of private interests and private spaces. The site of industrial labour retains only a utopian potential as the source of such socialist solidarity and progress.

In the light of *Der geteilte Himmel*'s suspicion of private spaces, its epilogue is a curious addition. Whilst Rita sacrifices the private space of her isolating 'Zimmergondel' with Manfred (*GH*, 99) and notes the way in which Meternagel neglects his own home, denying himself and his wife material comforts to pay back the money he was responsible for losing for the factory, (*GH*, 197–98) the text ends with Rita, recovered from her mental collapse and experiencing her first day of 'Freiheit', (*GH*, 199) looking into the windows of apartments, where she sees happy families enjoying their well-earned evening rest. (*GH*, 199) This final emphasis on the happiness to be found in the private sphere represents an important contradiction in terms of the text's symbolic topography. If the prospect of an unalienated existence in a socialist community is kept alive only by the self-sacrificing commitment of individuals engaged at the site of

collective industrial labour, at what point could the private sphere and its private interests, viewed so critically elsewhere in the text, achieve a form in which they could be enjoyed without jeopardising the socialist project? Wolf's text provides no answer to this question, but this epilogue is perhaps a concession to the human necessity of that private sphere, even at the point where its renunciation is celebrated.

Erik Neutsch's novel *Auf der Suche nach Gatt* once again revisits the site of industrial labour in order to establish its meaning for socialist society as a whole. Neutsch's text can be regarded as an attempt to re-emphasise this theme after an officially-sponsored trend, in the final years of the Ulbricht era, towards an engagement with the 'Planer und Leiter' of socialist society. Foreshadowing Zimmermann's claim about the potentially disruptive quality of proletarian experience, Bernhard Greiner suggests that the direct depiction of the site of manual labour fell out of favour precisely because it tended to highlight as yet unresolved contradictions in socialist society, whereas an emphasis on the managers and technicians fitted better with Ulbricht's view of an 'entwickelten gesellschaftlichen System des Sozialismus', a stable social formation driven by the development of technology, not by class conflict.[8] However, writing at the beginning of the Honecker era, Greiner speculates that the new leadership's emphasis on the working class as the motor of social change in a society still experiencing class conflict, as promulgated at the SED's eighth Party Conference in 1971, might lead to a renewed focus on the working class in the industrial world.[9]

Auf der Suche nach Gatt can be seen as a response to this agenda. In a throwback to the novels of the *Aufbau*, the site of industrial labour is initially identified as the source of the wisdom of the worker, when a young miner, Eberhard Gatt, writes to a local newspaper suggesting that blackmarketeers be sent into the mines to serve '*die Volksmacht*'.[10] The location of

8 Bernhard Greiner, *Die Literatur der Arbeitswelt in der DDR. Vor der Allegorie zur Idylle* (Heidelberg: Quelle & Mayer, 1974), 195.

9 Greiner, 196. Cf. Marc Silberman, *Literature of the Working World. A Study of the Industrial Novel in East Germany* (Bern: Peter Lang, 1976), 79.

10 Erik Neutsch, *Auf der Suche nach Gatt* (Halle: Mitteldeutscher Verlag, 1973), 27. Referred to in the following as *SG*. Hereafter references will be given in brackets

Gatt's place of work in the Mansfeld region, which the protagonist himself describes as '*rot wie seine Erde*', (*SG*, 26) represents the GDR's revolutionary heritage, and the Party soon identifies Gatt as a potential '*Stimme des Volkes*', (*SG*, 29) who can become one of a new breed of Party journalists.

Gatt's life is divided into three periods, equating to his rise, fall and rise again, and each marked by episodes relating to sites of industrial labour. The first period, his rise to the status of a successful journalist in the service of the Party, is set in motion by his identification as a source of proletarian truth guaranteed by his experience in the mine, even though, as Neutsch points out, this truth is manipulated by the Party: for example, we learn that Gatt's original unsolicited article is subjected to an ideological 'Verstümmelung' before it is printed. (*SG*, 29) In this period of his career, Gatt is praised for his 'Klasseninstinkt' (*SG*, 71) by his friend and mentor Jeremiah Weißbecher, an instinct informed by his origins in the mines. To emphasise this point, his particular value to the Party as a journalist is demonstrated by a campaign he runs against the manager in a local *Chemiekombinat*, who is ignoring suggestions for improving production put forward by his workers, thus demonstrating Gatt's particular connection to this source of proletarian insight.

Neutsch is critical of the Party's instrumentalisation of Gatt and shows his protagonist's growing estrangement from his origins: he becomes like the opportunist ideologues he originally despises, is too interested in maintaining his own position and too suspicious of modernisation. As in *Helle Nächte* and *Der geteilte Himmel*, the physical self-sacrifice of the worker figure is a key motif. In this case, however, the almost self-destructive disregard for one's physical well-being is placed not in the service of industrial labour, but in the service of ideological battles outside the industrial sphere, first in a fight with rioters on 17 June 1953 (which Neutsch portrays as an attempted fascist putsch) and then after Khrushchev's critique of Stalin in 1956, when Gatt rushes from one meeting to the next until he develops TB. The result of this self-sacrifice is not, as in the other texts discussed

in the text following quotations. All quotations in italics appear so in the original text.

here, a marker of his deep connection to the industrial world as the source of the socialist project, but rather the factor that means he can never go back to that world: he is no longer fit enough to return to the mine. (*SG*, 103; 105)

Gatt's estrangement from the site of his original working-class experience leaves him incapable of dealing with the complexities of the situations he encounters, not least in relation to his wife's trial for alleged industrial espionage. Instead, he retreats from everyday reality into the artificial clarity of ideological cant: 'Er maß die Theorie nicht mehr an der Praxis, sondern er benutzte die tägliche Welt nur noch wie einen Stoff, um sie nach dem Maße seiner Theorie zuzuschneiden, und er verdrehte dabei schon die Tatsachen'. (*SG*, 156) Gatt is shown in this second phase of his career, which ultimately leads to his downfall, as using his working-class roots to maintain his authority against the rise of a new, educated generation of what he calls '*Hörsaalkommunisten*', (*SG*, 179) represented by the journalist Jürgen Hartung. Gatt enters into a battle of wills with Hartung over a new piece of machinery in a local mine, which engineers would like to introduce against the opposition of the workers. True to form, Gatt takes the side of the workers, insisting upon the authority of those directly involved in industrial labour, only to be proved wrong by Hartung and lose his job at the newspaper.

This episode is curious in that it shows a diametrically opposed outcome to that which resulted from similar circumstances when Gatt defended the workers in the earlier conflict in the *Chemiekombinat*. If Gatt was right to follow the insights of the workers in one situation, how can this same class instinct be wrong in another case? The text does not offer any adequate explanation, but aligns Gatt's nemesis Hartung with the new faith in '*Herrschaft über Technik*' (*SG*, 185) that was characteristic of the late 1960s in which this episode falls. Gatt recognises that this devaluation of proletarian experience in favour of the driving force of technology and those intellectuals who master it constitutes a direct challenge to the centrality of the working class in the socialist project and to the authority invested in them by their sacrifices: '*ich wollte doch sehen, wer hier siegte. Die Hörsaalkommunisten oder diejenigen, die für den Kommunismus von Anfang an ihre Gesundheit aufs Spiel gesetzt haben*'. (*SG*, 185)

The final third of the book, which charts Gatt's progress after his fall from grace, performs a remarkable about face, in that it restores the centrality of the experience of industrial labour as the source of a superior insight and the motor of society. Again the familiar scenario is repeated when Gatt challenges the authority of managers and Party officials, who are disregarding the will of the workers. Gatt has returned to the Mansfeld mining region and is working in the stores in a mine, where he is elected a union representative. The mine is about to close, but neither the Party nor the management have included the miners in this decision or the plans for their redeployment in high-tech manufacturing. Gatt makes the Party listen to the workers, and on this occasion, is found to be in the right once more. In this respect, and in the spirit of the change of direction signalled by the Eighth Party Conference, the workers are no longer simply to be subordinated to the requirements of technological progress, although it is important to note that Neutsch does not give them the option of standing in its way. Nevertheless, Neutsch does allow Gatt to once again become the voice of the people now that he has returned to his origins in the mine.

The novel presents the reader with a final twist, however. To begin with, Gatt's return to the mine is presented as a return to his *Heimat* (*SG*, 203) that promises to restore the orientation he has lost, (*SG*, 244; 261) with the implicit suggestion that the society whose development Gatt's own career has so closely followed might also be in need of such a return to its allegedly proletarian origins in order to reorientate itself. Yet Gatt is finally required to participate in the dismantling of his spiritual *Heimat*, facilitating the transformation of Mansfeld into a region of high technology and helping to close down the mines. This engagement transforms Gatt into an almost mythical figure by the end of the novel, freed of all bitterness and contradictions, and representing a synthesis of the GDR's proletarian history and its technological future: 'Ein Mann mit Vergangenheit und ein Mann mit Zukunft'. (*SG*, 319)

The contradiction that Neutsch fails to spell out for the reader here, but which runs through the entire novel, is that the valorisation of the site of industrial labour is implicitly a threat to the authority of the Party and the state. In the beginning of Gatt's career, the voice of the people, which originates at the site of labour, serves the interests of their power, but is not

created by that power: it emerges from a realm, the mine, which predates the socialist system, even though it can be harnessed to support it.[11] At other times, however, this self-same voice challenges power by insisting on a standpoint that, as the novel makes clear to the reader, is misguided. The final sequence of the novel, which sees the transformation of the site of labour, represents an attempt to both harness and tame its potential. Gatt helps to transform the *locus* of labour according to the plans of the state and the Party, which instrumentalise technology in order to secure their own authority, so that the original site of industrial labour is destroyed. For Neutsch's novel then, the site of industrial labour is both essential to socialist society as the origin of working-class wisdom and energy, which is posited as socialism's point of origin, but simultaneously troublesome as a potential location of resistance to the state's wisdom. By transforming the site of industrial labour according to the state's plans, both Neutsch's text and its protagonist neutralise that troublesome potential.

In conclusion, this analysis of the function of the industrial world in a literary topography of the GDR highlights both the centrality of the actual site of manual labour in those attempts by authors to construct a stabilising spatialisation of the socialist state, and the ambivalence of that same site in relation to the socialist project. It was this ambivalence that critical writers of the 1970s and 1980s, such as Franz Fühmann, Angela Krauß, Wolfgang Hilbig or Gerd Neumann would eventually begin to address explicitly in their work.

11 Dennis Tate makes a similar point in relation to Franz Fühmann's fascination with this same Mansfeld mining region. Tate, *Franz Fühmann. Innovation and Authenticity. A Study of his Prose Writing* (Amsterdam: Rodopi, 1995), 155.

Authenticity and Violence in Nicolas Born's *Die Fälschung*

COLIN RIORDAN

Since the advent of a category of fiction known as 'post-war German literature' in the wake of the establishment of the two Germanies in 1949, it has become the convention to consider literary developments in terms of decade. This is a trend which the addition of new categories ('post-Wende' et al.) has done little to diminish. The 1970s are no different in this respect, but attempts to find some common features in the literature of a particular ten-year period are fraught with difficulty. There is not space here to explore in detail this kind of characterisation, nor would that be a fruitful line of enquiry. But some defining aspects of literature written in particular decades are hard to overlook: politicisation in the 1960s, catastrophism in the 1980s, the materialism of the 1990s are all easily identifiable. German literature of the 1970s is most frequently associated with a so-called 'Neue Innerlichkeit' or 'Neue Subjektivität', often ascribed to disillusionment with the student movement and the passionate political idealism of the previous decade. This form of introspection was, almost as soon as it appeared, dismissed as 'Nabelschau', which, some critics argued, amounted to little more than a narrow self-obsession with the minutiae of personal relationships and, by extension, the problems of the Federal Republic.[1] This is why Nicolas Born's novel *Die Fälschung*, which appeared in 1979, aroused a good deal of attention which cannot only be accounted for by the early death from cancer of its author in December of the same year at the age of forty-one.

1 Hans Krieger noted as early as 1976 that 'die Nabelschau einer sensitiven Innerlichkeit' was sufficiently prevalent to amount to a new literary trend. See Hans Krieger, 'Talfahrt durch das eigene Ich', *Die Zeit*, 30 July 1976.

There can be no doubt that the main protagonist of the novel, a journalist called Georg Laschen, is inward-looking. His self-absorption, however, takes place in a setting where external events repeatedly intrude with a violence which cannot be ignored: namely Beirut at the height of the Lebanese civil war during the few weeks spanning December 1975 and January 1976. Laschen is a reporter for a Hamburg-based weekly – perhaps *Der Spiegel* – who is undergoing a personal crisis while reporting on a public crisis with global implications. During the course of the book he has two affairs, the second almost leading to the break-up of his already fragile marriage. Throughout the novel he drinks heavily as his mental state worsens. Towards the end of his time in Beirut he apparently stabs an innocent person, and on his return to Hamburg resigns from his position.

Laschen's predicament is reminiscent in many ways of that experienced by the eponymous hero of Peter Schneider's *Lenz* (1973), also a text where personal crisis is linked with political crisis, conflict and failure. Even more striking is the parallel with Martin Walser's *Ein fliehendes Pferd* (1978), where the central male character Helmut Halm, like Laschen, feels 'durchschaut' and 'erwischt', feels life to be a sham and has problems communicating with women. But both of these works have a much more circumscribed horizon than *Die Fälschung*, sharing an insularity about the Federal Republic and its malaises, even if the eponymous hero of *Lenz* does escape Berlin for Italy. Is, then, the Lebanese crisis in Born's novel merely there as a form of distinctive variety? I want to argue that it is not, and that the transportation of an almost stereotypical protagonist of the 'Neue Innerlichkeit' to the Lebanon of the mid-1970s has a very particular purpose.

The novel is set in a period in Lebanese history that is characterised by confusion and complexity. Sadly, the chaotic nature of the events and alliances depicted is not unique to the mid-1970s, but it can have an alienating effect on the unwary reader and so an outline of the historical background will be of use. After being brutally driven from Jordan in September 1970, the Palestinians had to all intents and purposes moved their headquarters to Beirut in pursuit of a free and independent homeland. As Laschen is to discover, Beirut offered 'relaxed political controls and excellent access

to the world's press'.[2] The Palestinians' main opponents in Lebanon were the Lebanese army and the Lebanese Right. By 1973 the army had failed to achieve a clear-cut victory, and the Lebanese Right, in the form of armed militias, began to take matters into their own hands. There was a whole array of such groups, including the Christian Phalangists and the Christian Maronites, who fought to assert themselves in a context where there had been a shift in population from a Christian to a Muslim majority over several generations, culminating in the 1960s. Several of these groups figure specifically in *Die Fälschung*, especially the Lebanese National Party, the paramilitary Tigers and the so-called Guardians of the Cedars. By 1975 there was a heavy Palestinian presence in the country and the predominantly Christian Right had armed itself in turn and allied with the Palestine Liberation Organisation (PLO). Rising tensions and armed groups led inevitably to conflict.

The key events marked in *Die Fälschung* are the massacre of 200 Muslims in December 1975, and attacks on two PLO camps and subsequent atrocities on 12 January 1976 at Dubaya and on 19 January 1976 at Karantina, leading to 1,000 Muslim deaths. The response was the PLO occupation of the mainly Christian town of Damur, the killing of 500 of its inhabitants and the expulsion of 7,000 others. Damur is the key turning point of this novel: though it is not a 'Novelle', this incident nevertheless acts as the 'unerhörte Begebenheit' familiar from that genre.

The book treats the progress of the civil war and the complexity of the warring factions in astonishing detail, though always from the point of view of Laschen; that is, of a successful and well informed, high-level journalist. Though he despairs over 'die Aussichtslosigkeit, den eigentlichen Kriegsgrund wiederzufinden',[3] it becomes apparent that Laschen at least has recognised that the war is shaped by a complex dynamic which cannot be reduced to easily definable allegiances. Each side in the civil

2 Rex Brynen, *Sanctuary and Survival. The PLO in Lebanon* (Boulder: Westview Press; London: Pinter Publishers, 1990), 64.

3 Nicolas Born, *Die Fälschung* (Reinbek bei Hamburg: Rowohlt, 1979), 15. Hereafter references to the text will be given in brackets in the text following quotations.

war tends to disparage its opponents collectively in reductively Cold-War terms; the Christian, right-wing Phalangists condemn all the Palestinians as 'Kommunisten', (108) and include some Muslims who have allegedly become 'angesteckt'. By the same token, a PLO officer regards the enemy as 'Imperialisten, Faschisten und Zionisten'. (174) Of course, as is always the case in such conflicts, this impersonal labelling of the enemy allows brutal atrocities to be carried out against them. But beyond such simplistic and dehumanising categorisation, the position is complicated by an extraordinary diversity of affiliations, not least religious ones. Not every Muslim is necessarily allied with the PLO and the Left, for example, while some Palestinians are Christians. And there is much evidence that Laschen, although he attempts to depict the problem from both sides, cannot escape from his subjective position as a child of the Federal Republic. He reserves much scepticism for the position of the Christian militias, which he sees as bandits run by power-hungry warlords bent on securing their own established position in Lebanon and exploiting the situation to pursue a policy of ethnic cleansing against Muslims.

Chapter XII is devoted to a portrait of the leader of the Maronite Christian militia which is described as a 'Privatarmee', generally thought to be responsible for a massacre of Palestinians returning to Beirut after a funeral. (103) The leader, known only as Tony, is the son of the President, and rules over an organisation more akin to the Mafia than a guerilla army. He lives in sybaritic luxury, rather incongrously addressed with the honorific 'Exzellenz' and surrounded by deeply sinister guards wearing mirrored sunglasses and an array of cruxifixes. The crucifixes everywhere to be seen are clearly a badge of tribal allegiance rather than a religious symbol. The avowed aim of 'Exzellenz Tony' is to dominate the country, and this whole section seems designed to reinforce a heavy bias in the book against the Christian factions. They are depicted as perpetuating the feudal, hereditary rule of a small number of families in Lebanon. Christian fighters are described as particularly brutal and ruthless; 'Geschulte Mordbrenner'. (51) Sympathy for the Palestinians is equally evident; they are, it seems, in danger of falling victim to an international plot against them. Laschen's sympathies seem only reinforced by what he sees and the evidence he gathers, until his experience of a crucial event: the attack on and occupation of

Damur by the PLO. With his photographer Hoffmann, Laschen enters the occupied town and is, in contrast to the hard-boiled reporter image one might expect, shocked to find a Christian family grotesquely dead in their home amid photographs of themselves the previous Christmas. He is then witness to the summary execution of a father and son within earshot of the wife and mother, left with two small children. He even attempts to intervene, and afterwards remonstrates with the PLO officer responsible. The latter justifies his actions, (183–84) but Laschen's belief in the justice of their cause is irretrievably shaken.

This is not, however, a question of political beliefs: the change that occurs in him is personal. And that is the importance of this setting. Lebanon and its crisis offers to Born a scene where introversion cannot remain impervious to external influence. The change in Laschen is described as follows: 'Auf die Palästinenser war er aber trotzdem wütend, weil sie ihn, der sympathisierte, vor den Kopf gestoßen hatten. Ihre Forderungen waren nicht mehr gerecht, sondern verwerflich, weil ihre Methoden verwerflich waren. [...] Er hatte jetzt keine Lust mehr zu differenzieren, sondern alle, alle zu disqualifizieren'. (183) Thus for Laschen does the public become private; the political, the regional struggle for power and justice, become part of Laschen's personal crisis. Laschen now despairs of talk of rights and justice, and cannot accept that atrocities committed by the Phalangists permit brutal violence by the Palestinians: 'Recht und Unrecht rotierten als Begriffe so schnell, daß sie ununterscheidbar waren, Recht und Unrecht waren bis zur Unkenntlichkeit vertauscht worden, gab es nicht, schien es nie gegeben zu haben'. (185)

One of the key characteristics of the Middle East conflict in this context is, then, that it undermines or even removes certainty and conviction. A new introversion as a response to the conviction politics of the 1960s is itself invaded and destroyed by external events which, in their shocking brutality, insist on a reaction but provide no legitimate basis for that reaction. It is this that leads Laschen to become strongly critical of his own role as a reporter. Laschen's dilemma is that the journalist's calling demands that events be registered objectively, and yet he has to personalise them for his readers. That process of personalisation means that Laschen has to force himself into an inauthentic process of emotional reproduction: 'So mußte

er weiter sein Berufsbild erfüllen und sich unter Aufbietung von Kräften an Gefühle erinnern und sie simulieren'. (188) The simulation becomes necessary because there is no adequate basis on which to re-experience those feelings: it is this that leads to the process of 'Fälschung'. The 'Fälschung' comes to permeate all aspects of his behaviour. The absence of authenticity which has come to characterise Laschen's life – and via his role in the media as a high-profile reporter, to characterise society in the Federal Republic of the 1970s – emerges starkly amid the sharply delineated and violent contrasts of the Lebanese conflict.

The chronic ambiguity that faces Laschen in both his emotional life and his assessment of political and military developments in the Lebanon has its origins in the erosion of the bonds between self and place. Lebanon is a paradigm of transition. Repeatedly we, and Laschen, are confronted by borders that define differences. Allegiances are defined by place, or to put it another way, group identity demands a physical space within which to delineate itself. In the acutely heightened environment of war-torn Lebanon, these spaces are manifestly present in the form of front lines and check-points. The problem is that the front lines and check-points shift, often undetectably. A failure to recognise the lines dividing the warring factions could lead to extreme violence and death. Crucially, these borders go beyond the tribal allegiances that lie at the root of the civil war. As his personal crisis develops, Laschen's generally liberal outlook gives way to a series of prejudices concerning national identity. The certainties of his Federal Republic background, the rejection of fascism and its associated ideology, the student movement's assumption of Christian authoritarianism, the embracing of the Palestinian cause against Zionist oppression, all these convictions begin to break down under the pressures of a conflict that is very different from the suppressed hostilities of the divided Germany.

The personal pressures created by this erosion of conviction emerge in the affair Laschen has with Ariane, a German citizen working at the German embassy who is the widow of a Lebanese Maronite Christian. She has lived in the Lebanon long enough to have begun losing her Germanness: 'Ich vergesse auch immer mehr die Bundesrepublik Deutschland [...], und ich frag mich oft, ob es mich verlassen hat, das Deutsche, weil ich es

vielleicht verraten habe, es verschwindet nämlich'. (46) There are several other expatriates from Germany here who cannot or will not return to their native land despite the ever-present danger of life in Beirut. Laschen fantasises about being in that position, but his experience of war in the Lebanon points up another reason for Born to have chosen the crisis to expand the horizons of 1970s German literature: it relativises the problems of the Federal Republic. In the mid-1970s the Federal Republic may well have been in the throes of an oil crisis and struggling to respond to political terrorism, but Laschen is confronted by a reality which simultaneously puts those problems into perspective and exposes his own prejudices. As the novel progresses, and in particular after the Damur atrocity, Laschen increasingly abandons his presumption in favour of the Palestinian cause and begins to despise Arabs, at first by implication and then in a patently racist way, although he never expresses these feelings openly. When his position as Ariane's lover is supplanted by an Arab rival he gives free rein, internally at least, to his malicious stereotypes: 'Wie konnte sie es überhaupt aushalten, sich von diesem Araber *und von ihm* berühren zu lassen?'. (249) Ariane describes herself as having become an Arab, but Laschen feels that Ahmed, the rival, cannot make her love him, 'nur sie erobern und ausplündern und besudeln mit seinem Dreck und Sperma'. (252) Laschen's sexual jealousy becomes inextricably entwined with his revised view of the Palestinian factions. His previously sympathetic view of the PLO has now been refracted through a racist lens that is wholly at odds with his liberal outlook. As he tells himself: 'Er durfte nicht vergessen, daß sie Araber waren, und grundsätzlich blieb bei ihrem Anblick das Gefühl, sie wechselten selbst im eigenen Lager ständig die Front, Tücke und Intriganz seien ihr eigentümliches, unüberwindbares Verhalten'. (206) The daily immediacy of violence and brutality in Beirut have stripped away the veneer of Laschen's liberal values to expose the prejudice beneath. The Lebanese setting allows Born to reveal the 'Fälschung' that characterises society in the Federal Republic of the 1970s.

There is one common feature at the heart of the Lebanese crises, of Laschen's personal crises, and, by implication, of the social malaise of the Federal Republic, and that is a crisis of masculinity. In his collection of short stories *Die Wette* (1978), Peter Schneider, in a spirit of self-criticism,

was one of the earliest male representatives of the student movement to point out the heavy irony of the thoroughgoing chauvinism which characterised that struggle for freedom from the yoke of authoritarian oppression. In *Die Fälschung*, 'Männlichkeitssucht' is depicted as the ultimate driving force in the Lebanese war, and it is Laschen's failure to come to terms with his own identity as a man which leads him into a state that borders on illness. Laschen, of course, fails to recognise this in himself and ascribes the problem to Arab culture and mentality; indeed, his lack of self-knowledge is everywhere apparent. His feeling that his life lacks authenticity, that 'das Leben' in general is a forgery, is an expression of his failure to achieve an authenticity of experience as a man, even though he is 'mitten in Ereignissen'. (259) Both Greta (his wife) and Ariane are, by contrast, strong, independent women who obviously have no especial need of him. Laschen's desperation finally leads to an unmotivated act of violence when he lashes out with a knife while sheltering from artillery fire. This episode, in which Laschen stabs a body (whether alive or dead we cannot tell) that collapses onto him during the shelling, is reminiscent of Helmut Halm's sudden resorting to violence in *Ein fliehendes Pferd* when, after a long period of suppressing his real feelings, the accumulated frustration is vented in a single act of physical violence. The act in Laschen's case seems unmotivated; it is not clear how this will help his predicament when the most urgent necessity is to get out of the shelter. Not even Laschen is clear about what has happened: 'Er mußte hier heraus, ganz gleichgültig, was ihn draußen erwartete. Hatte er eine Leiche getötet, einen Betenden?'. (272) We are clearly faced with an emotional rather than an intellectual sequence of events. The crisis is perpetuated as lack of authenticity gives rise to frustration, violence, and further detachment between self and world. 'Er wollte nur einen Zustand beenden', we learn at the end, 'den des Fälschens ebenso wie den der moralischen und kritischen Empörung'. (308) Neither Laschen personally, nor the Federal Republic more broadly, are in a position to assume the moral and critical high ground so long as their understanding of self and world remain inauthentic. Only once does Laschen achieve the authenticity for which he searches, in an article he wrote about Damur. That was achieved only by means of observing and failing to prevent an act of shocking violence:

despite his strong protestations, the father and son were still shot. Ultimately, then, his representation of authentic experience is an account of disastrous failure. As the novel ends, Laschen has not resolved his difficulties; the Lebanon experience has revealed that they go well beyond the individual, and are perhaps symptoms of an incurable malaise of the human condition.

Sport, Identity and War in Saša Stanišić's *Wie der Soldat das Grammofon repariert*

BRIGID HAINES

For Rhys, who loves sport, and life.

> It is through the middle of Bosnia that East meets West; Islam meets Christianity; the Catholic eyes the Orthodox across the Neretva, the line of the Great Schism; Bosnia divided the great empires of Vienna and Constantinople; Bosnia was perhaps the only true reflection of Yugoslavia.[1]

> Some people believe football is a matter of life and death. I am very disappointed with that attitude. I can assure you it is much, much more important than that.[2]

Sport features in contemporary literature and film as a cipher to identity and as metaphor; sometimes as both. The identities explored via sport can be individual, group or national, the emphasis varying across cultures. The British tradition of football writing, for example, tends to focus on the club scene, from Nick Hornby's *Fever Pitch* (1992), about the author's love for Arsenal, which began the genre, to Adrian Childs's *We Don't Know What We're Doing* (2007), about his life as West Bromwich Albion fan, and David Peace's *The Damned United* (2006), which explores Brian Clough's disastrous short tenure as manager at Leeds United. The emphasis in West Germany, and later Germany, is, by contrast, on the national story, as the country's route to 'normality' is increasingly told through sport. F. C. Delius's *Der Sonntag, an dem ich Weltmeister wurde* (1994) and the

1 Misha Glenny, *The Fall of Yugoslavia. The Third Balkan War* (London: Penguin, 1992), 162.

2 Bill Shankly, http://www.shankly.com/lifeanddeath.htm, date accessed 10 January 2009.

film *Das Wunder von Bern* (2003), for example, both trace the rebirth of West German national pride after the Second World War to the national team's 1954 victory over the 'mighty Magyars', the – until then – largely unbeaten Hungarian side.[3] More recently, Germany seemed to many to come of age with the phenomenon in 2006 of World Cup Fever. For this event prompted an unprecedented outpouring of national sentiment and provided the mass spectacle of Germans waving their flags without embarrassment or irony for the first time in fifty years. Sport can also be used to explore postmodern, globalised identities fit for a supposedly post-national age, as in Joseph O'Neill's bestseller *Netherland* (2008). This novel, set in New York in the aftermath of the attack on the World Trade Centre, uses cricket to 'generate meaning in a post-colonial age'.[4] O'Neill's deracinated protagonist, who is undergoing a variety of personal crises, finds unexpected solace in the hidden underworld of the New York cricket scene and in taking part in a joint project to create a world-class cricketing venue on American soil.

While *Das Wunder von Bern* refers to a real sporting encounter, one of many through which the course of the Cold War was charted by Europe's divided population, completely fictional sporting encounters can also be employed as metaphors of a more complex, often political reality, as in the Bollywood film *Lagaan* (2001), which sees a group of illiterate Indian villagers under the Raj beat the British army at their own game, cricket, or the Hollywood film *Escape to Victory* (1981), in which a group of allied prisoners of war beat their German guards at football. What is valuable about the sporting arena here is its simplicity and rule-boundedness, which famously prompted Albert Camus to declare that, 'All that I know most surely about

3 For more examples see Paul Cooke and Christopher Young, 'Selling Sex or Dealing
 with History? German Football in Literature and Film and the Quest to Normalize
 the Nation', in *German Football. History, Culture, Society*, eds Alan Tomlinson and
 Christopher Young (London and New York: Routledge, 2006), 181–203.
4 Peter Beaumont, *The Observer*, 25 May 2008, http://www.guardian.co.uk/
 books/2008/may/25/news.usa, date accessed 6 January 2009.

morality and the duty of man I owe to sport'.[5] In these examples, sport is prized for its purity, its superiority to life; merit can bring victory on the sports field, if not in reality. But the closeness of the sporting encounter to war (the training involved, the absolute opposition of the sides, the need for victory) also makes it suitable for *representing* war and may rob it of its innocence, as in the ultimate sporting film *Rollerball* (1975), in which sport replaces war as future society's only outlet for aggression.

Saša Stanišić's remarkable new novel, *Wie der Soldat das Grammofon repariert* (2006), uses sport thematically and as metaphor. It explores a rather different set of identities to British or German ones, namely Yugoslavian and specifically Bosnian ones during the 1990s, a time of extreme crisis. In contrast to football's role in the construction of a West German and then a German identity, Stanišić's sporting references chart the break-up and disappearance of a country, Yugoslavia, and the transformation of one of its constituent republics, Bosnia, and catalogue the effects this has on the identities which are constructed out of that state and that republic. Furthermore, in one key scene, a fictional sporting encounter is used metaphorically to represent the Bosnian conflict of 1992.

An autobiographically inspired text, *Wie der Soldat das Grammofon repariert* focuses on a boy, Aleksandar Krsmanović, caught up in the fighting in the Bosnian town of Višegrad, scene of ethnic cleansing, who flees to Germany, then returns as an adult in order to fill in the holes in his memory. The novel has been very well received at home and abroad and has been widely translated.[6] Its effectiveness lies in its formal daring and

5 'Car, après beaucoup d'années où le monde m'a offert beaucoup de spectacles, ce que finalement je sais sur la morale et les obligations des hommes, c'est au sport que je le dois, c'est au RUA [Racing Universitaire d'Alger for whom Camus played in goal as a student] que je l'ai appris'. Quoted from http://pagesperso-orange.fr/esmmaix/rua/Camus-n.HTM, date accessed 6 November 2008.

6 Links to reviews can be found on Stanišić's website, http://www.kuenstlicht.de/rezensionen.html, date accessed 14 January 2009. The English translation of the novel, by the widely respected Andrea Bell, was published by Weidenfeld & Nicolson in 2008. Stanišić was shortlisted for the *Deutscher Buchpreis* in 2006; in 2008 he won the Chamisso Prize and was designated an emerging author at the Guardian Hay Festival.

lack of nostalgia: when war intrudes, the narrative fractures into something
approaching a mosaic in order to reflect the difficulty of representing war,
and the more the mature protagonist investigates the Bosnia of his youth,
the more its innate fragility is revealed, so that the protagonist emerges
as 'ein geheilter Nostalgiker'.[7] Despite the pervasive sense of loss – of the
country, of innocence and of the beloved, a Muslim girl whom Aleksandar
briefly meets when sheltering from the violence and devotes himself to find-
ing again – Stanišić's text is life-affirming and shot through with humour.
It is also deeply intertextual. For in bringing the tragic story of Bosnia up
to date, *Wie der Soldat das Grammofon repariert* is a homage to, and con-
tinuation of Ivo Andrić's *The Bridge over the Drina* (1945), which chroni-
cled the history of Višegrad through its bridge, built by the Ottomans,
taken over by the Austrians, damaged in the First World War. The Nobel
citation for Andrić's novel says that he showed, using 'the light of reason',
'what forces [...] act to fashion a people and a nation'.[8] For Stanišić, one
of these forces is sport, which offers multiple sites of identification in a
world which, as in O'Neill's *Netherland*, has lost the faith in reason which
marked Andrić's text. His more chaotic, fluid, postmodern structure arises
from the viewpoint of the witness, moving through history rather than
standing outside it.

Some of Stanišić sporting references are trivial and humorous, some
deathly serious, a mix that reflects the comic-tragic border crossings of this
novel itself. Early in the novel sport functions as a sign of harmony, leisure
and healthy competition, though there is always an edge. In the opening
scene, for example, Aleksandar's beloved grandfather Slavko, a loyal sup-
porter of Tito who has passed on the baton of storytelling to the boy, dies
just as Carl Lewis beats the world record for the 100 metres during the 1991
World Championships.[9] This is one of those moments which have the ring
of magic realism about them but later appear more nuanced as the mature

7 Unpublished interview with the author, 29 May 2008.
8 http://nobelprize.org/nobel_prizes/literature/laureates/1961/press.html, date
 accessed 6 November 2008.
9 Saša Stanišić, *Wie der Soldat das Grammofon repariert* (Munich: Luchterhand, 2006),
 13 and 28.

recollecting narrator is forced to problematise his unthinking youthful enthusiasm for Yugoslavia and its chief architect, Josip Tito. Another such undermining of the apparent idyll occurs when a visiting Italian engineer working on the local dam teaches the locals *bocce*, the Italian version of boules. This harmonious scene of cross-cultural understanding is wrecked, however, by the community's homophobia when the rumour spreads that Francesco is gay and Aleksandar too becomes complicit in spurning his friendship. This is an early example of the scapegoating which was to be used as a political tool in the war and comes back to haunt Aleksandar when the still loyal Francesco shows concern from afar for his Bosnian friends during the fighting.

Before the start of the fighting, Aleksandar's passions are playing football with his friend Edin, fishing in the river Drina, storytelling and painting. But as he registers the disappearance of normality in the build-up to war, the sporting references become more sinister. He is an excellent fisherman with a love of tall fishing yarns, but when he wins a local championship he cannot attend the final for it is too near the fighting. When the soldiers arrive, their idea of sport is to fish with a hand grenade, kill a horse by tipping it off the bridge into the river, and shoot a dog, showing off to local children; the purity of sport becomes abased. In the cellar, as the radio now names his own town up above as the scene of fighting, Aleksandar destroys his own marbles, perhaps signifying his child's understanding that the possibility of play is suspended, or his rejection of the play hijacked by nationalism, as the soldiers dance to the songs played on the eponymous gramophone, repaired by a soldier with a kick. When his family hurriedly load the car and leave, he is not allowed to take his football, so he gives it to his friend Edin. His last view through the rear view mirror is of Edin chalking up some goalposts on a wall and taking some shots, clinging to normality. Later, his friend Zoran, who remains behind, reports that no one plays anything any more and the sports hall is full of people, prisoners or refugees, he is not sure which. When Aleksandar returns years later to a shattered country where the Muslim population has gone and the ethnic cleansers, including his own uncle, walk the streets unchallenged, the goal posts have been removed from the school playing field.

But sport is also used as metaphor. The key sporting scene in the novel is set up to function as a microcosm of the Bosnian war, that genocidal conflict orchestrated from outside by the likes of Slobodan Milošević, which turned communities against themselves and ended with a re-mapping of the area which seemed to some to hand victory to the aggressors. The year is 1992, the place Mount Igman, Bosnia. During a ceasefire in the fighting between the Serbian and the Territorial Defence forces over a strategically important route to Sarajevo, a football match is held. It is the third such match; the Serbs have won the previous two. Before it starts, two players from opposite sides who are old school friends, Kiko and Mikimaus, embrace over the body of a dead comrade (shot, in the fog of war, by Mikimaus). During play, with the Serbs two-nil up, the Territorial Defence player Meho accidentally kicks the ball into the woods, which are mined. Ordered to fetch it, he shits himself, metaphorically and literally, but succeeds, after some tense moments, in retrieving the ball. Afterwards, he cries as he borrows clean trousers from the dead comrade. On returning to the match, he discovers that 'sein Scheißtag noch lange nicht zu Ende war', (245) for the ceasefire has finished and the Serbs, under their brutish commander, General Mikado, have turned their guns on their opponents. When one of the Territorial Defence players dithers, he is shot dead by the Serb goalie. The desperate Territorial Defence captain Dino Zoff, fearing for the lives of the rest of his men, challenges Mikado to let them continue the game, promising that if his side wins, no one will die. The challenge is accepted, and the match continues. However, Mikado, now the referee, threatening bullets in lieu of yellow cards, disallows two opposition goals which would have evened up the score. A disputed Serb goal raises the score to three-nil. When a Territorial Defence player scores, bringing the score to three-one, his reward is a blow to the head with a rifle butt. Kiko also scores for the Territorial Defence, raising the score to three-two. When forced to play again, the now delirious Meho, in his clean trousers, nets the ball when it lands at his feet, wanders off and is shot by the Serb goalie. The score is now three all. Mikado misses a penalty, and Zoff scores for the Territorial Defence, bringing the score to three-four, a turning point in the match. When General Mikado tries to disallow a further goal, Mikimaus, the normally silent, giant farm boy who is only in the war in order to escape the

drudgery of farm work and who only realised that he was a Serb when the war was looming, leads a mutiny of the Serb side in the name of fairness, insisting that the goal stand and the match be continued. With the last shot of the game, Mikimaus scores for the Serbs, bringing the final result to four all; 'Niemand klatschte. Niemand jubelte'. (255)

This scene occurs late in the novel and forms a separate chapter; in line with Stanišić's aesthetic of showing rather than telling, it contains no authorial commentary. With its obvious echoes of those famous fraternisations between German and British troops who discovered a common humanity on the Western front on Christmas Day 1914, Stanišić has also constructed it to bring out the peculiarities and absurdities of the Bosnian conflict: both sides speak the same language, they often know each other, their personal motivations have nothing to do with the strategic aims of those directing the fighting from afar.[10] In its representation of the war, the scene shows the bewildering speed of events and the – even for a war situation – grotesquely deadly stakes: when the referee, one of his own side, gestures to Meho to fetch the ball from the minefield, it is described as 'eine Geste, die es wohl bei keinem anderen Fußballspiel auf der Welt gab'. (242) (A further touch revealing the carelessness with human life is that Meho is lent a bullet-proof vest for the mission – not for himself, but to wrap the precious ball in.) (242) One could also comment on the particular brutality of the Serbs, though it is shown to be chance that they grab their weapons first when the ceasefire ends. Until the moment of the mutiny, this match, with its dirty tactics, aggression and contempt for human life, is far from Camus's ideal sporting encounter. Kiko's mutiny, however, re-asserts the ideal and opens up the gulf between this match and

10　'The atrocities in Bosnia in 1992 were not committed by old men, or even by young Bosnians nursing grudges about the second world war. The pattern was set by young urban gangsters in expensive sunglasses from Serbia, members of paramilitary forces raised by Arkan and others; and though the individuals who performed these acts may have gained some pathological pleasure from them, what they were doing was to carry out a rational strategy dictated by their political leaders – a method carefully calculated to drive out two ethnic populations and radicalize a third', Noel Malcolm, *Bosnia. A Short History* (London: Macmillan, 1994), 252.

the war it represents. The mutiny restores fair play in, and proper closure to the game, which serves to highlight the messiness, open-endedness and stalemate of the actual fighting.

The economy and pace with which this brief scene suggests so much about the tragic course of this apparently domestic conflict are a perfect rebuff to those few critics, such as *Die Zeit*'s Iris Radisch, and Sam Munson in *The New York Sun*, who accuse Stanišić of kitsch and whimsy respectively.[11] Their critique is worth addressing, though, for, particularly in the first half of the novel, Stanišić plays with bucolic Balkan stereotypes and risks the sentimentality which can attend a child narrator. But as I have indicated, even in those early scenes, the rise of nationalism and the consequent hatred of the other are shown to be always already present. When the war catches up with Aleksandar, and his family escapes from the Višegrad cellar, in which they have sheltered, and flees, first to Serbia and then to the safety of Germany, the narrative form fragments in order to reflect 'Das Splittern des Glases von Aleksandars Wahrnehmung und Lebensweg'.[12] The football match is one of several ways in which the adult Aleksandar, who was present but did not witness the ethnic cleansing for which Višegrad has become infamous,[13] seeks to represent (for he is a story teller) the horror. Others in this increasingly polyphonous and fractured novel are: the testimony of his friend who witnessed the bodies of Muslims being thrown into the river and saw, in an intertextual echo of Andrić, the women washing the blood from the bridge afterwards; Aleksandar's increasingly desperate phone calls home in the search for Asija; his obsessive lists; and the breakdown in family relations when the adult Aleksandar meets his uncle, a former member of the Serb militia who has participated in the killing and the rape camps but has never been brought to justice.

11 Iris Radisch, 'Der Krieg trägt Kittelschürze', *Die Zeit*, 5 October 2006, and Sam Munson, 'The Naive Fiction of Saša Stanišić', *The New York Sun*, 23 April 2008.
12 Unpublished interview with the author, 29 May 2008.
13 An account of the massacre can be found in Ed Vulliamy and Nerma Jelacic, 'The Warlord of Visegrad', *The Guardian*, 11 August 2005, http://www.guardian.co.uk/world/2005/aug/11/warcrimes.features11, date accessed 10 January 2009.

It is worth considering why, when much of the novel is autobiographically inspired, Stanišić's invented this match.[14] Four characteristics of football are its relative simplicity (its only requirements being a ball and two improvised goals), its near universality (it is played all over the globe), the fierce loyalty local teams engender, and the fact that it is the national sport for a majority of the world's countries (with the notable exception of Wales).[15] Its simplicity and universality lend it, as I hope has been clear, a suitability for metaphorical use. But Stanišić also uses football to chart the disappearance of Yugoslavia and the transformation of Bosnia and to trace the changing identity of his protagonist as he migrates West. Vic Duke and Liz Crolley argue that 'football captures the notion of an imagined community perfectly,'[16] and that the politics of football in relation to the state is most straightforward where the state 'overlaps to a large degree with the nation.'[17] Yugoslavia, however, was never that simple. On the one hand, its leaders aspired to creating a national identity, and the success of its national football team no doubt helped.[18] Bosnians, incidentally, because of the multi-ethnic nature of their republic, had the largest stake in this collective project. Yet the country was actually composed of a variety of nations held together in a federation under a communist system, and the nationalism of the various ethnicities was often expressed through club loyalties. These tensions are explored in what follows.

14 A survivor Stanišić interviewed about life in the trenches told him that fraternisation and trade in goods between the two sides did occur but that they did not play football because they did not have a ball. Unpublished interview with the author, 29 May 2008.

15 Vic Duke and Liz Crolley, *Football, Nationality and the State* (Harlow: Longman, 1996), 1. Stanišić appreciates the value to Wales of its national sport: on signing my copy of his book after a reading in Vienna, he wrote 'Für Brigid, mit den besten Grüßen nach Wales!', adding, in English, 'Go Rugby!'.

16 Duke and Crolley, 4.

17 Duke and Crolley, 5.

18 As Jonathan Wilson reminds us, 'There was a time when Yugoslavia was the Brazil of Europe', *Behind the Curtain. Travels in Eastern European Football* (London: Orion, 2006), 98.

The protagonist Aleksandar is a Red Star Belgrade fan who, though brought up in a secular household, has been known to pray for his team's success in the mosque. Red Star, one of the most successful teams in former Yugoslavia, were a Serbian team strongly associated with Serbian nationalism, whose supporters, led at one stage by the warlord Arkan, were involved in a famous riot with Dynamo Zagreb fans in 1990 just before Croatian independence. Praying for this team in a mosque is therefore a gesture heavy with ironies which Stanišić characteristically does not draw attention to. For Aleksandar there is no contradiction, however, for he is half Serbian and half Bosniak. It is because his mother is a secular Muslim that the family has to flee when the Serbian troops start rounding up Muslims in Višegrad. Aleksandar's Bosnian and Yugoslav identity only becomes troublesome as the state is threatened. Forced to state his loyalty in the school playground when nascent Serb nationalism disrupts a family party, he says 'Ich bin ein Gemisch. Ich bin ein Halbhalb. Ich bin Jugoslawe – ich zerfalle also'. (54)

Aleksandar is not the only Red Star fan for whom his team allegiance does not map seamlessly onto his ethnic identity. Before venturing into the forest on his potentially deadly mission during the football match, Meho, who is playing for the Territorial Defence, the Bosniak (Muslim) side, takes off his precious Red Star Belgrade shirt, lest it get damaged, and entrusts it to Marko on the other side. When asked by Marko how he, a Bosniak, can support a Serbian team, Meho reacts with an expression of unswerving loyalty which Nick Hornby himself would recognise: 'weißt du, es ist mir egal, woher meine Mannschaft kommt, die Jungs spielen doch nur Fußball. Als ich so groß war [...] waren sie meine Helden. Das Finale gegen Marseille einundneunzig! Dieser Sieg! Dieses Elfmeterschießen!'. (244) For Meho, what matters is not that Red Star is a Serbian team but that it is his team. (And in fact, despite the Serbian nationalism of their supporters, that very team which beat Marseilles in Bari in 1991 contained a Macedonian, a Croatian, a Montenegrin and a Slovene. Red Star was thus never a purely Serbian phenomenon.) When Meho is shot, his precious Red Star shirt, with all that it symbolises of potential unity across and beyond the newly imposed ethnic boundaries and of the ability of sport to rise above nationalism, is also destroyed.

But Aleksandar is not like the old men he meets in Sarajevo years later, who mourn the good times when the Yugoslav team was great, 1962 in Chile (232), and bemoan the loss of a national side: 'wären wir heute ein Land, wären wir unbesiegbar'. (231) They may be right: the 1987 Yugoslavian youth team were outstanding and they might have achieved greatness. Both Jonathan Wilson and Vic Duke and Liz Crolley are also gloomy about the prospects for football in eastern European countries under market forces. While Russian football is healthy because of the huge funds available, and national sides sometimes benefit from players having the opportunity to play for western clubs, club sides all over eastern Europe are struggling.[19] But this is not the point. Even though, as his friend Kiko puts it in one of the most telling sporting metaphors, the whole country was relegated when war threatened, (257) Aleksandar, with the adaptability of youth, moves on. He develops a new team loyalty in Germany, to Schalke 04. He continues to fish, and spends his time playing Sensible Soccer on his friend's PC. Meanwhile, his mother in the USA takes up ice-skating and looks forward to attending an American football game. (153) While the old men remembering 1962 see only the negative, 'Zweiundsechzig in Chile [...] dem Land ging es gut, und wenn es dem Land gut geht, geht es auch dem Sport nicht schlecht. Heute ist es so: Scheiße hier – Scheiße dort', (232) Aleksandar is not stuck in the past. But interestingly, his national affiliation, it seems, does not transfer to Germany. Angered by the glib discourse of German multiculturalism which suggests that he represents 'ein gelungenes Beispiel für Integration', he notes that 'Ich freue mich für fünf Nationalmannschaften'. (156) He doesn't name them – he leaves this comment hanging – but presumably they are Bosnia, Serbia, Croatia, Macedonia, and Slovenia. Yugoslavia may have disappeared as a state, but that is not the end of its story.

Stanišić is one of a number of young writers from eastern Europe who have moved west since the fall of communism, and are writing in German.[20]

19 See Wilson, 300–4, Duke and Crolley, 95–99.
20 A snapshot listing of these authors from September 2007 is available at http://www.swan.ac.uk/german/docs/haines%20ee%20biblio.doc.

Like him, many are concerned with redefining their nation in the light
of the fall of communism and the rise of nationalism, exploring identities
in post-communist Europe and combating recent definitions of Europe
based on the Franco-German heart of the EU. They tend to look for their
country's roots in Europe's history of empires.[21] Like the other Yugoslav
writers among them, Stanišić has a more tragic tale to tell, yet his novel
is not nostalgic or backward looking, as the final words, 'ich bin ja hier',
(315) imply. Unlike Andrić's *The Bridge over the Drina*, with its sovereign
perspective, his novel is about the limits of storytelling – some events will
never be told, some wounds never do heal. But like Andrić, he shows 'what
forces [...] act to fashion a people and a nation'.[22] One of these, today, is
sport. Stanišić's website contains a link to a cartoon showing two desper-
ately thirsty men in a desert, one of whom holds a water bomb they have
just found. When asked what he's waiting for, he says 'Ich wäge noch ab
zwischen meinem Überlebenswillen und dem Kind in mir', and laughs.[23]
Wie der Soldat das Grammophon repariert also asserts the deeply serious
human need to play. Joseph O'Neill's *Netherland* shows how sporting
identities, uncoupled from the usual club, county or national identifica-
tions, can still offer unexpected support in their fluidity. Stanišić loosens
but does not uncouple these links. As well as a source of metaphor, used by
Stanišić in the match scene to represent the occurrence of the unthinkable,
sport, as the arena of pleasure, companionship and group loyalties, where
people can continue to inhabit their inner child, offers sites of multiple
and shifting identifications.

21 See Brigid Haines, 'The Eastern Turn in Contemporary German, Swiss and Austrian
 Literature', *Debatte*, 16 (2008), 2, 135–49.
22 http://nobelprize.org/nobel_prizes/literature/laureates/1961/press.html, date
 accessed 6 November 2008.
23 See http://www.nichtlustig.de/toondb/080604.html, date accessed 9 January
 2009.

Identity, Irony and Denial: Navid Kermani's *Kurzmitteilung*

JIM JORDAN

Inevitably, and often misleadingly, migrant writers and those with diasporic backgrounds are frequently positioned by critics, commentators and academics primarily in relation to their ethnicity. Some respond by accepting this 'burden of representation', and seek to navigate as constructively as they can between 'host' and 'migrant' cultures: Rafik Schami, for example, embraces his role as cultural mediator between German society and the Middle East; Yüksel Pazarkaya has performed a similar intermediary role between Germany and Turkey. Others, such as the bestselling crime and thriller author Akif Pirinçci, refuse to accept any role for ethnicity in their work, asserting their right to be considered solely in relation to the German mainstream. Recently, Tom Cheesman identified two further modes of response.[1] The strategy of parodic ethnicisation takes the proclivity to assign labels and deflates it in its own terms, for example in the satirical work of Osman Engin[2] or in the exaggerated self-ascription of the label 'Kanak(e)' by Feridun Zaimoğlu in his works from the 1990s.[3] The other approach identified by Cheesman is the linking of the local/national with the global (glocalism), for example in Kemal Kurt's millennial romp *Ja, sagt Molly*.[4]

1 Tom Cheesman, 'Juggling Burdens of Representation: Black, Red, Gold and Turquoise', *German Life and Letters*, 59 (2006), 4, 471–87.
2 Osman Engin, *Alle Dackel umsonst gebissen* (Berlin: TÜ-DE, 1989) or *Kanaken-Gandhi. Roman* (Berlin: Espresso, 1998).
3 The most notable of these is of course *Kanak Sprak. 24 Mißtöne vom Rande der Gesellschaft* (Berlin: Rotbuch, 1995).
4 Kemal Kurt, *Ja, sagt Molly* (Berlin: Hitit, 1998).

The debate on the representative role (or not) of the diasporic writer arose from questions of discrimination and racism, of the extent of cultural openness of a society which had indeed seen population and culture transfers, but all within a broadly central European framework. Should the diasporic writer be the mouthpiece of social criticism on the part of migrants? Or should their role be to mediate their culture of origin to German society, build intercultural bridges, file away the snaggy bits of cultural interaction? Since 11 September 2001, this debate has taken on a new dimension, extending to a whole range of further questions. To what extent are the practices of Islam compatible with the expectations of liberal secular societies? Who speaks for Islam?[5] How widespread is Islamic fundamentalism, and its terrorist arm? Where do the real loyalties of Muslims lie: to the nations in which they live, and for the most part are citizens of, or to the *umma*, the supra-national collective of Muslim believers?

With some specific and notable exceptions, 9/11 is marked in fictional works of literature not so much by its representation as by its absence. The reasons for this are often complex, and vary from case to case. For some writers, 9/11 was an event which for one reason or another failed to impinge directly on their lives or their sphere of cultural activity. Some have rejected the inauthenticity of writing about concerns in which they have little personal experience, while others resist the imposition of political priorities on their literary development. While writers may well respond – or be called on to respond – to political events in their immediate aftermath, the representation in their works of these events and the issues they give rise to tends to follow at some distance. Indeed, some may not even know themselves how to acknowledge such events in their work. Yet one group of writers stands in a significant relationship to the events of 9/11. Diasporic writers have re-emerged as convenient mediators to a public which fails to grasp why such events have been visited on them. And, just

5 See Amartya Sen's arguments against treating 'Islam' as one religious-ethnic bloc irrespective of differences such as nationality, gender, generation and location in *Identity and Violence. The Illusion of Destiny* (New York, London: W. W. Norton, 2007).

like the communities they have come once more to represent, these writers feel the backlash of such events in increased hostility, suspicion, incomprehension and rejection.

One way of confirming the profound effect which 9/11 has had on political, intellectual and cultural life in Germany is to examine the sheer number of public debates which have taken place since and which have been sparked by, among other things: tensions both within the Muslim community and between it and majority German society; questions of artistic freedom and its relationship both to religious sensitivities and liberal rights such as freedom of speech; issues concerning the place and rights of women in society; nationalist and ideological sensitivities; integration and exclusion. Before coming to my discussion of Navid Kermani's short novel *Kurzmitteilung*, I shall try to give a brief and selective overview of the debates concerning terrorism, Islam and integration which took place in the German media during 2005 and 2006, the period of the work's inception and writing.[6] This overview will be helpful in examining the novel's central figure, Dariusch.

The caricatures of the prophet Mohammed published in the Danish newspaper *Jyllands-Posten* in September 2005 and the images of the enraged response of Muslims both in Europe and globally gave rise to debates in Germany as elsewhere, heightened in this case by the historical sensitivities in German society to suggestions of curtailment of freedom of expression and of effective self-censorship by the press in the face of (in this case) religious pressure. The issue came closer to home with the cancellation of the run of the opera *Idomeneo* in Berlin by the *Deutsche Oper* in September 2006, on the basis that a scene featuring the severed heads of, amongst others, Jesus Christ and Mohammed would be likely to give rise to violent protest. Feridun Zaimoğlu's response to what he saw as the inauthentic polarisation of the debate was characteristically robust:

6 Navid Kermani, *Kurzmitteilung* (Zurich: Ammann, 2006). Referred to in the following as *KM*. Hereafter references will be given in brackets in the text following quotations.

Papperlapapp. Was ich in diesem Deutschland, meinem Mutterland, gelernt habe, ist: Dass man bitte, bitte, bitte die Bodenhaftung nicht verlieren darf. Ich sehe im Grunde auf der einen Seite die üblichen Verdächtigen, die nur einen Grund suchen, um schon wieder beleidigt zu sein. Und auf der anderen Seite sehe ich die Aufklärungsspießer, die es ja sehr einfach haben und nun erklären, man sei vor den Islamisten in die Knie gegangen. Das ist doch Humbug.[7]

The plans for large mosques in Berlin and Cologne provoked both outcry from those who saw this as part of the 'stille Islamierung' of Germany and from others who viewed this as a step towards religious equality and the normalisation of the Muslim presence in Germany. The German-Iranian author and Islam specialist Navid Kermani, himself a resident of Cologne, intervened several times in the debate, emphasising that the media's concentration on the comments of Ralph Giordano – to the effect that the building of the mosque in Cologne would be the first step in the creation of a parallel society – were unrepresentative of the high levels of tolerance, common sense and support for religious rights shown at well-attended public meetings on the issue.

It was partly the controversy about converts which initiated Wolfgang Schäuble's German Islam Conference at the Chancellery in Berlin in September 2006. Schäuble invited amongst others Kermani, describing him as a formative participant in the debate on Islam. In an interview the day before the conference in *Der Spiegel*, Kermani argued against any group-specific legislative conditions for Muslims.[8] On the same day in *Die Zeit*, the sociologist Necla Kelek was calling for moderate Muslims to distance themselves from extremists, and for the application of basic liberal rights to all, especially children, who should not be compelled to wear the headscarf and had a right to a normal childhood. The Islam Conference was also in part a by-product of the first integration summit in July 2006, which sought to establish the contours of a national plan for integration. One year later, a second integration summit, boycotted by a small number of

7 'Interview mit Feridun Zaimoğlu', *Der Spiegel*, 27 September 2006.
8 'Interview mit Navid Kermani', *Der Spiegel*, 26 September 2006.

Turkish associations in protest at changes to the *Ausländergesetze*, approved a plan with over 400 separate action points.

It has been a consistent strategy in the public interventions by diasporic writers to resist the assumption that problems arising from the presence and integration of foreigners are either not a German problem or are some kind of imposition from outside. Kermani has insisted, 'die westeuropäische Debatte über den Islam ist eigentlich eine Debatte über Europa'.[9] A debate on the nature of German identity is being overlaid by discussions about the foreign presence. The impression the media projects that the foreign presence is giving rise to widespread serious problems, he argues, does not reflect the fact that integration is taking place successfully in Germany day by day.

The recent prominence of migrant writers amongst those commenting on these events is perhaps unsurprising, given the publication in September 2006 of a study commissioned by the Berlin *Integrationsbeauftragter*, concluding that only two percent of journalists active in the Federal Republic were from a migrant background. I believe we have seen the emergence of a new porousness between (literary) writer and (journalistic) commentator. This had always been classically represented by Zafer Şenocak in his numerous newspaper columns and collections of essays, but he is, as we have seen, now joined by Kermani. This is, in my view, a promising normalisation of diasporic writers, who now fit the established role of German writers as public intellectuals and political interventionists. It also brings German-language diasporic writers into alignment with their counterparts in other countries, for example in France where *beur* writers regularly comment on social and political topics, and the UK where writers such as Hanif Kureishi or Zadie Smith regularly feature as media talking heads, particularly on issues such as Islam, migration and integration.

But, to mix my metaphors woefully, these talking heads are operating in shifting sands. In discussions on integration – and the key issue of Islam in Western societies – strange constellations have formed which transgress

9 Navid Kermani, 'Wer ist wir? Die europäische Debatte über den Islam ist eigentlich eine Debatte über Europa', *Süddeutsche Zeitung*, 7 December 2007.

and re-draw previously accepted political divides. Feminist support for the rights of women – in particular Muslims – sits often uneasily with the Left's traditional support for migrants and their communities. The operation of Islamic law in Iran and Afghanistan often brings liberals into alignment with right-wing forces keen to pursue ever further the 'war on terror' and the blanket imposition of western democratic political models in the Middle East and Asia. The list of contradictions is long, but its importance lies in the difficulty it poses for diasporic writers in navigating controversies and avoiding often wilful misunderstandings or misrepresentations of their positions.

In *Kurzmitteilung*, the text I shall now discuss, Navid Kermani does not avoid controversial issues, but neither does he deliver pat answers. He aligns himself with writers who, risking their own marginalisation for being 'difficult', nudge the reader towards critical self-reflection and an engagement with uncomfortable issues. In his fiction, Kermani problematises the issues he commentates so eloquently and analytically in his journalistic and non-fictional work. I shall argue that in *Kurzmitteilung*, he opens up another strategy which I shall call 'ironic denial'; that is to say, he establishes a fictional central character who, through denial of the problems surrounding his own ethnicity, collapses into a crisis through which the author is able to open up new avenues of exploration and address issues present but unarticulated surrounding the position of second-generation migrants in German society.

Kermani, born in Siegen in 1967 of Iranian parents, made his name initially as an orientalist and expert on Islam, publishing a range of books on Islam and Middle Eastern politics. This led to several literary works – including the fascinating *Das Buch der von Neil Young Getöteten* (2002) – and ultimately to *Kurzmitteilung*, his first novel. He is also involved in theatre in Cologne and in publicity work, and this link provides the stimulus for the novel: on 8 July 2005 his theatre colleague and renowned actress Claudia Fenner, to whom the book is dedicated, died unexpectedly at the age of forty-one of a cerebral haemorrhage. The date of Fenner's death coincides significantly with the bomb attacks in London on 7 July 2005 carried out by second-generation British Muslim extremists.

The novel follows the fortunes of Dariusch, a second-generation German-Iranian, a publicist who organises high-profile celebratory events for businesses and the wealthy. He is apparently successful, widely networked, fully up to speed with the latest means of communication. Yet, as the novel unfolds, he reveals himself to be in deep denial regarding his own ethnicity and painfully aware of his own non-integration into 'German' society, though unable to admit it to himself. He is commissioned by Ford AG in Cologne to organise the farewell celebration for its dynamic fictional American chairman Patrick Boger. Maike Anfang, one of the Ford colleagues Dariusch liaises with, and whom he knows only fleetingly, dies suddenly and unexpectedly. Pretending much closer acquaintance than was actually the case, he inveigles himself into the confidence of her family and participates in their grief, despite his confusion as to the authenticity of his feelings. Fearing exposure at her funeral, he seeks redemption and belonging in the US-based personality cult founded by Boger.

The deeply complex Dariusch is at the nodal point of many networks and interconnections: his flat is in Cologne, his second home in Catalonia; he commutes between them through France; he stands on the axis between Germany and Iran, between nationality and ancestry. Though entangled in so many networks, both personal and professional, he is central to none, constantly seeking to define himself in relation to something or somebody else. His career is secondary, insubstantial, parasitic, and attunes him to the finest external nuances of social forms, appearance and dress – 'Auf den Stil zu achten gehört zu meinem Beruf' (*KM*, 40) – without him achieving any substantial knowledge or understanding of those around him.

Among his most deeply unlovable traits is his outrageous sexism. His approach to most women is restricted to his assessment of his chances of persuading them to sleep with him. He divides them into targets for sexual conquest and candidates for the mother of his children.[10] His sexual

10 Dariusch is a prime example of the concept of 'autistic masculinity' outlined by Roger Horrocks in *Male Myths and Icons. Masculinity in Popular Culture* (Basingstoke: Macmillan, 1995) and *An Introduction to the Study of Sexuality* (London: Macmillan, 1997).

confusion is only a part, though, of a broader emotional and social dys-functionality and dissociation. His febrile obsession with communication technologies – mobile phones, laptops, the internet – is part of a reflex strategy to mediate contact with others, so that he can reflect and position himself before he responds: 'Gefühle hatte ich genug für den Abend gesimst. Es war 0:23 Uhr'. (*KM*, 46) The interrupted signal of his mobile phone on the TGV becomes a metaphor for the disjunctures in his attempts to communicate with others and to connect with his feelings. Uncertain of these feelings and of what is permissible and expected, Dariusch 'reads' others, anticipating and interpreting, and aligning his overt reactions to accord with mood and the expectations of others.

At times, Dariusch comes tantalisingly close to a recognition of his feelings and the contradictions they give rise to, but Kermani snatches away the prospect at the last moment. Considering his inappropriate and inau-thentic self-invitation into the grief of Maike Anfang's family, he muses: 'Ich hatte mich wie ein Eindringling gefühlt, wie in einer Intimität, die ich nicht verdiente'. (*KM*, 64) The 'wie' of course speaks volumes. As he flees the unmasking of his insincerity which would almost certainly ensue at Maike Anfang's funeral, he comes closest to self-awareness when he pleads 'Ich will nicht so sein'. (*KM*, 139) He recognises his callous and exploitative treatment of his Iranian former girlfriend Natascha, when he has unpro-tected sex with her and risks a pregnancy he is completely unprepared for. Yet his emphasis is not on the consequences for Natascha, but on how close he came to becoming trapped in a commitment which he was not equipped to service: 'Allein, dieser bloße Akt, ein Kind haben zu wollen, egal wie, nur um rauszukommen aus meinem verfickten Leben, rauszukommen aus all dem Scheiß, war nicht vertretbar'. (*KM*, 140)

The tragic circumstances of the novel's inception and Dariusch's morbid fascination with the banal practicalities of death have led some reviewers to interpret the novel as a meditation on mortality.[11] On this view, Maike

11 Good examples of this are Wolfram Schütte's online review of the text at http://
 www.titel-magazin.de/modules.php?op=modload&name=News&file=article&s
 id=5505&newlang=deu, date accessed 22 September 2007, and Oliver Fink, 'Die

Anfang's premature death becomes an opportunity for Dariusch to search for meaning in the superficiality of his life. This universalist interpretation seems to me to be deeply problematical, because it overlooks the multitude of strategically placed references to Dariusch's ethnicity, nationality, cultural and religious identities. In some reviews, these aspects have been almost entirely overlooked or intentionally de-emphasised in a manner reminiscent of universalist interpretations of Camus's *L'étranger* before Edward Said's seminal post-colonial re-interpretation of the text.[12] Previous existential-ist interpretations had disregarded the murder of an Algerian by a French *pied-noir* in French colonial Algeria in favour of examining the quest for personal meaning undertaken by the protagonist Meursault.

Dariusch is not shy of exploiting his 'Oriental' background to his commercial advantage, and in pursuit of this he perpetuates uncertainty about the precise nature of his ethnic antecedents. In unreflected moments, however, he admits: 'Überhaupt hat mich die iranische Herkunft einen Scheiß geprägt'. (*KM*, 91) Yet his parents seem even more Europeanised than him, and eager to jettison their links with Iran, reflecting the gener-ally assimilationist attitudes of first-generation migrants. Paradoxically, this seems to drive Dariusch nonetheless to assert or even create some link with Iran, for example by learning Persian. Here, too, though, his confu-sion becomes apparent: 'Der Persischkurs an der Volkshochschule genügte als Ausrede, um mich weiterhin mit etwas anderem als Deutschland zu identifizieren'. (*KM*, 48)

Dariusch is deeply confused about his relationship to his Iranian back-ground and this is mirrored by his attitude to his German citizenship, which he must at some stage have actively acquired.[13] While he occasion-ally refers to himself as German – 'ein Deutscher in meinem Alter' (*KM*,

Verwandlung' (www.fr-online.de/_inc/_globals/print.php?sid=41fbecc1eae8380
6ee292518185, date accessed 5 September 2007.

12 Edward Said, *Culture and Imperialism* (London: Vintage, 1993), 204–24.

13 Despite being born in Germany, Dariusch would have been required to apply for
 German citizenship, as the *ius soli* did not apply in the Federal Republic at the time
 of his birth. This principle has conditional validity in Germany since the reform of
 the citizenship laws instituted in 2000.

25) – he more frequently describes others as German, as though this were a category distinct from himself ('ein hochgewachsener Deutscher' (*KM*, 82)). His attitude towards his German co-citizens betrays disinclination and contempt: he describes the reactions of Maike Anfang's mother as 'stockdeutsch' (*KM*, 91) and he speculates that cuts to his budget for Patrick Boger's leaving celebration are down to 'so ein scheißdeutscher Beamtenfuzzi'. (*KM*, 82) In a rare moment of apparent honesty, he admits to his lack of connection with German-ness: 'Bier trinke ich deutsch, die einzige Regung meines Deutschtums, bevorzugt allerdings Kölsch, weil der Lokalpatriotismus immer überwiegt'. (*KM*, 46) Thus, it would appear, the connection at a local level provides a territorial identification which the more problematical national connection cannot.

Equally contradictory is Dariusch's attitude towards Islam, the faith in which he was at least nominally brought up, and which he no longer practises. In moments of stress, confusion or adversity he recites to himself the Fatiha, the first Sure of the Koran: 'Es hat nichts mit Frömmigkeit zu tun. Die arabischen Verse liegen gut auf meinen Lippen und helfen mir über die Sekunden hinweg, in denen ich nicht weiß, was ich tun oder denken soll'. (*KM*, 18–19) Thus Islam offers a potential framework to guide his actions, given that he seems unable to generate any principles of his own; but this is a reliance on, rather than a critical engagement with the religion, and the fact that he only recites – perhaps is only able to recite – the first Sure indicates clearly the superficiality of his knowledge and allegiance to Islam. This does not prevent him, however, from pouring scorn on his sister Minu's allegiance to Sufism 'als Onanie für linkssozialisierte Rassisten, die nichts gegen Muslime haben wollen, sondern nur etwas gegen den Fundamentalismus'. (*KM*, 100)

Sufism is one of the areas of Kermani's expertise, and this mock self-deflation is a key pointer to how the novel should be read. While it broaches serious and far-reaching issues, it is ultimately a work of fiction rather than one of the commentaries which Kermani more frequently writes.[14] I

14 Cf. Jörg Magenau's discussion of Dariusch as a 'Doppelgestalt' in his review of *Kurzmitteilung*, 'Gefühle hatte ich genug für den Abend gesimst. Ein Ekelpaket auf

would argue that this opens up a space, in which Kermani is at liberty to explore the contradictions faced by second-generation migrants without being obliged to explain or defend. The atypicality of the protagonist also pre-empts (even well-meaning) attempts to read off from Dariusch the mindset of the second generation as though this were some psycho-social case study. The ironic distance at which the book has both been written and requires to be read produces a work which is absorbing and entertaining without compromising its underlying seriousness.

His lack of commitment to Islam does not prevent Dariusch from using that too as a means of creating a niche profile for himself and of furthering his career. As he considers inviting a young female Turkish-German author to an Oriental multicultural festival he is organising in Baden-Württemberg he drifts associatively to anti-islamic attitudes in German society: 'Mich selbst widert die Hetze der Medien gegen den Islam so an, daß ich mir immer wieder ins Gedächtnis rufen muß, gar nicht besonders islamisch zu fühlen'. (*KM*, 47) In this way, the islamophobia of the media is shown to be counter-productive, as it evinces even amongst diffident Muslims a level of self-identification with Islam which is not sustained by them at other, less fraught times. In the case of Dariusch, Kermani leaves it delicately poised as to whether this is a reflex self-identification or an indication that Dariusch is in denial as to the real extent to which he is influenced by Islam.

The unresolved dichotomy in his attitude towards Islam is put under severe strain against the background of the terror attacks in London, references to which occur sporadically but insistently in the text. From the very beginning, he cannot engage with the attacks and their implications directly. As he is waiting to meet up with Maike Anfang's boyfriend, he is confronted by reports on the attacks in the local newspaper, but seeks constantly to interest himself in less important news stories – albeit unsuccessfully, as his attention is dragged back reluctantly to the lead story. When he sees reports on television, he switches off, but is plagued by the compulsion to

der Jagd nach Liebe: Navid Kermanis Roman *Kurzmitteilung*', *Süddeutsche Zeitung*, 2 April 2007.

switch on again and watch them. He is obliged to acknowledge the attacks, but struggles to avoid engaging with their implications.

Instead, he re-channels his anger, shame, frustration and fear into incoherent outbursts against the bombers, militant Islam and Western attitudes. He puts down the bombers' activities to sexual frustration, in a neat sideswipe by Kermani against Richard Dawkins. He had poured scorn on the 9/11 bombers on account of their alleged belief that their act of martyrdom would entitle them to access to forty-two virgins in the hereafter. Dariusch describes the bombers as 'Arschlöcher', misled by their Mullahs, who equally deserve to be fucked. (Kermani has some fun here too with the radical Dutch-Somalian Islam critic Ayaan Hirsi Ali, whom he recommends for this task.) Dariusch is clearly afraid of being taken for a bomber on account of his appearance, strenuously emphasising that he is Iranian and not Arab – and 'nicht einmal Türke'. (*KM*, 126)

His fear of being implicated in co-responsibility on account of his upbringing, appearance and religion is balanced by incoherent rants against Western anti-Muslim attitudes and the failure of the West both to intervene in support of Muslims and its interference in the affairs of Islamic countries. Into these rants he mixes colonial oppression in general, repression of Black people and suspicions about the covert activities of the CIA. This is a potent mix of fear of commitment and an even greater fear of having a commitment thrust upon him which he has not chosen, which he sums up in the formulation 'daß die Welt voller Arschlöcher sei, […] die Araber, die sich in die Luft jagen, und die fetten Weißen, die uns deswegen alle für Araber halten'. (*KM*, 53) On the train fleeing from Maike Anfang's funeral, he confesses with unusual candidness: 'Ich bekomme den Dreck ja nicht aus meinem Kopf heraus'. (*KM*, 143)

We learn from an epistolary final chapter addressed to the charismatic captain of industry Patrick Boger that Dariusch returns to Cologne, falls under Boger's sway and, resolved to purify his life, goes to the headquarters of Boger's mystic cult in the US for moral and spiritual rehab which, he is convinced, has transformed him into a worthwhile human being. It is apparent, though, that he has merely repackaged his old traits and reflexes, using Boger's moral system in order both to distance himself from his previous existence and to lend spurious ethical legitimacy to his new

incarnation. Temporarily, he has managed to avoid his crisis of (insufficient) self-knowledge, arising from his lack of what we may call *Herkunftsbewäl-tigung*, the fundamental engagement of second-generation migrants with their ethnic, cultural and religious background.

The similarity of this term to *Vergangenheitsbewältigung* is intentional on my part. I believe that Kermani's novel is in part an exhortation to the second generation not to try to ignore real issues arising from their position and their family past, and that Dariusch is intended as a cautionary tale in this respect: his subscription to a vapid, materialist, postmodern, post-ethnic and post-political lifestyle is only a postponement of his personal day of reckoning. Kermani is reminiscent of post-war German critics such as Böll and Grass in his suggestion that a healthy future can only be based on an honest engagement with the past.

In no sense, though, does Kermani displace the responsibility for this coming to terms merely on to the second generation itself, nor does he exculpate German society and its inauthentic integration of migrants and their descendants. However, just as the strength and vitality of Dariusch as an individual has allowed reviewers to elide the ethnic dimension of the novel, Kermani's locking of horns with ethnic deniers, integration-ists and 'happy hybrids' inevitably de-emphasises the German dimension. Similarly, the questionability and partiality of Dariusch's perceptions del-egitimise and obscure any real experience of racism or rejection he may have experienced.

These caveats to one side, the novel is undoubtedly a highly original contribution to the literature produced by migrant and postmigrant writ-ers, combining seriousness of purpose with a delicious black humour. From the perspective of Germany's 'new citizens', Kermani addresses issues and faultlines in European discourse which are often either left undiscussed for fear of committing acts of political incorrectness or which, having been pent up, burst forth occasionally in startlingly racist polemics in the media. The novel sketches the contours of intolerance, illiberalism and racism from the musings of a deeply conflicted and tortured individual, whose ironic denial of the problems in his position in German society opens up a space for an unfettered airing of the issues confronted daily by those immersed in the reality of Europe's multicultural *Schlaraffenland*.

A Political 'Brief': Performativity and Politicians in Short Works of Austrian Satire

ALLYSON FIDDLER

The Brief

This essay approaches the theme of our volume by focusing on a particular aesthetic characteristic and a particular methodological idea. The primary texts addressed here are very short works of satire: short dramas, or 'dramolets', by Antonio Fian, and a comic book by Leo Lukas and Gerhard Haderer, genres of writing that are, arguably, not designed for *actual* performance. Dramolets are often conceived as resistant to, or at least ironically challenging towards the very notion of performing them. The discussion here will nevertheless use insights from performativity theory to offer a reading of these works as political, resistance writing. In particular, Fian's and Lukas/Gerhard's publications present an ironically deconstructed version of the late, right-wing, Austrian politician and controversial populist leader, Jörg Haider.

Acting Political

Theatre and Politics are frequent companions. Plays can enlist political themes as material to be memorialised, mimicked, travestied, or simply documented, and the results can range from comedy to tragedy. The *dramatis personae* can include fictional political characters or indeed characters named after real politicians, dead or alive. Alternatively, plays can reflect

– allegorically perhaps – a political situation (deliberately or inadvertently) and promote some kind of message or call to action. The reader or spectator is often indispensable in accomplishing or 'performing' this kind of reading by recognising the contemporary, socio-political allusions. For many theorists of performativity, the role of the viewer or reader is acknowledged as fundamental. Bert O. States draws on Mikel Dufrenne to illustrate this idea, noting that for the latter, 'a reader (of a novel or poetry) *becomes* the performer of the work and can "penetrate its meaning only by imagining the performance in his own way – in short, by being a performer, if only vicariously and in imagination"'.[1]

That contemporary politicians require acting skills as well as good oratory would seem to be confirmed by the successful politicians who had a previous career in film or stage acting. One thinks immediately of former U.S. President and erstwhile governor of California, Ronald Reagan, or indeed the current Austrian-American incumbent of that post, the 'governator', Arnold Schwarzenegger. There are fewer examples of politicians-turned-actors, but it is a career direction mooted by satirical commentators to counter the wave of conservative cultural policy reforms brought in as a result of Austria's 2000 government coalition between the People's Party (ÖVP) and the right-wing Freedom Party (FPÖ).[2] Dramatist Peter Turrini jibed that all the failed artists-turned-politicians were avenging themselves after 1999 on Austrian culture and artists.[3] As a way of countering this 'Turrini-Theorem', Rayk Wieland suggests diverting these 'Untalente' by offering them the chance to publish a slim volume of their poems or a little theatrical role. It is well known that when he was young Haider had wanted

1 Dufrenne quoted in Bert O. States, 'Performance as Metaphor', in *Performance. Critical Concepts in Literary and Cultural Studies*, ed. Philip Auslander, 4 vols (London: Routledge, 2003), vol. 1, 108–37 (117–18).

2 See the report by the European Institute for Comparative Cultural Research (ERICarts): Veronika Ratzenböck and Franz-Otto Hofecker, 'Austria', in *Compendium of Cultural Policies and Trends in Europe*, 9th edition (2008), at www.culturalpolicies. net/web/austria.php?aid=1, date accessed 20 October 2008.

3 Peter Turrini, 'Für Österreich', *Freitag*, 18 February 2000, www.freitag.de/2000/08/ 00081301.htm, date accessed 20 October 2008.

to become an actor, and so, Wieland urges, 'das Linzer Landestheater sollte sich nicht zu schade sein, Haider mit einer Offerte aus dem Landeshauptmannamt zu locken: ein kleiner Schritt für das Ensemble, ein großer Schritt für die Menschheit.'[4]

Fian: Performing Haider

Antonio Fian has penned many occasional newspaper pieces and published one novel, *Schratt*, but he is best known for his collections of 'dramolets'.[5] Veronika Doblhammer sees Fian as a most likely successor to compatriot Robert Neumann, whose short parodies of the 1920s played on the styles and themes of many of the cultural and literary figures of his day,[6] but Fian prefers to target his skill for mimickry at the utterances and actions of public figures. Literary and media figures are often the subject (or object) of Fian's dramolets,[7] but we are most interested here in protagonists who

4 Rayk Wieland, 'Die Welt als Wille zur Vorstellung', in *Braunbuch Österreich. Ein Nazi kommt selten allein*, ed. Hermann L. Gremliza (Hamburg: Konkret, 2000), 151–58 (152).

5 All published with Droschl: *Schratt* (Graz: Droschl, 1992), *Was bisher geschah. Dramolette 1* (1994), *Was seither geschah. Dramolette 2* (1998), *Alarm. Dramolette 3* (2002), and *Bohrende Fragen. Dramolette 4* (2007). The term 'dramolet' is adopted here to reflect Fian's own preference and because the English term, 'short drama', does not aptly suggest the very short length of Fian's pieces.

6 Veronika Doblhammer, 'Fian, Antonio: Die Welt als Dramolett', *Wiener Zeitung*, 25 March 2006, www.wienerzeitung.at/Desktopdefault.aspx?TabID=3946&Alias =WZO&lexikon=Auto&letter=A&cob=224965, date accessed 20 October 2008. In honour of Rhys Williams, see especially Neumann's parodies of Carl Sternheim ('Der neue Hamlet') and Dylan Thomas ('Othello unter dem Milchwald'), in *Die Parodien* (Vienna: Desch, 1962).

7 See Jacques Lajarrige, 'Antonio Fian als Satiriker der österreichischen Literaturszene', in *Österreich (1945–2000). Das Land der Satire*, ed. Jeanne Benay and Gerald Stieg (Berne: Peter Lang, 2002), 241–67.

are named after real-life politicians, not after literati or intellectuals. The intention is to examine how Fian's literary material performs these public personae, that is to say, how Fian's dramolets interact with utterances or political performances politicians have themselves made. Especial focus will be placed on how one of the writer's favourite targets, Jörg Haider, is realised as a fictional character. The following considers a number of trans-formations of politicians into what we might call materials for perform-ance by us as readers, 'works of literature, after all, are quasi-*speech-acts*; they require readers to give the substance of fully operative conventions to language that lacks it'.[8]

With the dramolets of Antonio Fian, it should be clear that we are not dealing with *pièces à clef*, since his are, for the most part, not evasively named characters who happen to bear resemblances to real people. In this sense, as Konstanze Fliedl describes, they 'savagely or mockingly negat[e] the self-referentiality of art'.[9] 'The polemical writer pays no heed to [...] discreet anonymity', she points out, '[...] from this perspective, the legal problem of the *roman* or *pièce à clef* is reversed, so that empirical persons become no more than the arbitrary appendages of their names, and it is the name that has gained the textual status of a unique character'. One of Fian's most explicit Haider satires is entitled 'Jörg Haider arbeitet an seiner Aschermittwochrede'.[10] The title alludes to the scandal following the speech that Haider made on Ash Wednesday 2001 in which he slandered Ariel Muzicant, the leader of Vienna's Jewish community, contriving a pun sug-gesting the irony of his first name's evocation of a washing powder, given his alleged 'dirty' practices in stirring up anti-Austrian sentiment abroad. Fian only rarely provides contextual, 'factual' information, but with this dramolet, the stage direction '*(Vorhang)*', is followed by a line or two of 'Material' in which he states the source for his reworking. This dramolet also bears an epigraph quotation from the ÖVP politician Andreas Khol

8 Sandy Petrey, *Speech Acts and Literary Theory* (New York: Routledge, 1990), 72.
9 Konstanze Fliedl, 'A Field Guide to Names in Literature: Notes on Austrian Onomastics', *Austrian Studies*, 15 (2007), 1, 155–68 (164).
10 Fian, *Alarm*, 64–67.

opining that he has never experienced Haider being directly anti-Semitic: 'er hat immer sorgfältig versucht, nie diesen Fehler zu machen'. (64) The action takes place in Haider's study and consists of Haider plus a chorus, working together on his forthcoming speech. The dialogue alternates between the chorus chanting ideas for the speech and Haider's reactions to these. The chorus's quick-fire litany of sugggested targets of blame, 'Musikante Sinti Roma/ Jud Zigeuner/ alle schuld' is met with ironic performances of what the epigraph has described as Haider's careful avoidance of mistakes: 'Haider: "Zu allgemein zu/ angreifbar zu wenig/ Sorgfalt … Lueger nein/ Ich anders / Sorgfalt ich und/ keine Fehler"'.[11] In referring to the performed words of Haider's actual, political speech and ironically mutating and *re-performing* these in fragmented quotations in his dramolet, Fian's writing enacts a satirical, literary and linguistic mirroring of Haider and his speechwriter Herbert Kickl's anti-Semitism. Jacques Lajarrige describes how this literary process enacts or is tantamount to a kind of literary trial: 'Was [Fians] […] Dramolette betrifft, erlauben sie durch den sie grundierenden Dialogismus eine aussagestarke *mise en abyme* ironisierender Redeweisen, wodurch die Betroffenen gleichsam vor Gericht erscheinen'.[12]

In Fian's 'Der Einbruch des Akrostichons in die österreichische politische Kultur. Ein Ausblick', it is the FPÖ politician Reinhard Gaugg and his manner of speaking who stand trial. The former deputy-mayor of Klagenfurt's infamous 1993 interview answer to the question 'Was sagt Ihnen das Wort "Nazi"?' was 'neu, attraktiv, zielstrebig, ideenreich'. The dramolet features a membership candidate presenting himself at a political party headquarters, and it is the applicant's dialect rendition of various personal mnemonics from which the humour primarily derives. Most of his answers are to the interviewer's satisfaction even with the candidate's poor spelling (for example, 'Sozi' – 'solche Orschlecha zertritt i'), and the interview performance is deemed 'exzellent'. Despite applauding his innovative renditions

11 Fian, *Alarm*, 65. Karl Lueger was the anti-Semitic mayor of Vienna 1897–1910.
12 Lajarrige, 266.

of such acronyms as 'Wiener' and 'Busek',[13] the interviewer nevertheless rejects the applicant for his anti-democratic views and reminds him of the party's motto, 'Demokratiefeindlichkeit ist keinesfalls tolerierbar, alles Trachten unserer Republik!'.[14] After the applicant has left the room, the interviewer rings up party headquarters to pass on a great new suggestion for 'Busek', thus underscoring the hypocrisy of his supposed political correctness and pro-democracy stance.

The recorded, live reading of this piece lends more weight to the idea that these dramolets are conceived with what might be termed an epistemology of writing/reading in mind and are not primarily designed for physical performance. The audience does not pick up – at least not audibly – on the ironic implications of the unstated central acrostic of the party motto, which spells out 'D-i-k-t-a-t-u-r'.[15] Similar to the micro-dramas of Wolfgang Bauer, Fian's texts often contain lengthy passages of stage directions – a device more for the pleasure of the reader than for the irritation of the director. In the 'Akrostichon' dramolet, the stage directions describe not only the office with its 'altdeutsche Möblierung' and bright blue walls, but also state: 'aus Windmaschinen frischer Wind'. Stage props could include a wind generator (as opposed to a simple office fan), and the spectator might make some kind of connection, but unless the dramaturge or director stages this in a surreal fashion, perhaps with a banner stating 'frischer Wind' streaming from the machine, then the theatre audience would not pick up on Fian's reference to the self-styled, 'new era' or fresh atmosphere that this party is purporting to be bringing about.[16]

13 Erhard Busek (ÖVP) was Vice-Chancellor of Austria and ÖVP Chairman 1991–1995.
14 Fian, 'Der Einbruch des Akrostichons in die österreichische politische Kultur. Ein Ausblick', in *Was bisher geschah*, 116–17.
15 Fian's own public reading of this can be listened to on the compact disk *Café Promenade* (Graz: Droschl, 2004).
16 On Fian's stage directions, see Franz Haas, 'Die Komik und die Kürze in den Texten von Antonio Fian', in *Komik in der österreichischen Literatur*, ed. Wendelin Schmidt-Dengler, Johann Sonnleitner and Klaus Zeyringer (Berlin: Erich Schmidt, 1996), 300–8 (304).

In the tradition of Austrian satirical drama, be it by Nestroy, Kraus, Horváth, or Jelinek, this dramatist's aesthetic antennae are tuned to investigate and stage anew revealing language or discourse phenomena. In the example just cited, Fian plays with the acronym; in 'Rilke bei Schüssel' he has Chancellor Schüssel speak to Rilke in verse. Rilke has been summoned to help the Chancellor in convincing the people how good their lot is as Schüssel knows that a great poet is the man to help him. Weaknesses and inabilities in German grammar, a favourite Fian device, are used to comic effect as Rilke's famous lines are interrupted twice. Rilke has to persist to finish his line ('Denn Armut ist ein großer Glanz aus innen'),[17] as each time he says 'denn', Schüssel interrupts to point out that it is '*die* Armut, Rilke, Armut immer Femininum!'. (121) In 'Alarmist und Besonnener. (Einübung in die Normalität)', the propagandistic coinage 'umvolken', to describe the influx of immigrants, or being 'swamped' by immigrants, is ridiculed not by a protracted discussion of the facts or otherwise of the situation, but perhaps more acutely, by highlighting the difficulty of conjugating such a ludicrous verb. 'Der Zweite' asks, 'Und mit wem soll man diskutieren? ... Ob das P.P.P. von "umvolken" "umgevolkt" heißt oder "umvolkt"?'.[18]

Haderer/Lukas: Cartooning Haider

Racial tension is also a theme in the best-selling comic book entitled *Jörgi, der Drachentöter* by cartoonist and writer, Gerhard Haderer, and writer and cabarettist, Leo Lukas. Within months of its publication in 2000, it had sold more than 40,000 copies and been reprinted. The publishers specify

17 Fian, 'Rilke bei Schüssel', in *Bohrende Fragen*, 120–22 (121).
18 Fian, 'Alarmist und Besonnener (Einübung in die Normalität)', in Fian, *Bohrende Fragen*, 68–70 (68).

the genre as 'ein Bilderbuch für Kinder und Erwachsene',[19] but, as Kazi
Stastna points out, 'oddly enough, it appeared in the non-fiction rather
than the fiction category, alongside [...] *Forever Young – Das Ernährungs-
programm*'. Lukas reportedly saw this as a deliberate ploy to 'keep the book
from having to be described as a "No. 1 Bestseller", seeing as non-fiction
works sell many more copies than fiction'.[20]

Conceived along the lines of a light-hearted medieval tale, the nar-
rative transmits a humorous, but fairly generic moral account of the rise
and fall of an ambitious and power-seeking individual, complete with his
deposal from the throne and recuperation into the fabric of the community
as a future trainee chef in the castle kitchens. In purely textual-linguistic
terms, the reader would be at least slightly stretched to read it as a political
allegory with specific, Austrian reference, since the only named character is
the young protagonist and would-be dragon-slayer, 'Jörgi'. (Haider's given
name is most convenient, given that George/Jörg is the original dragon-
slayer name, at least in Christian tradition.)[21] True to the expected, for-
mulaic pattern, the other characters are merely given type-markers, 'Der
Prinz', 'Der König', 'Der Nachtwächter', 'Der Hofnarr'. There is, however,
also 'Der Chinese', whose food is much better than the inn-keeper's, as
the latter himself admits. Xenophobia becomes one of the cornerstones
of Jörgi's campaign to persuade the community to side with him in trying
to depose the Dragon-King who rules somewhat ineptly but peacefully
over their hitherto sleepy community. Jörgi even tries to persuade the
night watchman that it is predominantly because of the dangerous Chinese
population that he has to stand guard every night.

19 Gerhard Haderer and Leo Lukas, *Jörgi, der Drachentöter* (Vienna: Ueberreuter,
 2000).
20 Kazi Stastna, 'Jörgi, the Dragon Slayer', *Central Europe Review*, vol. 3, no. 10 (12
 March 2001), at www.pecina.cz/files/www.ce-review.org/01/10/books10_stastna.
 html, date accessed 20 October 2008.
21 The dragon-slayer narrative is ubiquitous, assuming a 'master type' position in Propp's
 morphology of folk tales. See Üto Valk's entry on 'Monogenesis', in *The Greenwood
 Encyclopedia of Folktales and Fairy Tales*, ed. Donald Haase, 3 vols (Westport,
 Greenwood, 2008), vol. 2, 636.

There is much pleasure to be gained for the junior reader of this book (aged six and above according to the publishers' blurb), and young people will enjoy the charming and hilarious pictorial detail as well as the mixture of contemporary vernacular and archaic language, but the illustrations are, in the way of much cartoon work, the primary source of *specific*, satirical reading for the adult readers. In interacting with this book, then, adult readers must recognise pictorial codes or signs and successfully identify the real-life models upon which the personal features of the protagonists are based, in order to perform their reading as a specific satire on Austria and not simply a more generic parable about greed and racism.[22] Haderer's pictures present a linguistic and physically diminutive Jörg[i] Haider as budding dragon-slayer; the prince in the likeness of the then Chancellor, Wolfgang Schüssel (ÖVP), the princess as Heide Schmidt (formerly FPÖ, then a founder member of the 1993 breakaway party Liberales Forum); the latter's lady-in-waiting as Susanne Riess-Passer (Haider's successor as FPÖ Party Chair, 2000–2002, and Vice-Chancellor of Austria 2000–2003), and court chaplain, Kurt Krenn (former Bishop of St Pölten).

After the young rabble-rouser first manufactures unrest and mobilises this in his quest to become king, he too, like the King and the Prince before him, begins to grow dragon features. And all become unhappy, downtrodden and poor in the new strife-ridden atmosphere of the village. The king's men are seen suppressing any signs of resistance in the community, and the Chinese restaurateur is packing up his belongings to leave. As in Fian's work, grammatical and linguistic competence is a highly charged signifier here, too, and in the graphic novel and comic genre more broadly. In this graphic novel, complicated protestations are written correctly and the accomplishment is imputed to the cartoon characters. Thus, the 'Widerstand' banner is spelled correctly, as is the placard, 'Frieden schaffen ohne Waffen'. 'Drachen, nein Danke!' nods comically to famous eco-campaigns

22 The book is suggested as material for use in teaching German, in particular for its theme of 'Öffnung zur Außenwelt', in Thérèse Behrouz, 'Der Einsatz von Bilderbüchern im Deutschunterricht', www.fba.uu.se/spraktradgard/ty/tyska611.pdf, 19, date accessed 20 October 2008.

of the past and DRACHE, with a crossed-out 'D' to foster revenge, sug-
gests a degree of political marketing and language intelligence amongst the
protesters. The misspellings of the racist graffiti, however: 'Wek mit denen
Kinesen!' and 'Tödet dem Trachen!' suggest ignorance and impression-
ability, while the infantile denigrations of Jörgi's inner thoughts perform
a double meaning in the book. Yes, Jörgi is a young boy, whose dreams
are not to become 'Schuster', 'Schneider', or 'Lokomotivführerin' like the
other boys and girls but 'Drachentöter', and one might *expect* a young lad
to exclaim 'Weichei!' or even 'Schlappschwanz!' when he at first fails to
persuade others to join in with him. On the other hand, the character is
drawn as an *adult* resemblance of Jörg Haider, but with a diminutive stature.
The words thus also become less a realist device and more a performative
marker of immaturity and wrong-headedness.

The materiality of the comic book and its layout of words and pictures
provides a useful key to the genre's performative force. Ole Frahm draws
attention to the 'precarious, different appearance of the words in comics.
[...] They are not spoken but exposed in their materiality throughout the
graphic space of the page. [...] The words are not utterances by somebody
but material enunciations.'[23] If, following Bert O. States, a framing device
is necessary to 'create the sense of restored behavior – and hence a per-
formance – that is somehow separated from normal empirical behavior',
then perhaps we may see cartoonist-text writers as the quintessential per-
formers of texts, in their entrapment of utterances. The cartoon places the
text within a frame within a frame, applying a graphic *mise-en-abyme* on
a bordered page within the borders of a text box or a speech bubble. This
contributes, moreover, to the sense that Haderer and Lukas's book is not
so much a book about Jörg Haider as a book about Haider-like behaviour
and political scenarios, texts, in a sense that can be 'performed' by other
power-hungry individuals. Readers performing the combination of text and
image in their own minds are perhaps helped to 'de-demonise[]' Haider as

23 Ole Frahm, 'Too much is too much. The never innocent laughter of the Comics',
 Image & Narrative, 3 (October 2003), www.imageandnarrative.be/graphicnovel/
 olefrahm.htm, date accessed 20 October 2008.

Haderer was when drawing these images. Lukas emphasises the archetypal qualities of the book, claiming: 'Everywhere on the planet, Haider, and his many brothers (and a few sisters), are so alluring, because they appeal to the Jörg-like in very many people'.[24]

Reviewers of *Jörgi der Drachentöter* rejoice in the possibilities of him enjoying 'less destructive undertakings' and in the suggestions that 'in the end no one really needs leaders like him'.[25] After the villagers have had their moment of political epiphany and thrown away the crown and throne, the symbols of absolute power, the previously bestial Jörgi-King now becomes redeemed, one might say, and sheds his dragon form to assume a human body once more. Initially disappointed or perhaps surprised, rather, to see apprentice Jörgi cooking simple, 'German' fare (sausages), I was pleased to see the Chinese chef standing behind little Jörg and smiling at his culinary progress (although a wok and some noodles might have been a nice touch). Then I re-performed my visual reading of the book and delighted in the floating sausage signifier featuring on most of the book's pages (observant readers will notice its presence somewhere in close proximity to Jörgi each time he is depicted). Then the penny dropped: 'Es geht um die Wurst'! It is crunch time for Jörg [Haider] (and for Austrian politics). Jörgi looks contemplatively towards the sausage on the very sparse, penultimate page, before answering the question, 'Na, was willst du denn werden?'. The final illustration sees Jörgi successfully cooking, 'that elusive sausage in its proper place – that is, in the pot',[26] but adding to it what looks like a pinch of salt. Does the reader see this as Haderer and Lukas adding a metafictional caveat (this is art, not real life), or perhaps as the artists' loaded warning that something may still be cooking up? It is tempting to conclude, in the manner of a German pop song, 'Alles hat ein Ende, nur die Wurst hat zwei'.[27] Exactly what plan might Jörgi be cooking up? Political analysts and

24 Haderer and Lukas both cited in Stastna, n.p.

25 Rassi, Barbara, Review of Haderer, Gerhard and Leo Lukas (2000) *Jörgi, der Drachentöter*, in *Rethinking History. The Journal of Theory and Practice*, 6 (2002), 3, 365–67 (367).

26 Stastna, n.p.

27 Stephan Remmler, 'Alles hat ein Ende, nur die Wurst hat zwei' (1986).

the public alike speculated at great length when in 2000 Jörg Haider chose to stand down as leader of the highly successful FPÖ, allowing his deputy, Susanne Riess-Passer, to take over and consequently to adopt the office of Vice-Chancellor of Austria, preferring instead to withdraw to Carinthia and concentrate on politics in the provinces. More recently, Haider's return to the chairmanship of his breakaway party, *Bündnis Zukunft Österreich* (BZÖ) and the party's marked success in the *Nationalratswahl* of September 2008, sparked speculation as to a possible renewed higher-profile role for the controversial politician.

Another culinary illustration from *Jörgi, der Drachentöter* allows us to posit a more positive closure to the medieval fairy tale. A bunch of red radishes also features throughout the slim book, drawn as a crest on a knight's helmet. Kept whole until the final illustration, here they are sliced up to add into the meal preparation. It is tempting to see much more than a random piece of cooking in the choice of this ingredient. In the Middle Ages, the radish apparently had a 'predominantly negative symbolic meaning as a symbol of quarrel and strife. Because the radish [...] was said to be related to evil spirits, radishes [...] were sometimes consecrated, that is, rendered harmless'.[28] The radish picture can be read linguistically-etymologically, too, and not just as a visual symbol. The word comes from the Latin, 'radicem' or 'radix', meaning root. The related terms 'eradicate' and 'root out' are entirely relevant to the political message of the book, it would seem, at least to this reader-performer: the radishes have been chopped, xenophobia has been eradicated and radicalism (also etymologically related) has been deflected.

28 Udo Becker, *The Continuum Encyclopedia of Symbols*, trans. Lance W. Garmer (London: Continuum, 1994), 243.

In Short

The above examination does not attempt to adjudicate between the satirical art forms discussed here or determine which of these short works captures better the 'true' nature or political message of politicians' statements, nor indeed will an examination of art forms allow us to discover the 'true' identity of any given politician. Both Fian's and Haderer and Lukas's publications perform or encourage their readers to perform a comical version of the politician Jörg Haider and in so doing ask questions about the motivation behind his political agendas. It is not the 'real' Jörg Haider, then, that is our subject matter here, but instead a number of short artistic fictionalisations or literary enactments of him or his utterances.

In taking issue with the conception of performativity advanced by Erving Gofman, Kevin Hetherington argues that 'the main limitation of Gofman's work ... is that ... the dramaturgical references are often used metaphorically in order to suggest that, although people do assume personae and roles and take part in performances, there is a real and inaccessible self existing outside such practices – the real identity of the "I"'.[29] Nowhere more so than in the field of politics does the quest for straight talk and sincerity seem to demand such a unitary correlation between public persona and 'real' person. Political philosopher Elizabeth Markovits cautions, however, against the assumption of such sincerity, arguing, with Hannah Arendt, against trying to root out hypocrisy:

> Arendt claims it is actually impossible to disclose one's innermost motives, mostly because they also remain hidden to the person acting. [...] The urge for sincerity calls into question the very legitimacy of the performativity of political life, denying us

29 Kevin Hetherington, *Expressions of Identity. Space, Performance, Politics* (London: Sage, 1998), 150–51.

the ability to be actors and instead demanding a stripped-down authenticity that leaves no room for the public persona...[30]

This does not, however, offer political actors an intrinsic freedom from scrutiny. 'What is crucial', Markovits continues, 'is that our efforts be focused on the public person. Words and deeds are the real substance of political life and can be criticised on the basis of their correspondence to factual truth, their consistency and the ethical outlook they disclose.'[31]

In the days following the untimely death of Jörg Haider in a road accident on 11 October 2008, epithets were scattered liberally in death notices and news items: 'Der BZÖ-Chef sei "gestorben wie James Dean", ein "Robin Hood", das "größte politische Genie seit Bruno Kreisky"'.[32] These roles are no longer available for a living Jörg Haider to adopt, although they can and will still be ascribed to him posthumously, whether justifiably or not. His words and political deeds, however, can still be scrutinised for the 'ethical outlook they disclose', and Haider was rightly taken to task for the many veiled racist, or anti-Semitic and anti-immigrationist statements he made as well as for quips that can be interpreted as provocative, positive evaluations of Nazi policies.[33]

It is undeniably the 'words and deeds' of politicians that should attract scrutiny and relevant protest, but artists and writers can serve to draw our attention to these with stimulating and satirical prompts. The protest pieces considered here offer entertaining and astute scenarios for readers' own performances and provide a spur to encourage them to become more engaged or at least more politically knowledgeable. If it is the reader or spectator, or the visitor of an exhibition, who creates the 'duration-time'[34] of any given

30 Elizabeth Markovits, 'The Trouble with Being Earnest: Deliberative Democracy and the Sincerity Norm', *The Journal of Political Philosophy*, 14 (2006), 3, 249–69 (268).
31 Markovits, 268.
32 Thomas Mayer, 'Haider: Kein James Dean', *Der Standard*, 13 October 2008.
33 See 'Haider watch' at: www.smoc.net/haiderwatch/, date accessed 20 October 2008. Walter Ötsch analyses Haider's political style in *Haider Light. Handbuch für Demagogie* (Vienna: Czernin, 2002).
34 See States, 'Performance as Metaphor', 122.

performance, then our reading or performance of these laconic resistance texts is necessarily short in duration. This does not mean, however, that our engagement with the material need stop after the performance itself or that the subject matter is to be dismissed as trivial. Veronika Doblhammer's caution is entirely pertinent: 'kleine Form darf nicht mit kleinem Inhalt gleichgesetzt werden.'[35] Fian's and Haderer and Lukas's satires should not be given short shrift.

35 Doblhammer, 'Fian, Antonio: Die Welt als Dramolett'.

'Bloody Germans! They can't take a joke, can they?' The Impact of Humour in Recent German Film

OWEN EVANS

Jan-Christopher Horak remarked that 'in the narrative of German film history the very term German comedy seems to be an oxymoron. Germans are known for tragedy, for their love affair with death, not for comedy'.[1] Yet he refutes the notion emphatically, and correctly, that the Germans have no sense of humour, unlike Edmund Blackadder whose assertion to the contrary casts its mischievous shadow over the title of this paper.[2] Horak proposes that there is nevertheless an undoubted unease in Germany about comedy as a cinematic genre, referring to 'an inferiority complex', which he believes has always existed.[3] He points, therefore, not to an inability to make or take a joke, but to an intellectual disdain thereof, and it is a suspicion that also encompasses genre cinema in the broadest sense. To underline his argument, he cites the doyen of film criticism in Germany, Thomas Elsaesser, for whom the dislike of genre 'is based in part on the German intelligentsia's overwhelming preference for art cinema'.[4] Indeed, such disparagement of apparently lower forms of cinema has been evident in the attitude of other influential critics such as Eric Rentschler towards much post-Wall cinema in Germany, which the latter dubbed

1 Jan-Christopher Horak, 'German Film Comedy', in *The German Cinema Book*, eds Tim Bergfelder, Erica Carter and Deniz Göktürk (London: BFI, 2002), 29–38 (29).
2 *Blackadder Goes Forth*, 'Episode 4: Private Plane' (BBC, 1990).
3 Horak, 29.
4 Horak, 29.

the 'cinema of consensus' in his now oft-cited dictum.[5] As Ian Garwood
has observed, in contrast to the engaged productions of the New German
Cinema period, much contemporary German cinema has fared badly by
comparison in the eyes of the critical establishment: by being 'politically
complacent rather than politically engaged; genre-based rather than the
work of individual "authors"; and indebted to the "low" cultural forms of
television, rather than the high arts'.[6] In truth, the positive reception of
an array of films over the past few years – *Lola rennt* (Tykwer, 1998), *Good
Bye Lenin!* (Becker, 2003), *Der Untergang* (Hirschbiegel, 2004) and *Das
Leben der Anderen* (Von Donnersmarck, 2006) to name just a few of the
most prominent successes – has significantly redressed the balance. But
it certainly came as no surprise that both Rentschler and Elsaesser railed
against the so-called yuppie lifestyle comedies that filled the German mul-
tiplexes through the late 1980s into the 1990s with considerable success.
Any judgment on whether this popular cinema as a whole is complacent
is beyond the scope of this study. Nevertheless, it is worth stating that
there has been relatively little detailed analysis of German film comedy in
general, despite the plethora of films in the past decade or so which have
enjoyed widespread domestic success; notable exceptions include Seán
Allan's survey of comedies dealing with the GDR and its aftermath and
Dickon Copsey's analysis of women and romance in the new German com-
edy.[7] Both pieces though explore less the nature of the comedy per se than
the socio-political dimensions of the films. This lacuna may indeed reflect
the widespread critical preference for more intellectual fare in Germany, as

5 Eric Rentschler, 'From New German Cinema to the Post-Wall Cinema of Consensus',
 in *Cinema and Nation*, eds Mette Hjort and Scott Mackenzie (London: Routledge,
 2000), 260–77.
6 Ian Garwood, 'The *Autorenfilm* in Contemporary German Cinema', in eds Bergfelder
 et al., 202–10 (203).
7 Seán Allan, '*Ostalgie*, Fantasy and the Normalization of East-West Relations in
 Post-unification Comedy', in *German Cinema since Unification*, ed. David Clarke
 (London and New York: Continuum, 2006), 105–26; Dickon Copsey, 'Women
 against Women: The New German Comedy and the Failed Romance', in ed. Clarke,
 181–206.

well as an international suspicion about the quality and appeal of German comedy outside the country. The aim here therefore is to look at a few of the significant comedies of the recent past, and offer some thoughts on the reasons for their mixed success internationally. Is it possible to ascertain why a couple went on to achieve some, perhaps surprising, success, and why one, in particular, did not?

Horak's survey goes right back to the very origins of German cinema, and he bases much of his analysis on successful directors such as Ernst Lubitsch and Billy Wilder. Both are paradigms of the German-Jewish comic traditions that were a major feature of German film comedy before 1933, and both became highly influential in Hollywood thereafter with films such as *To Be or Not to Be* (1942) and *Some Like it Hot* (1959) respectively. In particular, Horak stresses the subversive, and often frankly sexual, nature of this comic vision, as its primary characteristic. He argues that 'the Holocaust obliterated that [German-Jewish] culture, and it took a generation for Germany's film industry to recover, once again allowing it to discover gender relations as a motor for comedy'.[8] Of course, the rupture affected German cinema in general, which only recovered in the late 1960s. But as Horak points out, Lubitsch and Wilder were intriguingly also rediscovered at the same time, coinciding with 'the first sex comedies [...] in the late 1960s, and certainly influenced subsequent German film comedy, as the traditions of Weimar and its exile cinema once again entered German cultural consciousness'.[9]

The most prolific exponent of the *Beziehungskomödie* in the last twenty years has been Doris Dörrie, whose films such as *Männer* (1985) and *Bin ich schön?* (1997) tap into the very traditions Horak identifies, whilst fusing them with elements of American popular culture now so ubiquitous in European cinemas, most specifically in the form of the genre cinema so reviled by certain critics. The main focus of Dörrie's films tends to be the complicated love lives of young middle-class professionals, who strive to balance careers with romantic fulfilment. For Rentschler, *Männer* marked the

8 Horak, 30.
9 Horak, 30.

end of the spirit of New German Cinema and heralded a different attitude, as it 'more than any German film of the 1980s, articulated a generation's deep disdain for the dreams of 1968 about a better life and an alternative existence'.[10] It transpired that with the collapse of the Berlin Wall in 1989, and the failure of the socialist 'experiment' on German soil, the early 1990s were marked with different concerns and priorities, as the newly enriched eastern Germans contributed to an economic boom that would ultimately prove short-lived. In effect then, in 1985 with *Männer* Dörrie established the thematic templates that many others were to follow relatively slavishly in the post-Wall period. A whole array of formulaic romantic comedies then appeared, such as *Ein Mann für jede Tonart* (Timm, 1992), *Abgeschminkt* (Von Garnier, 1993) and *Stadtgespräch* (Kaufmann, 1995), to name but three.[11] In particular, Dörrie's influence is evident in the film that in 1994 turned out to be one of the most successful of all time domestically in terms of box office receipts, namely Sönke Wortmann's *Der bewegte Mann*.

Based on a successful comic strip by Ralf König and at a stretch evoking Wilder's *Some Like it Hot*, Wortmann's film is an affable romp following the misadventures of the incorrigibly promiscuous Axel, played by then heart-throb Til Schweiger. At the outset of the film, Axel is caught red-handed by his girlfriend, Doro (Katja Riemann), having sex with a woman in the ladies toilet of the club he works in, and she throws him out. He finds a temporary abode with the sensitive homosexual Norbert (Joachim Król). What then ensues is an often entertaining, if rather obvious, farce that pokes fun at the extremes of egotistical machismo embodied by Axel and the faux sensitivity of the new men who comprise the 'men's group' he encounters, but who in reality are as flawed as he is. The film makes knowing swipes at political correctness – the men's group debate, for example, whether it is acceptable to use the word 'tits' – whilst also exploiting stereotypical perceptions of homosexuality, especially with several scenes that extract rather unsophisticated humour about large men dressing up in women's clothes. If its exploration of gender roles seems a little reminiscent of early

10 Rentschler, 272.
11 Copsey's article provides a detailed examination of these films.

German film comedies, *Der bewegte Mann* also evokes the tradition with its soundtrack, which is a delightful pastiche of bygone eras.

The film is not devoid of charm. The characters of Norbert and the long-suffering Doro, in particular, are sensitively portrayed. The affection, and indeed attraction, both feel towards Axel, despite his flaws, appears believable. Doro agonises at length over what is for the best with her neurotic best friend, while Norbert is torn between his own attraction to Axel and his conscience; this does not prevent him ending up naked with Axel in a cupboard, attempting to hide, unsuccessfully, from Doro who returns home unexpectedly. It is a scene comprising humour very much wrung from the same kind of excruciatingly lewd situation that characterised many a British *Carry On* film. Principally the segment serves to underline Axel's selfish, insensitive nature, as it takes him a good while to cotton on to Norbert's sexuality.

The film's Achilles heel is Axel himself, who never really gets the comeuppance he deserves for his inveterate philandering. When he bumps into an old flame, Elke, Axel resolves to cheat on Doro, who is by now his wife, and moreover also heavily pregnant. Axel persuades an obviously reluctant, yet still besotted, Norbert to let him borrow his flat for the callous deed, which inevitably has disastrous consequences. Doro bursts in to find her husband crouching naked on a table, in a trance provoked by an aphrodisiacal spray Elke has brought with her. The shock leads to Doro's waters breaking, and significantly it is Norbert who drives her to the hospital, displaying a hitherto absent assertiveness, a characteristic that Axel patently lacks. Despite subsequently missing the birth of his son, Axel is sure to be reconciled with his wife as the generic logic of the film dictates, and he appears suitably chastened at the end, not least because it was Norbert who acted as his substitute at the birth. In this way, the film essentially settles on the formulaic happy ending, if not quite a fairy tale, which favours the 'normal' heterosexual pairing over any possible re-alignment of the relationships. Ultimately, therefore, without a more provocative message or some deeper meaning added to differentiate it from myriad run-of-the-

mill romantic comedies, *Der bewegte Mann* is not quite the social satire it might have been.

But that is not to denigrate the film totally, for in its own terms, as a straightforward popular comic book adaptation, it does not set out with any other intention than to entertain its audience. And royally entertain them it did, with an audience of over six million Germans. Its success can be attributed to a large extent to the dream pairing of Schweiger and Riemann, both of whom were already big stars at home. For many years, Riemann in particular was a staple in these relationship comedies, becoming rather typecast in the process. Rentschler calls her, somewhat unkindly, a 'refurbished Doris Day', but Copsey is more sensitive to her abilities, describing her as corresponding to 'the model of the ideal heroine of romantic fiction in almost every respect'.[12] She did seek to discard her stereotypical image by playing more villainous characters in television films or roles in thrillers such as the neo-noir *The Long Hello and Short Goodbye* (Kaufmann, 1999). She largely went back to the theatre thereafter, but recently returned to the big screen in the adaptation of Martin Walser's *Ein fliehendes Pferd* (Kaufmann, 2007).

As for Schweiger, whom the German media were touting at the time as the country's answer to Brad Pitt, the attempt to break into Hollywood resulted merely in a series of bit parts, such as in Hong Kong action hero Chow Yun Fat's first English-language film, *The Replacement Killers* (Fuqua, 1998), in which the German is (perhaps rather mercifully!) a mute assassin. Nevertheless, he has continued his work at home with continued success, moving into writing and directing such features as *Barfuss* (2005), in which he ploughs much the same romantic comedy furrow as usual.

Following the massive success of the film at home, as part of the so-called 'new German comedy' phenomenon – in essence a media-generated synonym for Rentschler's far less complimentary assessment of the same period – there was much optimism that under the title *Maybe, Maybe Not* in the United States and *The Most Desired Man* in the United Kingdom, it would herald an international breakthrough for the first time since the

12 Rentschler, 273; Copsey, 185.

heady days of Fassbinder and his contemporaries of the New German Cinema, albeit reflecting radically different, and far less weighty, concerns. Yet hopes were almost inevitably dashed, despite several warm reviews in America, some of which rather optimistically compared it to *La Cage aux folles* (Molinaro, 1978) and mentioned Wortmann in the same breath as Lubitsch.[13] Britain was even more underwhelmed by the film despite some moments which would not have looked out of place in a *Carry On* film: *Time Out* damned it with the faintest praise, calling it 'moderately diverting'.[14]

So why did *Der bewegte Mann* fail? Neither of the rather clumsy English-language titles helped, that is for certain. But it can hardly be dismissed as being too risqué for Anglo-Saxon tastes in view of the sexual innuendo that was the staple of the entire *Carry On* canon, or anything produced thus far by the Farrelly Brothers, such as the decidedly coarse *There's Something about Mary* (1998). Might it just have been that the film was in some ways trying to be just *too* Anglo-Saxon for its own good? The film's production values are heavily American-inflected, recalling any number of contemporary Hollywood screwball comedies based on the types of characters that made *Friends* hugely successful on American television in the 1990s. Malte Hagener ventures that Til Schweiger even consciously adopted 'a US-acting style which is physical rather than verbally oriented' – and which clearly helped him land his groundbreaking role as the aforementioned mute assassin.[15] Whatever the reason, *Der bewegte Mann* did not revive widespread interest in German cinema: that honour would fall to Tom Tykwer's energetically colourful *Lola rennt* four years later, a film also striking for its self-consciously global style that renders Berlin a transnational space long before the very concept became a staple of Film Studies.

But German comedy continued to thrive at home even after the box office boom of the mid-1990s, kick-started by Wortmann's film, began to

13 See for example Roger Ebert, 'Maybe, Maybe Not', *Chicago Sun-Times*, 19 July 1996; Hal Hinson, 'Nimble Comedy of Eros', *Washington Post*, 6 August 1996.

14 Anon, 'Der bewegte Mann', *Time Out* – www.timeout.com/film/reviews/67704/ Der_Bewegte_Mann.html, date accessed 28 August 2008.

15 Malte Hagener, 'German Stars of the 1990s', in eds Bergfelder et al, 98–105 (99).

fade. The end of the decade produced gems such as *Sonnenallee* (Haußmann, 1999), of course, with its nostalgic reflection upon teenage experiences in the GDR, which succeeds simultaneously in challenging stereotypical perceptions of everyday life behind the Wall as well as ironising those who wished to reverse the reunification of Germany.[16] Though criticised in some quarters, the film might also be viewed as part of the *Zonenkinder* phenomenon which emerged at the time.[17] Despite being screened in London as part of the German film festival in 1999, it is interesting to note that *Sonnenallee* has still never been on general release, nor available on DVD, outside Germany, suggesting perhaps that someone within the German distribution network had learned a painful lesson from the attempt to push *Der bewegte Mann* so hard. Maybe it was felt that the subject matter was too esoteric for foreign consumption, even though the representation of being young and in love can surely be viewed as universal.

But if one wants to underline just how difficult it is to identify precisely what makes people laugh, especially when exporting comedy across frontiers, one need only consider the sleeper success *Bella Martha* (2001), Sandra Nettelbeck's début film which achieved widespread success in the United States with the title *Mostly Martha*, despite doing only modest business at home – and has since had to suffer the indignity of being remade for English-language audiences as *No Reservations* (Hicks, 2007), starring one of Swansea's finest alongside Rhys Williams, namely Catherine Zeta Jones. Although marketed as a romantic comedy, *Bella Martha* is to all intents and purposes a drama in which any humour gently offsets the melancholic tone that predominates until the inevitable happy ending. The film follows the eponymous heroine's efforts to look after her eight-year-old niece, Lina, after Lina's mother is killed in a car accident. Martha is an obsessive compulsive head chef, whose restaurant kitchen is ruled by her drive for the highest standards in all things, predicated on her undoubted

16 For an illuminating analysis of the film, see Paul Cooke, 'Performing "Ostalgie":
 Leander Haußmann's *Sonnenallee*', *German Life and Letters*, 56 (2003), 2, 156–67.
17 For more on this cultural trend, see my, '"Denn wir sind anders": "Zonenkinder" in
 the Federal Republic', *German as a Foreign Language*, 6 (2005), 2, 20–33.

culinary skills. Yet her private life is as soulless as the immaculately tidy kitchen in her apartment. The arrival of Lina naturally upsets the status quo she craves, a disruption mirrored in her professional life by the arrival of the maverick Italian chef, Mario. What ensues is a largely predictable, yet charming comedy of manners in which Martha struggles pyrrhically to preserve her idiosyncratic routines. Nettelbeck shows Martha regularly escaping to the walk-in freezer in the restaurant when the heat gets too much – an admittedly crude visual metaphor for the chef's determination to keep her emotions in check – but with Mario and Lina in her life, she begins to thaw out and gradually falls in love with them both.

The humour simply introduces much needed heart-warming elements to the film, which, at times, is more redolent of a tear-jerker, with its genuinely moving exploration of the consequences of tragic loss on close relatives, especially young children. In contrast to Wortmann's histrionic film, the overall tone of *Bella Martha* is much more nuanced. Although the happy resolution is not unexpected, as befits the conventions of the genre, the film never runs the risk of descending into the kind of schmaltz typical of a Nora Ephron movie, such as *Sleepless in Seattle* (1993), principally because Nettelbeck keeps things simple. She also draws strong performances from the three leads, especially Martina Gedeck, one of the rising stars of German cinema, who is utterly convincing in her depiction of the problems that Martha has in adjusting to the pseudo-maternal role thrust upon her by such tragic events and the ramifications for her career.

The same differentiation of mood is also a key feature of one of the most successful German films of all time, *Good Bye Lenin!* In view of the failure of *Sonnenallee* to find any particular resonance beyond Germany, it was perhaps something of a surprise that Wolfgang Becker's film about the GDR and its legacy took the international stage by storm, doing over four million dollars' worth of business in America and drawing a million cinemagoers in the UK. The film mines a rich seam of situational comedy, in the context of the *Abwicklung* of the GDR, by following Alex Kerner's increasingly desperate, and innovative, efforts to recreate the now defunct state in the family's apartment in order to try to shield his mother from a potentially fatal heart attack. Whilst some of the situations are simply comic, such as Christiane's birthday celebrations during which Alex bribes

two of her ruthlessly capitalist ex-pupils to sing and where his sister's *Wessi* boyfriend embarrassingly overplays his appointed role as a former FDJ organiser, there is an underlying socio-political critique which renders other episodes much more satirical in tone. As Allan puts it, the film additionally 'strives for a more differentiated understanding of the concept of *Ostalgie*, whilst at the same time highlighting the importance of memory (both individual and collective)' for eastern Germans.[18]

The film certainly never lets us forget the seriousness underpinning Alex's frantic efforts to keep the truth from his mother. For Christiane Kerner's story is a tragic one, of a marriage effectively destroyed by the State and of a painful secret she has kept from her children. As the film nears its climax, it is revealed that once her husband had defected, she was to have joined him in the West with the children, but was ultimately too frightened to do so. Consequently, she fabricated a story about him having fled to be with his mistress, and concealed all his letters to the family. In this way, her experiences reflect the psychological damage the GDR inflicted upon the majority of its citizens who were forced to make difficult choices, to extract the best of a situation that denied them certain fundamental freedoms or to tolerate the state impinging on their private niches. Indeed, the film opens with the Stasi interrogating Christiane about her husband's defection within earshot of the children.

Although Alex and his sister have adapted to the *Wende* without too much difficulty, the re-entry into their lives of their father, who fled to the West and waited in vain for their mother to follow with them, reveals how they too bear the scars of a totalitarian existence. Ariane's discovery of the letters is an especially heart-rending representation of the consequences of living under such a restrictive, and intrusive, regime.[19] Of course, Alex seeks to create a private niche in the unified Germany which is forever socialist, but ironically here too it proves impossible to keep the truth at bay indefinitely, from the unfurling of the Coca Cola banner on the apartment

18 Allan, 117.
19 The psychological effects of such state intrusion also lie at the heart of *Das Leben der Anderen*, but in a more overtly tragic idiom.

building opposite his mother's window to the emblematic airlift of the statue of Lenin. Yet by virtue of his ingenuity, in itself a useful capitalist trait, in adapting to circumstances in order to keep the potentially fatal truth from his mother, Alex succeeds in creating the illusion of a German Democratic Republic that would have been worthy of the name, as his poignant final voice-over makes abundantly clear: 'Das Land, das meine Mutter verließ, war ein Land, an das sie geglaubt hatte. Und das wir bis zu ihrer letzten Sekunde überleben ließen. Ein Land, das es in Wirklichkeit nie so gegeben hat. Ein Land, das in meiner Erinnerung immer mit meiner Mutter verbunden sein wird'. It is a coda which neatly defuses any suggestion that the film is pandering uncritically to notions of *Ostalgie*. What is more, the closing words gain added poignancy for, as Allan rightly observes, in the end 'it is Alex and not Christiane who is shielded from the truth'.[20]

Even more so than with *Bella Martha*, it would be easy to argue that Becker's film is, in fact, only very remotely a comedy. The wonderfully affective soundtrack composed by Yann Tiersen is as replete with melancholic inflections as Alex's narrative, so it is little surprise when his mother eventually succumbs. But as with *Bella Martha*, *Good Bye Lenin!* is about coping with all that life throws at you, and is ultimately a heart-warming film about the relationships that make it worthwhile, and the way that people are commemorated. Both films recount situations that appear wholly credible, yet for all the tragedy that befalls the protagonists, the comic elements are not precluded. It is a natural part of the human condition that the films seek to convey, as the characters negotiate their way through life. Arguably the same cannot be said for *Der bewegte Mann*, where the content largely appears to exist in and of itself to be funny, or at least to try to be, by virtue of the exaggerations and caricatures upon which it so heavily relies. That is not to say that the film does not succeed in part, but its lack of the same universal qualities evident in *Bella Martha* and *Good Bye Lenin!* might explain why the film enjoyed only muted success outside Germany.

Paradoxically, the international success of the latter two films might be attributed to their quintessentially German characteristics, in precisely

20 Allan, 123.

the same way that apparently parochial British comedy dramas such as
The Full Monty (Cattaneo, 1997) or *Bend it like Beckham* (Chadha, 2002)
succeeded against the odds on the global stage. All these films have an
entirely plausible authenticity, deriving from a concrete, recognisable situ-
ation: in the case of the latter two films, the problems facing the long-term
unemployed in post-industrial Sheffield, and the tensions that derive from
conflicting ambitions within a Sikh family in multi-ethnic Britain respec-
tively. With regard to the German films, *Der bewegte Mann* possibly failed
to travel well because it appeared too Americanised, too contrived in its
representations, premeditated to attain the kind of universality that can
be translated into significant box office takings abroad. In contrast, the
focus of *Good Bye Lenin!* is on the collapse of East Germany, for example,
an incontrovertible reality heralded as it was by the collapse of the Berlin
Wall that so transfixed audiences around the world. As for *Bella Martha*,
it deals with a hoary topos of German culture, namely the clash between
the disciplined and the sensual, the Apolline and the Dionysian. Martha
lives in a cold and frosty Hamburg, but is thawed by the emotional Mario,
an Italian. This is the world of Thomas Mann. It seems no coincidence
that Martha works in a bistro called Lido, and finally confronts her true
feelings in Italy, albeit without the tragedy that ultimately befalls Gustav
von Aschenbach in *Tod in Venedig*. The resonance of this clash of cultures
is excised completely in the American remake of the film where the new
chef is simply a man with, as the title puts it, 'no reservations'.

Having said all of this, it has to be admitted, with some reluctance,
that these successful films may well be exceptions proving the rule that
German comedy does not travel well. Domestically, German comedy has
continued to do relatively good business, but it has not struck any chords
abroad. Marcus Mittermeier received good reviews for his acerbic black
comedy *Muxmäuschenstill* (2004) and landed the Max Ophüls Prize. In
purely commercial terms, science fiction parody *(T)Raumschiff Surprise –
Periode 1* (Herbig, 2005) was the most watched film in domestic cinemas
that year, striking a blow against Hollywood's hegemony: Elsaesser's opinion
on that particular success might have been worth recording. In contrast,
Dani Levy has been prominent in recent years, first of all with the charm-
ing *Alles auf Zucker!* (2004), which won both the German Film Prize and,

perhaps more significantly in the context of this article, the Ernst Lubitsch Prize in 2005. He followed this up with the much more controversial *Mein Führer – Die wirklich wahrste Wahrheit über Adolf Hitler* (2007), which prompted Henryk Broder to remark memorably that 'no matter how skilled the cook, a pork chop can never be turned into a kosher delicacy'.[21] Ironically, in this regard, we have seen a resurgence of international interest in German film since 2000, with a string of Oscar wins and nominations for films which have once again revisited the country's totalitarian legacies. It does, however, seem unlikely that the world at large is going to embrace this latest representation of Hitler, not least given the suspicion which has previously greeted so-called Holocaust comedies such as *Life is Beautiful* (Benigni, 1997), Oscar-winner though it might have been. And so, while we can happily refute Blackadder's indictment of the Germans' capacity to enjoy a good laugh, the evidence overwhelmingly suggests that the world at large still doesn't really get the jokes they tell.

21 Henryk M. Broder, 'Dani Levy's Failed Hitler Comedy', *Der Spiegel* (Online), 1 September 2007. http://www.spiegel.de/international/spiegel/0,1518,458499,00. html, date accessed 28 August 2008.

Snowy Worlds:
Kafka's *Das Schloß* and Pamuk's *Snow*

ELIZABETH BOA

In 1827 Goethe suggested in conversation with Eckermann that national literature was of little consequence any longer, the epoch of 'Weltliteratur' was at hand.[1] In 2003, David Damrosch put the contemporary case. The term refers, he suggests, not just to authors: 'The great conversation of world literature takes place on two very different levels: among authors who know and react to one another's work, and in the mind of the reader, where works meet and interact in ways that may have little to do with cultural and historical proximity.'[2] On reading Orhan Pamuk's *Snow*, I kept sensing family resemblances to *Das Schloß*. But why would Pamuk draw on a novel written in 1922–3 in German when writing a novel in 1999–2001 so centred on Turkish affairs?[3] In *Istanbul*, an autobiographical reflection on his native city, Pamuk writes of seeing the city through Western eyes: 'Why this fixation with the thoughts of Western travelers ...? It's partly that many times I've identified with a number of them ... just as I once had to identify with Utrillo in order to paint Istanbul'. And further down: 'So whenever I sense the absence of Western eyes, I become my own Westerner'.[4] If *Das Schloß* is an intertext of *Snow*, is this Pamuk looking at

1 Johann Peter Eckermann, *Gespräche mit Goethe*, ed. Fritz Bergemann (Baden Baden: Insel, 1981), 211.

2 David Damrosch, *What is Comparative Literature?* (Princeton, Oxford: Princeton UP, 2003), 298.

3 Franz Kafka, *Das Schloß. Roman in der Fassung der Handschrift*, ed. Malcolm Pasley (Frankfurt am Main: Fischer Taschenbuch, 1992; orig. 1926); Orhan Pamuk, *Snow*, trans. Maureen Freely (London: Faber and Faber, 2004; orig. *Kar*, 2002).

4 Orhan Pamuk, *Istanbul. Memories of a City*, trans. Maureen Freely (London: Faber and Faber, 2005), 260.

Turkey through Western eyes? Does becoming 'my own Westerner' reveal
a subaltern mentality? Or is Pamuk seeking empowerment by tapping into
a modern classic. And if so, why Kafka?

Claudio Guillén proposes literary taxonomies based on genre, form,
and thematics.[5] To these I would add constellations of figures and 'mode' for
the largest category, keeping 'genre' for more defined sub-categories. Liter-
ary connections can stretch from modal or generic affinity, through passing
allusion, to intensive inclusion. *Snow* is full of allusions. For example, the
hero, Ka, has a favorite coat he bought in the Kaufhof in Frankfurt from
a salesman supposedly called Hans Hansen. Then later on, Ka pretends to
have a contact at the *Frankfurter Rundschau*, a handsome blond journalist
called Hans Hansen. Notoriously, the hero of Thomas Mann's *Tonio Kröger*
had a crush on a schoolmate, Hans Hansen, who was indeed blond and
handsome. In both texts the hero returns home from abroad, then travels
even further North (*Tonio Kröger*) or East (*Snow*), gets briefly arrested,
and feels melancholy longing to be like the locals. Pamuk also ironically
reverses the home/abroad values: besides wishing in vain to be like his
eastern compatriots, Ka dreams of happy return westwards to German exile
with evenings at the cinema with his beloved, followed up by that favourite
Frankfurt specialty, a döner kebab. But the imagined second *Heimat* will
be in reality Ka's place of execution. The allusions to *Tonio Kröger* do some
work, then, but are not much more than a black joke.

Allusions to *Das Schloß*, by contrast, are through-running, above all
the heroes' shortened names: K. and Ka. Both novels are quest narra-
tives: the hero seeks truth and understanding of the world he has entered.
And the quest mixes with romance: the hero wants to serve or to save the
beloved. In both novels the woman serves at once to further the quest
and is an obstacle who gets in the way. The converse holds true: the quest
leads towards the woman, but also hinders reaching her. There are similar
figural constellations: the women's allure stems in part from connections
to powerful men; the heroes desire either to reach the men through the

5 Claudio Guillén, *The Challenge of Comparative Literature* (Cambridge, Mass.:
 Harvard UP, 1993).

women or to seize the women from the men.[6] Another constellation is
male helpers who uncannily turn into alter egos and displace the hero. Key
motifs are village or urban topography, encounters in inns and hotels, and
the weather. The novels differ in genre, however. *Das Schloß* is a hermetic
allegory, *Snow* a political thriller. Thematically, both explore power rela-
tions, but *Das Schloß* is a study in the maintenance of power: the men the
hero wants to reach uphold the structure; the most charismatic of them is
a bureaucrat (Klamm). In *Snow* the men the hero wants to reach engage
in violent power struggles; the most charismatic of them is a rebel (Blue).
Formally too, there are differences: where *Das Schloß* is all talk, *Snow* is
action-packed, and whereas *Das Schloß* leaves K.'s past largely unvisited
and the future unknown, the first-person narrator of *Snow* provides past
information and flags up future deaths: we hear several times that Ka will
witness a murder; that a bullet will shatter the schoolboy Necip's left eye-
ball; that Ka will survive the Kars crisis only to be assassinated in Germany.
Compulsive repetition conveys the traumatising horror of political assas-
sination, whether the victim is an elderly civil servant, a young believer, or
a middle-aged intellectual. Finally, the narrator of *Snow* is called Orhan
in a more overt gesture of authorial identification than the hero's mere
initial in *Das Schloß*.

　　Summary may put flesh on these bones. In *Das Schloß* a man called
K. turns off the highway across a bridge into a village. Arriving at night
he senses the soaring presence of the castle but next morning it all looks
rather broken down. Its tower is half hidden by ivy and has a crazy look,
as if a maniacal inhabitant were breaking through the roof and otherwise
the castle is not much more than a huddle of village houses. Trying to
confirm his appointment as land surveyor K. has various encounters with
representative villagers such as schoolteachers or the village clerk, peers
through a keyhole at one castle official and has a face-to-face meeting with
another. Places include two inns, a school, the occasional household, and

6　In 'Headscarves To Die For', *New York Times*, August 15, 2004, Margaret Atwood
　　allocates *Snow* to 'the male labyrinth novel': men's attitudes to women drive the plot
　　but their attitudes to each other are more important.

paths that lead nowhere. A second aim is to settle in the village and marry Frieda, a village woman he falls in love with. But does K. want to reach the castle to be able to stay in the village, or to stay in the village in order to reach the castle? Frieda's attraction partly flows from her relationship with the castle official, Klamm: does K. want to reach Klamm through Frieda or to prove himself by seizing Frieda from Klamm? When relations with Frieda break down, she takes up with Jeremias, one of two assistants K. has acquired. These Proppian helpers mirror the primary relationships: Klamm is Frieda's previous lover who kept K. waiting outside in the snow; so too K. will be for Jeremias his wife's previous lover who kept him waiting outside in the snow.

A second strand concerns the Barnabas family. Rebellious Amalia rejected the castle official who came to woo her and since then the family has been ostracised. While Amalia looks after their parents, her brother Barnabas and sister Olga try to reach the castle to put things right. Although no order ever came from the castle, the villagers exclude the Barnabas family; they become outsiders who confirm the villagers' status as insiders. Incomer K. gets involved in the family efforts to right this injustice and it is this which precipitates the breakup with Frieda. Thus the object of the quest slips and slides: to reach the castle, to survey the terrain, to stay in the village, to get the woman, to right a wrong. Lacking an interpretive key, the reader is frustrated: the castle means either nothing or too much; the hero's quest is riven by paradox; and the weather is awful. Summer only lasts five or six days, K. hears, and even then it sometimes snows.

In *Snow*, a man, nicknamed Ka, arrives in Kars, according to Pamuk 'notoriously one of the coldest towns in Turkey'.[7] 'Kar' is Turkish for snow and there is a lot of 'kar' in Kars. On a journalistic quest to cover the local elections and investigate a suicide epidemic among young women, Ka sets about surveying the political terrain.[8] In Kafka's hermetic novel,

7 Orhan Pamuk, *Other Colours. Essays and a Story*, trans. Maureen Freely (London: Faber and Faber, 2007), 372.

8 Not Kars but Batman suffered an above-average suicide rate in the years 1995–2000. See Aybigye Yilmaz, 'Victims, Villains and Guardian Angels', *Westminster Papers in Communication and Culture*, 1 (2004), 1, 62–92.

the parabolic paths dividing castle rule and village practice are an abstract diagram of processes anywhere which turn neighbours into strangers. In *Snow*, by contrast, urban architecture signifies a specific history. Kars is a mix of shanty settlements on the outskirts and the fading splendour of the centre with oleander-lined avenues of decaying nineteenth-century mansions that once belonged to Russian merchants and Armenian traders and a scatter of crumbling public buildings from the early years of the Republic. This eclectic architecture houses ghostly absences, traces of the once multi-ethnic Ottoman Empire, of its end, and of the rise of nationalism and concomitant ethnic violence. The notabilities Ka meets represent different factions: secular authorities; the sinister intelligence agency MİT; a Kurdish leader; fanatical nationalists; radical Islamists; pupils at the local madrassa. Kafka's bureaucracy, though chaotic, is in the end monolithic and his villagers stabilise a fragile majoritarian unity by ganging up against minority scapegoats. In *Snow*, by contrast, a violent struggle is taking place as to who can seize power over townsfolk who are driven into factionalism by threats and violence.

In *Das Schloß* K.'s encounters, though edgy and frustrating, are mainly conversational, but in *Snow* Ka witnesses extreme violence: the murder of the education director by an Islamist fanatic; a (literally) theatrical coup when Kemalist soldiers who look like actors, open real fire from the stage, killing several people including the schoolboy Necip; a murderous rampage by ultra-nationalist militia who kill more pupils and kidnap the Islamist rebel, Blue. As in *Das Schloß* the quest intertwines with romance: alongside journalistic aims, Ka hopes to meet up with a childhood sweetheart, İpek, now living in Kars with her father and her sister Kadife. In *Das Schloß* rebellious Amalia flouts the socio-sexual order. In *Snow* rebellious Kadife leads protests against the government ban on headscarves in schools and universities. The military coup begins during the performance of a play from the 1930s, entitled 'My Fatherland or My Headscarf', by a secularist theatre troupe headed by an actor who often plays Atatürk. To achieve Blue's release, Kadife promises to appear in the play and bare her head in an act of public assent to the narrative which sets progressive westernising patriotism against religious reaction. But the plan goes horribly wrong. Blue is assassinated and Kadife, acting under duress, shoots the actor who has

planned his own spectacular assassination by substituting a real bullet for a blank. Amidst this mayhem, Ka moves from investigative journalism to the role of mediator trying to broker a truce by offering to get a statement, to be signed by all parties, published in the *Frankfurter Rundschau* by the imaginary Hans Hansen.

As in *Das Schloß*, then, the path and the goal get mixed up: Ka wants to sort out things in Kars so as to go off and live happily ever after with İpek, but he is interested in İpek because of her connections in Kars. In *Das Schloß* K. is drawn by power, embodied in Klamm, Frieda's former lover. In *Snow*, Ka feels the lure of rebellion, embodied in Blue, İpek's former and Kadife's current lover: 'ipek' is Turkish for silk, 'kadife' for satin; like Blue before him, Ka oscillates between the lure of silk and satin. Helpers form a further constellation. Necip and Fazıl are young, believing other selves that sceptical Ka might have been. Under Blue's spell and charmed by Necip, agnostic Ka even has flashes of belief. The boys are entangled in a mix of religious idealism and adolescent sex, as Ka's generation once were in Marxism and sex. Necip is in love with Kadife when he is killed in the theatrical coup. Just as Jeremias inherits Frieda from K., Fazıl will inherit Kadife from both Blue and his dead friend Necip. The narrator Orhan – like Pamuk author of a work entitled *The Black Book* – brings the reader up to date in an epilogue. Orhan too comes to Kars on a quest in search of his dead friend Ka's nineteen poems transcribed in a missing green notebook. And like Ka, Orhan falls madly in love with İpek. In *Das Schloß* the women look back to lost romantic love and the men look through the women to the men who obsess them. So too in *Snow*: Kadife will never forget Blue; İpek will never forget Blue or Ka; Fazıl, married to Kadife, will never forget Blue or Necip; Orhan, in love with İpek, will never forget Ka. The constellations of the hero and women and the hero and *his* heroes intertwine. Heterosexual love and homoerotic attraction mingle and infuse the interplay of power and rebellion. The object of the quest slips and slides: to report on politics, to investigate suicides, to confront the powerful, to get the woman, to broker a truce, to write poetry, to find what is lost, and, if only fleetingly, to see god.

Like Kafka's castle which in the end means nothing or too much, Pamuk's snow is the empty prime signifier. As Ka wanders the snowy streets,

he experiences moments of utopian and dystopian vision. Sometimes the snow blankets out architectural differences and hangs sparkling from oleander leaves, magically evoking a pristine world unsplintered by factional history, sometimes, however, it blinds and suffocates. But there is also the single snowflake. In his essays Pamuk alludes more to Thomas Mann than to Kafka. In *Der Zauberberg*, snow figures both as a beautiful yet deadly mass, but also as the single snow flake with its unique crystalline structure. Ka organises the nineteen poems that come to him in Kars around the six points and across the three axes of a snow flake. The poems are fuelled by politics and romance yet their arrival keeps interrupting his political quest and pursuit of love. Entranced by narcissistic romanticism, Ka is a Don Quixote wielding poems as his lance. In the frame-narrative, the lost poems become the object of the quest: instead of the prosaic novel, revelatory poetry may point the way towards truth and the good life. But like the paths that always curve away again from the castle, the poems are lost. Kafka does not elaborate on land surveying as a metaphor for literature, though it is a subterranean implication. Waiting for Klamm, K. opens the cognac bottle in Klamm's sleigh, releasing an entrancing aroma which seems to promise love, praise and good words. But the wait is vain, and alone in the snowy courtyard K. reflects upon how free he is, but how meaningless his freedom is. After the moment of bliss, then, the negative epiphany: an abysmal vision of meaninglessness. Kafka must have been writing this around the same time as Mann was writing the climactic chapter where Hans Castorp walks in circles through the snow, almost dies, but then has a double utopian and dystopian vision that juxtaposes beautiful youth with the blood sacrifice of infants. In Pamuk's snowy world, the beautiful youth, Necip, whose vision of god Ka shares for a moment, dies in a bloody massacre committed in the name of enlightened progress. K. never manages to survey, much less to map the terrain. Hans Castorp forgets the vision. In *Snow*, Ka's notebook is lost. Literature never reaches the goal, though writers keep seeking the path.

Turning now from the texts, cultural geography offers a context for comparison: Kafka's Europe after the First World War, the collapse of multi-ethnic Austria-Hungary, and the hopes and fears of minorities in the new Czechoslovakia, and Pamuk's Turkey, remnant of a once multi-ethnic

Empire, its disaffected minorities and thwarted efforts to join the Euro-
pean Community. East-West symbolism is a powerful, imaginary binary
structuring identity and claims to authority. Western Civilization gets set
against a multiplicity of Orients figured in hostile or in alluringly erotic
terms. Kafka's Orient was shaped partly by his fascination with Jizschak
Löwy's Yiddish Theatre Group. (In *Snow*, the secularist traveling theatre
has moved to the other side of the binary.) K.'s assistants echo comic figures
from Yiddish tradition. Yet Kafka could never be at one with Jews from
Galicia arriving as refugees in Berlin during the First World War though
he felt the longing, just as he dreamed of going to Palestine. On the other
hand, he shared the discomfort of secular Jews faced by the exotic archaism
of so-called Caftan Jews – the Lasemann household in *Das Schloß* obliquely
conveys such feeling, also present, in more terrifying guise, in the bearded
old men at Josef K.'s first hearing in *Der Proceß*. But nor was Jewish Kafka
wholly at home in Prague, a town still haunted by imaginary ghosts long
after the clearing of the physical ghetto. Arrogant yet shame-filled Josef
K., arrogant yet needy K. convey painful ambivalence.

Pamuk suggests that economic inequality and tensions between tra-
dition and modernization shape the East-West question.[9] Westernising
reforms in Turkey were driven by national pride mixed with shame at back-
wardness in the face of the dynamic, secular West. Today, as Turkey knocks
at Europe's door, the interplay of pride and shame continues: thwarted
pride induces shame; shame stokes excessive pride. And what once was
a source of shame may become the badge of pride, and vice versa. Ka is a
Western Turk brought up in European Istanbul. He has come East to poor
crumbling Kars from still further West in rich Frankfurt. He feels the pull
of religious faith while knowing that he could never enter the community
of believers. And he sees how the dreams are instrumentalised and fuel
violence, turning young idealists into assassins or victims. The East/West
binary also infiltrates literary matters. One of Kafka's letters alludes to the
notion that Jews can never write authentic German: they are like gypsies

9 Pamuk, *Other Colours*, 230–31.

stealing a Christian baby from its linguistic cradle.[10] So too assimilated Jews were accused of mimicry. In *Snow* Ka and other intellectuals are accused by secular nationalists and Islamists of mimicry: neither authentically Turkish or Islamic nor authentically Western either, they imitate European modernism when they ought to be renewing Turkish or Islamic tradition. In an interview Pamuk admits the shame which such accusations of mimicry provoke, but also launches a powerful attack on the discourse of authenticity and unitary cultural identity: the very essence of fiction lies in the capacity to imagine that one is someone else, to mimic the other or impersonate the other in the self. Literature is conversation with others.[11] And if the East-West binary infiltrates the self and destabilises identity, that is no bad thing, given the violent direction communal identity politics can take. Cultural purism is comically undermined in *Snow*: nobody knows the traditional tale of Sorab and Rustum any longer; instead everybody watches an imported Mexican soap opera on the telly; even the kidnappers stop beating up their victims to watch the latest episode. Local culture is global and hybrid. Europe has porous borders: the multi-voiced novel, not religion, is what makes Europe what it is, Pamuk declares.[12] Those who would exclude Turkey from 'Christian' Europe are perilously close to the racists who accused Jews of theft and mimicry. The myriad mirrorings in the constellation of the quester hero, his male helpers, and women are modal links connecting *Snow* with *Das Schloß* and feed into the theme of fiction as a kind of impersonation of other people or else as an author's metamorphosis into the other hidden in the self. Pamuk readily admits that the name Ka recalls Kafka's K. but plays down any further significance. Yet alluding to the motif of waking up one morning transformed into a cockroach, he adds that as an author he would need to imagine himself turned into Kafka – perhaps a hint, then, of input from Kafka.[13] The hero of *Der Proceß* dies like a dog and it is as if the shame would outlive him. Pamuk's

10 Franz Kafka, *Briefe 1902–1924*, ed. Max Brod (Frankfurt am Main: S. Fischer, 1958), 338.

11 Pamuk, *Other Colours*, 377.

12 Pamuk, *Other Colours*, 234–35.

13 Pamuk, *Other Colours*, 228.

close is not so shame-ridden. It is a novelist's lament for the murder of a poet-journalist at the hands of fanatics.

It is lament too by an adult for youthful deaths and by a man for the way that women are made tokens in power politics. The quest narrative centres the hero; other figures, male or female, are functions in his quest. But Olga's long narrative about her sister's rebellion against age-old custom is a female voice in *Das Schloß*. The sisters are thinly disguised versions of the virgin and the whore: Amalia refused sex, but promiscuous Olga seeks through relations with men to reach the source of power. Whorish Olga as quester heroine seeking justice for her virginal sister opens a window onto the world according to women. Thus Kafka impersonates, as Pamuk might put it, a female other. Moreover, K.'s long apology to Frieda that he may have used her but always loved her is a wry confession of narcissism. Pamuk too shows the narcissism of romantic love: the hero cannot see the actual woman for the projected image, or sees her only intermittently when he is not writing poems about her. This personal complex accompanies the political argument to do with headscarves. Among other things *Snow* is a mystery story: why are young women committing suicide? Ka collects conflicting explanations: the girls are really being murdered for offences to family honour, or being driven to suicide by poverty, by domestic violence, by pressure to marry men they don't love, by rejection by men they do love, or by government refusal to let them study if they wear headscarves. The puzzle expands: why do they wear headscarves? Is it because their fathers make them, or because the Koran supposedly ordains it, or out of fear of attack? Or is it because the government has forbidden it: where radical young women once patriotically bared their heads, they now cover their heads in democratic protest against militaristic authoritarianism and western hegemony? The tokens of pride and shame cross over. According to Kadife the girls wear headscarves not out of womanly shame, but out of pride. They proudly kill themselves as a free choice. The metaphor of the snowflake links the suicides and Ka's poems to questions of identity. A falling snowflake is subject to wind direction, atmospheric pressure, temperature and so on; so too a poem reaches the poet under the effect of myriad personal and environmental influences. Yet flake and poem retain a unique structure for a while, though they may finally melt away or disappear. The

girls who kill themselves are buffeted by pressures from all directions, but in the end it is their choice to die out of pride in their identity. Or at least so Kadife claims. Pamuk argues elsewhere, however, that 'schizophrenia makes you intelligent': Turkey should not worry about having two spirits rather than 'one consistent soul', as the politicians demand.[14] But the story of Hande, the exemplary suicide in *Snow*, suggests a pride in identity so extreme or else shame and a collapsing sense of self so extreme that either way – which it is remains undecidable – the snowflake structure of a livable identity is lost.[15] Young people may not live long enough to achieve either the liberatory heterogeneity which essayist Pamuk advocates or the pride in self advocated by Kadife, the woman whom Pamuk the novelist impersonates.

In the end *Snow* decentres the male quester-hero: İpek chooses to stay in Kars rather than following Ka; Kadife emerges from prison and along with Necip looks after their baby. Further frameworks could be the discourse of *Heimat* and exile. That Pamuk's hero returns to Turkey from German exile, but leaves again suggests the importance of political exile and economic migration as themes in Turkish self-reflection. But what of my opening question: why Kafka? In a much cited passage, Kafka writes about the little literatures of people such as the Warsaw Jews or the Czechs.[16] Under the pressure of big literature, texts in little literatures are necessarily political through being positioned relative to the powerful neighbour. In little literatures everybody knows everybody and positionality determines friends and foes. Ka and Orhan both stylise themselves as writers in a little literature; under the shadow of Europe their work is judged according to

14 Pamuk, *Other Colours*, 369.

15 In 'Can the Subaltern Speak?', in *Marxism and the Interpretation of Culture*, eds C. Nelson and L. Grossberg (Basingstoke: Macmillan, 1988), 271–313, Gayatri Chakravorty Spivak writes critically of competing interpretations by British and Indian men of the mentality of women committing suttee. That the dead girls' mentality remains unknowable signals Orhan's refusal of the subaltern role of interpreter of 'native' culture.

16 Franz Kafka, *Tagebücher in der Fassung der Handschrift*, eds Hans-Gerd Kock, Michael Müller and Malcolm Pasley (Frankfurt a. M.: S. Fischer, 1990), 312–15; 321–22.

its perceived position, and depending on the answer their lives may even be at risk. Kafka sketches one response to such constraints in the letter about German-Jewish writing which steals the German baby from its cradle. The stolen child is hurriedly trained to perform its tightrope dance: '(Aber es war ja nicht einmal das deutsche Kind, es war nichts, man sagt bloß es tanze jemand.)'.[17] A nameless someone dancing above the ground on a tightrope: here is the deterritorialization which makes Kafka exemplary of what Deleuze and Guattari term minor literature.[18] The refusal of national or group identification, refusal of any position within the field of power, makes Kafka's work truly political rather than factional. On the face of it, Pamuk's *Snow* is emphatically territorial and intervenes in a highly specific field of power. The effect of *Das Schloß* as intertext, however, opens up the wide world of the quest narrative. Thus *Snow* reaches out through *Das Schloß* to become political in a larger sense, without at all cutting off its vital connections to its Turkish point of origin. Conversely, reading *Das Schloß* through *Snow* confirms in our globalising age how Kafka's metaphoric village under the shadow of a castle continues to generate meaning.

17 Kafka, *Briefe*, 338.
18 Gilles Deleuze and Félix Guattari, *Kafka. Pour une littérature mineure* (Éditions de minuit: Paris, 1975).

Cramped Creativity:
The Politics of a Minor German Literature

MARGARET LITTLER

Deleuze and Guattari's notion of minor literature has been frequently invoked in discussions of minority writing in German, but its political implications have been only partially explored, and frequently misunderstood. It is commonly assumed that to designate these writers 'minor' is to consign minority authors to an ethnic 'ghetto', or that the role of minor literature is to 'represent' minority groups in both the aesthetic and political senses.[1] Indeed, B. Venkat Mani's recent study of Turkish-German writing dismisses Deleuze and Guattari's notion of minor literature on the grounds that it has been so often misrepresented, it is no longer a useful analytical framework.[2] Deleuze-scholar Christian Jäger, on the other hand, implies that the association of minority writers with minor literature might be no more than a form of wishful thinking on the part of the well-meaning critic.[3] This paper attempts to address the question of how minor literature is political, with reference to Deleuze and Guattari's materialist view of subjectivity, authorship and literary language. In focusing on literature as a site of experimentation and becoming, rather than representation of a known world, I hope to demonstrate that the challenge to dualist thinking

1 See for example Tom Cheesman, *Novels of Turkish German Settlement. Cosmopolite Fictions* (Rochester NY: Camden House, 2007), 99.

2 Venkat Mani, *Cosmopolitical Claims. Turkish-German Literatures from Nadolny to Pamuk* (Iowa: University of Iowa Press, 2007), 21.

3 See Christian Jäger, 'Grenzkontrollpunkte: Methodologische Probleme des Transitraums und der "kleinen Literatur"', in *Transitraum Deutsch. Literatur und Kultur im transnationalen Zeitalter*, eds Jens Adam, Hans-Joachim Hahn, Lucjan Puchalski and Irena Światłowska (Wrocław: Neisse Verlag, 2007), 41–51 (43).

posed by Deleuze's philosophy of difference offers a unique opportunity to reassess the potential impact of Turkish-German writing in terms other than intercultural dialogue, post-colonial hybridity, or even diasporic identity. Like Leslie Adelson, I am arguing not so much for a new category by which to define what she calls 'the literature of Turkish migration', but for a 'new critical grammar', or new reading strategies, to liberate from it genuinely unpredictable and potentially transformative meaning.[4] Unlike Adelson, however, who bases her textual analysis indirectly on a Cartesian model of iconoclastic 'lines of thought',[5] my own resistance to the idea of literature as figurative representation derives from Deleuze and Guattari's positive view of minor composition as a creative and critical engagement with precisely the social forces that produce stable, territorial notions of identity. I shall argue that although Turkish-German writers inhabit German language culture, they work within its constraints to deflect it from its familiar representative function. 'Cramped' by the conditions of the major language, they form new relations with German, and with the collective subject that it calls into being. Based on the premise that minor literature emerges in conditions of political constraint, imposed intimacy, and often linguistic contamination, Deleuze and Guattari elaborate an aesthetic which is unavoidably entwined with the social, in which every individual concern resonates with the social forces flowing through it. Their affirmation of the primacy of flows and difference rather than identity requires an approach to literature not as representation of an existing social reality, but as experimentation with the expressive potential of language to dismantle unitary notions of the national language and cultural identity, and to pursue new possibilities. The minor author function is neither a matter of ethnology, nor of group representation, nor even of individual expression, but the site of a collective enunciation unconstrained by existing national identities

4 Leslie Adelson, *The Turkish Turn in Contemporary German Literature. Toward a New Critical Grammar of Migration* (New York: Palgrave Macmillan, 2005). See also Daniel W. Smith, 'The Conditions of the New', *Deleuze Studies*, 1 (2007), 1–21 for an explanation of the philosophical foundations of Deleuze's understanding of difference as productive of radical novelty.

5 Adelson, *The Turkish Turn*, 22.

and dominant traditions. In order to elucidate further this point and in particular the political implications of minor literature I will first explore what is meant by minor politics, then illustrate my argument with reference to a short story by Zafer Şenocak, 'Der Saxophonspieler'.

In *Kafka. Toward a Minor Literature*, Deleuze and Guattari characterise minor literature as follows: 'The three characteristics of minor literature are the deterritorialisation of language, the connection of the individual to a political immediacy, and the collective assemblage of enunciation'.[6] Leaving aside the most often-invoked deterritorialisation of language, I will focus here on their notion of politics and on what is meant by a collective assemblage of enunciation. Paul Patton points out that in their two-volume *Capitalism and Schizophrenia*, Deleuze and Guattari do not provide a defence or critique of political institutions, but 'they outline a political ontology that enables us to conceptualise and describe transformative or creative forces and movements'.[7] The dynamics of capitalism constitute such a movement, however, as Nicholas Thoburn has shown in his study of Deleuze as a Marxian thinker. For Deleuze, as for Marx, the capitalist social machine exercised complete control over the flows of life, leading him to concede the 'impossibility of any easy or given political escape from the infernal capitalist machine, whilst simultaneously positing such possibility and potential on relations formed *within* and *particular to* capitalism itself'. In other words, for Deleuze 'it is the very impossibility of life that compels life'.[8] In terms of my own project, this implies not envisaging a state in which all marginalisation, negative stereotyping and prejudice will be overcome, but looking in the texts for an intense, creative engagement with their dynamics. It also implies a commitment to Deleuze's Spinozist and Nietzschean materialism, to a view of the world not in terms of stable, steady states, but 'as constituted in particular, varied, and mutable relations

6 Gilles Deleuze and Félix Guattari, *Kafka. Toward a Minor Literature*, trans. Dana Polan (Minnneapolis MN: University of Minnesota Press, 1986), 18.

7 See Paul Patton, 'Utopian Political Philosophy: Deleuze and Rawls', *Deleuze Studies*, 1 (2007), 41–59 (42).

8 Nicholas Thoburn, Deleuze, Marx and Politics (London and New York: Routledge, 2003), 3.

of force'.[9] Thus identities, like objects, are the temporary product of a channelling of the flux of matter into 'assemblages' or 'arrangements'.[10] Identities
are never 'finished', but embody difference within themselves as a 'virtuality'
or 'potential' to be actualised in different configurations.

While we always find ourselves in stratified, molar configurations,
occupying more or less coherent subject positions, and inhabiting territory
which is necessary to life, politics emerges in the deviation from norms,
as against the 'major' standard. Here, *major* and *majoritarian* represent a
standard against which everything is judged, *minorities* are subsystems of
the majoritarian norm, fixed in relation to it, and *minor* or *minoritarian*
denote a process of continual and creative becoming.[11] So the minor is not
a group with its own identity, nor is it the constitutive 'outside' of identity,
it is rather a tendency *within* identity, because all identity is always dissipating, major and minor are both tendencies in the flow of life.

If a major politics is based on juridically defined identities (such as
citizenship as the basis of representative democracy), a minor politics is
predicated on the *absence* of a 'people' to represent; it concerns precisely
those who lack the resources of citizenship, recognised histories or shared
cultures.[12] So, whereas discussions of Turkish-German literature are often
contextualised in relation to changes in German citizenship legislation –
implying a direct correlation between *darstellen* and *vertreten* – as *minor*
literary production its intervention is of an entirely different order. Rather
than 'representing' a people (in either sense), minor politics is about their
creation. Simply adding to the electorate in quantitative terms guarantees

9 Thoburn, *Deleuze, Marx and Politics*, 4.
10 An assemblage in Deleuze's terms is a provisional network composed of heterogeneous elements (such as content and expression, semiotic and material components)
 which are capable of producing emergent effects.
11 Mani, *Cosmopolitical Claims*, 9, notes (and occasionally reproduces) the frequent
 conflation of 'minoritarian' with 'minority', whereas a minority is a majoritarian
 formation for Deleuze and Guattari.
12 As Thoburn, *Deleuze, Marx and Politics*, 8, puts it, the minor is 'the creativity of [...]
 those who find their movements and expressions "cramped" on all sides such that
 they cannot in any conventional sense be said to have carved out a delineated social
 space of their "own" where they could be called "a people"'.

no transformation of the majoritarian norm (it could signal complete assimilation of immigrant communities). What is needed is a *qualitative* transformation of the affects, beliefs and political sensibilities of the (majoritarian) people, which amounts to the creation of a *new* people. Minoritarian becomings occur when those who do not conform to the standard change the way that the standard is defined.

Literature can be a site of such transformative and creative practice, and when Deleuze and Guattari insist that 'everything is political' in minor literature, they imply that life and literature are suffused with the same social forces. Whereas in major composition, the social is just a backdrop, and facilitator of molar, individual forms (individual psycho-social types are in the foreground), in minor composition, the social milieu is paramount; there are individual concerns, but no autonomous space of identity: 'Each individual concern is comprised of a conjunction of many different individual concerns of different forms and scales cramped and interlaced together, all of which are in intimate contact with the social forces that traverse and compose them'.[13] That is, the individual subject is never finished or stable, *and* always a composite formation, permeable to the forces of its milieu. This differs radically from a humanist approach to literature in which a personal perspective on the world and individual agency are paramount, and historical forces play a secondary role. The focus on the quotidian, mundane detail in minor composition is not to be understood as a focus on the individual, in any psychological manner; instead, the particular offers a 'cramped space' to be explored, experimented with, and new permutations of its constraints invented. The focus on the particular also means that the politics of minor production are specific to the particular contours of the situation, which suggests to me the importance of proper contextualisation of literary texts.[14] By context I mean *both* past and future dimensions: on the one hand the vitally important 'territorial' history of

13 Thoburn, *Deleuze, Marx and Politics*, 24.
14 In this I diverge from Adelson, *The Turkish Turn*, 13, on the importance of the Turkish contexts of this literature, while I do not treat them as immutable sources or 'roots'.

the Turkish Republic's experience of rapid modernisation, secularisation and labour migration; on the other, the deterritorialising lines of flight immanent to these contexts, anticipating global questions of the present such as the Middle East crisis, the 'war on terror' and the most recent phase of European Islam. The potential for radical transformation and mutation is inherent in the apparent stability of the nation state, individual and collective identities, as their virtual dimension. Thus the temporal orientation of minor literature is toward the future and the actualisation of collective subjects yet to come.

The final characteristic of minor literature is that it is a collective assemblage of enunciation. This refers *not* to the voicing of shared political concerns by particular authors, but to the social character of language itself, which originates not in the psyche of the individual, but in the social institutions they inhabit. In stressing the pre-personal origins of language Deleuze and Guattari pay tribute to Bakhtin's theory of the polyphonic novel, in which multiple social discourses coexist.[15] As John Hughes puts it, the text is 'the event of a non-personal and multiple voice' which passes through author, characters and readers and forms of them a new assemblage, productive of transformation beyond their individual identities.[16] This does not preclude innovation or singularity, the author is both of the milieu that she or he actualises *and* in a position to express a different sensibility or configuration. But the triggering of productive change is brought about by the connection to an assemblage, not by the creativity of the author alone. Thus minor author function is not quite the same as author function for Foucault or Barthes (which serves to produce a coherent individual *oeuvre*), but it is distributed across a milieu, in which the collective and the author are in a process of continual feedback. Together they form a collectivity based not on shared identity or opposition to an

15 Gilles Deleuze and Félix Guattari, *What is Philosophy?*, trans. Graham Burchell and Hugh Tomlinson (London: Verso, 1994), 188.

16 John Hughes, *Lines of Flight. Reading Deleuze with Hardy, Gissing, Conrad, Woolf* (Sheffield: Sheffield Academic Press, 1997), 57.

'outside', but on assemblages of desire and lines of flight.[17] The subject is not, as for Foucault, the product of a disavowed outside such as madness or infamy, but is produced in 'foldings' of the outside, co-present with and corresponding to its outside, which simultaneously offers a constant escape from 'self'.

My reading of Şenocak's 'Der Saxophonspieler' will attempt to demonstrate the openness of the subject to social forces, the 'cramped' situation of creativity, and the exploration of a possible line of flight.[18] The first person narrator of this very short story is the eponymous saxophone-player, a failed writer and moderately successful musician in New York bars, whose professional engagements and journeys to and from work on the underground occupy most of his solitary, semi-nocturnal existence. The sparse plot concerns his overhearing a late-night, fragmentary conversation in the dark hallway of his apartment building, leading him to suspect that a terrorist attack on New York is being plotted in the ground-floor restaurant. The narrative concerns mainly the narrator's response to this situation, and his reflections on the power of imagination to envisage other possible selves. It is characteristic of Şenocak's prose that we have no rounded psychological portrait, not a character with whom we are invited to identify, but rather fragmentary insights into a style of life seemingly detached from yet intimately connected with the city he inhabits. The story begins with an expression of longing for escape from his stagnant life in the city. Aside from his journey to work, he rarely ventures further than five hundred metres from his apartment building in its sixteen-kilometre long street. The mood of the story's opening is one of cramped, repetitive and mechanical existence:

17 A Deleuzian line of flight is defined as 'the threshold between assemblages, the path of deterritorialisation, the experiment' by Mark Bonta and John Protevi in *Deleuze and Geophilosophy. A Guide and Glossary* (Edinburgh: Edinburgh University Press, 2004), 106.

18 Zafer Şenocak, 'Der Saxophonspieler', in *Literatur und Migration*, ed. Heinz Ludwig Arnold (Munich: Text + Kritik, 2006), 30–35. Hereafter references will be given in brackets in the text following quotations.

Ich habe eine ständige Sehnsucht nach der Provinz, die ich zu dämpfen versuche,
indem ich mir einrede, dass die Provinz, von der ich träume, nicht mehr existiert.
Ich könnte an den Orten, die man gemeinhin als Provinz bezeichnet, genauso wenig
mein Leben ändern, wie hier in der Stadt, von der es heißt, sie würde pulsieren wie
keine andere. Doch ich fühle schon lange keinen Puls mehr, weder an irgendeiner
Stelle meines Körpers noch bei anderen Menschen, zu denen ich in engem Kontakt
stehe. Vielleicht sind es auch nicht die Menschen, die für den Pulsschlag einer Stadt
sorgen, sondern die rhythmischen Bewegungen der Apparate, der Kreislauf des Verke-
hrs, der Dietrich der Schlafdiebe, der die intimsten Räume öffnet, für jedermann zu
jeder denkbaren Zeit. (30)

This opening paragraph not only defamiliarises the New York setting, but
also de-humanises it, in ways that eschew a stable, personal point of view,
and point to the pre-personal dynamics operating in the milieu. The city
is a great machine, throbbing not with a human pulse but with the cir-
culation of the traffic and other machinic rhythms, which find their way
into the most intimate subjective spaces. This seems an apt articulation
of the human subject open to, and subject to the forces of its inorganic
environment, rather than closed off from them. Even the unconscious is
not impervious to the rhythms of the city's circulation.

A further, at first disturbing questioning of the organic integrity of the
human subject comes in the narrator's sensitivity to the diseased smell of
the underground carriages in which he and other aimless commuters travel.
This is later revealed as a reference to the AIDS virus, no less prevalent
than it had been, but now controlled by medication, producing an apo-
retic state of incurable health: 'So waren die unheilbaren Gesunden auch
im Publikum, in der Untergrundbahn, in den Geschäften, wo ich meine
Besorgungen machte'. (31) In counterpoint to the machinic rhythms of
the city, therefore, there is the circulation of the virus, mutating so that its
carriers survive to pass it on. The narrator recalls that his own father had
become a judge, believing himself able to stamp out the moral depravity
to which he himself had succumbed, suffering frequent bouts of sexually
transmitted diseases in his youth. (31–32) The futility of such a legalistic
response to physical frailty becomes apparent in a world where sickness
and health are no longer separable categories. The fact of the 'healthy' and
the 'infected' being superficially indistinguishable is later echoed in the

narrator's unsettling reflection that the same is true of the terrorist and the non-terrorist. Thus the narrative unsettles exclusive disjunctive categories of identity, which territorialise the terrorist threat as 'criminal'.[19]

The narrator's apartment building dates from the mid-nineteenth century, and has a history of criminality, its underground passages offering sanctuary and storage of contraband: 'Zur Zeit der Prohibition war das Lokal im Erdgeschoss eine besonders flüssige Adresse gewesen'. (35) With its subterranean vaults, its flow of illegal alcohol and transient inhabitants, the building evokes the Deleuzian 'house', which is at once an enclosed structure and open to the outside.[20] As a model for the work of art/literature, the house stands alone, continuous with human strivings but also independent of the human point of view; it is both the frame of the artwork and the threshold of chaos, the 'cramped' space within which affect is disaggregated from individual, subjective experience.[21] Şenocak's building houses a shifting population, even the ground floor restaurant frequently changing hands and ethnic cuisines. The narrator's encounter with its current Afghan owner occasions the first mention of his own background, even as he denies it and tells the man that he is from Seattle, of Russian parents (which is a variation on his usual 'Italian' lie). But markers of ethnic difference are meaningless, as the narrator reflects that the Afghan could easily be taken for an Indian, just as no-one had noticed that the owner of the previously Indian restaurant had been Taiwanese. (32) He himself resists all ascriptions of ethnic or religious identity, vehemently denying that he is a Muslim, (33) while privately recalling the secularism of his parents back in Tehran at the time of the Shah: 'Ich war stolz darauf, mich nicht preisgegeben zu haben, als Perser, als Muslim, als sonst was. Ich bin doch

19 The implied parallel is between the 'unhealthy' cell attacking the 'healthy' body, which is also an untenable distinction. Exclusive disjunction is the state of a subject resulting from choice between immutable terms (either/or), whereas inclusive disjunction is the structure of the subject which moves between different particular terms in ever new permutations (either, or, or ...). See Thoburn, *Deleuze, Marx and Politics*, 26.

20 See Deleuze and Guattari, *What is Philosophy?*, 179–80.

21 See Claire Colebrook, 'The Work of Art that Stands Alone', *Deleuze Studies*, 1 (2007), 22–40 (31) on the figure of the house in Deleuze's thinking on art.

auch gar nichts von all dem, ein Saxophonspieler bin ich, der noch nie in
seinem Leben in Persien war, nicht einmal in Europa'. (33)

When he overhears fragments of a conversation in Persian in the dark
hallway of the building one sultry August night, the narrator's first thought
is that a terrorist attack is being planned and that he should inform the
police. He then rejects this idea, his fear of annihilation suddenly becoming
an inspiration to write; the 'terrorist threat' is transformed into a compound
of sensations, a sudden unexpected intensity, with himself as a witness,
possible victim, or even undercover informer – his Iranian background
providing the perfect disguise: 'Ich als Muslim, als einer von ihnen. Auch
ich voller Hass auf das weiße Amerika. Gibt es noch ein weißes Amerika?
Fragen wie diese sind nicht erlaubt, bitte nur Sätze mit Ausrufezeichen
formulieren. Sonst gibt es kein Visum für die Unterwelt'. (34) Thus he
imagines his own complicity, slipping into the conspirator's polemical dis-
course, while simultaneously questioning its underlying assumption, and
implying that the criminal's territory also has borders to be policed. Thus
the moment of danger is infused with contradictory forces, but opens up
the potential for a moment of pure affect, exceeding all states of affairs 'to
capture the adventitious time of becoming, the interval of pure suspended
possibility'.[22] All the time he is occupied not with events as they unfold,
but with his own experimental narrative of them; he is no longer afraid
for his own safety, but intrigued as to where the story will take him, its
denouement promising an escape from the limited life he leads: 'Da könnte
ich endlich meine Geschichte zu Ende schreiben und in eine andere Stadt
ziehen. Aber in unseren Tagen ist nichts mehr berechenbar. Nicht einmal
die Terroristen sind es, sie tun so, als wären sie einer von uns. Sie haben
nicht mehr die Maobibel in der Tasche, sondern gleich die Bibel'. (34)

Provocatively substituting 'Bible' for 'Qu'ran', he refers to the frequent
conflation of terrorism with Islam, but resists territorialising the threat in
any *one* religion. He pronounces instead his firm conviction that all religion
is a sexual perversion with undeniable erotic, probably homoerotic appeal,

22 This is Hughes' formulation in *Lines of Flight*, 71 for literature's power to exceed
 actual reality and point to its virtual potential.

with the day of judgement promising untold sado-masochistic delights. At the same time he differentiates between Islamic mysticism's imagining of God as the unattainable beloved, and the new fundamentalisms for which God is 'die Domina, die befehlende, zürnende Kraft, die ab und zu auch Streicheleinheiten verabreicht'. (34) Devotion takes on connotations of sexual abandon, but also of states of potential transformation. These reflections on religion (echoed elsewhere in Şenocak's works) neither condemn nor exonerate it, identifying it rather with states of loving or erotic intensity, intensity which either subjugates the believer or liberates their potential to become.[23]

The narrator's musical occupation and his literary aspirations are intimately connected, both of them intensive forms of expression which go beyond mere communication of a given 'content'. He sees words as the mere detritus of music, 'fallen' sounds which stammer, as contrasted with the sonorous musical refrain: 'Wörter sind nur Abfall der Musik. Wer etwas zu sagen hat, besitzt eine Melodie. Die so genannte Kommunikation ist der hilflose Versuch gescheiterter Musiker sich Gehör zu verschaffen. Ich habe den Beruf des Musikers gewählt, um nicht sprechen zu müssen. Mit meinen Schreibversuchen kam ich überhaupt nicht weiter'. (31) In his otherwise understated, prosaic register, the only poetic moments come when he describes the tones of the saxophone in synaesthetic terms as deep red, and with a heavy, almost rotting fragrance, or short and almost unscented, so that they stick in the ear rather than penetrating into the bloodstream. (30) This interpenetration of sound and body recalls Deleuze and Guattari's view of music as the art form which most consistently transgresses the inside/outside distinction. Following Bergson, they note that 'musical beings are like living beings that compensate for their individuating closure by an openness created by modulation, repetition, transposition, juxtaposition'.[24] Thus it is perhaps significant that the only 'identity' to

23 See Margaret Littler, 'Erotik und Geschichte in Zafer Şenocaks *Der Erottomane*', in *Akten des XI. Internationalen Germanistenkongresses Paris 2005. Germanistik im Konflikt der Kulturen*, vol. 6, ed. Jean-Marie Valentin and Stéphane Pesnel (Bern: Peter Lang, 2007), 267–72.

24 Deleuze and Guattari, *What is Philosophy?*, 190.

which the narrator ever admits is 'Saxophonspieler'. Rather than a Romantic trope of struggling genius, I read this as an indication of his consistency as a character, which is that of a Deleuzian 'refrain', rather than a unified, recognisable substance. As Claire Colebrook has put it, fictional characters are collections of gestures, desires, motifs, a unique way of moving through life: 'The character we encounter is a sign, but not of something that we might know or experience so much as a sign of an entirely different "line" of experience or becoming'.[25]

The story ends with a terse summary; there was no terrorist attack, but an economic recession set in, rendering all employment and commercial activity unstable. (35) The narrator is fired, then hired, and fired again, in accordance with the flows of the capitalist machine. Yet there is also a coda which addresses the role of imagination in opening up the potential to become, and in counteracting memory which keeps one tied to one's origins:

> Ein Fremder braucht viel Einbildungskraft, um zu vergessen, was er hinter sich gelassen hat. Er muss seinen Erinnerungen mit Phantasie entgegentreten. Auch ich phantasierte, um das Herkommen zu vergessen, um abzuschütteln, was mich von meiner Umgebung unterschied. Doch meine Phantasie hatte mich wieder einmal im Stich gelassen. Ich kaufte mir mit meinen Ersparnissen ein Wohnmobil und zog durchs weite Land gen Westen, wie einst die Pioniere. (35)

With a self-ironic gesture of 'going West' the narrator mimics one of the models of Deleuze and Guattari's non-Oedipal 'society of brothers', American New World man, the model of 'the people' without fathers or roots, born of universal immigration. However, as Thoburn points out, this socio-political 'people' was reterritorialised with the birth of the nation in the USA, rendering social-democrat notions of the people redundant: 'Politics thus becomes a process not of the representation of the people but of the invention of "a new world and a people to come"'.[26] Despite the anti-climactic ending, I see the story as endorsing literature's role in

25 Claire Colebrook, *Gilles Deleuze* (Oxford: Routledge, 2002), 107.
26 Thoburn, *Deleuze, Marx and Politics*, 17.

such a politics, with its privileging of imagination as a future orientation, in preference to a rootedness in memory and origins, and with the intimation of literature's potential to set life on a new course. The fact that it ends with the reiteration of a clichéd trope does not detract from its affective, suggestive power, but demonstrates also the subordination of 'the people' to a tale told about 'the past'.

With its fragmentary assemblage of motifs (music, writing, the house, a moment of potentially violent intensity), Şenocak's story presents not a developed 'plot' nor a rounded psychological character, but a focus on the particular in ways which resonate with global significance. In the figure of the second-generation American of Iranian descent, and his ambiguous relationship to a supposed Iranian terrorist plot, we have a contemporary scenario viewed from the unsettling perspective of one for whom the threat is both real, and an opportunity. He may become a victim, but the terrorist attack is in some sense also directed against forces that confine *him* in a society where Muslims and Iranians are objects of fear. He is potentially 'one of them', by virtue of his origins; but he envisages becoming actually one of them, by power of his imagination. While 'nothing happens', the story unsettles notions of exclusive disjunctive identity, suggesting instead a self traversed by impersonal discursive and material forces (the forces of economic recession as well as those of tonal vibration), ready at any moment to launch itself off on a new course. It allows of no utopian outcome, but presents us with a moment of possibility and an intimation of other possible worlds.

Walter Benjamin and Gershom Scholem: On the Theory and Practice of Friendship in Letters

JULIAN PREECE

Walter Benjamin knew the joy that a correspondence could bring, as he reports to Ernst Schön about the letters he was exchanging with Werner Kraft during the First World War:

> Zu den wenigen ständig erfreulichen Dingen gehört ein Briefwechsel den ich seit mehr als einem Jahr fast ununterbrochen mit einem um mehrere Jahre jüngeren Menschen führe, der in einer Stellung in einem Lazarett sich befindet die ihm Denken und Schreiben erlaubt. [...] Ich weiß Ihnen in Ihrer Lage auch nichts Besseres zu wünschen als daß Sie Briefe oft erfreuen mögen und daß auch dieser es soweit er es kann tue. (25 February 1917)[1]

He made many similar remarks over his thirty-year letter-writing career about the enjoyment that he derived from writing and receiving letters from male friends on intellectual subjects.

Benjamin's Collected Letters show that he was always conducting at least one serious correspondence with a fellow intellectual. At any one time there tends to be one which takes pride of place. His friendship with Brecht is as significant as any of these, both in his life and for his work, but it does not leave its mark in letters. Their correspondence is functional,

1 Walter Benjamin, *Gesammelte Briefe 1910–1940*, eds Henri Lonitz and Christoph Gödde, 6 vols (Frankfurt: Suhrkamp, 1995–2000). Also consulted are the three 'Briefwechsel' so far published: Walter Benjamin/Gershom Scholem, *Briefwechsel 1933–1940*, ed. Scholem (Frankfurt: Suhrkamp, 1980); Theodor Adorno/Walter Benjamin, *Briefwechsel 1928–1940*), ed. Henri Lonitz (Frankfurt: Suhrkamp, 1994); and Gretel Adorno/Walter Benjamin, *Briefwechsel 1930–1940*), eds Henri Lonitz and Christoph Gödde (Frankfurt: Suhrkamp, 2005). Hereafter letter dates will be given in brackets in the text following quotations.

peremptory even, which is signalled by the ways they address each other: 'Lieber Brecht', 'Lieber Benjamin'.[2] The warmest letter from Brecht disproves the claim that he disdained Benjamin's different intellectual projects. It expresses unprompted praise for 'Eduard Fuchs, der Sammler und der Historiker', but his editors do not believe that he sent it and it survives as a draft among his miraculously preserved papers.[3] Not saying things to Benjamin preoccupied Scholem at various points.[4]

For writers, intellectual friendships have a purpose. On 2 December 1802 Hölderlin ended a letter to Casimir Böhlendorf with the following words: 'Schreibe doch mir bald. Ich brauche Deine reinen Töne. Die Psyche unter Freunden, das Entsehen des Gedankens im Gespräch und Brief ist Künstlern nötig'.[5] Benjamin included the letter in his anthology of letters from the 'bourgeois century', *Deutsche Menschen*. The majority of the 27 letters are associated with the type or genre of male intellectual 'Freundschaftsbrief'. They not only demonstrate such friendship in action, as many also reflect on their own textual status and the activity of epistolary exchange itself. They are, in other words, letter-writers' letters. One could make many links with Benjamin's own.

Benjamin's greatest epistolary friendship was with Scholem. It was also his longest, stretching from 1915 when they first met to the beginning of 1940, the year of Benjamin's suicide in Port Bou. After Scholem's emigration to Palestine in late 1923, they saw each other only three times, which means that their friendship existed almost wholly in letters for around two thirds of the time that they knew each other. Despite finally using 'Du'

2 On the jealousies and suspicions among Benjamin's other friends caused by this friendship, see Erdmut Wizisla, *Benjamin und Brecht. Die Geschichte einer Freundschaft* (Frankfurt: Suhrkamp, 2004), 19–40.

3 See Bertolt Brecht, *Werke. Große kommentierte Berliner und Frankfurter Ausgabe*, ed. Werner Hecht, Jan Knopf, Werner Mittenzwei and Klaus-Detlef Müller, 30 vols (Berlin, Weimar and Frankfurt: Aufbau and Suhrkamp, 1988–2000), vol. 29, 20.

4 See, for example, Gershom Scholem, *Tagebücher, nebst Aufsätzen und Entwürfen bis 1923*, ed. Karlfried Gründer, Herbert Kopp-Oberstebrink and Friedrich Niewöhner, 2 vols (Frankfurt: Jüdischer Verlag, 2000), vol. 2, 171.

5 Quoted in Walter Benjamin, *Deutsche Menschen. Eine Folge von Briefen* (Frankfurt: Suhrkamp, 1984), 28–29 (29).

from 1921, their tone is reasonably formal, their range of topics restricted. Women and sex are quite off-limits, as are politics. Emotions are bracketed out unless they derive directly from the general set of political, historical circumstances, such as exile from Nazi Germany (for Benjamin) or conflict with Palestinian Arabs (for Scholem). It may be surprising that Benjamin avoids comments on current affairs until they impinge on his activities. But after 1933, as an exiled German critic attempting to publish his work in his own language and get paid for it, this is, of course, all the time.

It has been said that once lovers are apart and communicate in writing, their correspondence becomes their love affair. The letters do not support or document a relationship which is happening elsewhere in real life: they are themselves the real thing.[6] This is surely also the case with other forms of correspondence. At best letters look forward to a physical encounter which will take place outside writing. They encircle its promise or anticipate it with dread. Those written after the letter-writers have met face-to-face give some impression whether it exceeded the possibilities of written communication or fell short. The three meetings with Scholem in 1927, 1932, and 1938, when they discussed topics they had thought about in advance over a period of several days, were sustaining. The week that Adorno spent in Paris in September 1936 positively enhanced his correspondence with Benjamin, leading to the use of first names for the first time. For Adorno the intellectual stimulation would not have come about without the personal dimension: 'Die Weite der Perspektiven, die [die Woche] eröffnete, ist das genauste Äquivalent der menschlichen Nähe in welcher sie spielte'. (To Benjamin, 15 October 1936)

The switches to and fro between life and letters were not always so welcome, however. While Benjamin's private life was probably no more

6 'Liebesbriefe, sagt Roland Barthes, sind keine Korrespondenz – also keine taktische Mitteilung –, sie *sind* eine Beziehung'. Konstanze Fliedl and Karl Wagner, 'Briefe über Literatur', in *Briefkulturen und ihr Geschlecht. Zur Geschichte der privaten Korrespondenz vom 16. Jahrhundert bis heute*, eds Christa Hämmerle and Edith Saurer (Vienna: Böhlau, 2003), 35–53 (41). See also Annette C. Anton, *Authentizität als Fiktion. Briefkultur im 18. und 19. Jahrhundert* (Stuttgart/Weimar: Metzler, 1995), 57.

chaotic than most, it involved divorce, adultery, partner-swapping, and all the concomitant jealousies. During spring 1921 he and Dora are visited by Ernst Schön and his partner Jula Cohn. At the end of the spring, Dora has switched to Ernst and Walter to Jula. Scholem draws the parallel with *Die Wahlverwandtschaften*.[7] From Benjamin's letters we know there had been a difficult moment two years earlier when he discovered that Jula remained on close terms with his ex, Grete Radt. He tells Schön that he is particularly perturbed that Grete should be 'taking part' in Dora's friendship with Jula (presumably because Jula is showing Grete Dora's letters to her). Furthermore he finds it inappropriate that the matter of his relationship with Grete should have been brought up in a letter. (To Schön, 19 March 1919) In advance of the partner-swap, the great allegorist argues that they can sort all this life business out if only they can get the epistolary protocol straight. On paper everything is so much easier to order.

Benjamin's first correspondence, with his schoolfriend Herbert Blumenthal, ends because the friendship is not working as he wants it to. Benjamin locates the problem in Blumenthal's epistolary attitude to him. He begins his last letter before the break: 'Ich freue mich sehr daß Du an mich geschrieben hast. Dein Brief hat aber die Form einer sachlichen Mitteilung und damit geht er über einige tiefe Voraussetzungen hinweg die meine Antwort in Hinsicht auf uns beide machen muß'. (Late 1916) Blumenthal has contravened the unwritten rules of such a correspondence as Benjamin is interested in conducting with him. There may be any number of reasons for this which lie outside their letters, but the transgression expresses itself in or through the letters themselves.

Benjamin's friendship and correspondence with Werner Kraft ended for similar reasons. Here he claims that it is Kraft's behaviour in conversation, his failure to respond to his interlocutor's expressed opinions, which prompts the break. Kraft was nearly four years younger, had not yet finished his studies, and quite in awe of Benjamin. 'Jeder Brief von ihm war für mich

7 Gershom Scholem, *Walter Benjamin. Die Geschichte einer Freundschaft* (Frankfurt: Suhrkamp, 1975), 120–21.

ein Ereignis', he recalls.[8] Kraft believes that their differing views on poetry, in particular his admiration for Rudolf Borchardt, made Benjamin impatient. He seems to have been surprised when he received these words:

> Der Umgang und das Gespräch mit meinen Freunden gehört für mich zu den ernstesten und aufs strengste zu behütenden Dinge. Dies ist so selbstverständlich, daß es mir peinlich ist, es aussprechen zu müssen – durch Sie dazu gezwungen zu sein. So wie ich selbst jedem gesprochenen Wort in meinem Denken Folge zu geben gewohnt bin, erwarte ich es auch von andern. Es tut mir weh Ihnen sagen zu müssen, wie oft Sie seit Jahren diese Forderung, die Sie sich stellen müßten, verletzten. (copied by Benjamin to Scholem, 16 February 1921)

Whatever the personal or intellectual differences between the two men, Benjamin argues that Kraft infringed the rules governing reactions to the other's views. Thus while the friendship flourished in writing through the war, it did not survive the transfer to real life. Both the termination and the return of the letters are actions more reminiscent of a love affair than a friendship.

In writing, misunderstandings can arise which could never occur in person and offence can be taken more easily. In the infancy of their exchange, Scholem misreads a nuanced comment comparing him with another friend (Felix Noeggerath), whom Benjamin referred to as 'das Genie'. After he has made his complaint, Scholem receives a teacherly explanation, encouraging him to take another look at Benjamin's text: 'Lesen Sie die Stelle bitte nochmals: Sie tragen an dem Mißverständnis selbstverständlich keine Schuld aber Sie werden finden daß die Stelle irgendwie doppelsinnig war; und ich meinte gerade dieses: daß zwischen uns ein ganz anderes völlig positives Verhältnis stattfinde als zwischen mir und dem Genie'. (7 December 1917)

There are elements of romance in the early phase of the friendship. Scholem notes Benjamin's gaze in his direction when they see each other for the first time outside the meeting where they heard each other make

8 Werner Kraft, *Spiegelung der Jugend* (Frankfurt: Suhrkamp, 1973), 71–83 (78).

interventions.[9] His feelings and generic reference points, as he notes them in his diary, are, however, all over the place. As their correspondence has just reached its first joyful climax in the spring of 1918, as he is preparing to move to Berne to be with Walter and Dora, he records reading Clemens Brentano's letters to Sophie Mereau (but not Mereau's to Brentano even though they are published in the same book), and resolves to read Goethe's to Frau von Stein next.

> Ich wünsche, die Liebesbeziehungen der Menschen in ihrer dauernden Verschieden-
> heit zu erkennen. Es ist jede Liebe anders, und wenn ich an meine große Liebe zu
> Grete denke, weiß ich, wie sehr hier etwas ganz Neues und Unglückliches in meinem
> Leben aufsteht. Ich habe das Bedürfnis, sehr viel an Walter zu schreiben. Ich sehne
> mich unbeschreiblich nach ihm. Erich Brauer muß am 25. die Grenze überschreiten,
> in Basel, o der Glückliche. Ich werde krank, wenn ich daran denke [...] Escha hat
> einen Brief geschrieben ...[10]

It is Escha rather than Grete that he will marry, but Walter, sandwiched here between the two women, that he is excited about. And well he might be. In his longest letter to date, Benjamin had suggested that they use first names to celebrate Scholem's leaving the army. (6 September 1917) An even more substantial letter the following month (22 October 1917), which ranged from Kant to Cubism, is included with his essay on Dostoyevsky's *The Idiot*. Scholem interprets this piece of literary criticism to be secretly about Benjamin's former closest friend, the late Christoph Friedrich Heinle, a poet who had killed himself at the beginning of the war. The loss had a profound effect on Benjamin, who was still arranging Heinle's *Nachlass* years later. Now Scholem's emotional intuition overwhelms him and he replies with the pathos only a Germanist could summon up: 'Mir ist seitdem ich Ihren Brief bekommen habe oft feierlich zumute'. (3 December 1917) His feelings for his dead friend were recognised now by his new one.[11]

9 'Ich komme ins Bibliotheks-Katalogszimmer, steht da mein Herr Benjamin und
 kuckt auf und kann seine Augen überhaupt nicht mehr von mir trennen'. (16 July
 1915) Scholem, *Tagebücher*, vol. 1, 131.
10 17 March 1918. Scholem, *Tagebücher*, vol. 2, 154.
11 On the importance of this letter, see Scholem, *Tagebücher*, vol. 1, 66–67.

All extant letters by Benjamin from the following spring of 1918 are to Scholem. His tone is euphoric, indeed his mood is getting in the way of his ability to express himself. He has too much he needs to tell him. (31 January 1918) But just as they seemed to have reached the limits of communication, they achieve perfection. On 23 February 1918 Benjamin thanks Scholem for his words and then writes, 'Es ist der Stil: die Fülle des Verantwortungsgefühls die Deutlichkeit und die Beschränkung die mich an Ihren Zeilen eben deswegen entzückt weil sie mir ganz und gar erwidert. "Eine richtige Antwort ist wie ein lieblicher Kuß" las ich dieser Tage bei Goethe'. Correspondence cannot get better than this and from here the friends can only go in one direction. Benjamin's next letter of 30 March is rather disjointed. A fortnight later, just as he is preparing to move to Berne to be closer to his recently married friend, Scholem thinks that he discovers why. Dora was on the point of giving birth. Evidently she has been pregnant since the previous summer. While Scholem is the first person outside the family to hear about the birth, he had known nothing about the pregnancy.

The year between April 1918 and April 1919 that the two men spend in close proximity in Muri on the outskirts of Berne cements the foundation of the friendship, but it was not plain sailing. The raw naivety of Scholem's diary captures the problems more effectively than the memoir he wrote more than fifty years later. In the memoir he reports being horrified by the rows that the new parents have in his presence, which by the autumn risk undermining his respect for his friend.[12] It is not only Dora who has come between them.[13] Scholem gives an account of an evening with a third male friend, Erich Brauer. Because it is impossible to get any kind of a conversation going with him, Scholem and Benjamin end up talking to each other. The whole evening is 'ein entsetzliches débacle'. But in a heated exchange a few weeks later, Dora blames Scholem for it.[14] Before

12 Scholem, *Geschichte einer Freundschaft*, 98–99.
13 7 October 1918. Scholem, *Tagebücher*, vol. 2, 395.
14 3 November 1918 and 21 December 1918. Scholem, *Tagebücher*, vol. 1, 402 and 417.

leaving for Switzerland he had expressed his jealousy of Brauer travelling there before him.

Once the messy business of Scholem's year-long stay has faded in the memory, correspondence gradually puts their friendship back on an even keel. But in the summer of 1923 when both are in Berlin, Scholem's repeated cancelling of planned meetings results in a row which could have led to a permanent rift. It is Scholem's disrespect for formalities which caused it. When he leaves Germany later that year, Benjamin positively relishes the prospect of switching the friendship to letters. He sets out his ambitious hopes: 'Lieber Gerhard es ist nicht meine Meinung, daß die lange Frist, die ich diesmal zur Antwort verstreichen ließ, das Zeitmaß unseres Briefwechsels andeuten soll [...] (I)ch hoffe, daß unsere Korrespondenz ein Tempo finden wird, bei dem wir uns nicht um allzuviel Wesentliches betrügen'. (5 March 1924)

Letters are from now on all they have. Tension can help to propel any exchange forward. It breaks through the surface more than a decade later, once Benjamin is beginning to establish himself in Parisian exile. He is offended by Scholem's apparently sloppy enquiry apropos his essay, 'Zum gegenwärtigen gesellschaftlichen Standort des französischen Schriftstellers'.

> Soll das ein kommunistisches Credo sein? Und wenn nicht, was eigentlich ja? Ich muß Dir gestehen, daß ich in diesem Jahr schon überhaupt nicht mehr weiß wo Du stehst. Es ist mir nie gelungen, trotz aller Versuche, an die Du Dich erinnern wirst, auch früher zu einer Klärung dieser Deiner Stellung mit Dir zu gelangen [...] Aber Du weißt das alles ja viel besser als ich. Du hast ja all meine intensiven Fragen, die mir durch keine Brechtschen 'Versuche' beantwortet worden sind, in Deiner inneren Registratur. (19 April 1934)

The background is complicated. For the last ten years Scholem had wanted to win Benjamin for studies in Judaism. He even arranged a scholarship for him to learn Hebrew with a view to bringing him to Palestine, but Benjamin gave up the lessons and never seriously contemplated the move. Similarly, Scholem had little time for conventional Marxism. Why anyone should read Brecht was beyond him. Until he met them in New York in 1938 he was suspicious of Benjamin's associates at the Institute for Social

Research because of the influence they exerted on Benjamin's intellectual interests.

In his response of 6 May 1934, Benjamin surrounds his distress in another explanation of the unwritten rules of a correspondence between friends:

> Aus Erfahrung wissen wir beide, welche Behutsamkeit der bedeutsame Briefwechsel fordert, den wir einer jahrelangen Trennung abringen. Diese Behutsamkeit schließt keineswegs aus, daß schwierige Fragen berührt werden. Aber das können sie nur als persönlichste. Soweit das geschehen ist, sind die betreffenden Stücke – das kannst du sicher sein – in meiner 'inneren Registratur' wohl aufbewahrt. Deiner letzten Frage kann ich das nicht versprechen: sie scheint mehr einer Kontroverse zu entstammen als unserm Briefwechsel. Daß wir den kontrovers nicht führen können, liegt auf der Hand. Und wenn in seinem Verlaufe Bestandstücke auftauchen, die so eine Behandlung nahe legen, so gibt es – scheint mir – hier für seine Partner kein anderes Verfahren, als sich an das lebendige Bild zu wenden, das einer von dem andern in sich trägt. Ich denke, daß das meinige in dir nicht das von einem Manne ist, der leicht und ohne Not sich auf ein 'Credo' festlegt.

Scholem's formulation perhaps lacked elegance and is an inadequate response to a piece of intellectual work. For a reader of their exchange, who follows it as a narrative, there is a logic to his question occurring at this point on this matter and to Benjamin's hurt response. Since Benjamin's exile, Scholem has shown forbearance, offered various sorts of help, and concentrated on his plight. Now he has secured him a commission to write an essay on Kafka, which provides them with a topic that they can discuss fruitfully. He can finally relax and lets out a hint of his views on those subjects of Benjamin's writing of which he does not really approve.

Benjamin took his time over his reply. 28 April 1934, when he began his draft, was a busy day of letter-writing, as we can now see if we switch from the Benjamin-Scholem correspondence to the Complete Letters. The two collections provide very different narratives. On this day Benjamin had unaccustomed access to a typewriter, which is why the draft survives (usually his letters to Scholem are handwritten). One letter is to the reviews editor of the *Frankfurter Zeitung*, in which he requests an advance, asks why a hitherto free contributor's subscription has been deducted from his last payment, and offers a review of Adorno's book on

Kierkegaard. Another letter is to Klaus Mann, editor of the newly founded exile journal *Die Sammlung*. The longest letter of the day is to Adorno. It is also about money and journalistic projects which have not borne fruit. He explains his new *nom de plume* (backwards it spells LATEO, meaning in Latin 'ich bin verborgen'). He then leaves the letter to Scholem for another eight days, perhaps unsettled that he should be using a typewriter for his 'Duzfreund'.

Really, it is Benjamin who is flouting a convention, that important one that requires both parties to remember what they have previously written to each other. The pair had argued over this same point in 1931. Benjamin wrongly remembers that he wrote to Max Rychner on the subject, whereas in fact it had been Scholem. Scholem's own letter survives because Benjamin filed it with other theoretical papers that he took with him from Berlin.[15] The rift is quickly mended and Benjamin excuses his lapse of memory: 'Ein Gedächtnis, welches die Eindrücke unabsehbar wechselnder Lebensumstände zu verarbeiten hat, wird selten so zuverlässig wie eines sein, das durch Stetigkeit unterstützt wird'. (9 July 1934) These special circumstances are on both their minds and make it necessary that both work harder at their letters to each other than they had done.

Benjamin's epistolary etiquette was refined in his own letter-writing practice and came partly from his reading of other writers' letters, which was extensive. As a reader he preferred 'Briefwechsel' to 'Briefe', as he told Schön. (19 September 1919) His last letter to Adorno (7 May 1940) is a mini-essay on the correspondence between George and Hofmannsthal. His last major letter to Scholem concludes their discussion of Kafka, which they began in the late 1920s, with a comment on the role that Max Brod played in Kafka's life. Benjamin finds it difficult to forgive Kafka for his friendship with Brod and cannot forgive Brod for his recently published biography of Kafka. The antipathy is, for sure, partly motivated by the role that Brod played in managing Kafka's estate, not to mention his failure as the *Feuilleton* editor of the *Prager Tagblatt* in the 1930s to publish Benjamin's work. As

15 His letters of 30 March 1931 and 6 May 1931 are reproduced in Scholem, *Geschichte einer Freundschaft*, 283–87 and 291–92.

Benjamin's own personal circumstances are becoming more desperate, he tells Scholem that he is becoming more convinced than ever that humour is the essence of Kafka's writing. This is why he needed a straight man, a 'Hardy' to his own 'Laurel'. (4 February 1939) Scholem and Benjamin is in some ways no less odd a pairing. The role he played with respect to Benjamin's writing is similar to Brod's with respect to Kafka's.

One unusual feature of the correspondence is that it appears to have been one between equals and was not motivated on either side by the prospect of gain. They both wrote regularly and at appropriate length. For the period after March 1933, for which both parts have survived, there are sixty-one from Benjamin and fifty-five from Scholem. Anything which covers under three to four pages in print is not considered by either of them to be 'a good letter'. There is a dialogue of sorts taking place and neither likes to write until a response to his last letter has been received. They complain if significant passages in that last letter have not been addressed. In particular other pieces of included writing, whether draft or off-print, have to be honoured with comments. This is what Benjamin complains about above and what Scholem finds increasingly difficult. As a busy academic pioneer at the new Hebrew University of Jerusalem, he was always going to find it hard to keep up with his friend's varied interests, most of which had nothing to do with his own specialism. There is often nothing that he can say beyond a few words of general encouragement. Scholem's understanding of literature was rudimentary (as his baffling comparison on 2.5.39 of the last chapter of Brecht's *Dreigroschenroman* with Kafka's 'Im Dom' chapter in *Der Process* shows). While he was extremely productive in the 1930s, his preferred language was Hebrew, not German, which Benjamin cannot understand. Apart from their discussion of Kafka, their discussions are not profound and serve an emotional rather than an intellectual function.

The appearance of equality is deceptive. Benjamin is the senior partner and the focus of the letters. Scholem ran book-buying errands for him when he was outside Germany, in Switzerland during the First World War or Vienna shortly afterwards, continuing even from Palestine when Benjamin was in Paris. In the imaginary university of Muri whose affairs they discuss regularly, Benjamin is the Rektor, Scholem sometimes a junior member of

the Faculty, sometimes the 'Pedell (caretaker – J. P.) am religionsphiloso-
phischen Seminar'.[16] While he got promotions which coincided with his
progress in his real career, the distinction is sharp. Benjamin was five and a
half years older. His background was the 'Großbürgertum' in Berlin's leafy
western districts, whereas Scholem stresses that he was 'kleinbürgerlich' and
from the traditionally Jewish working-class Scheunenviertel.[17] It may be
a telling image of Benjamin's Parisian isolation and the imperilled state of
German criticism that the Zionist pioneer Scholem is charged by him to
keep an archive of his papers, even with providing him with materials he
had lost or which had been stolen. Yet Scholem was looking after Benjamin's
papers shortly after they first met. (Benjamin to Scholem, 30 June 1917)

The last letter in *Deutsche Menschen* possibly gives a clue about the
friendship. It is from Franz Overbeck to Friedrich Nietzsche, that is, from
a correspondence Benjamin had mentioned several times when he was
first reading it towards the end of the First World War. (to Scholem, 23
December 1917, to Schön, 28 December 1917)[18] What interests him is not
the inequality as such between the two men but the essential and underes-
timated role that partners such as Overbeck can play in the production of
the canonical *oeuvre* by the more gifted friend. Arrogance was not one of
Benjamin's failings. There is no sign that he was using Scholem in this way
and, had he done so, their friendship is unlikely to have worked. But it is
for this role that Scholem will ultimately and rightly be remembered.

16 Scholem, *Geschichte einer Freundschaft*, 18.
17 Scholem, *Geschichte einer Freundschaft*, 17.
18 Overbeck to Nietzsche, 25 March 1883, in *Deutsche Menschen*, 85–87.

The Young Brecht's Predicament in *Tagebuch No 10*

STEPHEN PARKER

More German death and letters. For Rhys, who loves the comedy in it all.

Amongst the voluminous material that has appeared in recent decades, *Tagebuch No 10*, first published in 1989, stands out as Brecht's earliest surviving literary work.[1] Although its discovery has been hailed 'ohne Einschränkung als besonderer Glücksfall', since it offers a rare insight into the formative years of one of Germany's great writers, it has attracted only limited critical attention.[2] However, the diary suggests lines of enquiry with enormous potential for the biographical study of Brecht's life and work.[3] The fifteen-year-old Eugen made entries almost daily from May to December 1913, producing nearly a hundred pages of published text. The boy records life at home and at school, his friendships, his reading and the state of his health. In contrast to Brecht's highly stylised, later diaries, a

1 Bertolt Brecht, *Werke. Große kommentierte Berliner und Frankfurter Ausgabe*, eds Werner Hecht, Jan Knopf, Werner Mittenzwei and Klaus-Detlef Müller, 30 vols (Berlin, Weimar and Frankfurt: Aufbau and Suhrkamp, 1988–2000), vol. 26, 7–103. Hereafter references to this edition will be given in brackets in the text following quotations.

2 Jürgen Hillesheim, 'Tagebücher', in *Brecht Handbuch*, ed. Jan Knopf, 5 vols (Stuttgart and Weimar: Metzler, 2003), vol. 4, 416–24 (416).

3 The most recent extensive biographies are: Werner Mittenzwei, *Das Leben des Bertolt Brecht. Oder der Umgang mit den Welträtseln*, 3rd edn, 2 vols (Berlin and Weimar: Aufbau, 1988); and John Fuegi, *The Life and Lies of Bertolt Brecht* (London: HarperCollins, 1994). Mittenzwei's work pre-dates publication of the diary, while Fuegi makes only limited use of it.

much more naïve, confessional mode informs *Tagebuch No 10*, accompanied
by a lyrical self manifestly close to autobiographical experience. The diary's
eighty poems, interspersed with ambitious plans and drafts of dramas and
prose works, betoken the prodigious productivity of a compulsive writer,
eyeing future greatness. His admiration for the work of Dehmel, George,
Hofmannsthal, Liliencron and Verhaeren shows an embryonic taste that
is inevitably coloured by pre-1914 literary trends.[4] Indeed, by opening a
window on Brecht's compositions and his socialisation in Augsburg in that
Swabian-Bavarian corner of the German Empire on the eve of the First
World War, *Tagebuch No 10* re-grounds our understanding of his artistic
trajectory and individual development. The established image of the young
Brecht as *Bürgerschreck* – outspoken, street-wise and relishing polemical
exchange – captures elements of a self from the latter part of the War and
beyond, who attacked German chauvinist militarism, underpinned by a
mendacious Christianity and a compliant bourgeoisie, which brought
defeat and national humiliation. The diary reveals instead a sickly, nervous
adolescent, who is tormented by the fear of death from heart failure and
who from early childhood struggled with a tic on the left side of his face,
keeping it in check with a grimace.[5] The debilitating nervous and physical
ailments of this strange 'Sorgenkind'[6] clashed with the poet's certainty of
his calling, producing huge tensions within and a propensity to extreme

4 Hitherto, Brecht's early work has generally been read in terms of its anticipation
 of his later development. Hillesheim and Ronald Speirs have presented the most
 extensive studies to date of *Tagebuch No 10* which depart from this trend. Speirs'
 contributions are discussed below. In '*Ich muß immer dichten*'. *Zur Ästhetik des jungen
 Brecht* (Würzburg: Königshausen & Neumann, 2005), Hillesheim argues (25 ff.) that
 the evidence in *Tagebuch No 10* of hypersensitivity and hypochondria in the young
 Brecht merits analysis in relation to *fin-de-siècle* Decadence. Hillesheim's comparison
 and contrast of Brecht with Thomas Mann (35–40) is arguably less fruitful than a
 comparison would prove to be with the above poets and with other poets read by
 Brecht, including those who featured in his school curriculum.
5 See the photo section between pages 288 and 289 in Werner Frisch and K. W.
 Obermeier, *Brecht in Augsburg* (Berlin and Weimar: Aufbau, 1975).
6 Walter Brecht, *Unser Leben in Augsburg, damals. Erinnerungen* (Frankfurt: Insel,
 1984), 349.

mood swings.[7] He would later capture this propensity in his self-charac-
terisation as 'melancholerisch'. (26, 242) Like other similarly afflicted art-
ists such as Henry James and Georg Büchner, he was plagued by thoughts
of the transience of life and viewed the fulfilment of ambition as a race
against death.[8] Time and again in his diary he addresses his predicament
and seeks ways to overcome it.

The chauvinist trinity of God, *Kaiser* and Fatherland, which was incul-
cated at home, in school and at church, is reproduced with evident sincer-
ity in his early poetry. Mediated by his father's strong nationalism and his
mother's fervent Protestantism, his exposure to this toxic mix was little
different from the experience of other adolescents across pre-war Europe.
The impact of Brecht's upbringing within South German Protestant Pietism
in particular remains understated despite Eberhard Rohse's pioneering
research.[9] The clergymen from the family church of the Barefoot Monks
taught Brecht religion throughout his upbringing, both in school and at
church, within a Bavarian system that united church and state in an unyield-
ing spiritual and secular dogma.[10] The system ensured that the dogma was
reinforced in German lessons. The Franciscans drilled the earnest young
believer in the catechisms that he learnt by heart for his Confirmation in
1912.[11] His recitation from *Brief an die Hebräer* (13, 9) – well-known from
its use by Brahms in *Ein deutsches Requiem* – was probably selected, in con-
sultation with his mother, to combat worrying instances of free thinking

7 See Ronald Speirs, '"Kalt oder heiß – Nur nit lau! Schwarz oder weiß – nur nit
 grau!" Melancholy and Melodrama in Brecht's Early Writings', in *Young Mr Brecht
 Becomes a Writer. The Brecht Yearbook 31*, ed. Jürgen Hillesheim (Madison: University
 of Wisconsin Press, 2006), 43–62 (45).

8 For a discussion of Brecht's treatment of transience, see Ronald Speirs, 'Die Meisterung
 von Meister Tod', in *Brecht and Death. The Brecht Yearbook 32*, eds Jürgen Hillesheim,
 Mathias Mayer and Stephen Brockmann (Madison: University of Wisconsin Press,
 2007), 31–56.

9 Eberhard Rohse, *Der frühe Brecht und die Bibel. Studien zum Augsburger
 Religionsunterricht und zu den literarischen Versuchen des Gymnasiasten* (Göttingen:
 Vandenhoeck & Ruprecht, 1983).

10 Rohse, 32.

11 Frisch/Obermeier, 46.

and to steady his troublesome heart: 'Lasset euch nicht mit mancherlei und fremden Lehren umtreiben, denn es ist ein köstlich Ding, daß das Herz fest werde, welches geschieht durch Gnade, nicht durch Speisen, davon keinen Nutzen haben, die damit umgehen'.[12]

In his early school years Brecht was a quiet pupil, a bit of a weakling.[13] However, in 1912–13, he began to develop 'sehr eigenwillige Gedanken', and his teacher Richard Ledermann, 'vermochte mit Brecht im Deutsch-hunterricht nichts Rechtes anzufangen'.[14] Brecht's composition about the Italian-Turkish war – 'Die Italiener sollen Prügel bekommen,/ Zu diesem Entschluß bin ich gekommen./ Die Türken sollen nicht den Mut verlieren,/ Wenn auch schon Tripolis verloren' – drew Ledermann's response, 'Sieh mal an, ein angehender Dichter unter uns'. Lehmann declaimed his own compositions in the school's ritual celebration of the Christian mission of German military greatness.[15] In 1913, Brecht participated in the centennial celebration of the Wars of Liberation. He took part in physical education and sport at school, as well as in military training in the local *Wehrkraft*, until, to his dismay, such activity was forbidden on account of his heart.[16] However, he excelled at cerebral games that mimicked military strategy, insisting always on being the great commander-in-chief, Frederick the Great or Napoleon, and instructing his 'generals', played by his friends, in his battle plans.[17] Like his revered Stefan George, (26, 75) he regarded

12 Rohse, 51.

13 Frisch/Obermeier, 31.

14 Frisch/Obermeier, 44. The quotations immediately following are from the same source.

15 Frisch/Obermeier, 57.

16 A diary entry on 30 May 1913 suggests that the ban on such activity was quite recent: 'Endelin sehe ich nicht mehr. Neulich sagte er: "Aber kannst du in die Militärschwimmschule, du bist nicht mehr in der Wehrkraft!" Das kränkte mich sehr'. (26, 19) Without reference to a source, Werner Hecht's *Brecht Chronik 1898–1956* (Frankfurt: Suhrkamp, 1997) contains the following under 21 May 1912, 'Wegen seiner Herzbeschwerden darf er sich nicht an den sportlichen Wettkämpfen beteiligen'. (15)

17 Frisch/Obermeier, 32.

the Poet and the Warrior as matchless peers, pursuing their single-minded visions remote from the teeming masses. (26, 80)

His extreme ambition and mortal fears are enacted obsessively in portrayals of heroic individuals – be it Alexander the Great (26, 38–40) or Christ (26, 89) – confronting their own final trial in scenes of death and, frequently, transfiguration that echo the Passion, which so enthralled him. Similarly, 'Bannerlied' (26, 34) and 'Die Husaren' (26, 35) celebrate German soldierly sacrifice in the Wars of Liberation and the Thirty Years' War. Imagery of struggle with violent storms within the individual and in the external world populates his imagination, amounting to a recurrent metaphor for his life experience.[18] Ronald Speirs and Carl Pietzcker have highlighted the young Brecht's attempts in his writing to 'master' his condition through the articulation of frequently aggressive acts of will, viewing this as characteristic of the later Brecht, too.[19] While Speirs grounds his argument in an illuminating close reading of Brecht's poetry and diaries, venturing the argument that the young Brecht's writings display the characteristics of a 'Saturnine melancholic', Pietzcker delves into the biographical circumstances informing Brecht's work by means of psychoanalytic theory.[20] Pietzcker presents the challenging thesis that throughout his life Brecht suffered from cardiac neurosis, the origins of which lay in his early relationship with his mother, and that he responded to his suffering in a 'proactive' fashion.[21] Sufferers, Pietzcker maintains, are faced with an essential choice, either to acquiesce in the neurosis or to combat it 'counterphobically' through a pattern of behaviour that, in

18 In '"Kalt oder heiß – Nur nit lau!"', Speirs points out that Brecht's 'early poems are filled with such images of storms'. (52)

19 See Speirs, '"Kalt oder heiß – Nur nit lau!"', Speirs, 'Die Meisterung von Meister Tod', and Carl Pietzcker, *'Ich kommandiere mein Herz'. Brechts Herzneurose – ein Schlüssel zu seinem Leben und Werk* (Würzburg: Königshausen und Neumann, 1988).

20 Speirs' discussion of Brecht and Saturnine melancholy is in '"Kalt oder heiß – Nur nit lau!"', 44 ff. Speirs and Pietzcker's theses, in some respects complementary, merit scrutiny beyond the confines of the present paper.

21 Pietzcker necessarily relies principally on psychoanalytical theory rather than on empirical evidence in his discussion of the infant's relationship with his mother.

effect, denies its reality. Drawing on a wealth of material from later diaries and works, though without the benefit of *Tagebuch No 10* or of the latest Brecht edition, Pietzcker argues that Brecht's writings reveal his habitual, counterphobic response to his neurosis.[22] Whether or not we accept the psychoanalytical premise, the identification of this combative response to a condition that undoubtedly has a neurotic dimension contributes much to our understanding of Brecht's art and life.

Yet, as Pietzcker acknowledges, his thesis can provide only a partial understanding. The Brecht edition contains the information that from early childhood Brecht suffered from an organic complaint, cardiac dilatation, though no source of a diagnosis is given. (26, 496) He spent summers with his ailing mother at various sanatoria, among them Bad Dürrheim, Königsfeld and Bad Steben. (26, 496) Brecht always accepted the diagnosis of cardiac dilatation, noting in his journal in 1944, for example, that his heart 'durch Schwimmen und Radfahren etwas verbreitert war'. (27, 200) Earlier he had claimed to Arnolt Bronnen, with characteristic bravado, 'Von Jugend an kühn (in meinem dreizehnten Lebensjahr erzielte ich durch Verwegenheit einen nachweisbaren Herzschock)'. (28, 188) It remains to be established whether he was x-rayed as a child. If not, without other, more recent diagnostic technologies, any diagnosis depended largely on the outlook of the doctor.[23] Even though Brecht died following a heart attack, when arteriosclerosis – typical of the ageing process – was identified, a link to childhood heart dilatation appears not to have been established.[24] What is certain is that to the end of his life Brecht remained distressed by a condition that repeatedly threatened death, only for him to survive, prompting the fear that after an attack he might be buried alive. The morning after his

22 Pietzcker, 13. See too now Hillesheim, *'Ich muß immer dichten'*, who argues (23 ff.) that *Tagebuch No 10* substantiates Pietzcker's thesis.

23 I should like to thank Dr Carsten Timmermann for his comments on the issues dealt with in this section.

24 Letter of 14 August 1956 from Dr Hennemann to Dr Schmidt, in Pietzcker, 22, footnote 49. Intriguingly, Brecht's childhood friend, Otto Müllereisert, was one of the doctors who tended him in his final days.

death, his doctors followed his instructions, cutting open his corpse and slitting his aorta before the steel coffin was sealed for burial.[25]

The boy's diary records his anguish and confusion, as he obsessively registers his frequently exaggerated responses to pain, which was not restricted to his heart, and his awareness that others found his behaviour histrionic: 'Die folgende Nacht war miserabel. Bis 11 Uhr hatte ich starkes Herzklopfen. Dann schlief ich ein, bis 12 Uhr, da ich erwachte. So stark, daß ich zu Mama ging. Es war schrecklich. Endlich schlief ich ein. Am anderen Morgen [...] schleppte ich mich in die Schule. Nachmittags kehrte ich am Kreuz wieder um. Herzklopfen!'. (26, 9–10) He is terrified that he may die at any moment: 'In der Nacht hatte ich zuerst entsetzlich Herzklopfen, dann wurde der Schlag ganz leis und schnell. Papa wachte lange am Bett. Ich hatte Angst. Eine schreckliche Angst. Die Nacht war endlos! [...] Infolgedessen daheim geblieben. Vormittags kam der Arzt. Ein ganz junger, da Müller verreist war. Er untersuchte genau: nervöses Leiden! Ich soll nur wieder in die Schule. Das mache absolut nichts! Hm! Ich war sehr erbaut davon'. (26, 14) The young doctor registers not heart dilatation but a nervous complaint as the cause of his heart palpitations. This diagnosis clearly riled Brecht – his facial tic was settling in adolescence – but it was probably not unwelcome to his parents. They were caring for him as if he were a toddler at a time when their own health was a real cause for concern.

The boy is plagued by further complaints: 'Ab und zu ein wenig Kopfweh. *Angst*'; 'Habe Katarrh. (!)'; and, 'Katarrh schrecklich'. (26, 46/50/50) He then has a particularly nasty turn, 'Als ich heut früh um 8 Uhr vor der Schule mich in der Bank umdrehte, gab's mir im Rücken einen Ruck. Ich konnte nicht mal atmen. Der Schmerz beim Atmen dauerte bis 10 Uhr. Dann wuchs er. Ging heim ins Bett. Abends konnte ich kaum mehr Luft kriegen. Herz gut'. (26, 50) The bedridden boy receives another visit from the doctor, this time Müller, who adds bronchitis to his patient's list of ailments: 'Trockene Broncheritis. Interessante Krankheit. Schnupfen kann

25 Mittenzwei, *Das Leben des Bertolt Brecht*, vol. 2, 664. Mittenzwei dismisses these instructions as insignificant, on the grounds that they are out of step with everything else that is known about Brecht.

jeder haben. Wer Broncheritis!'. (26, 50) The doctor's knowing gloss on his diagnosis of his hypochondriac patient is not lost on the diarist. Much to his parents' displeasure, the boy continues to stay off school,

> Heute von der Schule daheim. Sonst sagt Mama, wenn ich noch mal krank werde: 'Hättst du gefolgt. Ich hab's jetzt wieder'. Natürlich. Und heut vormittags sagt sie: 'Warum bist du jetzt nicht in der Schule?' Es wär mir angst, krank zu werden. Papa ist unwirsch und Mama jammert immer über die viele Arbeit. Und diese Aufgeregtheit! Auf die vier Wochen ist's mir heut schon angst. Immer das Schimpfen! (26, 51–52)

The young poet's anxiety about the state of his health is now in competition with his parents' wrath, particularly his mother's. She will be supervising the fifteen-year-old more closely than he is accustomed to during their month together in the summer at Bad Steben, monitoring his behaviour against the yardstick of her strict Christian morality.

Although there are expressions of doubt about his Christian faith in 1913, they appear to fall short of the 'Glaubenskrise' that has been mooted for Brecht in that year.[26] At Bad Steben, Brecht is still a firm believer and that remains the case when the diary concludes at the end of the year. Life at the sanatorium has its rewards. He regularly attends the theatre and classical music concerts. He spends much time in the reading room, hatching grand literary plans and noting eleven poems in his diary. For the most part, his compositions are satirical verse about fellow guests and the ubiquitous portrayals of heroic deaths. He notes with satisfaction the view of his admired Frau Veeh from Weimar, 'Ich habe das Gefühl, Eugen, als ob Sie noch einmal ein ganz Großer unseres Volkes werden würden'. (26, 67) He takes regular baths, drinks a beaker of chalybeate water every morning and afternoon and notes cheerfully at the end of the stay, 'Befinden sehr gut. Herzbeschwerden fast verschwunden'. (26, 67)

Two poems noted in *Tagebuch No 10* that summer stand out by virtue of their contrasting poetic projections of resolutions to his predicament, 'Sturm', (26, 43) which was written just before Bad Steben, and 'Feiertag'.

26 Hans-Harald Müller and Tom Kindt, *Brechts frühe Lyrik. Brecht, Gott, die Natur und die Liebe* (Munich: Wilhelm Fink, 2002), 22.

(26, 65) Both contain imagery of struggle with violent storms, entwined with elements of, respectively, militarist and Christian discourses. Speirs identifies 'Sturm' as epitomising Brecht's vision of life as violent confrontation, typically expressed through stark, melodramatic contrasts.[27] Used in the sense of a military onslaught, 'Sturm' is an exhortation to the attainment of extreme ambition through ruthless action:

> Ihr müßt die Früchte gleich im ersten Ansturm pflücken!
> Müßt über Berg und Tal mutig hinweg euch heben
> Und müßt in gewaltigem Stürmen und Streben
> Nützen der ersten Begeisterung frohes Entzücken!
>
> Seht auf das Ganze, achtet nicht der Lücken
> Und seid eilfertig – denn sonst wird das Leben
> Das rastlos unermüdlich tätig, niemals euch vergeben
> Wird euch das Ziel von Tag zu Tag entrücken.
>
> Sonst werdet ihr, am Ende eures Lebens
> Dastehen ratlos, denn ihr habt vergebens
> Im Kampf mit Kleinigkeiten eure Kraft verloren.
>
> Seid mit Kleinem verzweifelt im Kampfe gesessen
> Im Tal und habt den Gipfel drüber vergessen – – –
> – Denn Großes wird im ersten Sturm geboren!

It is not difficult to associate the poetic voice in this spur to greatness with the boy as commander-in-chief delivering battle plans to his generals. Echoing the language of popular patriotic verse familiar from the school curriculum and ritual celebration, the poem is one of Brecht's more successful early experiments with the sonnet form. The form serves to structure an antithetical argument, which articulates an attitude of mind for the Warrior – and by implication for the Poet – in which prized ambition is to be seized through violent struggle. If success is to be achieved, that struggle must be strategically conceived and rapidly executed. Life is unforgiving to those who do not adopt such an attitude. The Warrior himself comes

27 Ronald Speirs, 'Gedichte 1913–1917', in *Brecht Handbuch*, vol. 2, 23–27 (24).

to embody the storm, at least for the duration of the onslaught. The over-riding imperative to secure greatness through decisive action renders all else insignificant.

By contrast, in 'Feiertag' he composes a poem which invokes the recovery of health and happiness through withdrawal from the stormy world into the immortal soul:[28]

> Einmal – – –
> Kroch ich ganz in mich selbst zurück
> Und blieb in meiner Seele dämmerfahl
> Allein mit meinem Glück.
>
> Ich belauschte des Herzens pulsenden Schlag
> Und fühlte brausen das rote Blut
> Da ward's in meiner Seele Feiertag
> Und eine Sonne strahlte rein und gut.
>
> Und ich dachte:
> Daß ich für mich allein, ganz allein ein Wesen wär
> Und hörte, wie meine Seele heimlich lachte – – –:
> Tobe, du Welt des Jammers, umher! (26, 65)

This pious son of a devout mother writes here with the devotional attitude encouraged by his Confirmation piece. In its reliance not on the will of the individual but on God's grace for the resolution of his predicament, 'Feiertag' acts as a counterpoint to 'Sturm' and other works that articulate the aggressive attitude identified, in their respective manners, by Speirs and Pietzcker. The poetic subject conceives of the soul, God's precious gift, as a haven within the self, into which he withdraws. From there, he joyously observes – and feels in the Pietist manner – the vigorous working of his heart. Nestled in his soul, he is immune to the ravages of the world around. Stark, melodramatic contrasts are banished from this blissful scene.

28 'Feiertag' has hitherto received no critical attention. Like the other verse in *Tagebuch No 10*, it lacks the qualities of the great poetry that Brecht began to write soon after.

Christian faith is affirmed in the imaginative projection of a healthy heart within a composition of sustained inwardness.

Brecht would, of course, later reject this lyrical stance in vehement terms, just as he would reject Christianity and any indulgence of feeling. Throughout his life, he would, however, cultivate other forms of contemplative writing in poetry and prose, for example *Geschichten vom Herrn Keuner* and *Buckower Elegien*, within a characteristically dialogic structure, frequently turning for inspiration to cultures beyond modern Europe.[29] However, in the summer of 1913 the boy attached a special significance to 'Feiertag': it was the first piece that he submitted for publication. (26, 67) For a short while, he could entertain the thought that the prospect of happiness attained through God's grace could be reconciled with his literary ambition. He had the makings of a Christian writer of Inner Emigration. However, after returning home from Bad Steben he noted, 'Erlebte auch dieser Tage meinen ersten Durchfall. Hatte das Gedicht "Feiertag" an die *Jugend* geschickt in voreiliger unüberlegter Weise. Bekam natürlich keine Antwort'. (26, 67) Like 'Sturm', 'Feiertag' offered the prospect of, at best, only a partial resolution of his predicament.

Doubts about Christianity arose when, in December 1913, his father fell ill with a serious abdominal complaint: 'Was ist das Christentum eine bequeme Religion: Man glaubt fest an *die* Hilfe Gottes! – Und ich zweifle!'. (26, 90) Shortly after, he notes a draft of the third scene of his first completed play *Die Bibel*. (26, 93) As Rohse has argued at length, *Die Bibel* is the work of a believer, who poses the question whether an osten-

29　For a discussion of the dialogic structure in Brecht's verse see Tom Kuhn, 'Brecht als Lyriker', in *Brecht Handbuch*, vol. 2, 1–21. Speirs, '"Kalt oder heiß – Nur nit lau!"', 56, acknowledges in the poem 'Sommer' an 'element that does not belong to the complex of Saturnine melancholy', namely poetic 'descriptions of the poet's tranquil mood'. Speirs further identifies Brecht's attraction to 'contemplative, unresisting or merely passive' figures, first and foremost Christ, and Brecht's depiction of them in his dramas, in which he embeds them in a 'melodramatic action driven along by the aggressive forms of behaviour that had dominated his imagination in his early poetry'. (57–58)

sibly Christian society is capable of following Christ's example.[30] After
his father's successful operation, near the diary's end comes 'Dank': 'Herr
Gott, ich danke dir!/ Ich schrei es heraus aus Not und Leid/ Und meine
Brust wird vor Liebe weit/ Herr Gott, ich danke!'. (26, 103)

Soon after, Brecht would start to gain the recognition he craved
through publications in local Augsburg newspapers. This recognition grew
with his publication of further patriotic pieces after the outbreak of the
First World War. However, the heart condition continued to plague him. In
diary entries on two successive days in 1916, he adopts contrasting attitudes
towards the storm. In the first, he invokes imagery drawn from military
strategy, with a view to mastering his heart: 'Jetzt werde ich gesünder. Der
Sturm geht immer noch, aber ich lasse mich nimmer unterkriegen. Ich
kommandiere mein Herz. Ich verhänge den Belagerungszustand über mein
Herz. Es ist schön, zu leben'. (26, 108) The following day he is reduced to
acknowledging, 'Nein. Es ist sinnlos, zu leben. Heute Nacht habe ich einen
Herzkrampf bekommen, daß ich staunte, diesmal leistete der Teufel erstklas-
sige Arbeit'. (26, 109) As the poetry poured out of him, his response to his
evidently intractable predicament shifted between violent assertions of will
and resigned acceptance of his condition, the former predominating in his
early writing. Essentially the same tension between the poles of an egotisti-
cal, vitalist and a selfless, cerebral individual would manifest itself – shot
through with irony – throughout his life within the multiple constellations
of the personas that he adopted and of the figures that he created in his
works.[31] In his later years, he would place the greater emphasis upon the
wisdom of the selfless, cerebral individual. From 1916, however, he could no

30 Rohse, 57–152.
31 For a discussion of those figures in his dramas see Frank Thomsen, Hans-Harald
 Müller and Tom Kindt, *Ungeheuer Brecht. Eine Biographie seines Werks* (Göttingen:
 Vandenhoeck & Ruprecht, 2006). Speirs, '"Kalt oder heiß – Nur nit lau!"', 58, con-
 cludes, 'With the invention of epic theatre Brecht was able to put his insight into
 the worth of ironic distance into dramaturgical practice. On the other hand, the
 melodrama generated by Saturnine "Dreckklöße" from the lineage of Baal proved to
 be just as necessary to inject life into epic theater as the alienating techniques Brecht
 later developed to hold life at a critical distance'.

longer accept the blandishments of Christianity, which became for him, at best, a mythology. The poem 'Die Bibel', written shortly after his mother's death in 1920, concludes with the lines, 'Jetzt liegt meine Mutter under der Erde/ Ich höre sie noch, wie sie meinen Konfirmationsspruch spricht:/ Es ist ein köstlich Ding, daß das Herz fest werde'. (13, 184)[32]

32 The poem was published in 1930 under the title 'Erinnerungen'. (13, 466)

Rhys W. Williams: List of Publications

Authored Books

Carl Sternheim. A Critical Study (Berne: Peter Lang, 1982). British and Irish Studies in German Language and Literature, 5; Europäische Hochschulschriften, 494. ISBN 3-261-04991-X, iv + 272 pp.

Edited Works

With Heinz Ludwig Arnold, *Carl Sternheim* (Munich: Text + Kritik, 1985), ISBN 3-88377-206-2, 112 pp.

With Helmut Peitsch, *Berlin seit dem Kriegsende*, Manchester New German Texts (Manchester: Manchester University Press, 1989), ISBN 0-7190-2668-7 / 0-7190-2658-X, 159 pp.

With Stephen Parker and Colin Riordan, *German Writers and the Cold War, 1945–61* (Manchester: Manchester University Press, 1992), ISBN 0719026628, vi + 250 pp.

General Editor, 'Contemporary German Writers' Series (Cardiff: University of Wales Press, 1995–2008).

Journal Articles and Book Chapters

'Carl Sternheim's Use of the Sea-Serpent Topos: An Amplification', *Arcadia*, 11 (1976), 3, 288–90.

'Carl Sternheim's Image of Van Gogh', *Modern Language Review*, 72 (1977), 1, 112–24. Reprinted in *Twentieth-Century Literary Criticism*, ed. Sharon K. Hall (Detroit: Gale, 1983).

'Carl Sternheim's Image of Marx and his Critique of the German Intellectual Tradition', *German Life and Letters*, 32 (1978), 1, 19–29.

'Heinrich Böll and the "Katharina Blum" Debate', *Critical Quarterly*, 21 (1979), 3, 49–58.

'Carl Sternheim's "Tasso oder Kunst des Juste Milieu": An Alternative History of German Literature', *Modern Language Review*, 75 (1980), 124–37.

'Carl Sternheim's Debt to Flaubert: Aspects of a Literary Relationship', *Arcadia*, 15 (1980), 149–63.

'From Painting into Literature: Carl Sternheim's Prose Style', *Oxford German Studies*, 12 (1981), 139–57.

'Martin Walsers *Ehen in Philippsburg*: Versuch einer Neubewertung', in *Martin Walser*, ed. Heinz Ludwig Arnold, 2nd edition (Munich: Text + Kritik, 1983), 38–50.

'Carl Sternheim und Molière', *Weimarer Beiträge*, 29 (1983), 6, 1030–47.

'Primitivism in the Works of Carl Einstein, Carl Sternheim and Gottfried Benn', *Journal of European Studies*, 13 (1983), 4, 247–67.

'Kampf der Metapher: Ideologiekritik in Sternheims Nachkriegskomödien am Beispiel des "Nebbich"', in *Carl Sternheim*, eds Heinz Ludwig Arnold and Rhys Williams (Munich: Text + Kritik, 1985), 35–48.

'Making up for Lost Time: Aspects of West German Fiction in the 1950s and 1960s', inaugural lecture (Swansea: University College of Swansea, 1985), 24 pp.

'Max Reinhardt and Sternheim', in *Max Reinhardt. The Oxford Symposium*, eds Margaret Jacobs and John Warren (Oxford: Oxford Polytechnic, 1986), 96–111.

'Carl Einstein's "Negerplastik" and the Aesthetics of Expressionism', in *Expressionism in Focus*, ed. Richard Sheppard (Blairgowrie: Lochee, 1987), 73–92.

'Alfred Andersch', in *The Modern German Novel*, ed. Keith Bullivant (Leamington Spa: Berg, 1987), 57–71.

'Siegfried Lenz', in *The Modern German Novel*, ed. Keith Bullivant (Leamington Spa: Berg, 1987), 209–22.

'The Forerunners of German Modernism', *Komparatistische Hefte* 15/16 (1987), 247–50.

'Culture and Anarchy in Georg Kaiser's "Von morgens bis mitternachts"', *Modern Language Review*, 83 (1988), 2, 364–74.

'"Nicht programmatisch, sondern human": Alfred Andersch in England', in *Common Currency? Aspects of Anglo-German Literary Relations since 1945. London Symposium*, ed. John L. Flood (Stuttgart: Hans-Dieter Heinz, 1991), 57–70.

'Deutsche Literatur in der Entscheidung: Alfred Andersch und die Anfänge der Gruppe 47', in *Die Gruppe 47 in der Geschichte der Bundesrepublik*, eds Justus Fetscher, Eberhard Lämmert and Jürgen Schutte (Würzburg: Königshausen & Neumann, 1991), 23–43.

With Colin Riordan, 'Introduction', in *German Writers and the Cold War, 1945–61*, eds Rhys W. Williams, Stephen Parker and Colin Riordan (Manchester: Manchester University Press, 1992), 1–6.

'"Und wenn man sich überlegt, daß damals sogar Leute wie Adorno daran teilgenommen haben…": Alfred Andersch and the Cold War', in *German Writers and the Cold War, 1945–61*, eds Rhys W. Williams, Stephen Parker and Colin Riordan (Manchester: Manchester University Press, 1992), 221–44.

'The Politics of Evasion: Alfred Andersch's *Sansibar oder der letzte Grund*', *Exeter Tapes*, ed. Keith Cameron (Cardiff : Drake Educational, 1992).

'Carl Sternheim and the Debate on German War Aims in 1914', *Modern Language Review*, 88 (1993), 1, 126–36.

'Culture and Anarchy in Expressionist Drama', in *Expressionism Reassessed*, eds Shulamith Behr, David Fanning and Douglas Jarman (Manchester: Manchester University Press, 1993), 201–11.

'Oskar Matzerath as "Heimatvertriebener": The Politics of Exile in Günter Grass's *Die Blechtrommel*', in *Connections. Essays in Honour of Eda Sagarra on the Occasion of her 60th Birthday*, eds Peter Skrine, Rosemary E. Wallbank-Turner and Jonathan West (Stuttgart: Hans-Dieter Heinz, 1993), 291–304.

'Andersch, Efraim und England', in *Alfred Andersch. Perspektiven zu Leben und Werk*, eds Irene Heidelberger-Leonard and Volker Wehdeking (Opladen: Westdeutscher Verlag, 1994), 122–30.

'Conrad Felixmüller: The Literary and Cultural Milieu', in *Conrad Felixmüller, 1897–1977. Between Politics and the Studio*, eds Shulamith Behr and Amanda Wadsley (Leicester: Leicestershire Museums, Arts and Records Service, 1994), 28–34.

'"Ich rechne vor allen anderen von jetzt ab vor allem auf Sie": The Unpublished Correspondence between Carl Sternheim and his English Translator B. J. Morse', in *Carl Sternheim 1878–1942. Londoner Symposium*, eds Andreas Rogal and Dugald Sturges (Stuttgart: Hans-Dieter Heinz, 1995), 151–68.

With Colin Riordan, 'Gespräch mit Peter Schneider', in *Peter Schneider*, ed. Colin Riordan, Contemporary German Writers, 1 (Cardiff: University of Wales Press, 1995), 24–35.

'"Ein gewißes Maß subjektiver Verzweiflung...": Peter Schneider's *Lenz*', in *Peter Schneider*, ed. Colin Riordan, Contemporary German Writers, 1 (Cardiff: University of Wales Press, 1995), 50–67.

'Politische und ästhetische Landschaften: Das Werk Alfred Anderschs als Reiseliteratur', in *Reisen im Diskurs. Modelle der literarischen Fremderfahrung von den Pilgerberichten bis zur Postmoderne*, eds Anne Fuchs and Theo Harden (Heidelberg: Carl Winter, 1995), 574–86.

'German-Speaking Countries', in *The Oxford Guide to Contemporary Writing*, ed. John Sturrock (Oxford: Oxford University Press, 1996), 165–83.

'"The Selections of the Committee are not in Accord with the Requirements of Germany": Contemporary English Literature and the Selected Book Scheme in the British Zone of Germany (1945–1950)', in *The Cultural Legacy of the British Occupation in Germany*, ed. Alan Bance (Stuttgart: Hans-Dieter Heinz, 1997), 110–38.

"'Ähnlich stehle ich mir auch alles zusammen...': Sarah Kirsch's *Das simple Leben*', in *Sarah Kirsch*, eds Mererid Hopwood and David Basker, Contemporary German Writers, 4 (Cardiff: University of Wales Press, 1997), 75–89.

"'Ein treuer Diener seines Herrn": Carl Sternheim und Franz Blei', in *Franz Blei – Mittler der Literaturen*, ed. Dietrich Harth (Hamburg: Europäische Verlagsanstalt, 1997), 139–51.

"'Community Plants the Forests of Justice": Gustav Landauer, Ecosocialism and German Expressionism', in *Green Thought in German Culture. Historical and Contemporary Perspectives*, ed. Colin Riordan (Cardiff: University of Wales Press, 1997), 55–73.

"'A pint für die vortragsreisende Lady": Sarah Kirsch, Dylan Thomas and Swansea', in *Fest Freundschaft. Short Essays in Honour of Peter Johnson*, eds Hugh Ridley and Karin McPherson (Dublin: University College Dublin, 1997), 71–79.

'German Literature and its Discontents: Jurek Becker's *Warnung vor dem Schriftsteller*', in *Jurek Becker*, ed. Colin Riordan, Contemporary German Writers, 5 (Cardiff: University of Wales Press, 1998), 85–93.

'Dear Uwe – Dear Mr. Frisch', *new books in german*, Autumn 1999, 9.

'Inventing West German Literature: Alfred Andersch and the Gruppe 47', in *The Gruppe 47 Fifty Years On. A Re-Appraisal of its Literary and Political Significance*, eds Stuart Parkes and John J. White, *German Monitor*, 45 (Amsterdam and Atlanta, GA: Rodopi, 1999), 69–87.

"'Uwe Timm oder unsicher in die 70er Jahre": *Heißer Sommer* and *Kerbels Flucht*', in *Uwe Timm*, ed. David Basker, Contemporary German Writers, 7 (Cardiff: University of Wales Press, 1999), 47–65.

'Nachrichten von der Grenze: Alfred Andersch's Prose Writings', in *Nachdenken über Grenzen*, eds Rüdiger Görner and Suzanne Kirkbright (Munich: iudicium, 1999), 161–73.

"'Fahrt ins Graue mit obligatem Schwellenreißer": German Literature in 1949', in *1949/1989. Cultural Perspectives on Division and Unity in East and West*, eds Clare Flanagan and Stuart Taberner, *German Monitor*, 50 (Amsterdam and Atlanta, GA: Rodopi, 2000), 59–71.

"'Jeder Band Goethe in Euren Bücherschränken [...] stärkt Eure gräßliche Geltung": Goethe among the Expressionists', in *'Nachdenklicher*

Leichtsinn: Essays on Goethe and Goethe Reception. Proceedings of the Conference 'Goethes offene Tafel', eds Heike Bartel and Brian Keith-Smith (Lewiston, Queenston and Lampeter: Mellen, 2000), 239–56.

"'Geschichte berichtet, wie es gewesen. Erzählung spielt eine Möglichkeit durch": Alfred Andersch and the Jewish Experience', in *Jews in German Literature since 1945. German-Jewish Literature?*, ed. Pól Ó Dochartaigh, *German Monitor*, 53 (Amsterdam and Atlanta, GA: Rodopi, 2000), 477–89.

"'Jeder Satz soll schön sein": Gespräch mit Hermann Peter Piwitt', in *Hermann Peter Piwitt*, ed. David Basker, Contemporary German Writers, 9 (Cardiff: University of Wales Press, 2000), 10–23.

"'Heimat als Aggregatzustand der Seele macht schwer und traurig": Hermann Peter Piwitt's *Deutschland. Versuch einer Heimkehr*', in *Hermann Peter Piwitt*, ed. David Basker, Contemporary German Writers, 9 (Cardiff: University of Wales Press, 2000), 47–65.

'Alfred Andersch 1914–1980', *new books in german*, Autumn 2001, 13.

'Die Geographie des Erzählens: Der Schriftsteller Hans-Ulrich Treichel', in *Zehn Jahre Nachher. Poetische Identität und Geschichte in der deutschen Literatur nach der Vereinigung*, eds Fabrizio Cambi and Alessandro Fambrini (Trento: Dipartimento di Scienzie Filologiche e Storiche, 2002), 271–82.

"'Mein Unbewusstes kannte ... den Fall der Mauer und die deutsche Wiedervereinigung nicht": The Writer Hans-Ulrich Treichel', *German Life and Letters*, 55 (2002), 2, 208–18.

"'Ich bin fast immer allein!": Carl Sternheim als Exilautor', in *Katastrophen und Utopien. Exil und innere Emigration (1933–1945)*, ed. Hermann Haarmann (Berlin: Bostelmann & Siebenhaar, 2002), 79–93.

Editor, 'Carl Sternheim, Briefe an Benjamin Joseph Morse', in *Katastrophen und Utopien. Exil und innere Emigration (1933–1945)*, ed. Hermann Haarmann (Berlin: Bostelmann & Siebenhaar, 2002), 215–71.

'Survival without Compromise? Reconfiguring the Past in the Works of Hans Werner Richter and Alfred Andersch', in *Flight of Fantasy. New Perspectives on 'Inner Emigration' in German Literature, 1933–1945*,

eds Neil H. Donahue and Doris Kirchner (New York and Oxford: Berghahn, 2003), 211–22.

"'Er klammerte sich an alle Gegenstände': Büchner, Peter Schneider and the Uses of *Germanistik*', in *Experiencing Tradition. Essays of Discovery. In Memory of Keith Spalding (1913–2002)*, eds Hinrich Siefken and Anthony Bushell (York: Ebor Press, 2003), 228–34.

"'Leseerfahrungen sind Lebenserfahrungen'": Gespräch mit Hans-Ulrich Treichel', in *Hans-Ulrich Treichel*, ed. David Basker, Contemporary German Writers, 12 (Cardiff: University of Wales Press, 2004), 12–27.

"'Caravaggio in Preußen'": Hans-Ulrich Treichel's *Der irdische Amor*', in *Hans-Ulrich Treichel*, ed. David Basker, Contemporary German Writers, 12 (Cardiff: University of Wales Press, 2004), 94–110.

'Martin Walser, Alfred Andersch and the *Süddeutscher Rundfunk*', in *Seelenarbeit an Deutschland. Martin Walser in Perspective*, eds Stuart Parkes and Fritz Wefelmeyer, *German Monitor*, 60 (Amsterdam: Rodopi, 2004), 35–45.

"'Das sichtbare und das unsichtbare deutsche Vaterland'": Die Zeitschrift *Das Innere Reich*', in *Heimat, liebe Heimat. Exil und Innere Emigration (1933–1945)*, ed. Hermann Haarmann (Berlin: Bostelmann & Siebenhaar, 2004), 93–105.

'Prosaic Intensities: The Short Prose of German Expressionism', in *A Companion to the Literature of German Expressionism*, ed. Neil H. Donahue (Rochester, NY: Camden House, 2005), 89–109.

'Wilhelm Worringer and the Historical Avant-Garde', in *Avant-Garde / Neo-Avant-Garde*, ed. Dietrich Scheunemann (Amsterdam and New York: Rodopi, 2005), 49–62.

"'Der werdende Mensch'": Georg Kaiser and Gustav Landauer', in *Georg Kaiser and Modernity*, ed. Frank Krause (Göttingen: V&R Unipress, 2005), 75–88.

"'Eine ganz normale Kindheit'": Uwe Timm's *Am Beispiel meines Bruders*', in *(Un)erfüllte Wirklichkeit. Neue Studien zu Uwe Timms Werk*, eds Frank Finlay and Ingo Cornils (Würzburg: Königshausen & Neumann, 2006), 173–84.

'"Und muß ich von Dante schweigen, zieht Italien gegen uns?": Carl Sternheim's Opposition to the First World War', in *The First World War as a Clash of Cultures*, ed. Fred Bridgham (Rochester, NY: Camden House, 2006), 118–28.

'"Selbstdeutung und Selbstfindung": Gespräch mit Uwe Timm', in *Uwe Timm II*, ed. David Basker, Contemporary German Writers, 14 (Cardiff: University of Wales Press, 2007), 12–25.

'A Perfectly Ordinary Childhood: Uwe Timm's *Am Beispiel meines Bruders*', in *Uwe Timm II*, ed. David Basker, Contemporary German Writers, 14 (Cardiff: University of Wales Press, 2007), 71–84.

'Memorialisation and Personal Memory: Uwe Timm's *Der Freund und der Fremde*', in *Uwe Timm II*, ed. David Basker, Contemporary German Writers, 14 (Cardiff: University of Wales Press, 2007), 85–97.

'Der Wiederaufbau der deutschen Literatur', *Aus Politik und Zeitgeschichte*, 18 June 2007, 12–18.

'Frau Wernicke kann's Maul nicht halten', in *Berlin im Kopf – Arbeit am Berlin-Mythos. Exil und Innere Emigration 1933 bis 1945*, ed. Hermann Haarmann (Berlin: Bostelmann & Siebenhaar, 2008), 122–36.

'Ich bin kein Emigrant, ich bin kein Dissident: Sarah Kirsch und die DDR', in *Deutsch-deutsches Exil: Schriftstellerinnen und Schriftsteller aus der DDR in der Bundesrepublik*, eds Walter Schmitz and Jörg Bernig (Dresden: Thelem, 2009), 385–400.

Articles in Reference Works

'Jürg Amann', in *Kritisches Lexikon zur deutschsprachigen Gegenwartsliteratur*, 1982, 9 pp. Supplement, 1984, 6 pp. Supplement, 1991, 16 pp.

'Alfred Andersch', in *Kritisches Lexikon zur deutschsprachigen Gegenwartsliteratur*, 1984, 15 pp. Supplement, 1988, 6 pp. Supplement, 1991, 7 pp.

'Hermann Kasack', 'Heinar Kipphardt' and 'Elisabeth Langgässer', in *Metzler Autoren Lexikon*, ed. Bernd Lutz (Stuttgart: Metzler, 1986).

'Arnolt Bronnen', in *Metzler Autoren Lexikon*, 2nd edn, ed. Bernd Lutz (Stuttgart: Metzler, 1994), 108–9.

'Carl Sternheim', in *Reference Guide to World Literature*, 2nd edn, ed. Lesley Henderson, 2 vols (London and Detroit: St James Press, 1994), vol. 2, 1151–54.

'Wilhelm Hausenstein', 'Julius Meier-Graefe' and 'Wilhelm Worringer', in *The Dictionary of Art*, ed. Jane Shoaf Turner (London: Macmillan, 1996), 14, 234; 21, 57–58; 33, 383–85.

'Carl Sternheim', 'Georg Kaiser' and 'Ernst Toller', in *Encyclopedia of Literary Translation*, ed. Olive Classe (Chicago and London: Fitzroy Dearborn, 2000), 751–53, 1334–35, 1398–400.

'Carl Sternheim', 'Carl Einstein' and 'Wolfgang Koeppen', in *Encyclopedia of German Literature*, ed. Matthias Konzett (Chicago and London: Fitzroy Dearborn, 2000), 245–47, 605–7, 903–5.

'Georg Kaiser (1878–1945)', 'Sternheim, Carl (1 April 1878–3 November 1942)' and 'Ernst Toller (1893–1939)', in *Literary Encyclopedia*, September–November 2006.

Note on Contributors

DAVID BASKER is Senior Lecturer in German at Swansea University. He has published on contemporary German literature and inner emigration and has edited several volumes in Swansea's Contemporary German Writers series. His publications include: *Chaos, Control and Consistency. The Narrative Vision of Wolfgang Koeppen* (1993); *Sarah Kirsch* (co-editor Mererid Hopwood, 1997); *Uwe Timm* (1999); *Hermann Peter Piwitt* (2000); *Hans-Ulrich Treichel* (2004); and *Uwe Timm II* (2007). He is currently working on German crime fiction.

ELIZABETH BOA is Emeritus Professor of German, University of Nottingham. Her publications include: *Critical Strategies. German Fiction in the Twentieth Century* (with J. H. Reid, 1972); *The Sexual Circus. Wedekind's Theatre of Subversion* (1987); *Kafka. Gender, Class, Race in the Letters and Fictions* (1996); *Heimat – A German Dream. National Identity and Local Loyalties in German Culture 1890–1990* (with Rachel Palfreyman, 2000); *Women and the Wende* (co-editor Janet Wharton, 1994); *Anne Duden. A Revolution of Words* (co-editor Heike Bartel, 2003); and *Pushing at Boundarie. Approaches to Contemporary German Women Writers from Karen Duve to Jenny Erpenbeck* (co-editor Heike Bartel, 2006).

DAVID CLARKE is Lecturer in German, University of Bath. His publications include: *'Diese merkwürdige Kleinigkeit einer Vision'. Christoph Hein's Social Critique in Transition* (2002); *Christoph Hein* (co-editor Bill Niven, 2000); *German Cinema since Unification* (2006); *Reinhard Jirgl – Perspektiven, Lesarten, Kontexte* (co-editor Arne de Winde, 2007); and *Place in Post-War German Literature* (co-editor Renate Rechtien, 2009).

PAUL COOKE is Professor of German Cultural Studies, University of Leeds. His publications include: *Speaking the Taboo. A Study of the Work of*

Wolfgang Hilbig (2000); *The Pocket Essential to German Expressionist Film* (2002); and *Representing East Germany. From Colonization to Nostalgia* (2005). He is currently writing a monograph for Manchester University Press on Contemporary German Cinema.

NEIL H. DONAHUE is Professor of German and Comparative Literature, Hofstra University, New York. His publications include: *Forms of Disruption. Abstraction in Modern German Prose* (1993); *Invisible Cathedrals. The Expressionist Art History of Wilhelm Worringer* (1995); *Voice and Void. The Poetry of Gerhard Falkner* (1999); *Karl Krolow and the Poetics of Amnesia in Post-war Germany* (2002); *A Companion to the Literature of German Expressionism* (2005); and *Flight of Fantasy. New Perspectives on Inner Emigration in German Literature, 1933–1945* (co-editor Doris Kirchner, 2003).

OWEN EVANS is Senior Lecturer in Media and Communication Studies at Swansea University. His publications include: *'Ein Training im Ich-Sagen'. Personal Authenticity in the Prose Work of Günter de Bruyn* (1996); and *Mapping the Contours of Oppression. Subjectivity, Truth and Fiction in Recent German Autobiographical Treatments of Totalitarianism* (2006). He is co-founding editor of *Studies in European Cinema*, and is currently working on a new study of German film in the twenty-first century.

ALLYSON FIDDLER is Professor of German and Austrian Studies, Lancaster University. Her publications include: *Rewriting Reality: An Introduction to Elfriede Jelinek* (1994); *'Other' Austrians. Post-1945 Austrian Women's Writing* (1998); and *From Perinet to Jelinek. Viennese Theatre in its Political and Intellectual Context* (co-editors W. E. Yates and John Warren, 2001). Recent articles on Austrian writers and filmmakers deal with Carinthia and interculturalism, sport and national identity in drama, and intermediality in Jelinek's *Die Ausgesperrten*. She is currently working on a monograph about protest art in contemporary Austria.

FRANK FINLAY is Professor of German, University of Leeds. His publications include: *The Rationality of Poetry. Heinrich Böll's Aesthetic Thinking* (1996); *Recasting German Identity. Culture, Politics and Literature in the*

Berlin Republic (co-editor Stuart Taberner, 2002); *'(Un)-erfüllte Wirklich-keit'. Studien zu Uwe Timm Werk* (co-editor Ingo Cornils, 2006); *New German Literature. Life-Writing and Dialogue with the Arts* (co-editors Julian Preece and Ruth J. Owen, 2007). He is a member of an international team working on the complete edition of Heinrich Böll's work.

BRIGID HAINES is Reader in German at Swansea University. Her publications include: *Dialogue and Narrative Design in the Works of Adalbert Stifter* (1991); *Herta Müller* (1998); *Contemporary Women's Writing in German. Changing the Subject* (with Margaret Littler, 2004); and *Libuše Moníková in memoriam* (co-editor Lyn Marven, 2005). She is currently working on German-language writers from former eastern bloc countries.

MERERID HOPWOOD is a tutor in German through the medium of Welsh at Swansea University. She was the first woman to win the prestigious Chair at the National Eisteddfod in 2001. In 2008 she was awarded the Eisteddfod's Prose Medal for her book *O Ran*.

JON HUGHES is Senior Lecturer in German at Royal Holloway, University of London. His publications include *Facing Modernity. Fragmentation, Culture, and Identity in Joseph Roth's Writing of the 1920s* (2006) and numerous essays and articles on German-language literature and culture of the interwar period. In addition to continued research on Joseph Roth, he is currently engaged in a project examining aspects of the cultural impact of sport in Germany.

JIM JORDAN is Associate Professor of German Studies, University of Warwick. His publications include: *The unpublished poems of Ernst Toller* (2000); *Migrants in German-speaking Countries. Aspects of Social and Cultural Experience* (co-editor Peter Barker, 2000); *Culture and Politics in Twentieth-century Germany* (co-editor Bill Niven, 2003); and *Crossing Boundaries* (special edition of *German Life and Letters*, 2006). He is currently working with Rob Burns on a book about diasporic culture in contemporary Germany.

DUNCAN LARGE is Professor of German, Swansea University. His books include *Nietzsche and Proust. A Comparative Study* (2001); and *The Nietzsche Reader* (co-editor Keith Ansell Pearson, 2006). Duncan has translated two of Nietzsche's works for Oxford World's Classics.

MARGARET LITTLER is Professor of Contemporary German Culture, University of Manchester. Her publications include: *Gendering German Studies* (1997); and *Contemporary Women's Writing in German. Changing the Subject* (co-author Brigid Haines, 2004). Margaret is a member of the editorial board of *German Life and Letters*. Her current project is on Turkish-German writing as a form of minor literature, as elaborated by Deleuze and Guattari.

MORAY MCGOWAN, Professor of German (1776), Trinity College Dublin. His publications include numerous pieces on modern and contemporary German literature and cultural studies. He is currently working on the theatre and drama of the later GDR and on literatures of migration in German.

STEPHEN PARKER is Henry Simon Professor of German, University of Manchester. He is the author of: *Peter Huchel. A Literary Life in 20th-century Germany* (1998); *The Modern Restoration. Re-thinking German Literary History 1930–1960* (2004, with Peter Davies and Matthew Philpotts); and *Sinn und Form. The Anatomy of a Literary Journal* (2009, with Matthew Philpotts). He is currently working on a biography of Brecht, supported by the Leverhulme Trust.

JULIAN PREECE is Professor of German at Swansea University. His publications include: *Nine Lives. Ethnic Conflict in the Polish-Ukrainian Borderlands* (with Waldemar Lotnik, 1999); *The Life and Work of Günter Grass. Literature, History, Politics* (2001); *New German Literature. Life-Writing and Dialogue with the Arts* (co-editors Frank Finlay and Ruth J. Owen, 2007); and *The Re-discovered Writings of Veza Canetti. Out of the Shadows of a Husband* (2007). He is currently working on a book project with the working title *German Literary Letters. Exchanges, Editions, Readers.*

COLIN RIORDAN lectured at the University of Wales, Swansea for twelve years and became Professor of German at the University of Newcastle upon Tyne in 1998. Since 2007 he has been Vice-Chancellor of the University of Essex. He has published widely on post-war German literature and on nature and the environment in the works of Timm, Sebald, Johnson and others.

IAN ROBERTS is Director of German at the University of Leicester. His publications include *German Expressionist Cinema. The World of Light and Shadow* (2008). He is currently working on representations of warfare in German cinema.

CHRISTIANE SCHÖNFELD currently teaches at Limerick and Galway. Her publications include: *Dialektik und Utopie* (1996); *Commodities of Desire. The Prostitute in German Literature* (2000); *Processes of Transposition. German Literature and Film* (2007); and articles on expressionism, autobiography, nineteenth and twentieth century women writers, German and Irish film, and Lion Feuchtwanger.

STUART TABERNER is Professor of Contemporary German Literature, Culture and Society, University of Leeds. He has published widely on contemporary German Literature. His publications include: *Recasting German Identity. Culture, Politics and Literature in the Berlin Republic* (co-editor Frank Finlay, 2002); *German Literature of the 1990s and Beyond* (2005); and *Contemporary German Fiction. Writing in the Berlin Republic* (ed. 2007). He is currently working on a reappraisal of West German fiction since 1949.

Index

Tabula Gratulatoria

Petra M. Bagley

David Basker

Elizabeth Boa

Hilary Brown

Anthony Bushell

Tom Cheesman

David Clarke

Paul Cooke

Ingo Cornils

Nicola Creighton

Richard B. Davies

Winifred V. Davies

Neil H. Donahue

Owen Evans

Allyson Fiddler

Frank Finlay

Axel Goodbody

Brigid Haines

Terence M. Holmes

Mererid Hopwood

Jon Hughes

Jim Jordan

Florian Krobb

Tom Kuhn

Duncan Large

Margaret Littler

Moray McGowan

Pól Ó Dochartaigh

Stephen R. Parker

Stuart Parkes

Georgina Paul

Chloe E. M. Paver

Julian Preece

T. J. Reed

Colin Riordan

Ian Roberts

Ritchie Robertson

Christiane Schönfeld

Stuart Taberner

Jo Tudor